P9-BID-412

Art: Images and Ideas

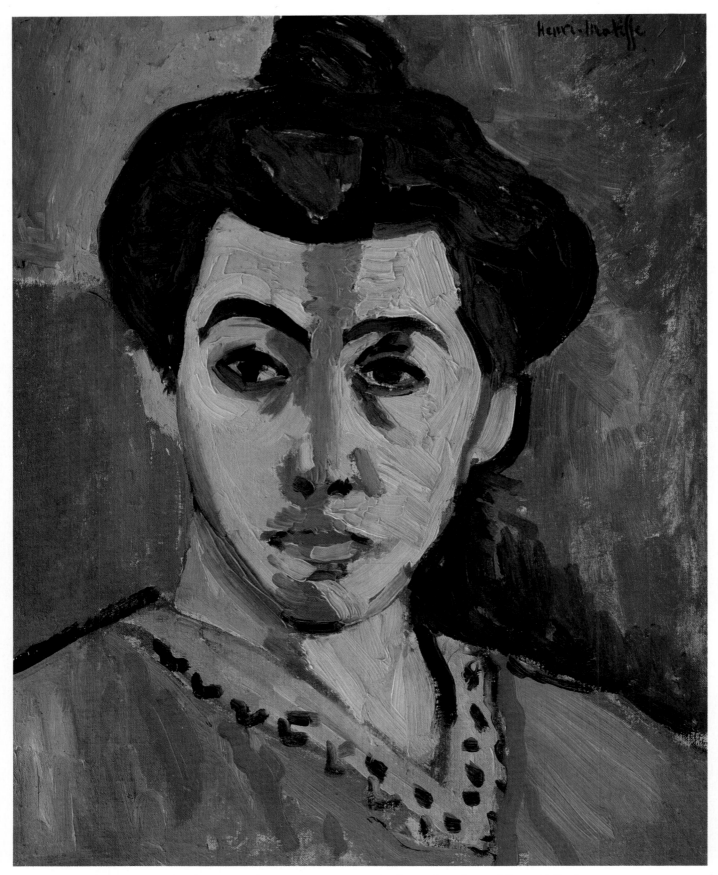

Henri Matisse, *The Green Stripe (Madame Matisse)*, 1905. Statens Museum for Kunst, Copenhagen. J. Rump Collection.

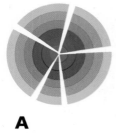

**A
Discover
Art
Book**

Art:Images and Ideas

Laura H. Chapman

Davis Publications, Inc. Worcester, Massachusetts

Copyright 1992
Davis Publications, Inc.
Worcester, Massachusetts USA

All rights reserved. No part of this publica-
tion may be reproduced or transmitted in
any form or by any means, electronic or
mechanical, including photocopying,
recording, or any storage and retrieval
system now known or to be invented, except
by a reviewer who wishes to quote short
passages in connection with a review written
for inclusion in a magazine, newspaper or
broadcast.

Every effort has been made to ensure that
the information in this book is accurate.
However, the author and publisher take no
responsibility for any harm that may be
caused by the use or misuse of any materials
or processes mentioned herein; nor is any
condition or warranty implied.

Managing Editor: Wyatt Wade
Production Editor: Nancy Dutting
Photo Acquisition: Victoria Hughes and
 Dawn Reddy
Graphic Design: Douglass Scott
Illustrator: Susan Christy-Pallo

Set in Minion and Frutiger types by
Cathleen Damplo at WGBH Design

Printed in the United States of America
ISBN: 0-87192-231-2
SE 8

10 9 8 7 6 5 4 3

Front cover:
Wassily Kandinsky,
Sketch 1 for *"Composition VII"*, 1913.
Oil on canvas 30 $\frac{1}{4}$" x 39 $\frac{3}{8}$
(78 x 99.5 cm).
Stadische Galerie im
Lenbachhaus, Munich.

Back cover:
Navaho Eye–Dazzler Blanket,
1880-1890. Woven wool.
Courtesy of the Hurst Gallery.

Editorial Advisory Board:

David Baker, Professor of Art,
University of Wisconsin, Milwaukee

Nancy Berry, Director of Public Programs,
Dallas Museum of Art, Texas

James Clarke, Supervisor of Art, Aldine, Texas

Bill McDonald, Art Education Consultant,
North Vancouver School District, Canada

Connie Newton, Professor of Art,
University of North Texas, Denton, Texas

Jerry Tollifson, Art Consultant,
Ohio State Department of Education

James Tucker, Chief, Arts and Humanities Section,
Maryland Department of Education

Editorial Consultants:

James Biggers, Art Coordinator,
Gaston County Public Schools, North Carolina

Faith Clover, Portland Public Schools, Oregon

Lillia Garcia, Dade County Public Schools, Florida

Vicki Jones Pittman, National City, California

Stephena Runyan, Coordinator of Art,
Virginia Beach City Public Schools, Virginia

Scott Sanders, Chattanooga Public Schools, Tennessee

Emmy Whitehead, Coordinator of Arts Education,
Pitt County Schools, North Carolina

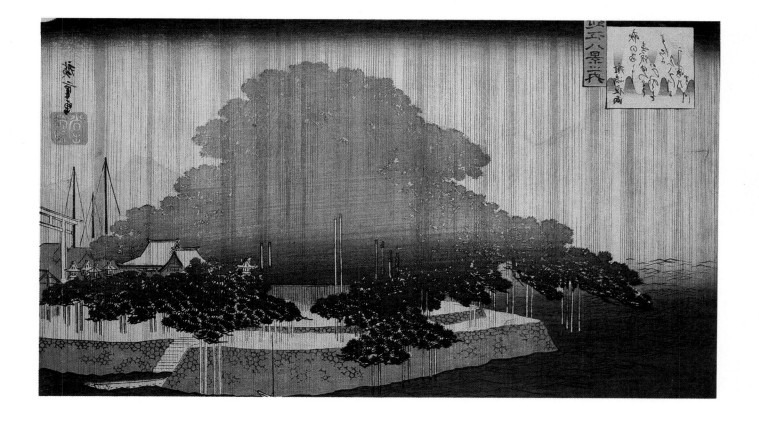

Contents

Introduction 2

1 The Creative Process and Careers in Art 5

Creativity in Art 6
Features of the Artistic Process 8
Education and Training in Art 9
Careers in Art 10
Career Awareness 18
Summary 19
Using What You Learned 19

2 Design: The Language of Art 21

Elements of Design 22
Principles of Design 34
Design Vocabulary 40
Summary 41
Using What You Learned 41

3 Aesthetic Perception and Art Criticism 43

Aesthetic Perception 44
Art Criticism 47
Criteria from Philosophies of Art 54
How Experts Use Art Philosophies 58
Agreements and Disagreements in Judging Art 59
What is a Masterpiece? 60
Summary 61
Using What You Learned 61

4 Art: A World View 63

Pre-Columbian Art 64
African Art 66
Oceanic Art 68
Indian Art 70
Southeast Asian Art 72
Chinese Art 74
Japanese Art 76
Korean Art 78
Islamic Art 79
A Closer Look 80
Summary 81
Using What You Learned 81

5 Early Art in North America 83

Native North American Art 84
Hispanic Influences 86
African Influences 87
Asian Influences 88
Women Artists 89
Early Colonial Period 1500-1700 90
Late Colonial Period 1700-1776 92
Quest for Independence 1776-1786 94
Industrialization and Growth 1860-1900 98
Ending One Era, Beginning Another 103
Timeline: North American Art to 1900 104
Summary 105
Using What You Learned 105

6 North American Art: Twentieth Century 107

Architecture 1900-1950 108
Architecture 1950-Present 110
Design 1900-1950 112
Design 1950-Present 113
Painting 1900-1950 114
Painting 1950-Present 117
Sculpture 1900-1950 120
Sculpture 1950-Present 122
Photography 1900-1950 124
Photography 1950-Present 125
Timeline: North American Art: 1900-Present 126
Summary 127
Using What You Learned 127

7 Drawing 132

Gallery 130
Meet the Artist: Katsushika Hokusai 132
Ideas for Drawing 134
Approaches to Drawing 135
Media for Drawing 136
Using Design Concepts 138
Other Ideas to Explore 146
Student Gallery 151
Summary 153
Using What You Learned 153

8 Painting 155

Gallery 156
Meet the Artist: Claude Monet 158
The Visual Elements of Painting 160
Ways to Design Paintings 161
Studies in Color 162
Media and Techniques 164
Other Ideas to Explore 168
Student Gallery 175
Summary 177
Using What You Learned 177
Careers and Painting 177

9 Printmaking 179

Gallery 180
Meet the Artist: Käthe Kollwitz 182
Ideas for Prints 184
Planning Your Prints 185
Methods of Printmaking 186
Materials for Printing 187
Relief Prints 188
Stencil Prints 192
Silkscreen Prints 192
Intaglio Prints 194
Monoprints 195
New Directions in Printmaking 196
Student Gallery 197
Summary 199
Using What You Learned 199

10 Graphic Design 201

Gallery 202
Meet the Artist: Bradbury Thompson 204
Idea Sources 206
Designing Graphics 207
Posters 208
Other Ideas to Explore 210
Student Gallery 217
Summary 219
Using What You Learned 219

11 Camera and Electronic Arts 221

Gallery 222
Meet the Artist: Charles Csuri 224
Photography 226
Images in Motion 230
Ideas for Camera Art 233
Design in Camera Arts 234
Computer Art 236
Holography 238
Student Gallery 239
Summary 241
Using What You Learned 241

12 Sculpture 243

Gallery 244
Meet the Artist: Louise Nevelson 246
Design in Sculpture 248
Media and Processes 250
Assemblage 250
Modeling 252
Carving 254
Casting 256
Metal Working 257
Other Ideas to Explore 258
Student Gallery 263
Summary 265
Using What You Learned 265
Careers and Sculpture 265

13 Crafts 267

Gallery 268
Meet the Artist: Louis Comfort Tiffany 270
Finding Ideas 272
The Design Process 272
Ceramics 273
Fiber Arts 278
Jewelry 284
Mosaics 286
Papermaking 288
Student Gallery 289
Summary 291
Using What You Learned 291

Glossary 292

Bibliography 304

Index 308

Acknowledgements 314

Photograph by Verna E. Beach.

Introduction

What are the visual arts? They are things people create for others to see and appreciate. Visual arts are not just paintings and sculptures you see in museums. They include the music video you might have watched last night on television and the pottery bowls you might have seen at a crafts fair. They include forms of art created for everyday use, like a pattern on wallpaper or a study lamp for your desk. A carved statue in a church and an elaborate Native North American headdress are examples of visual arts.

In some cultures, young people learn to create and appreciate art by watching adults create it. Most students in industrial countries today study art in school, as you are doing now.

This book will help you understand and appreciate many kinds of art. It will help you develop your skills in creating art – expressing feelings that cannot be put into words.

Some of the artworks you will study are important records of history. You might find some of them so inspiring and imaginative that you will never forget them. You will also learn to see how many ways art is part of your everyday life.

Jeff Long, *Flotsam and Jetsam*, 1982. Gouache on paper. Courtesy McDonald's Corporation.

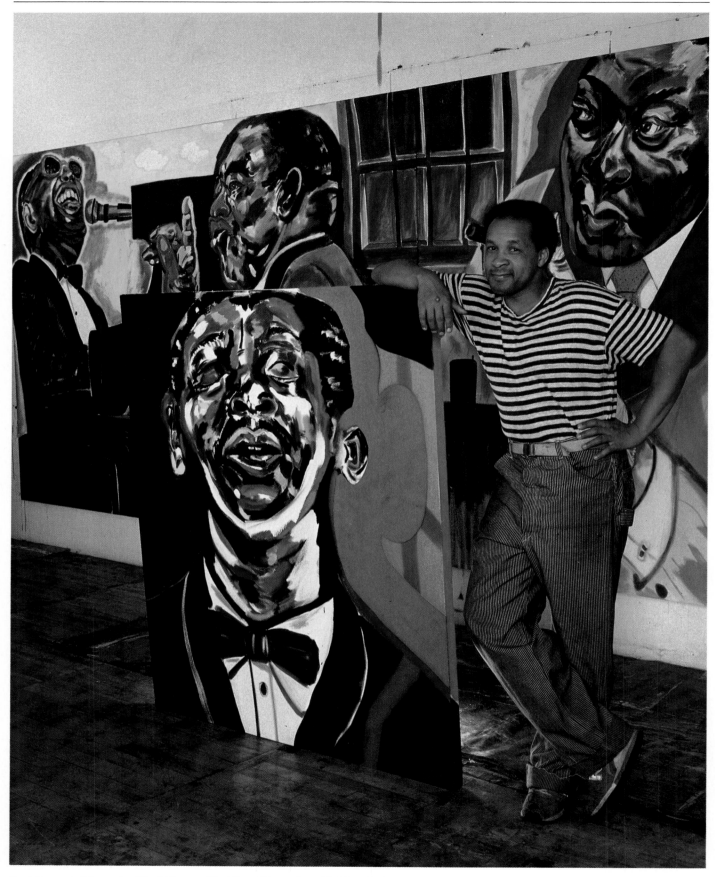

Fred Brown in his studio. Work Shown: *The Piano Players* from his Blues Series.

Chapter 1

The Creative Process and Careers in Art

Chapter Vocabulary

creative process
aesthetic perception
imagination
symbolic thinking
invention
folk art
careers in art

Artists use their eyes, hands, minds, feelings and imagination when they create art. Their work can be as personal as expressing the love of a mother for her child or as practical as designing telephones.

The kind of work artists create can make a difference in how they approach their work. For example, an industrial designer knows that products must be safe and attractive. If an artist creates an oil painting, changes can be made easily and quickly. An artist who welds sculpture in steel or who carves in stone must plan ahead, because changes are hard to make.

Art experts say that art is a link to our past and our gift to the future. Art depends on the creativity of artists and the sensitivity of the people who look at art. Without artists, there would be no gifts of art to the future. After you study this chapter and try some of the activities, you should be better able to:

Creating Art
- understand the creative process in art.
- understand the variety of careers in art.
- judge your interest in art as a career.

Aesthetics
- understand the meaning of aesthetic perception.
- understand why people create art.

Art History
- appreciate differences in the way artists from different cultures learn about art.
- understand the importance of work done by art historians.

Art Criticism
- understand the importance of evaluation in the creative process.
- understand the role of art critics and other people in the art world.

Creativity in Art

Art seems to come from a human urge or impulse to create. This human urge is a trait that animals do not have. There are five human traits that make people able to create art.

1. The Human Mind

Scientists tell us that the human brain has two sides that work together. The left half of the brain helps organize our speech and coordinate our muscles. The right half of the brain helps organize what we see, feel and remember.

Human creativity comes partly from the brain's power to integrate, or put together, our thoughts, feelings, information and actions. This means that all people are creative to some degree.

2. Aesthetic Perception

Aesthetic perception is what happens when you put together your sensations – what you see, hear, taste, smell or touch – with what you know and feel. *Aesthetic* is a Greek word for sensation based on feeling and thinking. The opposite word is *anesthetic*, which means that you can't unify, or organize, your thoughts, feelings and sensations.

Your aesthetic perceptions begin to develop as soon as you are born. You begin to see, taste, touch, hear and smell things. You get thoughts and feelings about your sensations.

Aesthetic perceptions are what make your imagination work and help you appreciate art. All people can use aesthetic perception for creating and appreciating art.

3. Imagination

Imagination means being able to picture or visualize something with your mind. It is one way you remember things. Your mind can also imagine things that you invent or make up.

Imagination starts the creative process in art. Your imagination lets you see one thing as a symbol for something else. For example, you can make scribbles or doodles on a paper. Then you can start imagining the lines as something else – faces, clouds, brooding land-scapes. Imagination is the trait that helps you understand and create symbols.

Aesthetic perception is an ability everyone needs to appreciate art and beauty in the environment. Photograph by Roy F. Bourgault.

Photograph by Verna E. Beach.

4. Symbolic Thinking

Symbolic thinking is the ability to understand that one thing (like the word "dog") is related to something else (like a real dog.) When you learn to read, write, speak and listen, you are using a system of symbols based on words.

Visual art is also based on a symbol system that uses images. You communicate through lines, shapes and other *visual elements* – things you can see. Visual elements can be put together using *principles of design*, which are guides that help visual elements work together as symbols. When that happens, the visual symbols become a form of communication. They bring out certain responses in the people who see the artwork. You will learn more about these elements and principles in Chapter 3.

5. Inventive Use of Materials

Experts think that art also comes from an urge people have for *invention*. People in all cultures have invented ways to shape materials into art. *Folk arts* and crafts are based on traditional designs and ways of using materials. Many self-taught artists – people who have no formal training in art – create art without following rules.

Critical Thinking Imagine a world in which people did not have the five traits listed here. They would be uncreative. They would be unable to perceive their world aesthetically. They would be unimaginative and uninventive. They would be unable to use symbols to communicate. Describe what would happen to our world if these traits of people were not valued or developed.

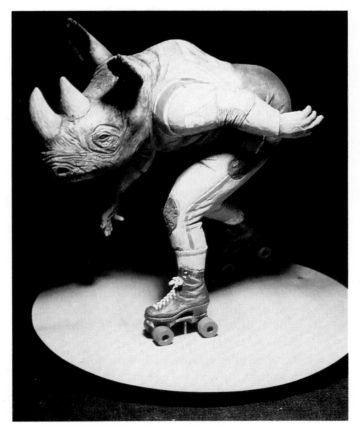

Steve Geddes, *Roller Rhino*, 1984. Carved wood, 30" (76 cm) high. Courtesy of the artist.

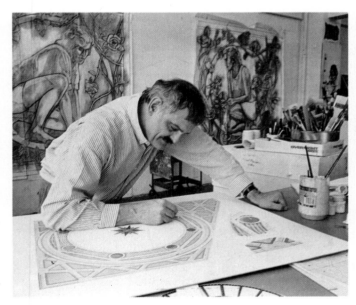

Richard Haas in his studio. Photograph by Michael Dechillo.

Julius Vitale, *The Defeat Garden Series.* Julius Vitale uses photographs as inspiration to create a variety of artworks. He adapts the colors and shapes of realistic photographs into other media. While experimenting with different materials, unexpected mistakes often occur. Vitale uses these mistakes to plan and develop new artworks. Left to right: Photograph, oil painting and video image.

Features of the Artistic Process

How do artists start to create their artworks? Researchers have learned that artists approach their work in very different ways.

Some artists work quickly and seem to have no definite plan. They are sometimes called *intuitive* artists. Intuitive means that they create art but cannot explain how or why they do it.

Some artists plan their work first and follow their plans without making many changes.

Most artists seem to combine these two ways of working. They make intuitive choices, but they also have a general plan or idea.

Researchers have also found similarities in the way all artists work. They say there are the four main steps in the artistic process:

1. *Developing ideas.* Artists get ideas for their work in many ways. They may observe the natural or constructed environment. They may use their imagination, dreams or fantasies as inspiration. Some have ideas and feelings they want to express. Others have practical problems to solve.

2. *Exploring and refining ideas.* This part of the process often involves making sketches or creating models for an artwork. Sometimes ideas are refined by experimenting with materials and processes.

3. *Using art materials and techniques effectively.* At some point in the artistic process, the artist shapes materials into a form that others will see as artwork. Designers and architects create their finished plans and supervise the final work.

4. *Evaluating.* After the work is completed and seen by others, there are many evaluations of the work. These are made by other artists, viewers and art experts such as critics and historians.

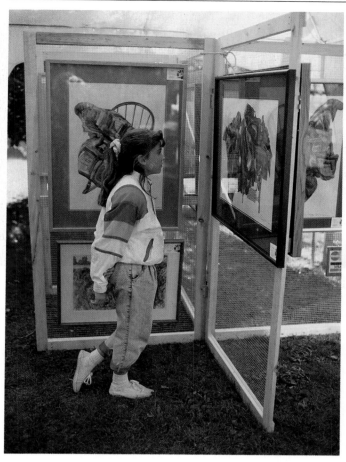

Many artists first exhibit their work in community art shows like this one. Photograph by Barbara Caldwell.

Drawing is still considered one of the foundations for education in art. Student art.

Education and Training in Art

You have learned that people create art because of the special urges and abilities human beings have. But education in art is also important.

In many cultures, learning about art is a natural part of growing up. Art skills are passed from one generation to another. Artists learn from each other without going to school.

In ancient Egypt, slaves were trained to create art following strict rules. Most of the art was created to please and honor powerful rulers and their gods.

During the Renaissance – a period from 1400 to 1600 in Europe – artists were educated by an apprentice system. As an apprentice, you would live with a master artist and be a helper. In exchange for your help, you would learn art skills. Your apprenticeship might begin between the ages of nine and fourteen.

Today, many people are well-educated amateurs in art. This means they take classes in art and practice on their own. They love to create art but have no interest in art as a career or job.

Most professional artists begin as amateurs. They love to create art and study it, but they also want art to be a lifelong career.

You may want to have a career in art. Even if you don't, you can learn about the varieties of careers in art. You will meet many people in art-related work. You will discover that almost every job requires some art-related skills.

Careers in Art

Today there are hundreds of careers in art. All of them require a love of art and interest in learning more about it. Most art careers require education in an art school or college. The best way to prepare for an art career is to learn about many kinds of art and to study art history.

A few art careers are reviewed in the rest of this chapter. Your teacher and school counselors can help you learn more about art schools and colleges with programs that fit your interests.

Architecture and Environmental Art

Architecture is the art of planning buildings and spaces for people. The buildings must be well-constructed and practical to use. They also must be aesthetically pleasing – they must fit into the community and have special meaning to the people who see and use them.

Some *architects* work for home owners. Others specialize in design for offices, hotels, stores, hospitals or government buildings. Architects have an excellent backround in mathematics and are interested in three-dimensional design on a large scale. Most have drawing skills. Many are now using computers as tools to help design buildings.

Landscape architects design outdoor spaces. These include parks, areas around buildings, play areas, natural preserves and golf courses.

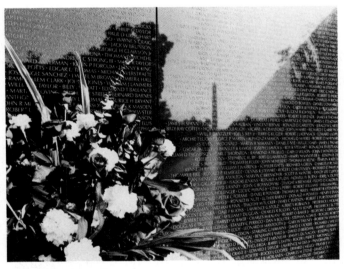

Maya Ying Lin, Vietnam Veterans Memorial, (detail) 1980-1982. Black Granite. Constitution Gardens, Washington, DC. Photograph Courtesy National Park Service.

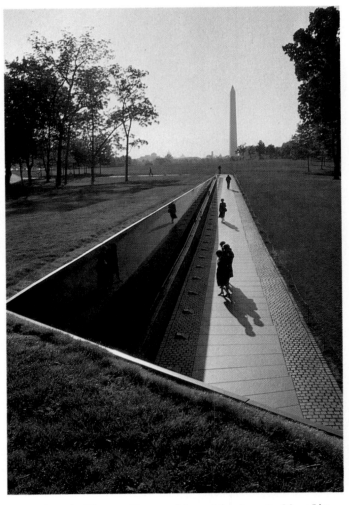

Maya Ying Lin, Vietnam Veterans Memorial, 1980-1982. Maya Lin was a student of architecture when she submitted her plan for the Vietnam Veterans Memorial in Washington, DC. Black Granite. Constitution Gardens, Washington, DC. Photograph Courtesy National Park Service.

Landscape architects plan the way flowers, trees, shrubs, ponds and other natural parts of the environment are kept the same or changed. They think of the way people and nature affect each other and try to improve on that. Most landscape architects work with building architects. Some set up their own companies. Their work combines an interest in nature, art and architecture.

Interior designers plan the interior spaces of rooms so they are attractive and useful to people. They help clients decide on a design for the lighting, furnishings, wall coverings, floors and accessories. They help clients make choices by presenting plans, drawings and models of interiors.

Interior designers are familiar with historical styles of interiors. They keep files on all up-to-date products and materials for interiors. Some interior designers specialize in planning spaces for stores, museums and the like.

City planners help cities plan for the growth and redevelopment of city spaces. This process is often called urban renewal. One part of urban renewal is preserving historic buildings.

City planners give advice on how to use land and improve basic services such as transportation. They try to solve problems by working with many different groups and specialists. They consult neighborhood groups, business people and technicians such as engineers. Some city planners design entirely new communities.

Interior designers often work with architects. This cooperation produced built-in furnishings and a rich use of natural materials in this house.

Benjamin Thompson and Associates, Inc. Thompson has been a leader in preserving and giving new life to old buildings in cities. His plans usually include a mixture of cafés, shops, and entertainment. Photograph copyright 1983 Steve Rosenthal

Cheryl Hughes, of John Fluke Mfg. Co. Inc., sketches graphic design ideas.

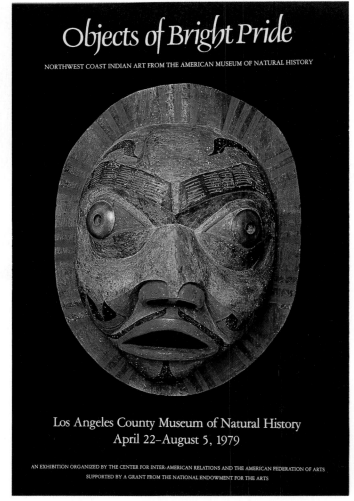

Leon Auerbach, *Objects of Bright Pride.* Courtesy of the American Museum of Natural History, New York.

Art and Design for Business

Many artists work for business and industry. The major fields are graphic design, industrial design and fashion design.

Graphic design is art based on communication with printed words and illustrations. Most graphic design is artwork prepared for printing in books, magazines and other publications. Graphic designers use plans, called layouts, to show the spacing and placement of elements in their designs.

Graphic designers also plan posters, billboards, advertisements, books, record covers and packages. Some create plans for corporate identity programs – ways to give companies a look, or visual identity, that people recognize as special for those companies. In a corporate identity program, the designer creates a logo, or visual symbol. The logo is used on printed material, packages, uniforms, trucks and other items.

Many graphic designers use computers to help create their work. For some, making computer-based graphic images for clients is the only thing they do. Related fields of work are illustration, editorial cartoons, comic strip art, photo illustration and graphics for television.

Noel Mayo, Designer and Eminent Scholar. Noel Mayo owns a design firm in Philadelphia. His company works on graphic, product, and interior design. The Ohio State University. Photograph by Lloyd Lemmerman.

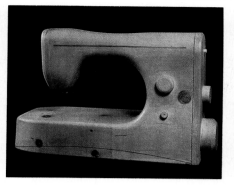

Neechi Co.

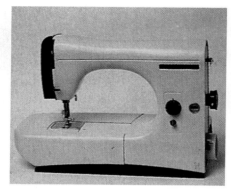

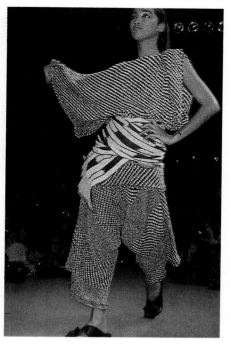

Issey Miyake's fashions combine ideas from traditional Japanese attire and a modern desire for comfort. Missoni.

The industrial designer's plan for a sewing machine (below) was first tried out by creating a model of the form in wood (above). Courtesy of Neechi Co.

Industrial designers plan products for industry. They plan the three-dimensional forms of things such as automobiles, furniture, dinnerware, telephones and appliances. Some specialize in package design. Others design machinery and medical equipment.

Industrial designers often work with engineers and other technicians. The designer plans the product so it works well and has an attractive form that fits the way it is used. Industrial designers must understand the materials and methods used to manufacture products. They draw plans and create working models, called prototypes, of products that will be mass-produced later.

Fashion designers plan clothing and accessories such as shoes, hats, jewelry and handbags that we wear. Some work only in high fashion, or *haute couture*. Haute couture designs are created to attract international attention and rich buyers. Sometimes the designs are copied by people who manufacture low-priced clothing.

Fashion design is a broad field that includes textile design, costume design and specialties such as jewelry design. Some people trained in fashion design work on children's clothing, uniform design and other specialites.

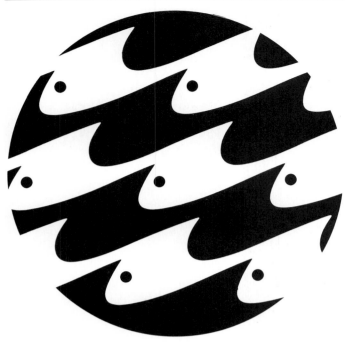

Chermayeff and Geismar. This logo for the National Aquarium is used on publications, signs, uniforms, and other visual communications.

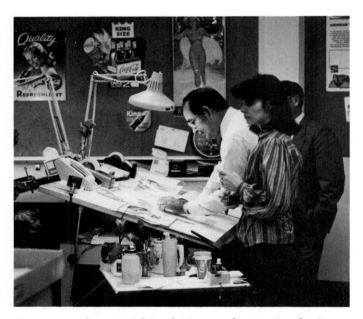

Corporate art director Dick Loyd, Director of Art Services for Coca Cola of Los Angeles, helps some members of his staff develop a promotional program layout.

Entertainment, Journalism and Advertising

Most of our entertainment and news today depends on visual images. This means that many art-related careers can be found in film, television, theater and places where news and information are put together.

Photography is widely used in these careers. Photo-journalists use cameras to report news. Some specialize in still photography. Others are trained in using cameras for motion pictures or television.

All major advertising companies have art directors who work with writers and other artists. Together, they work out plans for advertising in places such as television, magazines and billboards. They create layouts for the ads. Other specialists help in the final production.

Most publishers of books, magazines and newspapers have art directors who coordinate the work of other graphic designers and illustrators. Art directors are also employed for films, television dramas and stage plays. They work with scenic and costume designers, lighting specialists, makeup artists and hairstylists. Motion picture and television companies hire artists who are skilled in using cameras and in editing film or tape.

Animation and special effects are also fascinating careers. Film *animations* are created from many separate drawings or illustrations – about twenty-four for each second of motion picture film. The films are planned around storyboards – sketches that look like comic strips.

The final artwork is prepared by artists who specialize in drawing the characters or the background scenes, or filling in outlined areas. Animated films can also use puppet-like figures, clay models and other flexible materials. Computers are now being used for film animation. Computers make this long production process easier.

Special effects are visual "magic" that artists create for film, television and theater. These artists create illusions by combining things such as lighting, backgrounds, costumes or animated figures. Some illusions are created with computers and trick photography. Other illusions rely on papier-mâché, cardboard models and the like. Special effects artists are inventive, versatile and know how to work with other technicians.

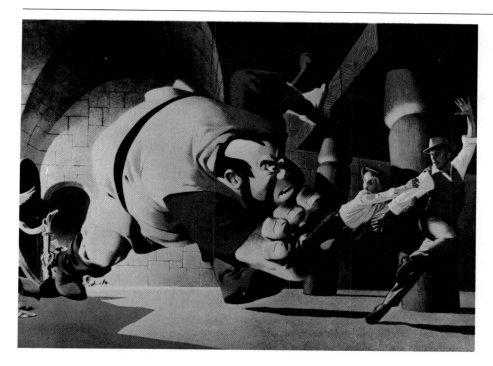

Special effects photograph - cartoon figures with live actors. *Jack and the Beanstalk,* Hanna-Barbera Productions, Inc.

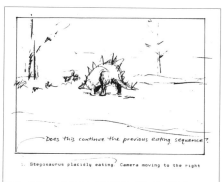

Photograph by John Senzer for Fashion Institute of Technology.

Computer-animation storyboard by John Donkin. This computer–assisted animated film begins with a sketch. The sketch is part of a storyboard. The simple "skeleton" of the dinosaur is drawn by combining polygons. The form is then developed with finer wire-like lines. Later, the image will have color, texture, and motion. Advanced Computing Center for the Arts and Design. The Ohio State University.

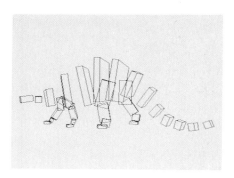

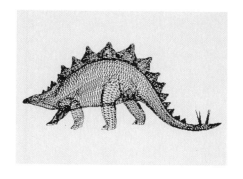

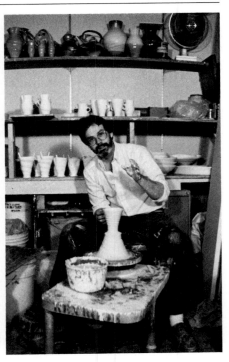

Audrey Flack, *The Artist with Self-Portrait*, 1974. Acrylic on canvas, 80" x 64" (203 x 163 cm). Louis K. Meisel Gallery, New York. Photograph: Jeanne Hamilton.

David Saul, *Lee Rexrode* (detail). Selinum toned silver print, 5 ¹/₂" x 13" (14 x 33 cm). From "The Artist's Domain," 1988.

Fine Arts and Crafts

Almost all people who choose art as a career start out with an interest in drawing, painting, sculpture or crafts.

Fine artists create paintings, sculpture and other kinds of art mostly to please themselves. Their work is called fine art because it is created for personal expression and satisfaction.

Many craftsworkers also approach their work as a fine art. They create ceramics or fiber art, or work in other materials because they find it challenging. Even if the craft is useful, such as pottery or basketry, they design and make the craftworks to please themselves more than the purchasers.

Most fine artists and craftsworkers sell their work through galleries or other exhibitions. Because these fields of art are so competitive, many artists and craftsworkers have other jobs to earn a living.

Only a few fine artists and craftsworkers achieve national or international reputations. Many well-known artists were unrecognized during their own lifetimes. Others who were very popular at another time are nearly forgotten today. Because judgments about artistic merit do change, most fine artists believe the best way to work is to be true to themselves as they create art.

Art Research, Service and Education

Many careers have to do with the study of art and supporting the work of artists.

Many people are trained in art work for art museums. *Curators* are experts in the history of art who do research on artworks in museums. Preservation specialists learn ways to save artworks from decay. Restorers carefully clean and repair damaged work. Exhibition designers plan displays of items in museums. *Docents* give tours to people who visit museums. Education curators teach people about the museum and its collections.

Photograph by Barbera Caldwell.

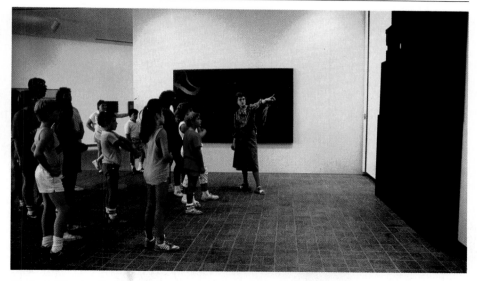

Students Viewing Sculpture. Museums employ many experts in art. Specialists in education develop programs to help children and adults appreciate art displayed in the museum. Courtesy Wichita Art Museum, Wichita, Kansas. Photograph: Henry Nelson.

Art educators help people learn about art. Art teachers help people learn about the whole world of art – creating art, studying it and appreciating it. Artist-teachers are people who create art and also teach it.

Art therapists work in hospitals, clinics and other centers that help disabled or troubled people. They introduce art as one of many ways for people to think about their talents and understand themselves.

Scholars do research in art. Art historians study works of art, artists and the cultural conditions that explain artists' works They write about their research and often teach art history. Many work in museums or universities.

Some scholars are psychologists who want to find out how and why people become interested in art. Some lawyers help artists and art agencies solve problems.

Aestheticians are philosophers of art. They specialize in logical thinking and writing about art. Most aestheticians teach in universities. They help people understand how art theories can influence all kinds of work in art.

Art critics are also writers. Some are journalists who write for newspapers. Others write for art magazines. Their job is to describe, analyze, interpret and judge art as thoughtfully as they can.

Other important people in the art world are gallery owners, who sell art; collectors, who buy art; and art consultants or dealers, who help buyers find artwork to purchase.

The most important people in the art world are you and other citizens. Your role is important even if you do not choose art as a career. All art is created to be seen and understood. The freedom of artists to create their work depends on the ability of people to appreciate and support it.

Critical Thinking Why is education in art important in a democratic society? Can you see why dictators might want to limit the kind of art people can see or create?

Robb Armstrong's characters, he says, are lively and intended to show African-Americans in funny, family situations. Courtesy United Feature Syndicate, Inc.

Career Awareness

Complete either option A or option B:

Option A Look over the questions listed below. Answer each one on a separate sheet of paper. If you have more yes answers than no answers, you may want to consider a career in art.

1. Do you enjoy seeing colors, lines, shapes and other visual elements in your world?

2. Do you like to draw, sculpt or create other kinds of art?

3. Do you often create or study art on your own, outside of school?

4. Do you enjoy experimenting with ideas and materials in art?

5. Do you work on complex art projects until they are completed?

6. Do you enjoy finding out about unusual styles or kinds of art?

7. Is it easy for you to find original ideas or designs for your artwork?

8. If you are dissatisfied with your artwork, do you try again?

9. Do you enjoy talking about art with other people?

10. Do you sometimes find yourself teaching friends or classmates about art?

11. Is art one of your favorite subjects or hobbies?

Option B If you are already sure that you would want to go into a career outside of art, write your career choice on a sheet of paper. Then list the ways your career can use skills or products from people trained in art.

Jump Start

Summary

Art is a creative process that takes many forms. Artists work in different ways but follow four major steps when they create art: they develop ideas for art, explore and refine those ideas, use materials and techniques to create the works, and evaluate their work.

To some degree, everyone has the urge and ability to create art. The reason this is true has to do with certain traits and potentials that all human beings have: the structure of the human brain and mind, aesthetic perception, imagination, symbolic thinking and the inventive use of materials.

Education and training play important roles in the development of interest and ability in art. The way art is taught has changed through time. It also differs from one culture to another. Today, there are hundreds of art-related jobs and many careers for art specialists.

The most important people in the art world are citizens who understand, appreciate and support art. Freedom of artistic expression is a vital part of democratic life. Almost every aspect of our daily life is influenced by the skills of people educated in art and design.

Using What You Learned

Creating Art

1 List the four main steps of the creative process in art.

2 List at least six careers in art. Briefly describe the main purpose of each one.

3 Choose one career in art. Read more about it. Write a one-page report stating: (A) the name of the career, (B) related careers, (C) typical jobs and tasks, (D) abilities and traits required for success in the field, (E) education required, and (F) possible summer jobs to learn more about the career.

4 Complete either Option A or Option B: Option A – Imagine you have selected a career in art, and create a sketch of your ideal studio or workplace. Option B – Draw a series of sketches, comic-book style, that shows three or four steps in achieving a career in one art field.

Art History

1 Describe four ways that education in art was done in the past.

2 State three reasons why the work of art historians is important.

3 List three careers in art museums.

Art Criticism

1 When does evaluation, or art criticism, occur in the creative process?

2 What are the main aims of art criticism?

3 List four careers in the art world that involve the sale or exchange of works of art.

4 Why is it important for all people to be well-educated in art?

Aesthetics

1 Write a sentence or brief paragraph that gives the meaning of these terms.
 • *artistic process*
 • *aesthetic perception*
 • *imagination*
 • *symbolic thinking*
 • *invention*
 • *folk art*

2 Why is aesthetic perception important in art?

3 What do aestheticians do? Why is their work important?

4 List five reasons why all people have the potential to create art.

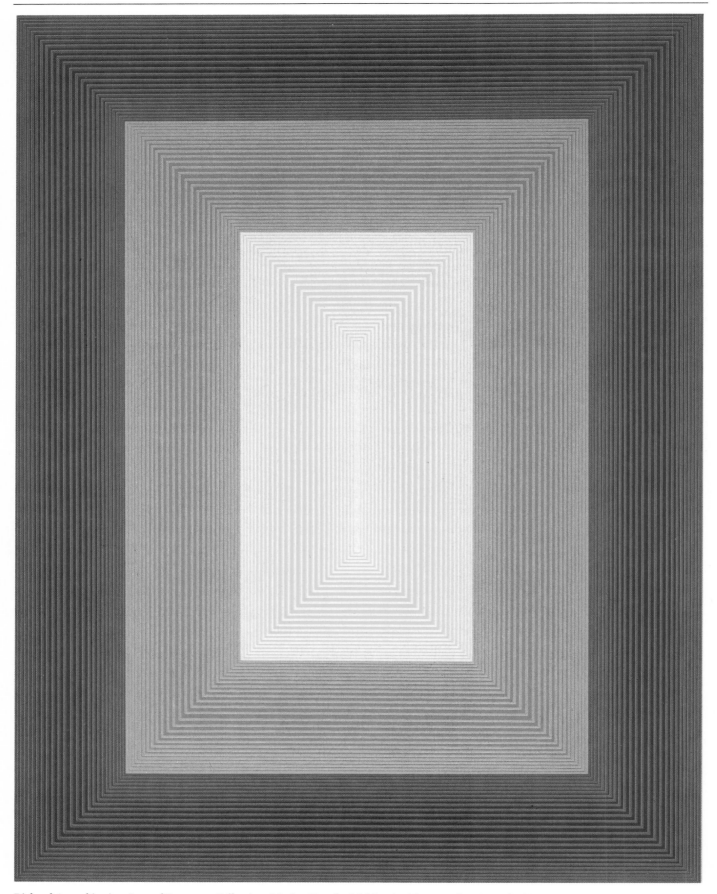

Richard Anuszkiewicz, *Inward Eye*, 1970. Collection, Marion Koogler McNay Art Museum, San Antonio, Texas.

Chapter 2

Design: The Language of Art

Chapter Vocabulary

Elements of design
line
shape
form
color
value
texture
space

Principles of design
balance
rhythm
movement
proportion
emphasis
pattern
unity
variety

Music reaches out to you with sounds. The art of dance speaks to you through body movements. In the visual arts, design brings ideas together for you to experience. This process is also sometimes called *composition*.

The qualities an artist creates for you to see are called elements and principles of design. The elements of design include ***line, shape, form, texture, value, color*** and ***space***. The principles of design are ***balance, rhythm, movement, proportion, emphasis, pattern, unity*** and ***variety***. These elements and principles are used to plan artworks. They are also important in analyzing artworks.

Designing a work of art involves planning. The purpose of the artist's design or plan is to share an experience with people who will look at the work. You can think of the design process as a problem-solving activity. Your knowledge of design elements and principles can help you show your ideas best. If you understand design elements and principles, you can also appreciate art more.

In this chapter, you will review the elements and principles of design. They are guideposts for looking at all kinds of art. They are also mental "tools" for you to use in creating your own art.

After you study this chapter and do the activites, you will be better able to:

Creating Art • use the elements and principles of design to create art.

Aesthetics • use the vocabulary of design to describe artworks.

Art Criticism • use your knowledge of design to describe, analyze and interpret art.

Art History • use your knowledge of design to study art history.

McDonald Bane, *D-1-67*, 1967. Do you see how lines can create the illusion of form and motion? Pen and brush and ink, 18 ³/₄" x 24 ¹/₈" (48 x 61 cm). Collection, The Museum of Modern Art, New York. Given anonymously.

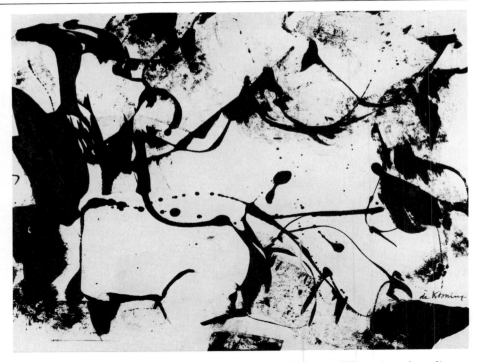

Willem de Kooning, *Landscape Abstract*, 1949. Linear qualities are different in each medium. They are also influenced by the artist's technique. What technique was used to create these lines? Oil on paper, 19" x 25 ¹/₂" (48 x 65 cm). Collection of Whitney Museum of American Art, New York. Gift of Mr. and Mrs. Alan H. Temple.

Elements of Design

Almost a hundred years ago, an American artist and teacher of art named Arthur Wesley Dow wanted his art students to be able to see, describe and create visual qualities in a systematic way. Dow wrote about the "elements of art" in 1899. Within the next 20 years, his vocabulary for describing art was being taught in almost every art school. Over the years, it has been changed and expanded by other artists and experts. Sometimes experts disagree over the best use of terms. The terms you will learn here are among the most commonly used today.

Line

Lines are usually thought of as paths or marks left by moving points. People often describe lines with words that suggest motion or its opposites: active or passive, calm or jerky, flowing or still.

Artists remember these qualities when they create art. They plan their use of straight or curved lines, thick or thin lines. They know that qualities of line such as dark or light, continuous or broken, can communicate ideas and feelings.

Artists see and think about lines in other ways. Lines can be outlines or edges of shapes and forms. The contours may be geometric – precise and regular. They may be organic and irregular – like forms seen in nature.

In two–dimensional (2-D) art, lines can create the illusion of shadows, textures or forms in space.

Implied lines can suggest motion or organize an artwork. Implied lines are not actually seen, but they can seem to be present in the way edges of shapes are lined up. In architecture, sculpture and other three-dimensional (3-D) forms, lines can actually twist, turn and move up or down in space.

People enjoy qualities of line in the art of *calligraphy* – beautiful handwriting. Most people also enjoy linear *caricatures*. In a caricature, an artist may use just a few lines to capture the personality of a person or situation.

David Smith, *Hudson River Landscape*, 1951. Line can be used in three-dimensional art. Welded steel, 49 ¹/₂" x 6' 3" x 16 ³/₄" (126 x 190 x 43 cm). Collection of Whitney Museum of American Art. Purchase.

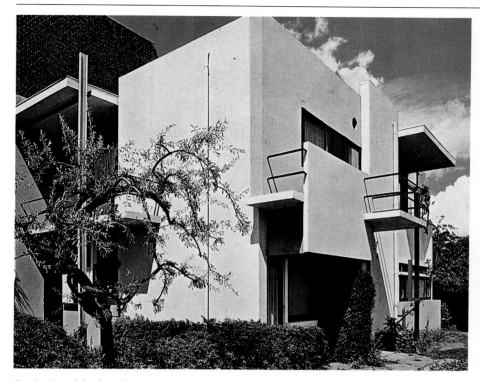

Gerrit Rietveld, *The Villa Schröder at Utrecht*, 1924.

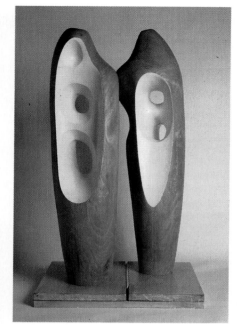

Barbara Hepworth, *Two Figures*, 1947-1948. Compare the organic forms here with the geometric forms in the villa on the left. Elm wood with white paint, 38" x 17" (97 x 43 cm). University Art Museum, University of Minnesota, Minneapolis. John Rood Sculpture Collection.

Shapes and Forms

Shapes are two-dimensional surfaces such as circles or squares. Forms are three-dimensional, like spheres or cubes. A *concave* form has a pushed-in surface that goes down like the inside of a crater or bowl. A *convex* form has a raised surface that goes up like a mound or the outside of a bowl. Forms can be solid like a rock or have voids like a hollow tube. A void is an empty space.

Your eyes and mind work together when you see shapes and forms. You always see them as a *figure-ground* relationship. The shape you see first is called a *figure*, or *positive* shape. The area around it is called the *ground*, or *negative* shape. Artists often plan their work so that people must shift their eyes back and forth between positive and negative shapes. When positive shapes are incomplete or unclear, you still see them as a unit without even realizing you are doing it.

Shapes and forms are also described in other ways. Organic shapes look like the natural curves in trees, clouds, people and the like. Geometric shapes and forms are usually precise and regular. Shapes look like flat circles, triangles or squares. Forms are like three-dimensional spheres, cones, pyramids or cubes. Artists often use geometric forms to suggest things and places created by people. A *free-form* is an invented shape or form. It often has qualities of a geometric form or an organic form or both.

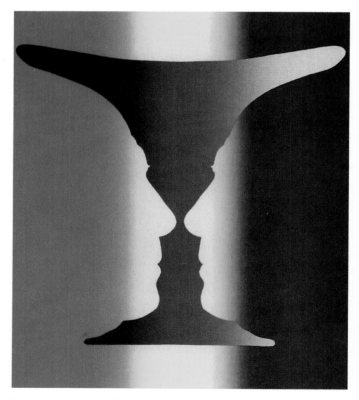

Jasper Johns, *Cups 4 Picasso*, 1972. Do you see two profiles of Picasso? Do you also see a vase or cup? Which shapes are the positive ones? Lithograph, edition of 39, 22 ¹/₂" x 32 ¹/₄" (57 x 82 cm). Published by Universal Limited Art Editions, Inc. Collection, The Museum of Modern Art, New York. Gift of Celeste Bartos.

Light, Value and Color

Light is what lets you experience color. The retina inside the normal human eye has pigments (coloring agents) that are sensitive to different lengths of light waves. The colors you see as red have long wavelengths. The colors you call blue have short wavelengths. The wavelengths you see as green are medium length.

People who are color-blind are not able to respond to certain wavelengths of light. They may be unable to see red, green or blue. Some people can only see grays, white and black. Some animals – bees, for example – are sensitive to light waves that people cannot see.

The wavelengths of light that humans can see are called the visible color spectrum. You see this spectrum in a rainbow. The spectrum was first identified by Sir Issac Newton. He found that a prism splits sunlight – white light – into colors. A prism is a clear wedge-shaped form. A color wheel shows the spectrum of colors arranged in a circle.

Color Facts and Terms

In order to use color expressively, artists learn some of the following basic facts and terms about color. Many are easiest to remember by using a color wheel diagram.

Hue refers to the common names for the colors in the spectrum: red, orange, yellow, green, blue and violet. A *pigment* is a coloring agent such as paint or dye that reflects certain wavelengths and absorbs others. White pigments reflect all wavelengths equally. Black pigments absorb almost all wavelengths.

Primary hues in pigments are red, yellow and blue. These hues cannot be mixed from other hues. With the primary hues, along with black and white, you can mix almost every color. *Secondary* hues – orange, green and violet – are mixed from primary hues. You mix red and yellow for orange, red and blue for violet, and yellow and blue for green. *Intermediate* colors are mixed from a primary hue and secondary hue that is next to it on the color wheel. You mix red and orange for red-orange, blue and violet for blue-violet and so on.

The visible spectrum of light. Courtesy of Bausch & Lomb.

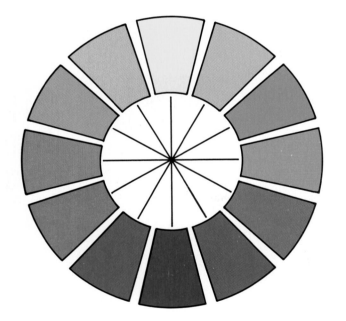

Artists refer to differences in light or dark as differences in *value*. Values can be changed very gradually to create shading. They can be used to create a strong contrast, or difference, in areas of light and deep shadow.

You can change the value of any color by adding white. A light value is called a *tint*. To darken a color, add black. A dark value of a hue is called a *shade*. Artworks dominated by tints are called *high key* works. They are usually seen as cheerful, bright and sunny. *Low key* artworks are dominated by dark values. They are often seen as dark, mysterious or gloomy.

Sudden changes in value from light to dark create contrasts. Strong contrast is called *chiaroscuro* (Italian for light and dark). Chiaroscuro gives a work drama or excitement. Gradual changes in value can make it appear that there are shadows on a form, or that the atmosphere is misty or that the mood is calm and quiet.

Milton Avery, *Boats in Yellow Sea*, 1944. This is a high key work. It is dominated by light values (tints). Gouache on paper, 27" x 30" (69 x 76 cm). The Wichita State University. Endowment Association Art Collection.

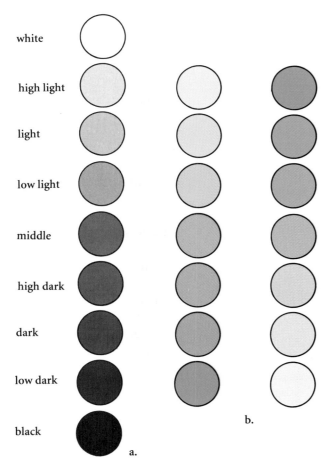

white
high light
light
low light
middle
high dark
dark
low dark
black

a.

b.

The value scales indicate some of the shades of gray between white and black (and several hues).

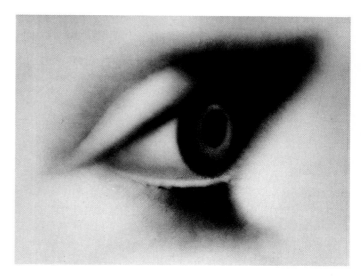

Rodolfo Abularach, *Vinac*, 1970. Value changes and contrasts are one way to create the illusion of form. Pen and ink on paper, 23" x 29" (58 x 74 cm). Archer M Huntington Art Gallery, The University of Texas at Austin. Archer M. Huntington Museum Fund, 1979.

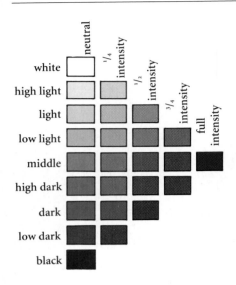

The intensity of color (its purity or saturation) can be changed along with changes in its value.

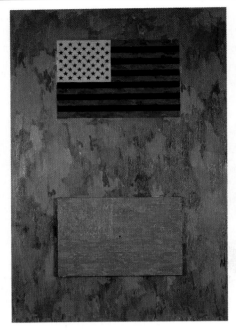

Jasper Johns, *Flags*, 1965. Stare at the flag for about 1 minute. Then stare at the dot in the middle of the lower rectangle. What do you see? Oil on canvas with raised canvas, 72" x 48" (183 x 122 cm). Courtesy Leo Castelli Gallery, New York.

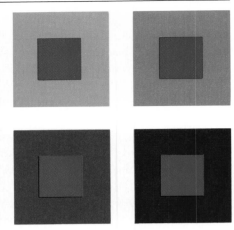

Simultaneous contrast refers to the fact that our perception of any one color is affected by the colors that surround it.

Intensity, refers to how bright or dull a color is. Bright, high-intensity colors are like those in the spectrum. Dull, or low-intensity, colors are created by mixing *complementary* colors (colors that are opposite each other on the color wheel). If you mix a small amount of green with its complement, red, the red looks duller. Many grays, browns and other muted, *neutral* colors can be mixed from complements.

Color interactions can be used to create expressive qualities in artwork. For example, complementary hues such as blue and orange tend to "vibrate" and create visual excitement if placed side by side. Changing the value or intensity of hues changes the expressive quality.

Simultaneous contrast refers to the way you perceive one hue in relation to another. For example, a yellow-orange square in the middle of an orange square will appear to be more orange than if it is in the middle of a yellow square. A dull or muted blue will look brighter on a gray background.

Color Schemes

Color schemes are often used to unify artworks. Some of the most common schemes, or plans, for using color are noted below. These plans are based on impressions you have when you see different colors.

WARM. Reds, oranges and yellows remind you of warm things and feelings such as fire, sun or people with "sunny" personalities.

COOL. Blues, greens and violets remind you of cool things such as water, or moods of people such as "feeling blue."

NEUTRAL. True neutrals are grays, black and white. Artists, designers, and architects often refer to varieties of brown as neutral colors.

Neutral colors can be slightly warm – rust, reddish gray, tan. These colors are often used to suggest the idea of warm, earthy nature.

Neutral colors can also be slightly cool – brownish violet, greenish gray, light gray-blue. These colors may remind you of very business-like, industrial or "cool," impersonal things.

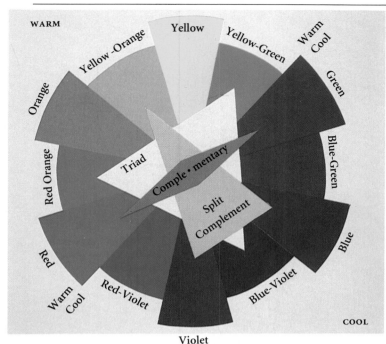

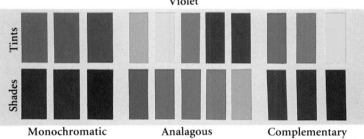

Monochromatic Analagous Complementary

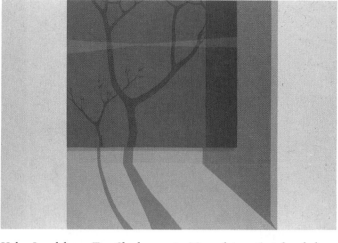

Helen Lundeberg, *Tree Shadows*, 1982. Monochromatic colors help give this work a feeling of calm, cool beauty. Acrylic on canvas, 35" x 50" (89 x 127 cm). Courtesy of Tobey C. Moss Gallery. From the collection of Colet Seiler.

Imagine that the shapes marked Complementary, Split Complement, and Triad could be turned like spinners. The points of each spinner indicate color schemes you might use.

When neutral colors of about the same value are the main ones used in a work, it usually has a quiet, somber or reserved quality. Any bright colors will tend to stand out as accents or centers of interest.

MONOCHROMATIC. These color schemes are based on several values of one hue. *Monochrome* means "one color." This kind of plan unifies a work, but it can also be boring. Artists and designers often use color accents or a related hue to add visual interest.

ANALOGOUS. In this plan, colors have a common hue. Blue, blue-green and blue-violet are an example. Analogous hues are next to each other on the color wheel. They are usually pleasing to look at. You tend to see them as related or part of a unit.

COMPLEMENTARY. These hues are opposite from each other on the color wheel. Intense pairs of complements tend to attract your attention.

Complements seem to "sing" or "shout." They are often used for signs and other commercial designs to attract attention. They can also be the source of strong afterimages. An *afterimage* occurs when you stare at color for thirty seconds or so and then close your eyes or look at a white paper. You will see an afterimage of opposite or complementary colors. The eye seems to create these sensations as a way to rest.

SPLIT COMPLEMENT. This scheme is often more interesting than complements. A split complement includes one hue and the two hues on each side of its complement. An example would be yellow with red-violet and blue-violet.

TRIAD. A triad is based on any three colors spaced at an equal distance on the color wheel. Examples are the primary colors (red, yellow, blue), the secondary colors (orange, green, violet) or other sets such as yellow-orange, red-violet and blue-green.

Intense triads, like intense complements, seem to attract attention, especially if one hue is stronger than others. For quieter effects, artists may use a triad with neutral colors or change the intensity or value of colors in the triad.

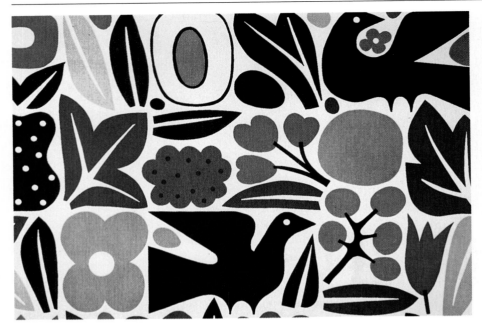

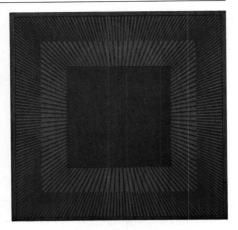

Richard J. Anuszkiewicz, *Radiant Green*, 1965. What color interactions are present in this work? Synthetic polymer paint on composition board, 16" x 16" (41 x 41 cm). Collection, The Museum of Modern Art, New York. The Sidney and Harriet Janis Collection.

Alexander Girard, *Eden*, 1989. This design reflects the use of decorative color. It also has an analogous color scheme with arbitrary hues. Courtesy Herman Miller.

Expressive Uses of Color

Artists refer to the dominant hue or pigment in something you see as *local* color. For example, a coat made of red cloth has red pigment in all the fibers. Its local color is red. The local color of a cloudless sky at noon is blue.

Optical or atmospheric color is the result of seeing how light and the atmosphere change a local color. A red coat, for example, might have pink highlights or appear to have shadows that are red-violet or blue-violet. A sky at noon might be a vibrant, intense blue right over your head. Near the horizon, the same sky might be a very light blue or light blue-green.

In representational art, atmospheric colors are used to show space and distance. In general, lighter and duller colors seem to move back or make things seem far away. Cool colors tend to look farther away than warm hues. Intense, warm colors usually seem to move forward.

Impressionistic color looks like shimmering light. In this use of color, black is usually left out. Warm colors are used on the nearest forms to make them seem closer. Cool colors are used on forms that are supposed to look farther away.

Arbitrary color is often used in art. Arbitrary means that the artist makes up meanings for colors. Arbitrary colors may be used as symbols – such as red means stop, and green means go. Sometimes artists use arbitrary colors to create moods. They might suggest a dreary feeling by using blue-grey. They may choose colors to set up feelings of shapes and lines jumping, pushing or pulling in space.

Decorative color is usually chosen to fit a purpose. Decorative colors may be selected to give a pleasing, restful background for daily living. Colors can also draw attention to something so it seems dramatic or stylish. Decorative color is often used in advertising and interiors of stores.

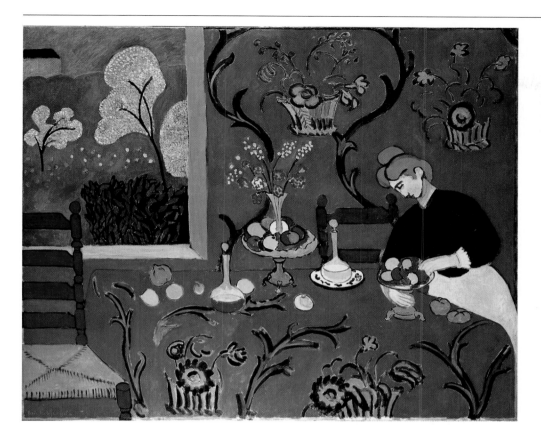

Henri Matisse, *The Red Room (Harmony in Red)*, 1908-1909. This artist has used arbitrary colors in a decorative manner. Can you find some areas where the artist used local color? Oil on canvas, 69 ³/₄" x 85 ⁷/₈" (177 x 218 cm). The Hermitage Museum, Leningrad.

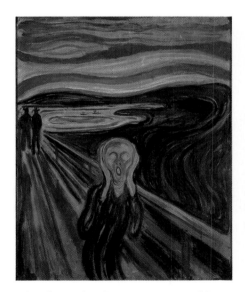

Edvard Munch, *The Scream*, 1893. In this work, arbitrary colors are used to express a definite mood. Oil on canvas, 36" x 29" (92 x 74 cm). Munch-museet, Oslo.

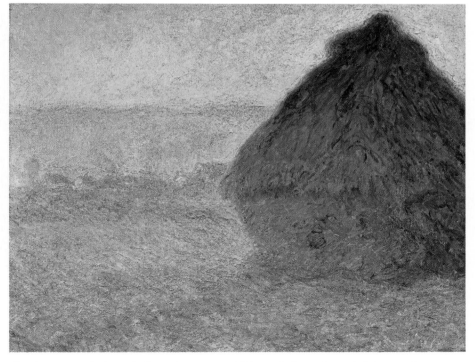

Claude Monet, *Grainstack (Sunset)*, 1890-1891. This work shows the artist's interest in impressionistic color. He has also used atmospheric color to suggest the distant sky. Oil on canvas, 28 ⁷/₈" x 36 ¹/₂" (73 x 93 cm). Courtesy The Museum of Fine Arts, Boston. Juliana Cheney Edwards Collection.

Texture

Texture refers to the way a surface feels when you touch it, such as rough or smooth.

Actual or tactual textures are what you feel when you touch things. Actual textures are an important feature of three-dimensional artworks. For example, in architecture and interior design, smooth materials such as glass, metal, or polished stone may seem to be harsh or cold. Textured fabrics, woods and other materials often make a space or building feel more inviting or warm.

In some two-dimensional arts – such as weaving, painting and collage – textures are created by the way a material is used. For example, fibers can be chosen for their texture. They can also be woven so there is another texture of raised or lowered surfaces.

In painting, thick layers of paint can be used to create textures. This technique, called *impasto*, is often used with oils, acrylics and encaustic (wax-based paint). Sometimes paint is combined with other materials such as fine sand, sawdust or collage to make actual textures.

Visual textures are the illusion of actual textures. There are many ways to create them. Visual textures can be simulated or invented. *Simulated* textures are seen in two-dimensional art such as photographs, paintings or drawings, where they look like the actual textures of fur, velvet, grass and the like. You see many simulated textures in daily life. Smooth plastic tables may look like wood. Plastic may be spray-painted to look like cloth.

Invented textures are arrangements of lines, values and shapes that you see as real textures. Very small repeated patterns can be seen as invented textures. Many artists have developed techniques for inventing texture with paint and in printmaking. A few are noted here.

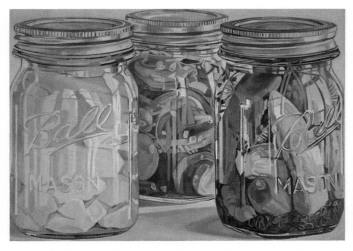

Janet Fish, *Three Pickle Jars*, 1972. The smooth textures of glass and metal are simulated here. How does the artist capture these textures? Oil on canvas, 30" x 42" (76 x 107 cm). Robert Miller Gallery, New York.

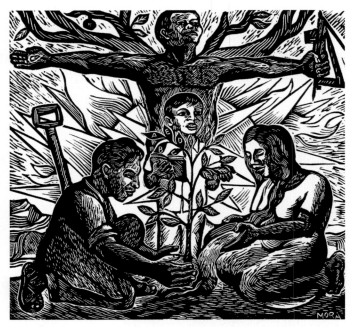

Francisco Mora, *Tree of Life.* What textural effects do you see? How do you think they were created? Woodcut 7" x 7" (18 x 18 cm). Courtesy of the artist.

TEXTURE RUBBINGS. Place paper over a textured surface and hold it firmly. Then rub the paper with the flat side of a crayon or piece of chalk or charcoal.

FROTTAGE. Apply a layer of fresh paint on a canvas or paper. Place the canvas or paper paint-side up over a textured surface. Scrape the paint with a flat tool. This will leave a textured pattern like the surface.

GROTTAGE. Scratch into wet paint with a comb, a stiff cardboard, or other tool.

DECALCOMANIA. Place thick paint on two papers or canvases. Place the painted surfaces face-to-face and rub them. Then pull them apart. The random textures often resemble a fantasy landscape.

Textures can also be described by the way they reflect light, such as matte or glossy. A *matte* surface absorbs light, so it looks dull. *Glossy* surfaces are shiny. They reflect light and glisten.

In ceramic art, a work may have a rough or smooth actual texture and be finished in a matte or glossy glaze (reflective texture). A semi-gloss paint is halfway between a very shiny surface and a dull, or flat paint. Photographs can be printed on glossy or matte surfaces. The paper itself may be smooth or have a subtle texture.

Artists also speak of textures of materials as hard or soft. You can only experience these qualities by pressing or shaping a material. Using different ways to create the illusion of hard and soft textures has fascinated many artists. A painting or other art form that imitates the textures of other materials is called a *trompe l'oeil* work, which is French for "fool the eye."

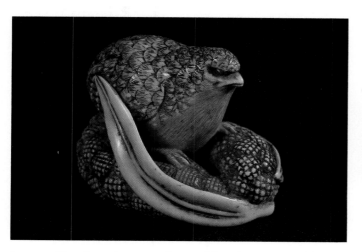

Meret Oppenheim, *Object,* 1936. Actual textures are presented in an unexpected manner in this surrealist work. Fur-covered cup, saucer and spoon, overall height: 2 ⁷/₈" (7 cm). Collection, The Museum of Modern Art, New York. Purchase.

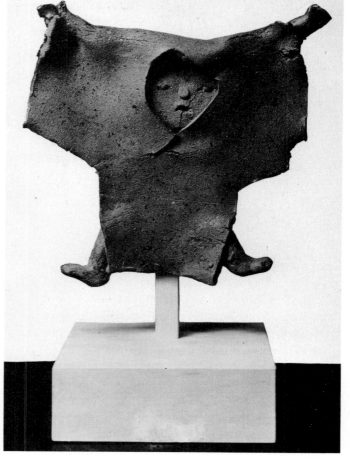

Isamu Noguchi, *Big Boy,* 1952. The natural textures of clay are a major element in this work. Karatsu ware, 10 ¹/₂" x 6 ⁷/₈" x 20 ³/₄" (27 x 18 x 53 cm). Collection, The Museum of Modern Art, New York. A. Conger Goodyear Fund.

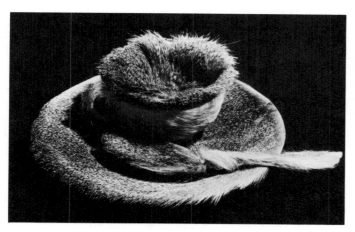

Japanese Netsuke, 19th century. Ivory, 2" (5 cm). Courtesy of the Hurst Gallery.

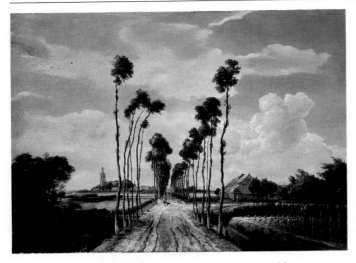

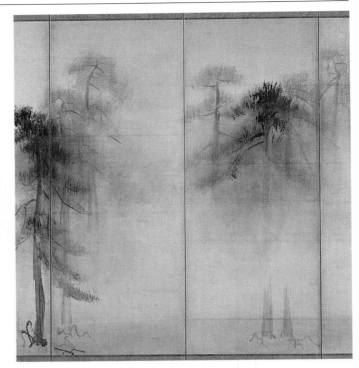

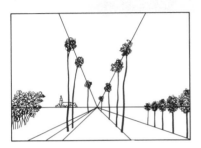

Meindert Hobbema, *The Avenue Middleharnis*, 1689. Oil on canvas, 41" x 56" (104 x 141 cm), The National Gallery, London.

The straight line across this diagram is the horizon line. The main lines converge to a vanishing point near the center of the horizon line.

Hasegawa Tohaku, *Pine Wood*, 1539-1610 (detail from a pair of six-fold screens). Atmospheric perspective is often used in traditional Japanese art. Ink on paper, 61" (155 cm) high. Tokyo National Museum, Tokyo. Photograph courtesy the International Society for Educational Information.

Space

Today people talk about exploring outer space. Usually, you think of space as being empty. It seems to be the "air" around and between the things you see. Artists think about space as a two-dimensional flat area or as a three-dimensional volume.

Artists refer to spaces as *positive* – occupied by something, or *negative* – the surrounding area. They see spaces as open or as closed, as filled or empty. They think about *actual* space, which can be measured in some way, and *implied* space, which is the illusion of space on a flat surface. Space can also be defined by its *orientation* – vertical or horizontal, and *scale* – huge and endless, or small and confined.

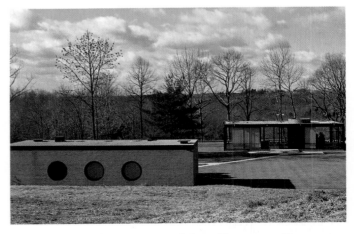

Philip Johnson, Johnson House and Guest House, 1949. New Canaan, Connecticut. The interior spaces of the house at the right allow you to see as much of the exterior space as possible. Does the guest house at the left have the same amount of glass.

Perspective Techniques

Overlap. One object appears to be behind the other.

Shading. Light and shadow create the illusion of form and space.

Placement. Objects higher in the picture appear to be in the distance.

Size. If the objects are the same size, the distant ones look smaller than the nearest ones.

Value and Focus. Lighter values and less detail suggest distance.

Linear Perspective. Parallel lines and edges seem to go toward one or more vanishing points.

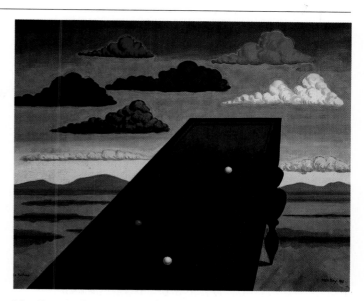

Man Ray, *La Fortune*, 1938. This artist has used linear perspective to create a strange landscape. What other perspective techniques did he use? Oil on canvas, 24" x 29" (61 x 74 cm). Collection of Whitney Museum of American Art. Gift of the Simon Foundation.

Architects are sensitive to the way interior and exterior spaces relate to each other in buildings. Sculptors and architects are concerned with open spaces and enclosed spaces. Graphic designers are concerned with the spacing of elements, such as blocks of type and borders on pages. They notice spaces between lines of sentences, between words and between the letters within words.

In television and filmmaking, ideas of space, time, and motion can be mixed together. Dramatic events happen in an actual space, or place. But the film can be edited so that you seem to be in several spaces at one time. Comic strips are presented in a series of spaces that show different events over a period of time.

In two-dimensional art, the illusion of space and distance can be created in many ways (see the diagrams above). Most of these techniques were developed by Renaissance artists. The techniques are called systems of *perspective* – making things on flat surfaces look like they are close up or far away.

Principles of Design

Almost every artist has been inspired by nature – land, sea, sky, plants and animals. Artists have always wondered at the forms and structures that make up nature's designs.

Today's thinking about design owes a lot to Arthur Wesley Dow, whose art teachings included a list of principles for design. Those principles are guides for organizing visual qualities. They are also guides for understanding how a work is planned.

Over the years, Dow's list of principles has changed. Now the principles people usually talk about are balance, rhythm, movement, proportion, emphasis, pattern, unity and variety.

The principles of design also fit in with ideas such as trying to balance work and play, rest and activity.

Balance

Visual balance can be *symmetrical, asymmetrical* or *radial.* In symmetrical or formal balance, both halves of a work are like mirror images of each other. They are exactly alike or so similar that you see them as matched. Symmetrical balance is used to express ideas such as stability, uniformity and formality.

In asymmetrical, or informal, balance the halves of a work are balanced like a seesaw. A large shape on the left side might be balanced by two smaller ones on the right side. The feeling of balance comes from the importance or "weight" of the things in each half of the work.

For example, a small area with bright colors can have as much visual weight and interest as a large area with a dull color. Rough textures and dark colors seem to be visually heavier than smooth textures and light colors. Asymmetrical balance is used to express action, variety and informality.

In radial balance, parts of a design seem to move toward or away from a central point. Radial balance is often symmetrical. Restful, quiet wheel-like church windows are one example. Radial balance can also be asymmetrical. In an explosive fireworks display, sparks fly from a center point, but some may shoot farther than others. Can you think of other examples of radial design?

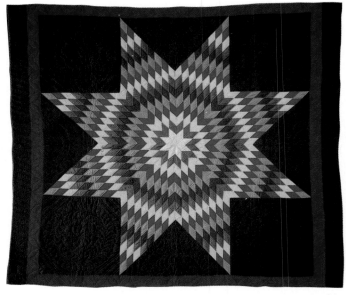

Mrs. David Bontraeger, *Lone Star Quilt*, 1923. The star pattern in this quilt is an example of radial balance. Cotton, 84" x 74" (213 x 188 cm). Collection of the Museum of American Folk Art, New York. Gift of David Pottinger, 1980.

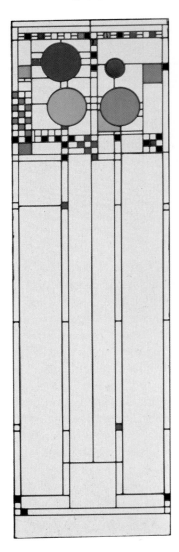

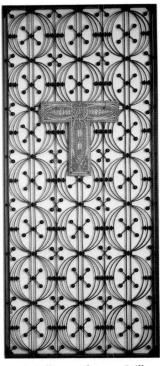

Louis Sullivan, *Elevator Grille*, 1893-94. This elevator gate has symmetrical balance. The stained glass window on the left has asymmetrical balance. Both works were designed by well-known architects. Bronze-plated cast iron, 73" x 31" (185 x 79 cm). Collection High Museum of Art. Atlanta, Georgia. Virginia Carroll Crawford Collection.

Frank Lloyd Wright, American Stained Glass Window. Glass, lead and wood, 86 ¹/₂" x 28" x 2" (220 x 71 x 5 cm). The Metropolitan Museum of Art, New York. Edgar L. Kaufmann Charitable Foundation gift.

Rhythm and Movement

Visual rhythms, like rhythms in music, are created by repeating elements in a regular beat or order. Several types of rhythms are commonly used in visual art.

Visual rhythms can be very simple, as in a *regular* one-beat rhythm. An example might be a series of identical circles repeated one after another. An *alternating* rhythm is like a regular series of visual changes – circle-square, circle-square, circle-square and so on. A *progressive* rhythm is built on regular changes in a repeated element. An example would be a series of squares, each slightly larger than the next.

A *flowing* rhythm has a graceful path of repeated movements with no sudden changes. In a *jazzy* rhythm, the repeated elements are varied in complicated patterns and combined with unexpected elements.

Can you give examples of visual rhythms in nature, everyday life or dance?

Not all of the visual movements in an artwork are rhythmic. Sometimes a work has a *dominant path of movement* that adds to a mood. The sense of movement may come from a tall, vertical form reaching upward. Sometimes there is a path of motion leading to a center of interest. Even the absence of motion can be expressed. For example, a quiet, still, calm feeling may come from the use of many horizontal lines or forms.

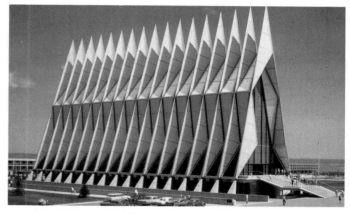

Skidmore, Owings and Merrill, US Air Force Academy Chapel, 1956-1962. The alternating forms in this building make a visual rhythm. Courtesy of the US Air Force Academy.

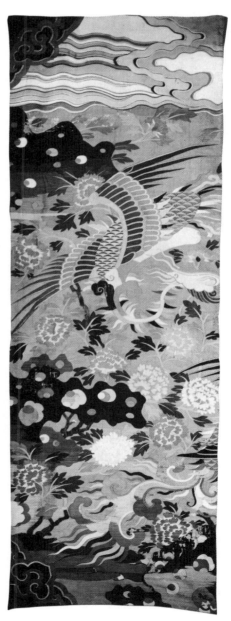

China, Ming Dynasty, *K'o-Ssu Tapestry*. What kinds of rhythms can you identify in this tapestry? Silk and gold threads. The Cleveland Museum of Art, Cleveland. Gift of Mr. and Mrs. J.H. Wade.

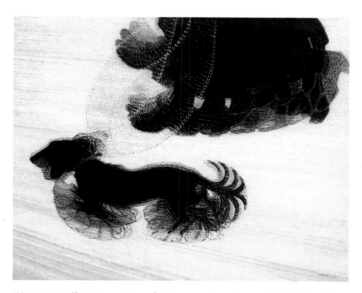

Giacomo Balla, *Dynamism of a Dog on a Leash*, 1912. This Futurist artist was interested in capturing the rhythmic movements of his subject. Oil on canvas, 35 ³/₈" x 43 ¹/₄" (89 x 110 cm). Albright-Knox Art Gallery, Buffalo, New York. Bequest of A. Conger Goodyear and Gift of George F. Goodyear, 1964.

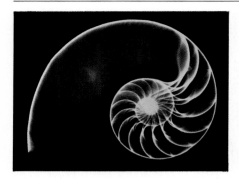

Radiograph of a nautilus shell.

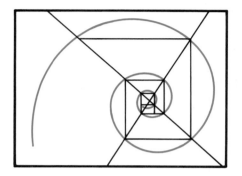

The spiral form in the nautilus shell follows the proportions of the Golden Mean.

Luis Eades, *Salute to Dawn, the Rosy-Fingered*, 1959. How do the unexpected proportions in this work affect your response to it? Oil on canvas, 8" x 12" (20 x 30 cm). Private collection.

The Fibonacci number series explains many designs found in nature.

Proportion

Proportion refers to the relationships of parts to a whole. Our sense of proportion in art comes from the human body. We say artworks are life-sized, *monumental* (much larger than life-size) or *miniature* (very small). Proportions are often *normal* and expected. They can also be *exaggerated* and distorted. Sometimes proportions are *idealized* – more perfect than you might see in nature.

Systems of mathematical proportions fascinate artists. The ancient Greek sculptor Polykleitos used a mathematical formula for his idealized sculptures of athletes. The height of the body was eight times the length of the head.

Another formula, known as the *Golden Section* or *Golden Mean*, states that the dimensions of the small part (a) must relate to a larger part (b) as the larger part (b) relates to the whole (b + a). In artwork, you can use the ratio 1 to 1.6 to draw shapes with proportions like the golden mean.

A related system of proportion, discovered by the medieval mathematician Fibonacci, is a progression of numbers often seen in nature. Each number is the sum of the two numbers that go before it. The numbers are 1, 1, 2, 3, 5, 8, 13, 21, 34 and so on. These numbers grow in size but not in proportion.

Scale is the relative size of something compared with what you expect. You do not expect to see a toothbrush bigger than a bed. Artists often change the normal size, scale or proportion of things to show their importance in artworks. *Caricature* is the use of exaggerated proportions, usually for humor and satire.

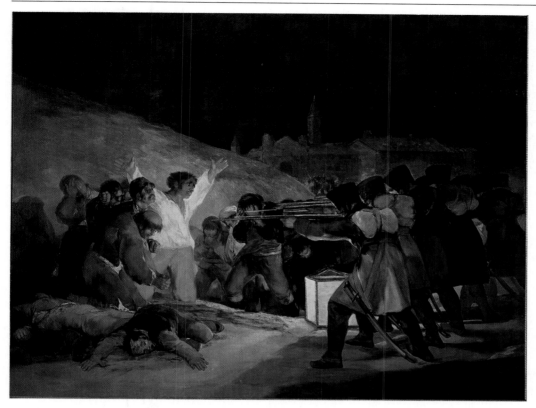

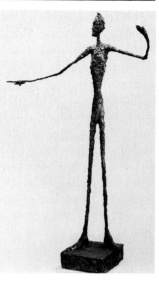

Alberto Giacometti, *Man Pointing*, 1947. How is emphasis achieved in this work? Bronze, 70 ¹/₂" x 40³/₄" x 16 ³/₈" (179 x 102 x 42 cm). Collection, The Museum of Modern Art, New York. Gift of John D. Rockefeller III.

Francisco de Goya, *The Third of May, 1808*, 1814. Lighting, color, and the grouping of figures are used for emphasis in this work. Where is the center of interest? Oil on canvas, approximately 8' 8" x 11' 3" (264 x 343 cm). Museo del Prado, Madrid.

In many classical sculptures, the length of the body is eight times the length of the head.

Emphasis

Emphasis is a principle that artists use to control what you first notice about a work. Emphasis can be achieved in several ways. One way is *dominance* – making one element the strongest or most important thing in work. The dominant element might be a certain kind of brushstroke, color or shape.

A second method is to set up a *focal point* or *center of interest*. This may be done by isolating an important element from the space around it. The most important element might be larger than others or be placed near the center of a work. A contrasting element – one bright element in a dark area – can also be a center of interest or focal point. An arrangement of lines or paths that come together can seem to flow toward one main point in the work.

Pattern

A pattern is a repeated use of lines, colors or other elements. A familiar example is a repeated pattern of dots in a piece of polka dotted cloth. Each dot is part of the pattern.

Two-dimensional patterns are created by using a motif over and over again. A *motif* is one complete unit in a larger design. A motif might be a simple flower-like design or a geometric shape used in a fabric pattern.

In three-dimensional art, a *module* is one complete unit. A brick is one kind of module. Others might be columns on a building or cylinders made of clay on a sculpture. Patterns tend to unify a work of art. When the motifs or modules are arranged in a regular pattern, the design is often called an *all-over pattern*.

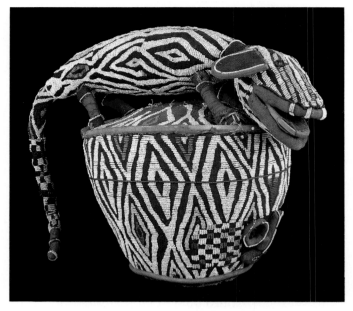

Beaded leopard mask. Grasslands, Bamileke, Cameroon, Africa. Raffia splints, cloth, glass beads, 31" x 48" (80 x 122 cm). Collection of Charles W. and Janice R. Mack.

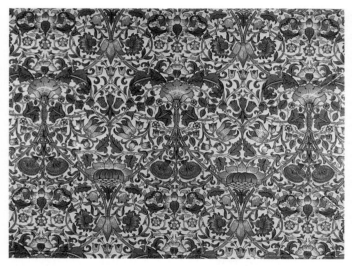

William Morris.

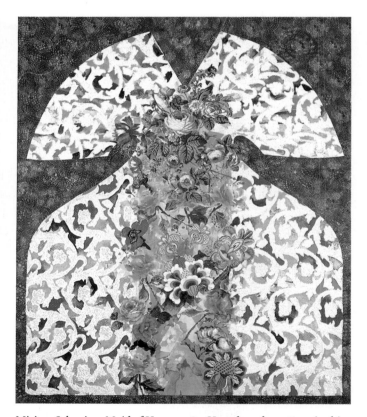

Miriam Schapiro, *Maid of Honor*, 1984. How does the pattern in this work differ from those in the leopard mask and the wallpaper? Acrylic and fabric on canvas, 60" x 50" (152 x 107 cm). Courtesy Bernice Steinbaum Gallery, New York City.

Unity and Variety

Unity is the feeling that everything fits together. It is a feeling of oneness. The opposite of unity is disunity, a feeling of disorder. In art, unity is often achieved by the repetition of a shape, color or another visual element.

Another method is *simplicity*. Simplicity is the use of one major color, kind of shape or element to unify a work.

In a third technique, called *harmony*, related colors, textures, materials might be combined. A fourth technique is *theme and variation*. In this case, an artist might organize a work around one major element like a circle, then include variations on the circle – showing it in different sizes and colors, or including some half-circles.

Sometimes works are unified by *proximity* or *continuity*. Proximity means that parts are grouped together, enclosed or clustered into sets. Continuity means that edges of forms are lined up so your eye moves from one part to another in a definite order.

Variety is often said to be "the spice of life." In art, variety is like a spice. A totally unified work is likely to be boring. Variety is the use of contrasting elements to make something interesting.

The contrast, or difference, may be subtle, such as a slight change in texture or color within an area. It may be more obvious, such as a sharp difference in the materials, sizes of shapes, color or lighting.

Just as we appreciate unity and variety in nature, we seem to want unity and variety in our lives – and in our art.

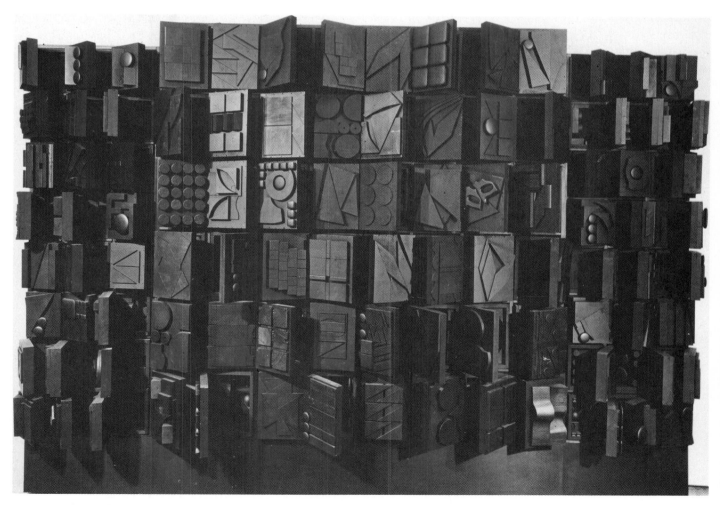

Louise Nevelson, *Black Secret Wall,* 1970. What elements and principles can be used to describe the unity in this work? What elements and principles can be used to describe the variety that you see? Blackwood, 100" x 139" x 7" (254 x 353 x 18 cm). The Pace Gallery, New York.

Design Vocabulary

Elements of Design

Line

path of movement
active – passive
bold – delicate
flowing – light
straight – curved
thick – thin
dark – light
broken – continuous
geometric – organic
implied – actual
precise – irregular
contour – outline
calligraphy
caricature

Shape/Form

2D – 3D
solid – void
concave – convex
positive – negative
figure – ground
ambiguous – complete
organic – geometric – free-form
circle – sphere
square – cube
triangle – pyramid – cone

Space

2D – 3D
positive – negative
open – closed
filled – empty
actual – implied
interior – exterior
scale
orientation
spacing
illusion of space
systems of perspective

Light/Color/Value

visible color spectrum
color wheel
value
 shading
 contrast
 chiaroscuro
 tint
 shade
hue
 pigment
 primary
 secondary
 intermediate
 neutral
 color interactions
 simultaneous contrast
color schemes
 warm
 cool
 neutral
 monochromatic
 analogous
 complementary
 split complementary
 triad
intensity
 bright – dull
 high key – low key
local
optical (or atmospheric)
symbolic

Texture

actual (tactual) – visual
simulated – invented
matte – semi-gloss – glossy
techniques
 impasto
 rubbings
 frottage
 grottage
 decalcomania
 trompe l'oeil

Principles of Design

Balance

symmetrical
asymmetrical
radial

Rhythm, Movement

types
 regular
 alternating
 progressive
 flowing
 jazzy
dominant path of movement
 vertical
 horizontal
 diagonal
 curving

Proportion

life-size
monumental
miniature
normal – exaggerated – idealized
Golden Section or Mean
scale
caricature

Emphasis

by dominance
by focal point
by center of interest
by isolation
by size
by contrast
by converging lines

Pattern

repetition
motif (2D)
module (3D)
allover

Unity and Variety

by repetition
by simplicity
by harmony
by theme and variation
by proximity
by continuity
by contrast

Summary

A design is a plan or composition that brings parts together into a unified whole for a purpose. In order to see, describe and plan artworks, it is useful to have a vocabulary for design.

The most common vocabulary used in the art world today is based on a system of ideas called the elements and principles of design. This general system of thinking about design comes from a theory developed by Arthur Wesley Dow. Dow's basic sytem has been changed over the years, but it is still used in almost every branch of art.

The elements of design include qualities of line, shape, form, texture, value, color and space. The principles of design are balance, rhythm, movement, proportion, emphasis, pattern, unity, and variety. These concepts are guides for planning and analyzing artworks.

Using What You Learned

Art History

1 Who first developed the idea of "elements and principles" as a way to analyze design?

2 During what period were many techniques for creating the illusion of space developed?

3 Choose one work of art in this chapter. Describe it using at least ten terms from the Design Vocabulary. Be sure the terms you choose fit the artwork you're describing.

Aesthetics and Art Criticism

1 Look through old magazines or color advertising sections of newspapers for examples of color schemes. Cut out at least three examples of different color schemes and label them. Describe the mood or feeling created by the use of each scheme.

2 Choose one element of design and one principle of design. Write at least three sentences that combine the terms for one element of design with one principle of design. Examples: The curved *lines* are centered for *emphasis*. The analogous *hues* create a progressive *rhythm*. The geometric *shapes* have exaggerated *proportions*.

3 Find an example of art criticism in an art magazine or newspaper review. Copy on paper one paragraph that describes a work of art. Use two colors of crayon or highlighting markers. Highlight all words that refer to design elements in one color. Highlight all words that refer to design principles in the second color.

Creating Art

1 Choose three elements of design and two principles of design. Write down your choices on the back of a piece of drawing paper. On the front, create an original artwork that clearly shows the use of the elements and principles. When the artwork is complete, find out if your classmates can identify the elements and principles you used.

2 Plan two artworks based on the same subject or theme. Complete each artwork in a different color scheme. Describe the differences in mood created by each color scheme.

3 Cut twelve pieces of paper 1" x 1". On each one create a border-to-border illustration of one design element. Complete at least two different examples for each of the elements. When you have finished, arrange the squares on a backround paper and paste them down. Plan the arrangement so it shows your knowledge of design principles.

Georgia O'Keeffe, *Summer Days*, 1936. Oil on canvas, 36" x 30" (91 x 76 cm). Collection, Whitney Museum of American Art. Promised gift of Calvin L. Klein. Photograph by Malcolm Varon, New York.

Chapter 3
Aesthetic Perception and Art Criticism

Chapter Vocabulary

aesthetic perception
art criticism
multisensory associations
criteria for judging art
philosophies of art
 art as imitation
 art as formal order
 art as expression
 art as instrumental
masterpiece
sensory qualities
technical qualities
formal qualities
expressive qualities

Every day, you glance at thousands of objects. As soon as you know what an object is, you probably look at something else. Sometimes your eyes are open, but your mind is not paying attention. For example, you can watch television, but your thoughts may not be on the program. In ordinary perception your eyes and mind work together so you can achieve a definite goal, like crossing a street or throwing a basketball through a hoop.

In art, you need to develop your *aesthetic perception* which means using your senses, mind and feelings – all at the same time. In aesthetic perception, things you see seem extraordinary. They seem special because you are not just glancing at them. You are really looking at them and becoming fascinated with what you see.

You have probably had an aesthetic experience while watching a spectacular sunset or sparkling dew on grass. Many works of art are created to give you an aesthetic experience. For this to happen, you need to learn how to "tune up" your aesthetic perception.

Aesthetic perception is one part of appreciating art. A second part is learning to analyze and judge art as experts do. This process is called *art criticism* because it requires critical thinking. Critical thinking is logical thinking. Every idea fits with every other idea.

After reading this chapter and doing the activities, you will:

Aesthetics and Criticism	• understand and use guidelines for perceiving, interpreting and judging art.
Art History	• understand and be able to apply standards for judging art based on historically important art philosophies.
Creating Art	• understand and be able to use your knowledge of aesthetic perception and art criticism while creating art.

Claude Monet, *Rouen Cathedral, West Facade*, 1894. Canvas, 39 ¹/₂" x 26" (100 x 66 cm). Courtesy of the National Gallery of Art, Washington, DC. Chester Dale Collection.

Claude Monet, *Rouen Cathedral*, 1894. Oil on canvas, 39 ¹/₄" x 25 ⁷/₈ (100 x 66 cm). The Metropolitan Museum of Art. Bequest of Theodore M. Davis, 1915. Theodore M. Davis Collection.

Aesthetic Perception

When you use your eyes to see as artists do, you look for qualities of line, color, shape, texture and other visual elements. You will notice small differences in these elements.

Perceiving Subtle Qualities

Scientists say that the normal human eye can see thousands of colors. Experiments have shown that your perception of one color comes from comparing it with other colors around it. Your mind makes these comparisons.

Unless your mind is ready to look for subtle (small, fine) differences in colors, you don't notice them. All you see is a kind of "average" color, which you might call red or blue, when you're really seeing an orangey red or a purplish blue.

This connection between your mind and eye is important in art. How you see your world depends on how alert you are. It also depends on what your goal, task or purpose is.

Like other skills, your perceptual skills for art can be improved through practice. They can also be used in so many ways that each person's insight into art is unique. Even if you don't pursue a career in art, the perceptual skills you learn can make your life richer.

How good is your perception? To find out, try this. Choose one color. Ask everyone in the class who is wearing clothes of that color to stand up. Try to describe all the differences you see in just that one color. Try this with the following colors: red, yellow, orange, green, blue, violet, black, white and brown. Do you see some in-between colors, such as bluish white or yellowish white? Which color do you see the most? Why?

Here are other ways to test your perception: Create a drawing or painting on colored paper with only two additional colors. Try to combine the two colors with the color of your paper to show off the possibilities of all three colors.

Or, choose any element of art discussed in Chapter 2. Create a collage emphasizing the subtle qualities of that element.

Imaginative Seeing

Imaginative seeing is looking at something and imagining that it is something different. About 500 years ago, the famous Renaissance artist Leonardo da Vinci wrote about this way to see. He suggested that artists look at cracks in stones and imagine the lines as something else, such as a great river, a mountain range or even a person's face.

Perhaps you have looked at clouds and pretended they were animals, people or fantastic landscapes. Artists often create imaginative art in this way. They put unlike ideas – clouds and animals – together.

Imaginative perception can also help you appreciate artworks, especially art from other cultures. You should first learn why the art was created. Then you can imagine yourself living within that culture.

Nonobjective artworks often require imaginative skills to create or appreciate them. You can appreciate nonobjective artworks if you imagine yourself as the artist, making all the decisions you see in the work. For example, you might imagine yourself becoming fascinated with a cool, blue-gray color to capture quietness, sadness or loneliness.

Practice using your imagination. In your room or school yard, find a natural crack or pattern. Place paper over it and make a rubbing with unwrapped crayon. Look at the rubbing until you imagine another image. Add lines or shapes to change your rubbing into that image.

Here are other ways to practice: Place ten dots at random on a sheet of paper. At random, connect the dots with curved or straight lines. Transform your lines into an abstract picture with elements you can recognize.

Secretly choose one of the following words and write it on drawing paper: *delicate, flowing, strong, restful, sad, lonely.* Turn your paper over and create a nonobjective drawing that goes with the word. See if your classmates can tell which word you selected when they look at your drawing.

Do you have a cultural background different from other students? Have you lived with a cultural group different from your own? If so, find several ways to help your classmates imagine and appreciate one important art idea in that culture.

Erika Davis Wade, *Red River,* 1990. Watercolor, 5 ¹/₂" x 8" (14 x 20 cm). Courtesy of the artist.

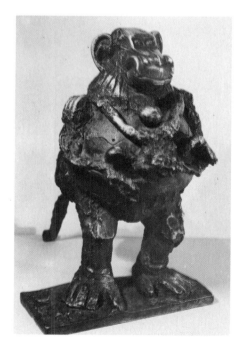

Pablo Picasso, *Baboon and Young, Vallauris,* 1951. Imaginative thinking and seeing are important in art. What is the unexpected element in this work? Bronze, (cast 1955), after found objects, 21" x 13 ¹/₄" x 20 ³/₄" (53 x 34 x 53 cm). Collection, The Museum of Modern Art, New York. Mrs. Simon Guggenheim Fund.

Rita Blitt, *Dancing*, 1980. Steel, 26' x 10' x 5'. Bannister Mall Collection, Kansas City. Photograph by E.G. Schemph.

Perceiving with More Than Your Eyes

Your senses work together to give your mind information. This process is called *multisensory association* ("multi" means many). Some music, for example, is hard to enjoy if you sit perfectly still. It makes you want to move to the rhythms or hum the melody.

Some art is hard to appreciate unless you see and "feel" the action. The action might come from the implied movement of lines or the "push and pull" of intense colors. It might come from the swirling or gliding qualities of brushstrokes.

To help you understand movement in art, try this. Choose any artwork in Chapter 12. Develop a pantomime that fits the work. See if your classmates can identify the work you pantomime. You may want to have other students do the pantomime with you. The pantomime may include sounds or movements but no recognizable words.

Or, with your teacher's help, select three different kinds of instrumental music to play for about three minutes each. On three sheets of paper, create a nonobjective drawing that seems to go with each kind of music. Display the drawings for each musical selection. Discuss qualities of the music that are captured in the drawings. Explain which musical qualities can and cannot be suggested with visual qualities.

Here's a third idea about movement: Select your favorite sport or physical activity. Create a drawing that communicates one of the main sets of motions in the sport. Do this in a nonobjective drawing. Do not show a person or any athletic equipment.

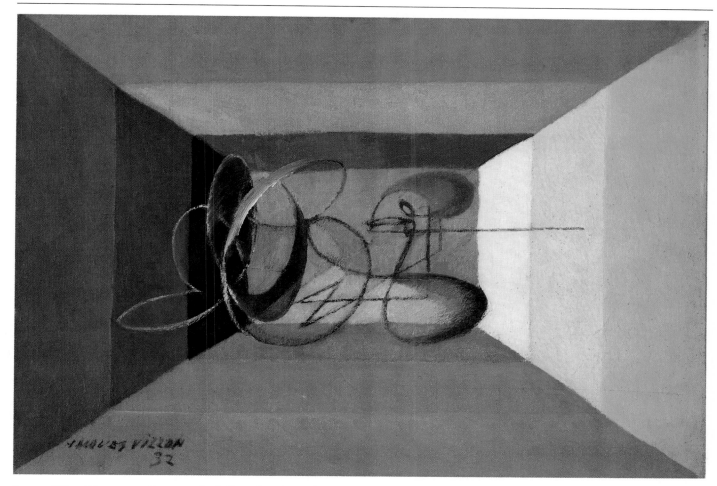

Jacques Villon, *Dance*, 1932. Compare the feeling of motion and space in this two-dimensional work and the Rita Blitt sculpture. The titles are similar. Can you move your body in a way that matches the visual "dance" in each work? Oil on canvas, 15 ¹/₈" x 21 ⁵/₈" (38 x 55 cm). Collection, The Museum of Modern Art, New York. Gift of Mrs. Arthur L. Strasser.

Art Criticism

When people look at art, they say "I like it" or "I don't like it." That is a natural way to respond. It is called expressing a personal preference or opinion.

A *critical judgment* of art is more than an opinion or preference. It is based on critical thinking – logical steps in thinking.

In art criticism, your job is to interpret what an artwork means to you and why, following a step-by-step process. Similar steps are used by scientists, lawyers and everyone who presents ideas logically and clearly. It is a process used by art critics, art historians and others who judge art.

The four major steps in art criticism are description, analysis, interpretation and judgment.

Step 1. Description Take time to look at the work and describe it objectively. Objective description means that you can point out each object or thing you describe.

Step 2. Analysis Analyze the evidence. Look for relationships – similarities, differences or repeated patterns – in what you have seen. You should be able to observe all of the connections you find within the work.

Step 3. Interpretation In this step, you formulate a hypothesis – a good guess – about the meaning of the work. A good interpretation explains the experience you get from the artwork.

Step 4. Judgment A critical judgment can be made after you have interpreted an artwork. Judging art is always a matter of being fair and logical.

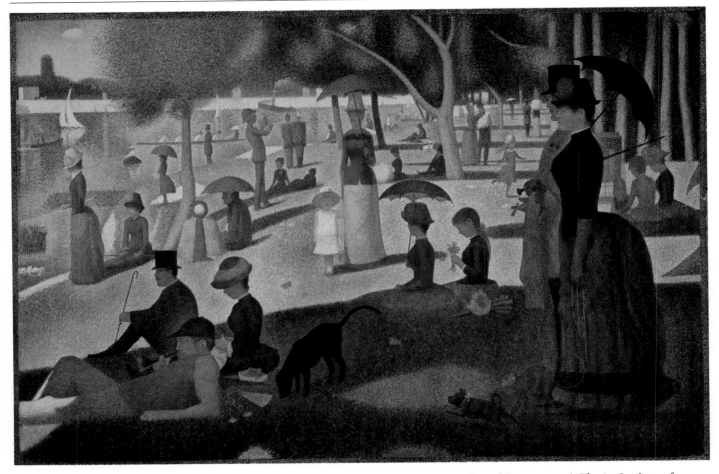

Georges Seurat, *Sunday Afternoon on the Island of La Grande Jatte*, 1884-1886. Oil on canvas, 82" x 121" (208 x 307 cm). The Art Institute of Chicago. Helen Birch Bartlett Memorial Collection, 1926.

Step 1. Description: What Do You See?

Take time to describe everything you see in the artwork. In this step you are gathering visual clues – looking for evidence – that you will later analyze and interpret.

Use factual, objective language. This means that you will avoid terms such as pretty, ugly, weird or sloppy.

Describe only features you can point to. You should be confident that other people will be able to see the same features.

Here are some topics for your description:

ART FORM AND MEDIUM. Name the kind of art and the medium or process used to create it. Is the work a painting in oil or watercolor? Is it a sculpture? If so, what materials were used?

DIMENSIONS. State or estimate the dimensions of the work. If you write them out, the first number should be the height and the second is the width. A third number will be the depth. If you are looking at a photograph of art, visualize the size of the original work.

SUBJECT MATTER. Name things you recognize, such as a tree, grass, sky, people, a man or a boy. Be cautious. For example, you may see a man and a boy. Do not jump to the conclusion they are father and son!

SENSORY QUALITIES. Describe the visual elements you see. Combine words into sentences and phrases such as "I see a large bright red square," or "I see a smooth horizontal form with a concave oval near the right end." Refer to the vocabulary list in Chapter 2 to recall other visual elements and sensory qualities to look for and describe.

TECHNICAL QUALITIES. Describe how the artist used materials, tools and techniques. Use your knowledge of art materials and processes when you can. Here are some sample statements: "I see thick ridges of paint." "I see V-shaped chisel marks in the wood." "The windows are supported by a thin metal grid."

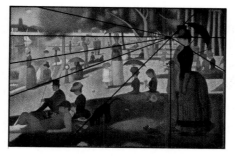

Analysis means you look for relationships. These diagrams show a few ways of looking at the structure in the painting by Seurat.

Notice the repeated curves and their rhythmic placement throughout the painting.

The vanishing point is in the upper right corner, creating the illusion of a deep space.

This diagram shows the placement of warm colors. The whole work is dominated by cool colors.

The foreground is dark and takes up about ⅓ of the picture. The main figures are looking to the left.

Step 2. Analysis: How Is the Work Planned?

Analysis is the process of finding relationships in what you see. Some of the most important relationships can be found if you refer to the principles of design.

In this step, look for and describe *formal qualities* – the planned similarities and differences in parts of the work.

Analyze the work for relationships such as these:

BALANCE. Describe the placement of major forms. Are they near the top, center, bottom or all over? Do they follow a symmetrical, asymmetrical or radial plan? Notice empty or negative spaces. How are these planned? For example, do they have definite shapes or enclose spaces? Do they help to create a sense of near and far space?

RHYTHM, MOVEMENT. Is there a vertical, horizontal or diagonal structure in the work? Can you see paths of movement? Where do they begin and end? Are there rhythms in the colors, size relationships or other elements?

PROPORTIONS. Are the proportions of parts exaggerated? Are they about normal? Are they ideal? Are they based on a mathematical formula? Why?

EMPHASIS. Describe the most dominant visual elements and the smaller ones you see repeated throughout the work. These may tell you about the most important parts of the work. Is there a focal point or center of interest? Where?

PATTERN. Do you find any motifs or modules repeated within the work? Are they allover patterns or repeated in just parts of the work? Is there a definite pattern of light and shadow, color or other visual elements?

UNITY AND VARIETY. Look back over the five principles listed above. Do any of these principles help unify the work more than others? For example, are there main paths of movement that unify the work? Are there repeated patterns or rhythms? Are there dominant elements or contrasts in the work? What parts add variety?

RELATIONSHIPS IN SUBJECT MATTER. Are there related features in the work? How are they related? Do you feel like an observer of a scene or part of the action? Does the artist seem to invite you to walk through or around the work? How?

Step 3. Interpretation:
What Are the Main Expressive Qualities?

When you interpret a work of art, you are trying to sum up the observations you made in steps one and two. Your summary tells how the observations fit together and what they mean to you.

Experts in art think of their interpretations as hypotheses, or educated guesses about the meaning of works. An educated guess includes what you have discovered by careful observation as well as other knowledge you have about art and about life.

A good interpretation – whether written or spoken – meets four main standards.

First, a good interpretation includes expressive language to describe the main sensations you get from the work. Expressive language is not objective. It includes vivid adjectives and adverbs. For example, you might say a work has *lively* lines, *somber* colors, *sparkling* highlights, *energetic* brushstrokes, *gently curving* forms, *harsh* shapes, *swirling* motions or *silky* textures.

Second, a good interpretation includes analogies. These tell how things you see in a work are related to other things you know or feel. For example: "The lively lines seem to be dancing. The bold colors seem to be shouting."

An April Mood can be interpreted in many ways. Here is one interpretation.

The old bare trees dominate the land. They huddle in groups, reaching up and down and outward – like people who may fear and respect the dark, menacing sky. The young tree blossoms, a flower blooms and rays of light try to break through the heavy clouds.

The plowed field waits. The pond and jagged rocks are still, like part of a fortress. Old trees seem to plead or to pray, not for a storm and lightning, but for gentle rain, clear skies, and growth. The trees are like guardians or old warriors pleading to the heavens for renewal, not destruction.

Charles Burchfield, *An April Mood,* 1946-1955. Watercolor on paper, 40" x 54" (102 x 137 cm). Whitney Museum of American Art, New York. Gift of Lawrence A. Fleishman.

Third, a good interpretation tells about causes and effects. These statements can take several forms. For example, you might say "The trees look sad (effect) because the lines are limp and droopy and the colors are dull (causes)," or "The limp, droopy lines and dull colors (causes) make the trees look sad (effect)."

Fourth, a good interpretation explains how the work of art is related to other ideas or events. The message might be about the artist's world and culture. It might be about human courage or frailty. It might be a message about the majesty of nature or the cruelty of war. It might be a message about the beauty of color or power of the artist's imagination.

Finally, a good written interpretation can be as short as one paragraph or as long as several pages. Remember: An interpretation is a summary of the expressive qualities in a work. It tells about the most important sensations, feelings and ideas the work communicates to you.

An April Mood

The scene is gloomy! The dark clouds look heavy and somewhat mean. The air seems quiet and still, like just before a major storm. The trees have jagged limbs and sharp, spikey points. The fields are barren. Almost everything looks dead or old. Toward the right corner some birds are flying. They look as old and tired as large trees. It's more like autumn or winter than springtime.

I don't like this picture but the artist has done a good job of painting it. The whole place looks dull in color and lonely. He expressed a gloomy day that makes you feel depressed. The painting makes me feel sad, like a turtle without a shell. The scene is filled with hurt. It is hard to explain the exact feeling it gives me.

This student has used expressive language. There is also an analogy in the interpretation.

An April Mood

The sky looks gray and stormy, like it is angry. The hilly fields and clouds look like they are actually rolling toward you. You can see ripples from raindrops in the pond. A major storm is coming about.

The ground looks dark and bare. The crops have dried up and died. The trees are stumps with pointy bare branches. They look burnt and broken, like they are dying. The pond looks swampy, like a dump filled with dead branches.

There is no sign of people anywhere. The tired-looking birds and few flowers are the only signs of life. The scene is eerie and morbid. It is also cluttered with anger and fear. It makes me think of death and destruction. Everything is struggling to survive. April is the time you begin to find out if things have survived another winter. The artist has done a good job of expressing how things must struggle to survive.

Interpretations of art can be brief. This student's short essay has expressive language. It includes a good hypothesis about the meaning of *An April Mood.*

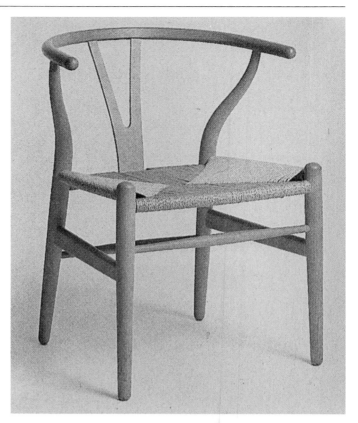

Hans Wegner, Ypsilon Chair, 1951. Chairs similar to this might be found in an office. Would it be a good chair to sit in if your job required you to draw architectural plans? Why? Victoria and Albert Museum, London, England.

Peter Murdoch, Paper Chair, 1965. Is this a chair you would choose if most of your workday was spent at a computer or typewriter? Why? Victoria and Albert Museum, London, England.

Step 4. Judgment: What Are the Strengths and Weaknesses?

People judge art for many reasons. Usually, a person makes short judgments such as "It's beautiful," "It's ugly," or "It's weird." These statements often reflect their first impressions about works of art.

A critical judgment of art is based on more careful thinking. It should be formed after you have completed the first three steps of art criticism: description, analysis and interpretation.

To present a critical judgment, you must state what you are judging and why, identify *criteria for judging art.* Give reasons why the work does or does not meet the criteria and state the judgment.

STATE WHAT YOU ARE JUDGING AND WHY. Identify the kind of art you are judging, such as architecture or sculpture, and its general style, such as fantasy or realism.

Now state your purpose for making a judgment. The criteria you use can depend on the purpose of making a judgment. For example, you may be asked to judge your own artwork. Your teacher may set standards for you to meet. The purpose of the criteria is to make sure you have learned certain ideas or skills.

In the art world, standards also depend on the purpose of making a judgment. For example, different criteria might be used to choose artworks for a new hotel than for an art museum collection. Different standards might be used to judge furniture for an office than for a living room.

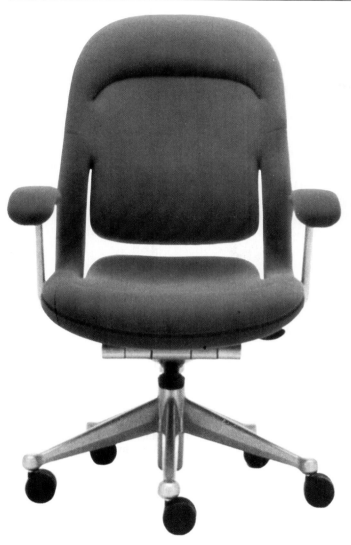

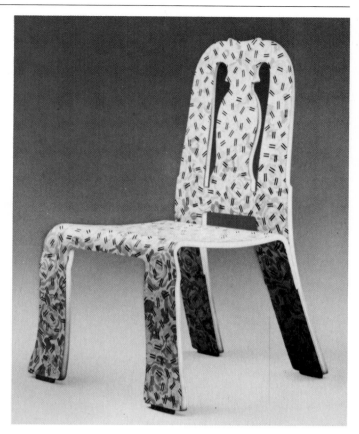

Robert Venturi, *Chair for Knoll* (Queen Anne), 1984. What qualities of this chair would make it suitable for use in an office? What features might make it an inappropriate choice? Courtesy, Knoll International.

Ettore Sottsass, Secretary's Chair. Why might a typist in an office want a chair similar to this one? Courtesy Herman Miller, Inc.

IDENTIFY CRITERIA. When you know the purpose of making a judgment and kind of art to be judged, you can state criteria. There are two main sources of criteria for judgment. One is your general knowledge of people and art. The second source is aesthetics – philosophies of art. (See pages 54-58.)

For example, suppose you are judging office furniture. Your knowledge of art and people tells you that furniture for office workers should be very comfortable. Whether or not the furniture is comfortable becomes one of your criteria for judging it.

Think of other criteria for office furniture or the artwork you are judging. Then list the criteria as questions or statements. Is this office chair easy to adjust? Can it be adjusted to fit tall or short office workers?

GIVE REASONS (CITE EVIDENCE). Go back to your "evidence," or observations and give reasons why the work does or does not meet the criteria or standards.

For example, you might state that a chair has no adjustable seat or that it has an adjustment that is hard to use. If you suddenly decide the chair is ugly, then you need to state your criteria for attractive office chairs, such as cheerful colors or colors that match the carpets.

STATE THE JUDGMENT. Summarize your judgment of the strengths and weaknesses in the work. You can start with sentences such as these: "I think this work is (or is not) important because…"; "I judge this work to be not very good because…"; "I do not like this work, but it is excellent because…"

Duane Hanson, *Tourists II*, 1988. Hard plastic, oil, paint, mixed media, life-size. Collection of the artist.

Curtis Erpelding, Three-legged Stacking Chair. These chairs are a clear example of the idea that form follows function. Can you explain why? Photograph by Joseph Feltzman.

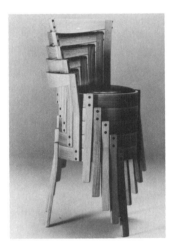

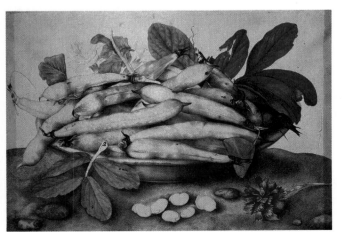

Giovanna Garzoni, *Plate of White Beans*, 1600-1670. Tempera on parchment, 9 ³/₄" x 13 ¹/₂" (25 x 34 cm). Palazzo Pitti, Florence.

Criteria from Philosophies of Art

Art experts believe that you need to know criteria from *philosophies of art* to make sound judgments of art.

A philosophy of art states how people should think about art and judge it. Philosophers of art are called *aestheticians*. They study the history of ideas about art.

Most aestheticians agree that there are four traditional philosophies of art and how to judge it: art as imitation, art as expression, art as formal order and art as instrumental.

Art as Imitation

Some philosophies say that art is a way to imitate what you see. Accuracy and honesty in art are highly valued. A work of art might be judged good if it met many of the criteria listed below.

First Impression:
The work looks real.

Design:
• The proportions of parts, colors and other elements seem natural and lifelike.
• The work is planned around patterns, rhythms and forms you see in nature or the human-made environment.

Subject/Theme:
• The subject or theme seems to be based on a real event or something the artist observed.
• The subject or theme is more realistic than abstract.
• It is honestly shown, not idealized.

Materials:
• You can see some of the natural qualities of the materials.
• The materials and techniques go with the mood rather than being the first things you notice.

Functional or Decorative Art:
• The use or function of the art can be seen in the form or design. (Form follows function.)
• Decorations are few or based on nature.

Try applying these criteria to the Garzoni painting and the Munch painting on page 55. Which artwork meets more of the criteria for art as imitation?

Art as Expression

Some philosophies of art are based on a respect for intense human feelings and originality. Standards for judging art include:

First Impression:
The work expresses a definite feeling.

Design:
• The proportion of parts, color and other elements is unexpected or exaggerated.
• The total design is dramatic or original. It gives you a definite feeling.

Subject/Theme:
• The subject or theme is unique, dream-like or fantastic.
• The subject or theme seems to come from the artist's desire to communicate a strong feeling (the great joys, sorrows or problems of people).

Materials:
• The use of materials is original or unexpected.
• The materials and techniques are an important part of the mood or feeling of the work.

Functional or Decorative Art:
• The work has an unusual function or combines several functions.
• The design of the work is unexpected and causes you to react in new ways.

Try applying these criteria to the Renaissance portrait bust shown here and the Hanson sculpture on the previous page. Which artwork meets more of the criteria for art as expression?

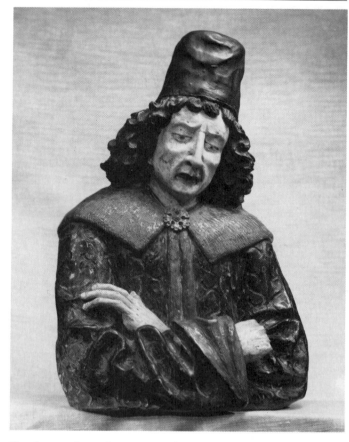

Renaissance, *Portrait Bust*, 1500. This late Gothic sculpture expresses human suffering. The work is probably a portrait of a dignified person. Glazed polychromed terra-cotta, 23" (58 cm) high. Boston Museum of Fine Arts.

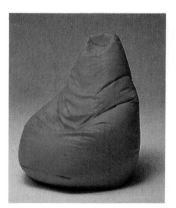

Gatti-Paolini Teodora, Sacco Chair, 1969. This chair has an unexpected form. It is filled with tiny balls of plastic. The form changes to fit the contours of the person who sits in it. Zanott Spa, Italy.

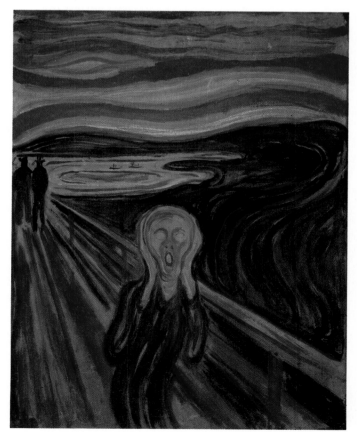

Edvard Munch, *The Scream*, 1893. Oil on canvas, 36" x 29" (92 x 74 cm). Munch-museet, Oslo.

Art as Formal Order

Some philosophies of art are based on a respect for logical order and idealized forms people can invent. Standards for judging art include:

First Impression:
The work is beautiful, harmonious.

Design:
• The work is unified by a kind of invented or mathematical order.
• The proportions of parts, colors and other elements are more perfect or idealized than you might see in life.
• The work is not filled with details you might see in life.

Subject/Theme:
• The subject or theme is idealized or has a spiritual quality unlike everyday, ordinary life.
• The work is more abstract than realistic.

Materials:
• You can see evidence of extreme care in using materials and finishing the work.
• You sense the artist knew exactly what to do with materials and techniques.

Functional or Decorative Art:
• The form of the art is elegant, refined or dignified.
• The practical use of the object seems to be less important than the design.

Try applying these criteria to Braque's painting and Woodruff's mural on the next page. Which artwork meets more of the criteria for art as formal order?

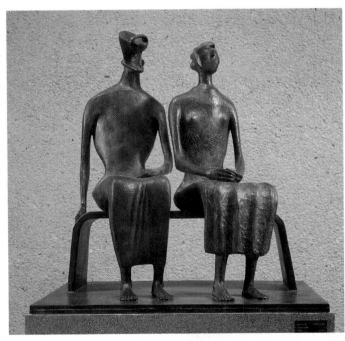

Henry Moore, *King and Queen*, 1952-1953. Bronze, 63 1/2" x 39" x 37 1/2" (161 x 99 x 95 cm). Hirshhorn Museum and Sculpture Garden, Smithsonian Institution. Gift of Joseph H. Hirshhorn, 1966.

Georges Braque, *Pipe et Raisins*, 1930. This cubist work and the sculpture by Moore meet several Formalist criteria. Which ones? Oil on canvas, 9 3/8" x 13" (24 x 33 cm). The Mary and Sylvan Lang Collection, Marion Koogler McNay Art Museum, San Antonio, Texas.

Gerrit Rietveld, Red and Blue Chair, 1918. Do you think the design of this chair is more important than its practical use? Painted wood, 34 1/2" x 26 1/2" x 26 1/2" (88 x 67 x 67 cm). Collection, The Museum of Modern Art, New York. Gift of Philip Johnson.

Art as Instrumental

Some philosophies of art emphasize the use of art in everyday life and for communication. Criteria for judging art are:

First Impression:
The work has an important message or function.

Design:
• The proportions of colors and other elements are planned to help you understand the message of the work.
• The total design is useful. It is part of the message the artist wants you to understand.

Subject/Theme:
• The subject or theme is related to the life of a cultural group.
• The subject or theme is important to almost all people at some time in their lives.

Materials:
• The materials and techniques help you understand the message in the artwork.
• The materials and techniques are practical and related to the function of the artwork.

Functional or Decorative Art:
• The work serves the purpose of communicating important ideas.
• The design or decoration is well-suited for its purpose. It is not too fancy or plain.

Try applying these criteria to Michelangelo's *Pietà* and the Moore sculpure on the previous page. Which artwork meets more of the criteria for art as instrumental?

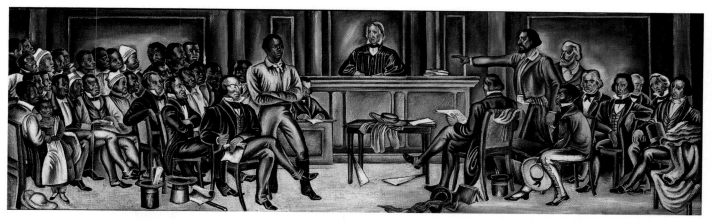

Hale Woodruff, *The Amistad Slaves on Trial at New Haven, 1840*, 1939. Many artworks are created to communicate about social problems. Woodruff's work depicts the plight of slaves on trial for mutiny. Oil on canvas, 12" x 40" (31 x 102 cm). Aaron Douglas Collection. Amistad Research Center at Tulane University, New Orleans, Louisiana.

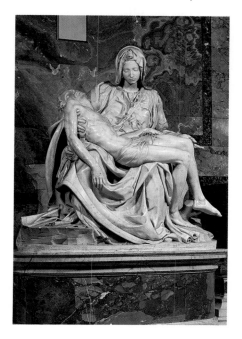

Michelangelo, *The Pietà*, 1499. This and most religious artwork was created to inspire faith or teach important lessons. Marble, 69" (175 cm) high. The Vatican, St. Peter's, Rome.

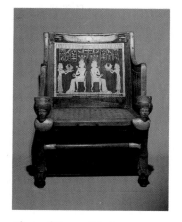

Chair of Tuyu, 18th dynasty. This chair is a throne. It has decorations related to the world of the Egyptian ruler who used it. Courtesy of the Egyptian Museum, Cairo.

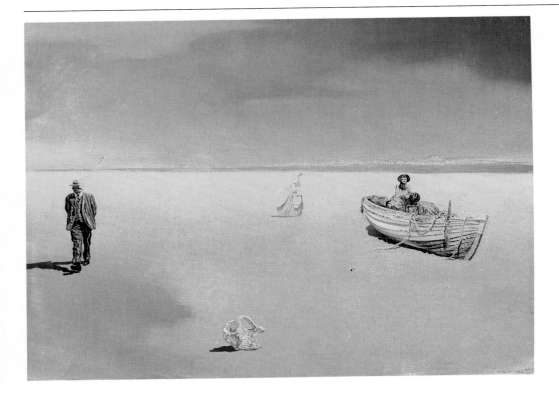

Salvador Dali, *Paranoiac-Astral Image*, 1934 (detail).

Salvador Dali, *Paranoiac-Astral Image*, 1934 (detail).

Salvador Dali, *Paranoiac-Astral Image*, 1934. Surrealism is one of many styles of art that combine different ideas. It has many unexpected elements but also many realistic elements. Oil on panel, 6 ¼" x 8 ¹¹/₁₆" (16 x 22 cm). Wadsworth Atheneum, Hartford. The Ella Gallup Sumner and Mary Catlin Sumner Collection.

How Experts Use Art Philosophies

Experts use criteria flexibly when they judge art. They know that only a few artworks would match up with the standards of a rigid philosophy.

Experts use criteria from different philosophies to explain new kinds of art. For example, critics invented the term *abstract expressionism* to help explain new paintings that were filled with expressive color and brushstrokes, but did not have subjects they could recognize.

You can use criteria flexibly, as experts do. For example, Surrealism is a well-known style of art. It combines realism and fantasy (imagination), like you see here in Dali's painting. What criteria might you combine to judge a painting in this style?

Study the chart on the right and the numbered statements below it. These are just a few of many ways to combine criteria. Can you give some other examples?

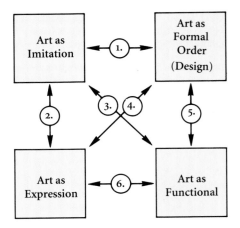

Combining ideas from art theories. This diagram and the numbered statements below it show just a few ways of combining ideas to judge art. Why are combinations often helpful?

1. The work looks real, and it has a harmonious design.
2. The work looks real, and it expresses a definite feeling.
3. The work looks real, and it has an important message or function.
4. The work has a harmonious design, and it expresses a definite feeling.
5. The work has a harmonious design, and it has an important message or function.
6. The work expresses a definite feeling, and it has an important message or function.

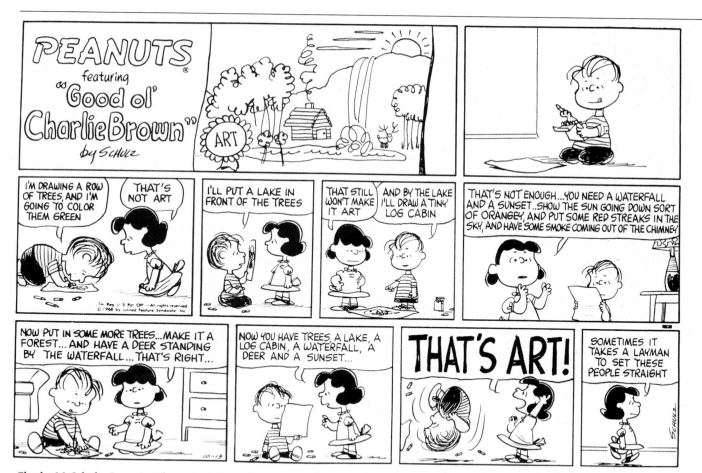

Charles M. Schulz, *Peanuts*. What criteria for judging art does Lucy mention? If you could give a title to Lucy's theory of art, what would you name it? Copyright United Features Syndicate, 1968.

Agreements and Disagreements in Judging Art

People will probably make similar judgments about art when they use the same process of judgment and have the same philosophy of art. Judgments about art are also likely to be similar when people live in the same culture and have similar personal experiences.

Disagreements about art are common. Even experts disagree. Three of the most important reasons for these differences are:

1. Differences in the process of judging. Sometimes a difference in judgment comes because people do not use the same art theories and standards for judgment.

Sometimes people disagree because they are using the same criteria but have not seen and interpreted the work in the same way.

2. Differences in culture and time. Today, most art experts think that criteria or standards for judging art are relative, not absolute. This means that they are not the same in every culture or time.

For example, much of the traditional African sculpture you see in art museums was created for religious ceremonies. Your standards for judgment cannot be exactly like those of the original audience for such work. However, you can try to understand the forms and powerful religious meanings of the sculpture.

3. Differences in personal background. Criteria or standards for judging art also differ among people who have different backgrounds. For example, if you are an expert in creating ceramics, your standards may be different from a person who has little or no experience in ceramics.

AESTHETIC PERCEPTION AND ART CRITICISM

What Is a Masterpiece?

You often hear experts call an artwork a "masterpiece." This word is used as a judgment about the quality of an artwork. It is the highest form of praise for an artwork.

A work is usually judged a masterpiece if it:

• presents an important idea using a perfect design and an appropriate technique.

• inspires people to want to look at it again and again.

• is an important achievement in the history of art.

Raphael's *The Sistine Madonna* is often judged a masterpiece. It presents an important idea in the Christian religion. The design is filled with complex curves that move your eye through the whole work. The technique includes a rich use of color and the illusion that the Virgin Mary, though human, can walk on air.

Tohaku's *Pine Trees* are a detail of a larger work. The sense of air and peacefulness of a morning mist are achieved with very few brushstrokes. The work is often judged a masterpiece of technique and mood, and a tribute to the quiet beauty of nature.

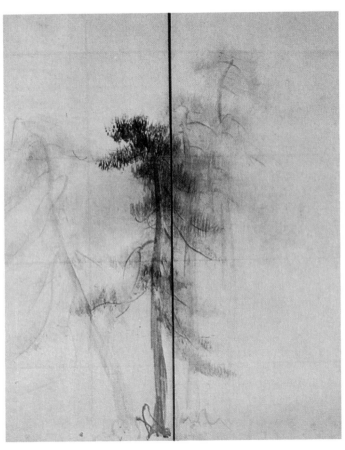

Tohaku, *Pine Trees*, late 1500's. Ink on paper, 61" (155 cm). Courtesy of the Zauho Press.

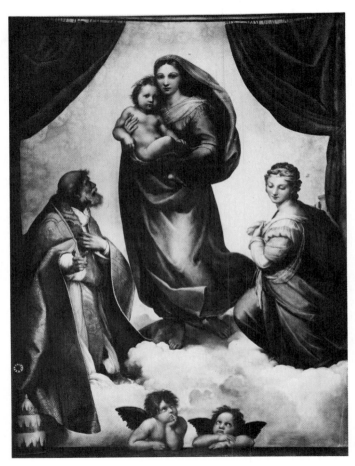

Raphael, *The Sistine Madonna*, 1512. Oil on canvas, 104" x 77" (265 x 196 cm). Gemaldegalerie, Dresden.

Summary

Looking at your world as artists do is called aesthetic perception – a blend of seeing, thinking, feeling and imagining. You look at very subtle qualities in art and your environment.

Art criticism is a process of using your aesthetic perception to understand and judge artwork. Art criticism is one kind of logical reasoning.

The main steps in art criticism are: describing what you see, analyzing what you see, interpreting your observations and judging art. When you judge art, you first identify the purpose and criteria for making the judgment. Then you go back to your observations, or visual evidence, and give reasons for your judgment.

There are four main philosophies about art and how to judge it: art as imitation, formal order, expression, and instrumental. The term masterpiece is used as the highest form of praise for an artwork.

A masterpiece is important in the history of art. It presents an important idea in a masterful design using appropriate techniques. It inspires people to look at it again and again.

Judgments about art differ for many reasons. Differences may happen because people do not look at the work in the same way. People may use different theories and standards. Their standards may not be related to the time and culture in which work was created. They may have different personal experiences.

Using What You Learned

Aesthetics and Criticism

1 Give one example of each kind of aesthetic perception: (A) subtle perception of a visual element, (B) imaginative perception, and (C) multisensory perception.

2 What is the main difference between art criticism and expressing a personal preference?

3 What are the four main steps in art criticism?

4 What are the main steps in judging art?

5 How can philosophies of art help you judge art?

Art History

1 What are four major philosophies of art?

2 What is meant when art historians call an artwork a "masterpiece"?

3 List three reasons why art historians and other experts may not agree in their judgments of the same artwork.

Creating Art

1 Choose one of the philosophies of art presented in this chapter. Create an artwork that meets at least three of the criteria emphasized in that philosophy.

2 Select one of your best completed artworks. Describe, analyze and interpret it. Then judge it using criteria that you think are appropriate to it.

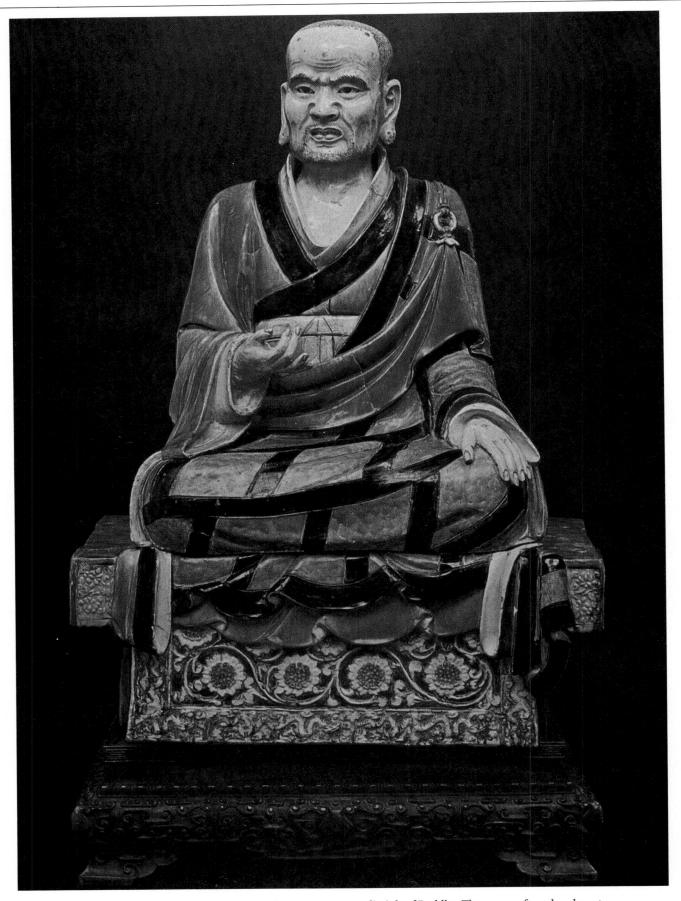

China, Ming, *Seated Figure of Lo han*, 1500's. This sculpture represents a disciple of Buddha. These were often placed on stone benches along the main hall in temples. Light gray terra-cotta with colored glazes, 3' 1" (94 cm). Ostasiatische Kunstabteilung-Staatliche Museum.

Chapter 4
Art: A World View

Chapter Vocabulary

Pre-Columbian art
African art
Oceanic art
Indian art
Southeast Asian art
Chinese art
Japanese art
Korean art
Islamic art

There are remarkable artistic traditions around the world. Some are part of the Western tradition of culture and art. This tradition began in the area of the Mediterranean Sea, especially in ancient Egypt, Greece and Rome. It developed throughout Europe during the Middle Ages and Renaissance to the present. The Europeans who settled North America brought their ideas about Western culture and art to their new land.

Non-Western cultures and art traditions are often very different from those in Europe and North America. Many of these differences come from religious beliefs, forms of government or social activities.

In many non-Western cultures, there is no word for art. People create many objects and visual images, but they rarely create art just to look at and enjoy. Instead, the items are made for special ceremonies or for use in every-day life. Each art form, material and design element has many meanings. These are usually well-known to the people who live in the culture.

In this chapter, you will learn more about the traditional art of non-Western cultures. *Traditional* art is created in about the same way from one generation to another. Some of the cultural groups you will learn about no longer exist. Others have existed for centuries but have undergone many changes. Some are so remote that scholars are just beginning to study them.

Studying this chapter will help you:

Art History • become familiar with traditional art of non-Western cultures.

Aesthetics • learn more about art terms, concepts, and values related to non-Western art.

Creating Art • understand that art is created around the world.

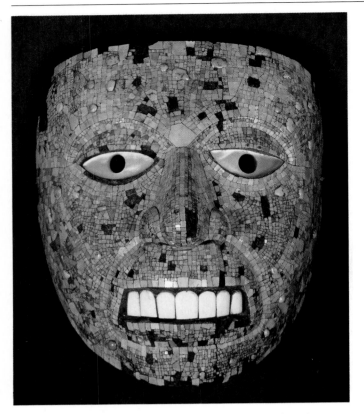

Mask of Quetzalcoatl, 1300-1450. This funeral mask is believed to represent a cultural hero of the Toltec people. Quetzalcoatl was a real prince named for an ancient Mayan god of sun and water. He encouraged art and learning but was forced into exile. He disappeared but promised to return at the dawn of a new golden age. Turquoise mosaic inlaid on wood. British Museum, London.

Pre-Columbian Art

Mesoamerica extends from present-day Mexico south to Honduras. Over 3,000 years ago, groups living in villages developed cities, ceremonial centers and states with military rulers. After Christopher Columbus's voyage of discovery in 1492, much of the region of Mesoamerica and South America was conquered by Spain. Art historians use the term *pre-Columbian* to describe the art of this region before the Spanish conquest.

Beginning around 1500 BC, the people in this region developed a civilization based on agriculture. They built cities and ceremonial centers with markets, plazas and temples. They developed a form of picture writing and a complex calendar. Their beliefs centered on gods who combined qualities of humans and animals. In addition to city planning and architecture, they developed great skills working in stone sculpture, painting, pottery, jade and gold.

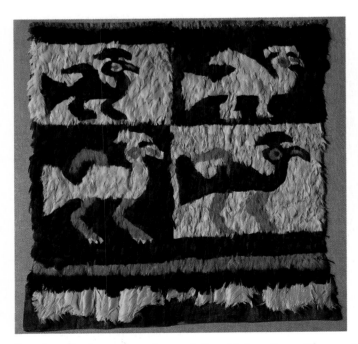

Peru-Inca, Featherwork mosiac panel: *Four Birds*, 1438-1532. The feather work on this poncho is one of many examples of highly developed textile arts in Peru. Featherwork. Metropolitan Museum of Art, New York.

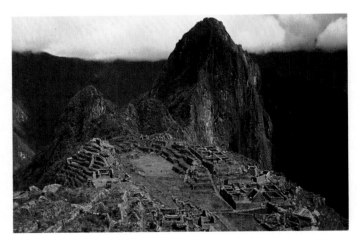

Temple of the Sun, an Inca ruin at Machu Picchu, Peru. This Inca city overlooks two mountains and a river 3000 feet (900 m) below. The steep slopes are terraced for gardens and connected to other levels by stairs. Some of the walls are built with perfectly fitted stone blocks of different shapes.

People of the Olmec, or "mother" culture created ceremonial centers with large sculptures of warriors, priests and athletes. The Mayans, another powerful group, built Teotihuacán, a large ceremonial city with pyramids, palaces, courts, a market, and many dwellings. Frescos and relief sculptures on buildings show animals, people, plants and gods. One of the most important figures was a plumed serpent-god known as Quetzalcóatl.

The last group to control the Mesoamerican region, the Aztecs, was conquered by Cortés in 1519. The Aztecs were war-like people who borrowed many ideas from Mayan art. One of their largest cities, Tenochtitlán, was destroyed in 1521. Present-day Mexico City was later built on the site.

Andean cultures in the region of Peru developed large public architecture and sculpture. They created pottery and worked in metals and textiles. Religious and agricultural ceremonies, as well as military rule, seem to explain much of the art.

The Mohica people built a 75 mile long (121 km) canal, a 50 foot high (15 m) aqueduct and a 135 foot high (41 m) pyramid with long ramps and terraces. People of the Incan empire built large fortresses, shrines, and sun temples, often with perfectly fitted blocks 20 feet high (6 m). They were conquered by Francisco Pizarro in the 1530's. The Incas were the last powerful native group in the region.

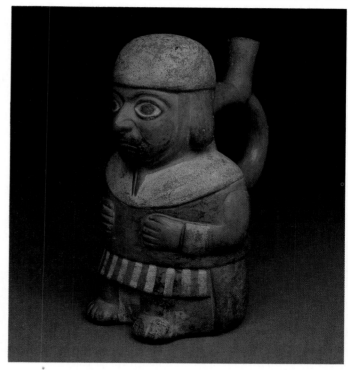

Mochica Culture Stirrup Vessel, ca. 500-800 AD. The artist-priests of the ancient Peruvian Mochica culture sculpted portraits in the form of clay vessels. Clay, 8" (20 cm). Collection of Charles W. and Janice R. Mack.

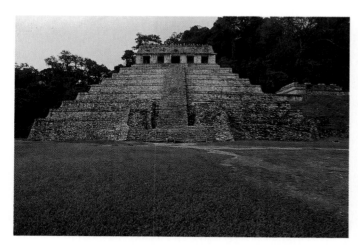

Palenque, Mexico, The Pyramid of the Inscriptions, ca. 700 AD. In Mayan culture, the pyramid often serves as a tomb or temple. The four sides of the pyramid represent the universe and sun god. The nine terraces stand for nine gods of the underworld. Thirteen steps join every other terrace. Thirteen represents the gods of the sky and names for days in the Mayan calendar.

Mexico-Southern Veracruz-Mextequilla area (Remojadas), *Smiling Figure*, 600-900. Many pre-Columbian artworks portray warriors or fierce rulers and gods. This smiling figure holds a rattle that suggests it may be a dancer. Painted ceramic, 18 ¹/₄" (46 cm) high. Metropolitan Museum of Art, New York.

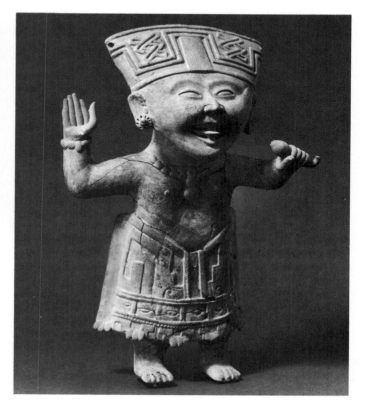

African Art

Africa is a vast continent with two major regions of culture and geography. In the north, around the Mediterranean Sea, there are many records of the ancient civilization in Egypt, near the Nile River. This civilization declined, but it influenced the growth of the Greek and Roman civilizations and the development of Western culture throughout Europe and much of Russia.

In the region of Africa south of the equator, there is a less complete record of early civilizations. The environment is damp, and wood – the most plentiful material for art – is rapidly destroyed by rot and insects. In addition, much of the art of the region has only recently been studied by scholars.

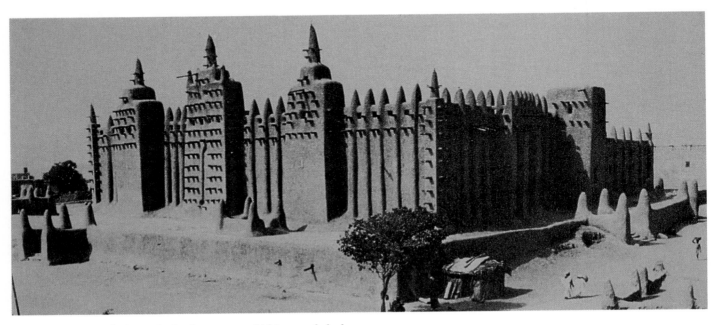

The Great Mosque of Djenne. In the desert areas of Africa, sun-baked mud is an inexpensive and practical building material. This mosque is an unusually large and tall example of the use of this material. Mali, West Africa.

Dance Mask, *Dan Tribe*, Ivory Coast, Africa, ca. 1900. This mask combines painted and carved wood with vegetable fiber hair, 9 ¹/₂" (24 cm) high. Collection of Charles W. and Janice R. Mack.

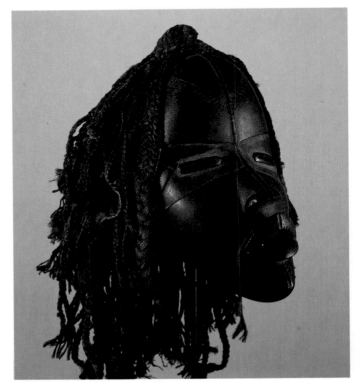

Within many groups, past and present, art has been created for use in ceremonies, rituals and everyday life. Sculptures, masks and costumes are often repainted, repaired or replaced as needed. They are often used to symbolize powerful spirits – ancestors, guardians, natural forces or other specific people. The process of creating an item is often as important to its meaning as the final product.

Traditions of representational art in clay have been discovered within an early Nok culture (about 500 BC). In the 1400's and 1500's, artists in the kingdoms of Benin (southern Nigeria) and Ife (west of Benin) mastered bronze casting. In the late 1800's, African art was first displayed in Europe. The abstract forms in much of the work influenced Pablo Picasso and other artists early in the twentieth century.

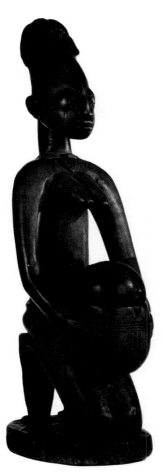

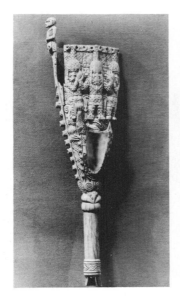

Nigeria, Benin Court, Gong. Ivory carvings are common in cultures where animals with tusks are abundant. Ivory, 14 ¹/₈" (35 cm) high. The Brooklyn Museum. A. Augustus Healy and Frank L. Babbott Funds.

Africa, Nigeria, Ilobu-Erin-Oshogbo Region, Shrine Figure. Wood, pigment, 22" (56 cm) high. The Brooklyn Museum. Gift of Dr. and Mrs. Robert A. Mandelbaum.

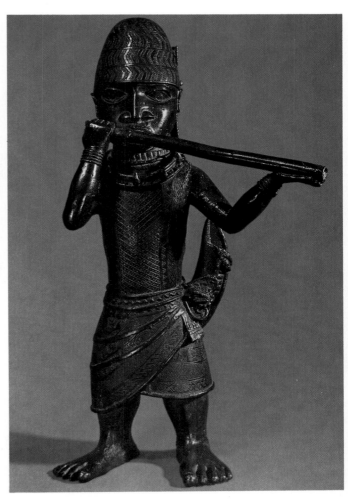

Benin culture, Nigeria, *Flute player*, 15th-16th centuries. This flute player is believed to represent a member of the court in the Benin Kingdom. The richly patterned woven clothing remains a tradition in much of West Africa. Engraved bronze, 24 ¹/₂" (62 cm) high. The British Museum, London.

Oceanic Art

Oceanic art is a general term for traditional art created by people who live in isolated groups on many Pacific islands and Australia. All of the art within this region was first created without the use of metal tools and techniques. Many works combine wood, shells, dyes from plants or fish, animal bones or tusks, feathers and other natural materials.

Local beliefs, myths, ancestor worship and heroes are common themes in art. Most of the art is created for ceremonial use or as decorations that symbolize a person's status in a group.

Melanesia includes many islands from New Guinea to Fiji. Architecture and many household items combine carved and painted surfaces. Raffia (fiber of a palm tree), reeds, tusks, shells, feathers and paint are among materials combined in richly embellished works.

Many groups use designs based on animals such as crocodiles, pigs, snakes, fish and birds. Myths and religious beliefs often determine the form and design of artwork. These beliefs center on the idea of supernatural spirits, faith in magic and the power of ancestors.

Micronesia includes many small islands north of Melanesia and east of the Philippines. Canoe and house building, as well as creating ornamental utensils, are highly developed crafts. Woven textiles and tattooing are major decorative arts. Carved figures honor ancestors and heroes. Design ideas follow local traditions.

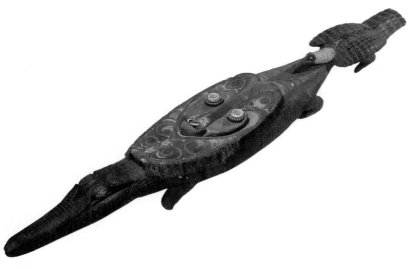

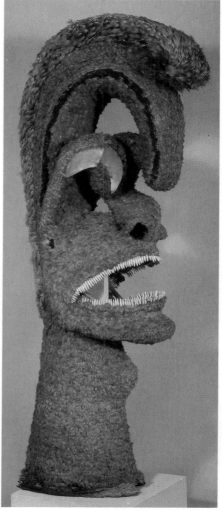

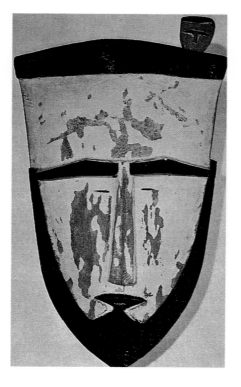

Melanesia, New Guinea, Sepik. *Crocodile Head.* Wood, about 1m. Musee de l'Homme, Paris.

Micronesia, Central Carolines, Wooden Face Mask from Mortlock. Painted with lime and soot, 17 3/4" x 19 3/4" (45 x 50 cm). Hamburgisches Museum fur Volkerkunde, Hamburg.

Headdress of War God. Feathered head-dresses like this were once worn into battle. The fierce face represents a war-god. Feathers on wooden frame. Polynesia, Hawaiian Islands, Kukaili-Moku. The British Museum, London.

Polynesia is a triangular area stretching from Hawaii to New Zealand and Easter Island. Many groups share a belief in the power of ancestors, a social ranking based on ancestors, and *mana*, a force for good or bad.

In Hawaii, a powerful form of wood sculpture developed to represent the war-god Kukailimoku. Feathers were inventively used. For example, large basket-woven masks covered with feathers were made and carried into battle. Feathered cloaks were worn by royalty.

Maori artists in New Zealand are known for intricate wood carvings, tattoos and textiles. Ancestor figures – guardians – are a common theme in carved house posts and doors. Tapa cloth, made by pounding and matting palm bark, is created by many groups. Designs are then stenciled with paint or ink stamps.

In Australia, the *aborigines*, or native people, have beliefs centered on Dreamtime. Dreamtime is known as the time of creation when giant animals arose from the earth and gave it form. These creatures had the power to take different shapes and change the world. They had human qualities and supernatural powers. When they died, they became stars in the sky. These spirits and stories about them are the main themes in Australian aboriginal art.

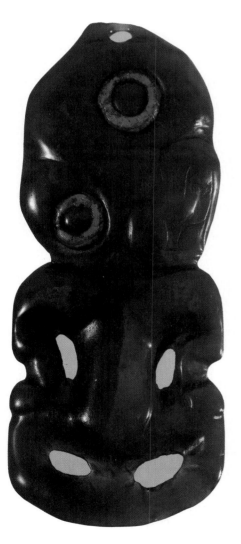

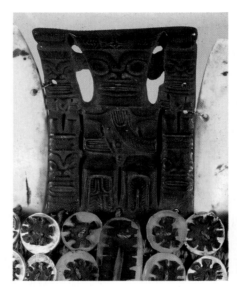

Marquesan Chief's Crown, 19th century. These stylized tiki images may represent important clan-members. This detail is part of a crown, worn by chiefs in the Marquesas Islands in Polynesia. Ivory, turtle shell, mother-of-pearl, 3" (8 cm) high. Courtesy of the Hurst Gallery.

New Zealand, Maori, Hei Tiki, 19th century. The Maori people of New Zealand create elaborate carvings. This ancestor figure is made from a very hard stone. It required weeks of carving. Green obsidian, red wax eye insets, 4" (10 cm) high. The Hurst Gallery.

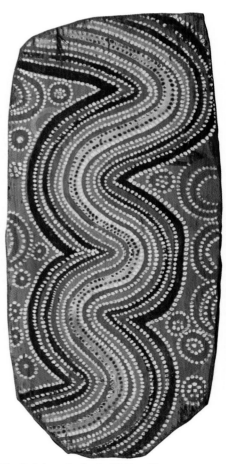

The Rainbow Snake. Indji. Port Keats Region, Australia. In this work, an aborigine (native) Australian uses circles to represent water holes. The rainbow snake is one of many creatures in the "Dreamtime," the aborigine system of beliefs. Painted bark 22 1/2" x 10 1/2" (57 x 27 cm). Collection of Louis A. Allen.

Indian Art

Indian art has developed over a period of at least 5,000 years. The first known civilization developed around the Indus valley. Murals in caves as well as sculpture in clay, stone and bronze were well-developed.

Early Hindu religion influenced many of the images in Indian art. The Hindu faith is based on the idea of reincarnation and myths about three main forces: *Brahma*, the creator; *Vishnu*, the preserver; and *Shiva*, the destroyer. Shiva, who can take many forms, is often shown dancing in a circle of fire or entwined with snakes.

A second major influence on Indian art is Buddhism, the religion founded by the teacher Buddha. Buddha is often shown in meditation seated on a lotus or water lily that symbolizes purity. He is often portrayed with large "all-hearing" ears or a third "all-seeing" eye. Sometimes he is portrayed sitting under a tree with royal attendants, or on a wheel-like throne that explains the laws of the religion. The hand positions have symbolic meaning. For example, one raised hand may symbolize that he is repelling fear.

In Buddhism, as well as in Hinduism, there is a great respect for nature and ancestors. Indian beliefs and art influenced much of the art in China and East Asia.

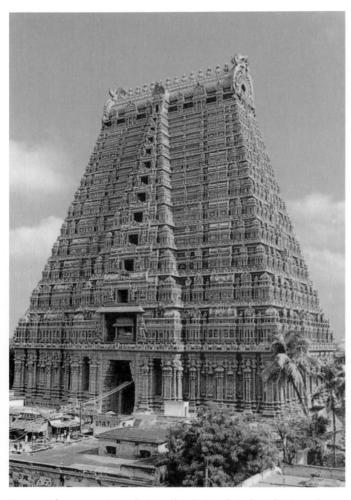

Ranganathaswanny Temple, Tamilnadi, South India. This temple was created to celebrate the conquests of a ruler in South India. The walls have many relief carvings based on Hindu myths and legends.

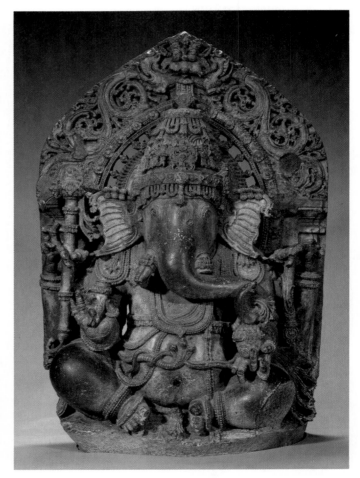

Mysore, India, *Seated Ganesha*, Hoysala period (12th-13th century AD). This elephant represents a four-armed god known as the "remover of obstacles." His lower hands hold a broken tusk from a mythical battle and a bowl of sweets which he delights in eating. Simple versions of Ganesha often appear on letters, and shop signs as a good luck sign. Chloritic schist, 35 1/2" x 23 1/2" (90 x 60 cm). Asian Art Museum of San Francisco. Gift of the deYoung Society.

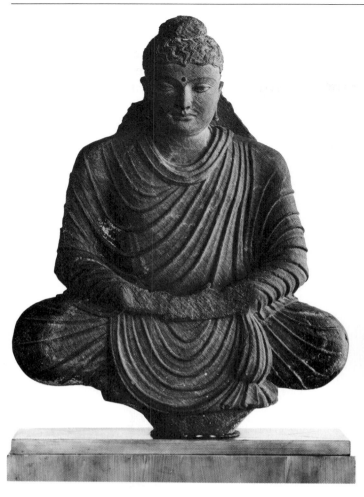

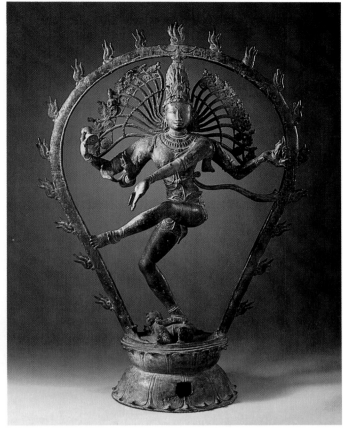

Tamilnada, *Siva, King of the Dancers, Performing the Nataraja,* Chola dynasty, India, 10th century. Siva dances on the back of a small figure that represents ignorance. The circle of flames represents the cosmos and forces of destruction. The right hand holds a small drum. It is a symbol for the sound of the heart beat and creative forces that come to life when Siva dances. Bronze, 30" x 22 ½" x 7" (76 x 57 x 18 cm). The Los Angeles County Museum of Art. Anonymous Gift.

India, Gandharan, *Gautama Buddha in Contemplation,* 1st-3rd century AD. Black schist from Taxila, 2' 4 ¾" x 22 ½" (73 x 57 cm). Yale University Art Gallery. Anonymous Gift.

India, Jehangir's Atelier, *The Zebra,* 1621. The court artists who created this painting had instructions to make an accurate visual record of anything of interest. The zebra had been a gift to the Emperor of India from the Turks. Gouache on paper, 8" x 10" (20 x 25) cm. Victoria and Albert Museum, London, England.

Southeast Asian Art

Southeast Asia is now identified by the names of countries. It includes the region of Vietnam, Cambodia, Thailand, Burma and the islands of Indonesia. Long ago, this region was settled by people known as the Dong-son (ancient Vietnamese), as well as the Mon, Pyu, Cham and Khmer people.

The art of the mainland region and Indonesian islands reflects influences from India and China. Local myths and legends as well as Hindu and Buddhist themes are often used for art. Human and animal figures are often symbols for ancestors or guardian spirits.

In Southeast Asian art, decorative designs and surfaces are often curved, flowing and based on plant forms or animals. Regional differences in design and subjects are especially obvious in the isolated Indonesian islands, where some artistic traditions are still practiced as they were centuries ago.

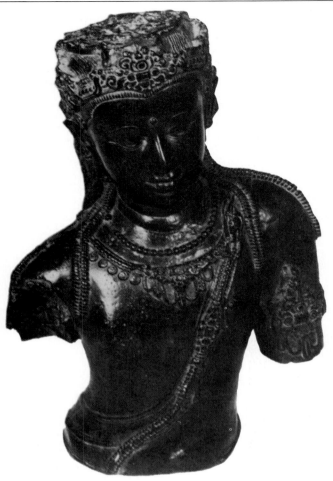

Chaiya, Thailand, *Bodhisattva,* mid-eighth century. A bodhisattva is a guardian spirit. This one has intricate jewelery – a crown, earrings, necklaces, and arm bracelets. Notice the graceful curves, an influence from India.

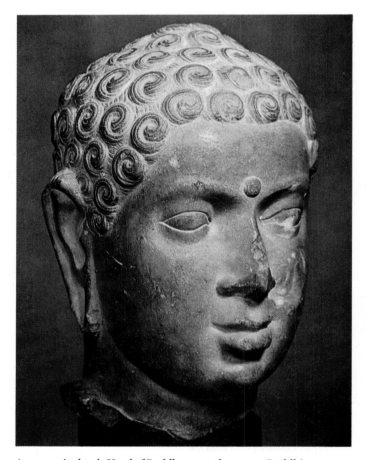

Amaravati school, *Head of Buddha,* ca. 2nd century. Buddhism spread from India to many parts of Asia. How does this sculpture differ from the Gautama Buddha? Marble, 8 ¼" (21 cm) high. Musée Guimet, Paris.

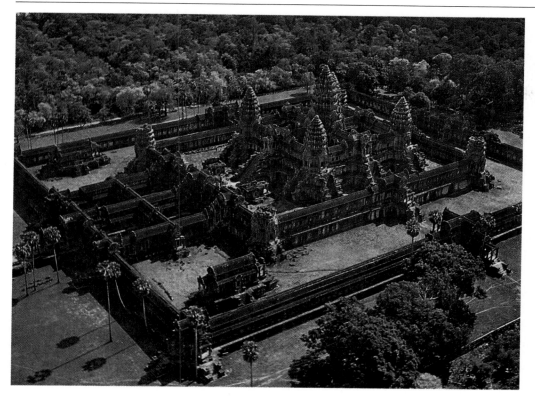

Angkor Wat, early 12th century. This temple-mountain is a tomb for the god-king who built it. It is surrounded by a moat. Relief carvings on the 2500 ft (800 m) walls depict Hindu myths and legends. Khmer architecture.

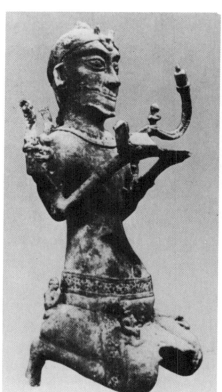

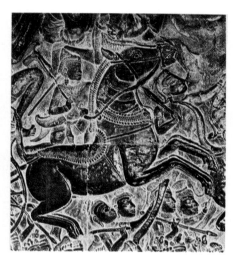

Angkor Wat, early 12th century (detail) This detail shows a frieze depicting *The Battle of the Pandavas and the Kauravas.*

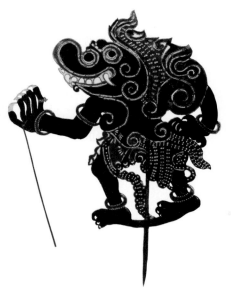

The God of Wine, 1st century BC. This ancient Vietnamese sculpture was found in a tomb. It was fashioned to hold a large candle. The ridges at the mouth are tongues. The god of wine was known as a "loosener of tongues." Bronze candelabrum, North Vietnam.

Kelantan Province, Malaya. *Shadow Puppet.* In Malaya, shadow puppets are still a popular art form. They are made with small holes so that light flows through them from behind. The puppet plays are based on myths and legends that have been retold for centuries. Smithsonian Institution, Washington, DC.

73

Chinese Art

China is believed to have the oldest continuous culture in the world. The Great Wall of China, 3,726 miles long (6,000 km), is only one of many accomplishments from over 2,500 years ago. Only a few of its earliest art treasures have been discovered. Among these are a vast tomb filled with thousands of life-size clay figures, chariots, horses and metal weapons. This treasury of art, hidden for 2,000 years, was discovered in 1974.

Chinese art has been influenced by Buddhist themes – ancestor worship and a respect for nature – as well as the teaching of Confucius. Confucius was a religious leader who emphasized proper conduct in everyday life.

Chinese art has also been influenced by different rulers. For example, during the T'ang dynasty (618–906 AD), ceramics, calligraphy and wood block printing were encouraged, along with paintings of birds, flowers and landscapes. The T'ang dynasty was an intense period of new discoveries often compared to the Renaissance in Europe.

During the Yüan and Ming Dynasties (1260–1368 AD and 1368–1644 AD), trade expanded and urban life developed. Ceramics and textiles, especially silk, were exported to Europe. A highly decorative, exotic kind of art developed under the Qing dynasty (1644–1911 AD). It has been compared to Baroque art in Europe.

As trade increased along with conquests, Chinese art influenced other countries, especially those in Southeast Asia, Japan and Korea.

Hall of Supreme Harmony, Imperial Palace, Beijing. Ming dynasty, begun 15th century. This building is part of a 180 acre walled city. Over nearly 500 years, 24 emperors lived here and ruled China. It is now maintained as a national monument open for public view.

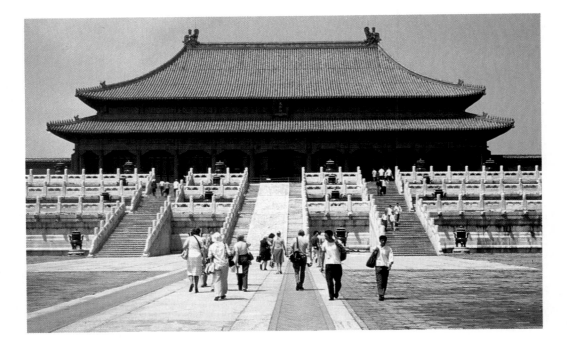

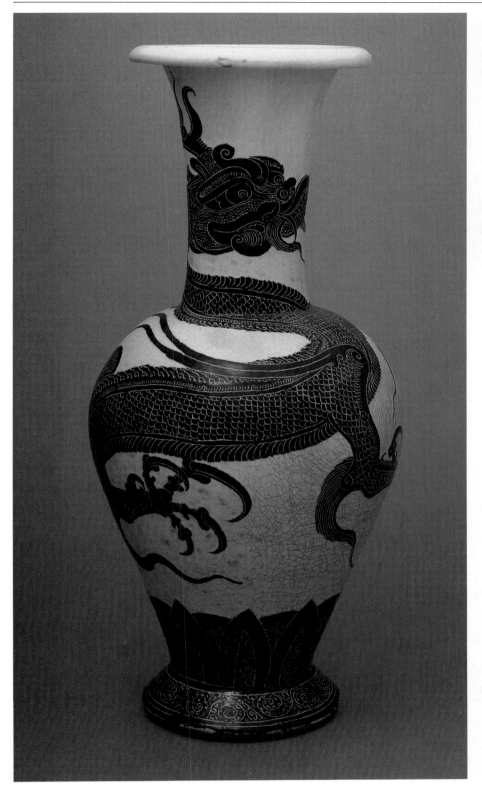

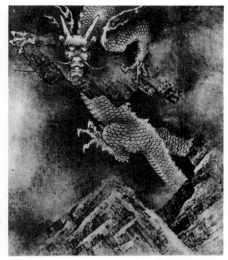

Chen Jung, *The Nine Dragons*, 1244 (Sung period). This is one section of a scroll. It swirls with dragons that move between the waves and sky. Ink and touches of red on paper handscroll, 18" x 431" (46 x 1096 cm). Courtesy, Museum of Fine Arts, Boston. Francis Gardner Curtis Fund.

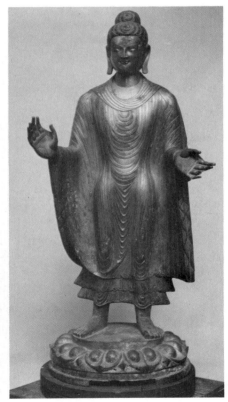

Standing Buddha, Northern Wei dynasty. Buddhism spread from India to China. This Buddha is one of the largest of its kind to survive. Compare the face with those on page 71 and 72. Gilt bronze, 55 $^{1}/_{4}$" x 19 $^{1}/_{2}$" (140 x 49 cm). Courtesy of the Metropolitan Museum of Art. John Steward Kennedy Fund, 1926.

Flower Vase, 12th century. In many Chinese ceramics, dragon images mean that the work was created in an imperial ceramic factory or for the emperor. Northern Sung dynasty. Ta'u-cho ware, porcelainous stoneware, 22 $^{3}/_{8}$" x 8 $^{1}/_{4}$" x 6 $^{1}/_{2}$" x 10" (57 x 21 x 17 x 25 cm). The Nelson-Atkins Museum of Art, Kansas City, Missouri, Nelson Fund.

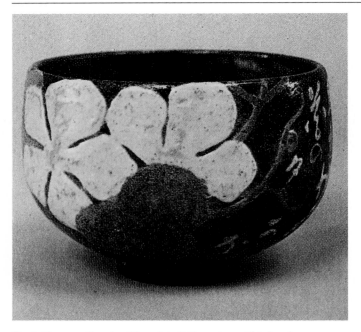

Ogata Kenzan, *Evening Glory*, late 17th century. This bowl was created for use in a tea ceremony. The tea ceremony is practiced by educated people as an aesthetic activity. The ceremony was first developed by Zen monks as a form of contemplation.

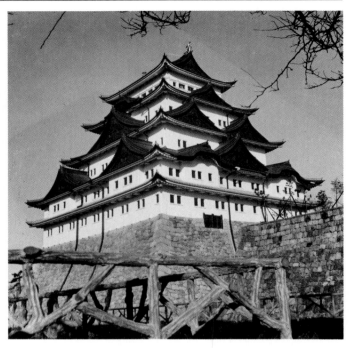

Nagoya Castle, exterior view. Momoyama period, Japan. This and smaller castles were elaborately decorated inside. Gold was often used on ceilings, walls, and folding screens to reflect light into the dark rooms.

Japanese Art

Buddhist themes and figures are also prominent in Japanese art. In addition to a deep respect for nature, Japanese art reflects the influence of the Zen religion and its aesthetic ideals. Three of the most important in art are: *wabi* (quiet, honest integrity), *sabi* (reserved, mellowed by time) and *shibui* (moderate, but refreshing and energizing).

These Zen-inspired qualities are sought in the arts practiced by well-educated people. Among these are the tea ceremony, flower arranging, gardening and painting with black ink and wash. Zen-inspired houses have a modular plan with room spaces created by sliding screens. These homes influenced American architect Frank Lloyd Wright.

Traditional Japanese paintings often take the form of folding screens or long scrolls – up to 36 feet (11 m) – which are unrolled and viewed in sections. Paintings on folding screens are often used to create private spaces. The Japanese are masters of multicolored woodcuts. Among many artists who excelled in this process are Hiroshige, Hokusai and Harunobu.

Japanese ceramic arts owe much to early Korean influences. They combine superior utility, subtle design and a sensitive use of materials. As in China, much of the sculpture of Japan is religious. During some periods, it was richly decorated with inlaid stone or gilded surfaces. Architectural monuments include palaces, fortresses and park-like shrines.

Trade increased between Japan and Europe during the 1800's. At about the same time, European art ideas began to appear in Japanese art, especially in work such as silks and ceramics created for export. European artists were also influenced by the linear qualities and flat spaces in Japanese art. The Impressionists and Post-Impressionists explored these and other design ideas.

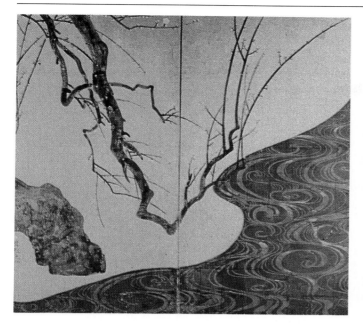 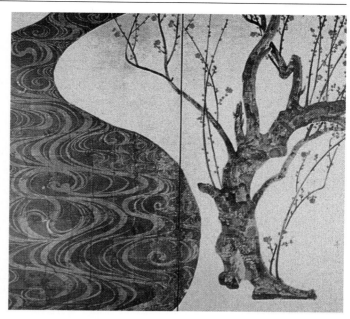

Ogata Korin, *Plum Blossom*, Middle-Edo period. Gold paper is the background for this folding screen. When the screens are placed together in a room, the water becomes a stream with a wide pool in the foreground. Pair of two-fold screens. Colors on gold paper, each screen 5' 5 3/8" x 5' 7 3/4" (166 x 172 cm). Atami Museum.

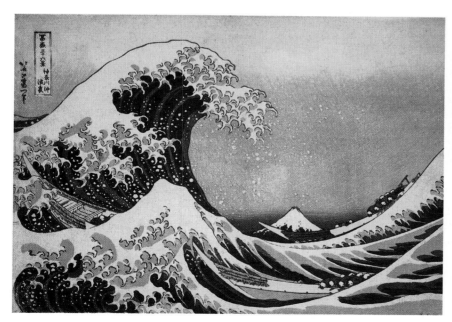

Katsushika Hokusai, *The Great Wave*. Hokusai was one of many masters of the art of multi-color woodcuts. This is one of 36 views of Mt. Fuji rendered in woodcuts. From the Series Egaku Sanjurok ei. Woodblock print. The Museum of Fine Arts, Spaulding Collection.

Muramachi period, *Portrait of a Zen priest, Abbot of a Monastery*. This realistic portrait shows a Zen priest. His hands are posed for meditation. Wood, lacquered, 36 1/2" x 22 1/2" x 17 1/2" (93 x 57 x 44 cm). The Metropolitan Museum of Art. Purchase, John D. Rockefeller III gift, 1963.

Korean Art

Korean art reflects the influence of Chinese art and the spread of Buddhism in eastern Asia. Many of Korea's early art treasures were destroyed in battles with China and Japan during the late 1500's. Under the Yi dynasty (1392-1910), artists in Korea worked in official studios to develop architectural projects, portraits of rulers and the like.

Unlike Chinese art, which is often angular, Korean art is typically graceful, refined and marked by gentle treatment of subjects. These qualities can be seen clearly in sculpture for shrines. In temple architecture, the roof lines seem to float and surfaces are richly decorative.

Korean potters invented the use of inlaid designs with different colors of clay. Their colors of glazes and subtle contours in form were widely admired. Korean potters, forced to leave their country in the 1500's, helped renew and refine Japanese ceramics.

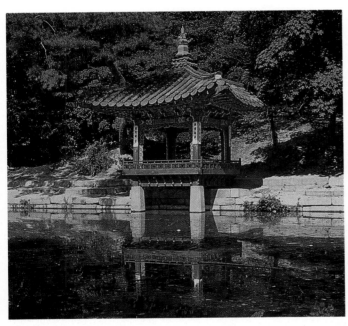

Late Yi period, *Pavilion in the Secret Garden.* This tranquil setting is part of a large garden near a palace. The pavilion is one of many used for conversation, banquets and festivals. Compare the roof lines here with those on the Hall of Supreme Harmony (page 74) and Nagoya Castle (page 76). Ch'angdokgugn Palace, Seoul.

Yi period, Porcelain jar with clouds and dragon. Grey porcelain with iron-oxide underglaze decoration, 14 1/8" (36 cm) high. Duksoo Palace Museum of Fine Art, Seoul.

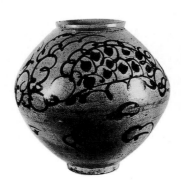

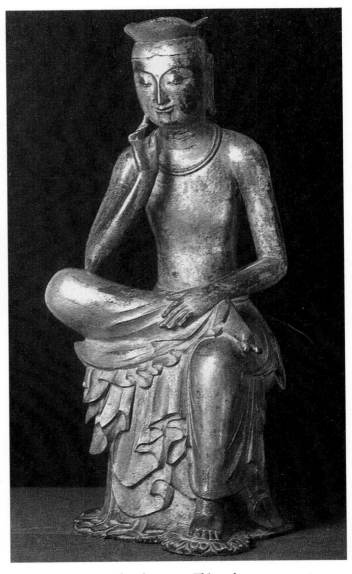

Paekche, *Maitreya,* early 7th century. This sculpture represents one of many guardian figures in a meditative pose. The general form and graceful curves appear to be influenced by Chinese art. Gilt bronze, 37" (93 cm) high. Toksu Palace Museum, Seoul.

Islamic Art

Islamic art takes its name from *Islam*, a religion started in 622 AD by the Arabian prophet Muhammad. Within a century, this religion had spread westward from the Arabian Penninsula to Spain and Africa and eastward to India and other parts of Asia. The followers of Islam – the Moslem faith – find their guidance in the Koran, a holy book.

The beliefs of Moslims have become a unifying artistic and cultural force in every region where Islam has been practiced. This unity has come about partly because artists are forbidden to represent people or the Moslem god, Allah, in religious art. It also has come about because the Arabic script (writing) serves as the basis for many designs.

Islamic art is richly ornamental. It combines curved and geometric forms in intricate patterns. Plant and animal motifs are often integrated with the calligraphic curves, called *arabesques*, used in writing. Moslem places of worship, called *mosques*, usually feature great domes, the inventive use of arches and distinctive towers called *minarets*, from which people are called to prayer.

In *secular* (nonreligious) art, people, myths and legends are portrayed. Many of the best known works were created for rulers of nomadic groups. Paintings are often miniatures or included in books so they can be transported easily. Other highly developed arts include enameled glass, ceramics, metalwork and textiles,

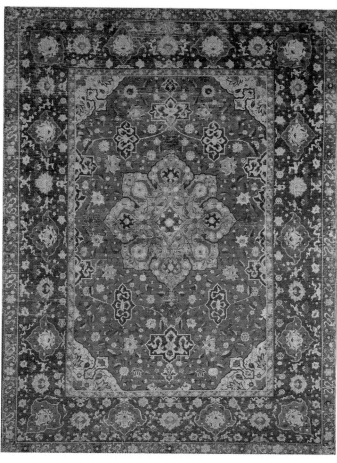

Persian, Anonymous, Silk Medallion Rug, ca. 1500-1550. Moslems have a long tradition of creating carpets on which they kneel for prayer. These skills were also used in carpets for trade and export. This work has fine naturalistic plant and animal motifs around a central medallion. National Gallery of Art, Washington, DC. Widener Collection.

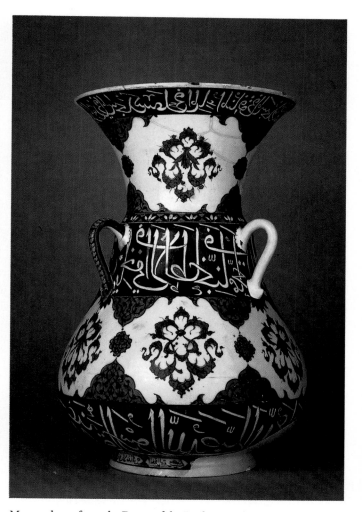

Mosque lamp from the Dome of the Rock-Jerusalem, 1549. This mosque lamp has a brilliant translucent glaze of many colors. The border designs are based on Arabic writing. Ceramic, 15" (38 cm) high. Isnik, Turkey. British Museum, London.

A Closer Look

Studying details and comparing them can be important in identifying art from different cultures. Notice, for example, the symmetrical design in Figure A. Symmetry is often used in Islamic carpet designs. Look at the patterns in Figure B and Figure C. How are they different? Are they only decorations, or do they serve as visual symbols for ideas?

Compare the curves in Figure C, Figure D, Figure E and Figure F. They are created in different media and by people in different cultures. Do many artists share an interest in the beauty of curves, even if they live in different cultures? Study Figure G, Figure H and Figure I. Which sculptures are most closely related? Why? Can you identify the culture in which each artwork was created?

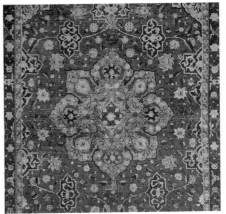

Figure A

Figure B

Figure C

Figure D

Figure E

Figure F

Figure G

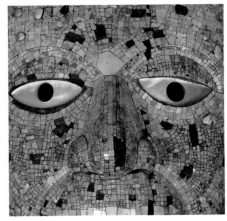

Figure H

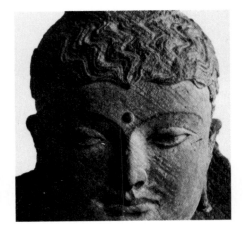

Figure I

Summary

The Western tradition of art and culture began in ancient Egypt, Greece and Rome. It was renewed during the Renaissance and has continued for the last 400 years. In this Western tradition, you learn to see art mainly as objects created for display and aesthetic enjoyment.

Much of the art you see in museums was not created just to be displayed as art. It was first created for use in everyday life and special ceremonies. The process of creating the artwork was filled with ritual or spiritual meanings. The objects might be seen as having power to help or to harm people. The way an object was used was just as important as its appearance. If you grew up in the culture, you learned the traditional meanings of the art forms. You knew when and how to interact with them.

You have learned about some of the arts of non-Western cultures. Most of these cultures have beliefs and values very different from those in the West. A knowledge of each culture can help you understand and appreciate its art. Equally important is your ability to imagine living in cultures where people have beliefs and ways of life that might be very different from your own.

Using What You Learned

Art History

1 In this chapter you have learned about non-Western traditions of art. What does non-Western mean? What does traditional art mean?

2 On a world map, identify the geographic regions that are included by each cultural style term. *Pre-Columbian art, Chinese art, African art, Japanese art, Oceanic art, Korean art, Indian art, Islamic art, Southeast Asian art*

3 What kind of subject matter is not shown in Islamic religious art?

Aesthetics and Criticism

1 Identify three works of art in this chapter that were created in different cultural regions. Describe the main differences in design, subject or materials and possible reasons for these differences.

2 Identify one of the artworks in this chapter that you find fascinating. *Fascinating* means you want to look at it even if you do not fully understand or like it. Give three reasons why you find it fascinating.

Creating Art

1 Every person has a cultural heritage. Your cultural heritage comes from the people with whom you have lived and grown up. Your heritage may go back to one of the cultures discussed in this chapter. It may have roots in Europe and North America. It may be a combination of several cultures. Create a work of art in any medium. In this work, try to express the best part of your cultural heritage.

2 Look back through this chapter. You will find many works created by artists who are unknown to us by name. Explain why the names of artists are often unknown to us.

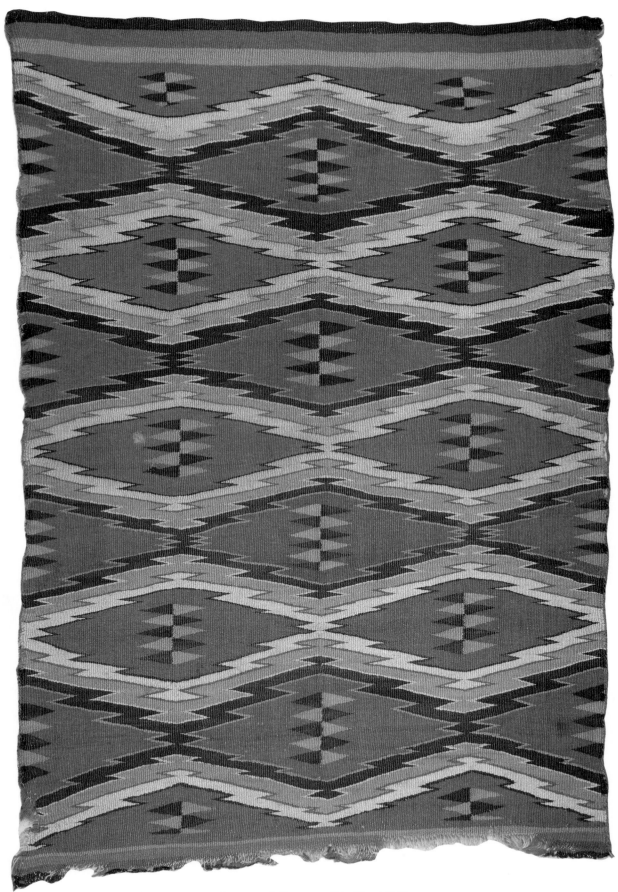

Navaho Eye-Dazzler Blanket, 1880-1890. Woven wool. Courtesy of the Hurst Gallery.

Chapter 5
Early Art in North America

Chapter Vocabulary

Native North American art
Mexican Mural Movement
Harlem Renaissance
Chicano art Movement
Colonial
Georgian
Churriqueresque
Furniture styles
 Chippendale
 Queen Anne
 Hepplewhite
Neoclassical
Revival (Greek, Gothic, Colonial)
Battle of styles
Chicago School of Architecture
prairie style
Victorian
Realism
Impressionism
Romanticism
Beaux Arts

When did people in your community come to North America? What kind of art did they admire and want to live with? To answer those questions, you need to study the art and architecture in your community. You also need to learn about art in your nation and in other parts of North America.

North America includes the region of present-day Canada, the United States and Mexico. Art in each nation has been influenced by its nearest neighbors and many other groups–from Asia, Africa and other lands. The earliest people in North America came from Asia. They crossed the Bering Strait to Alaska about 12,000 years ago. Their descendants became the first, or Native North Americans. They created art for thousands of years before Christopher Columbus and other Europeans arrived (see Chapter 4, "Pre-Columbian Art"). A Native North American artist created the beautifully made Navaho blanket you see on the opposite page.

The Colonial period in North America began when the Spaniard, Hernando Cortés, conquered the region of present-day Mexico in 1521. A century later, the first English and French colonists settled along the east coast. After a long quest for independence, three nations within North America were formed: the United States, Canada and Mexico.

Colonial art in these nations owes much to the first settlers from Europe. The European settlers also shared a similar heritage of art from the Renaissance, ancient Greece and Rome. This common heritage is one reason you can see similarities in North American art.

Art in the United States, Canada and Mexico also includes differences that come from the special history of each nation. Trade, industry and the religious beliefs of settlers have shaped trends in each nation's art.

In the first part of this chapter, you will learn about a few of the many cultural groups that have made North American art rich and varied. In the second part of this chapter, you will learn about changes in North American art from 1500 to 1900. In the next chapter you will learn about twentieth century art.

As you study this chapter, use the time line on page 104 to keep track of important trends in art. Choose a few of the artists, groups or periods for research. Visit museums or galleries to see original artworks. Sketch some of the historical styles of architecture in your community.

After you study this chapter, you will be better able to:

Art History and Creating Art	• understand the contributions of various groups to North America's art heritage.
Aesthetics and Art Criticism	• appreciate similarities and differences in art traditions within North America.

Native North American Art

Native North Americans have a deep respect for nature. You see this in their art. There are many visual symbols for the sun, moon, rain, wind, animals and plant life. These symbols are an important part of the meaning of the art. Natural materials are skillfully and creatively used. Some artists still create their traditional art forms and variations of them.

In the Arctic region, artists of the Inuit and Cape Dorset cultures carve ivory tusks and bones. They create ceremonial masks and fine work in leather.

In the Pacific Northwest, people of the Haida, Tlingit and other groups are known for wood sculpture. Their carved ceremonial masks, totem poles and other art forms express their beliefs, honor their ancestors and retell legends.

The Great Plains tribes include the Cheyenne, Sioux and others. They perfected art forms such as intricate work in beads, feathers and painting on hides.

The Iroquois, Oneida and other tribes of the eastern lands are known for their fine work in metal, woven baskets and colorful use of shells and porcupine quills. The Seminoles created highly patterned ceremonial clothing.

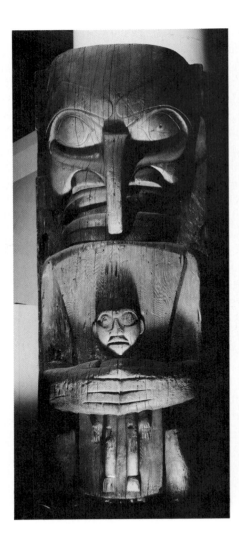

Northwest Coast, housepost, British Columbia, Bella Bella. This is one of four carved posts that were once placed in front of a home. Cedarwood, 9 1/2 x 3 1/2 x 17 1/4 (232 x 80 x 44 cm). The Brooklyn Museum. Museum Expedition of 1911. Museum Collection Fund. Photograph by Justin Kerr.

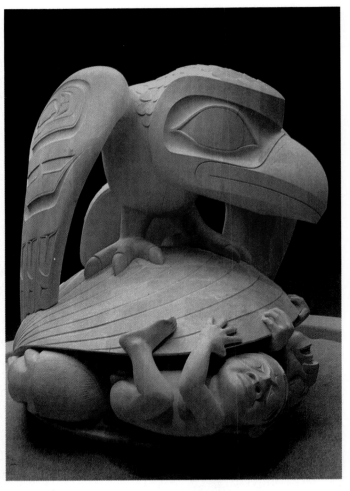

Bill Reid, *The Raven and The First Men.* Reid is a contemporary sculptor who works with themes from his heritage. Can you find similar design qualities in the housepost and this work? Laminated yellow cedar, 83" x 71" (210 x 180 cm). Museum of Anthropology, University of British Columbia. The Walter and Marianne Koerner Collection. Photograph by W. McLennnan.

In the Southwest, many groups have fine traditions of pottery, weaving and metalwork. For example, the Navaho are known for woven blankets, jewelry designs in silver and the creation of paintings with colored sand as part of healing ceremonies. The Pueblo and Mission Indians perfected the use of adobe (sun-baked clay bricks) to construct buildings.

The Native North Americans in Mexico are descendants of the Mayans, Toltecs and other groups who lived in the region before the Spanish conquered their land in 1521. Since then, the traditional art of these groups often includes symbols from their pre-Columbian history and the Catholic religion introduced by the Spanish conquerers.

When Europeans settled in North America, most of these native groups lost their land. Their cultural traditions were changed by the people who dominated or conquered them.

Today, many Native North American artists are trying to rediscover and preserve their traditions. Some have revitalized traditional crafts. Others are finding their own unique paths to creativity. There is not just one kind of Native North American art but many.

You might want to find out more about some of the following artists: (*United States*) George Hunt, Joyce Growing Thunder Fogarty, Fritz Scholder, Kevin Red Star, María Martínez, Pablita Velarde; (*Canada*) Bill Reid, Freida Desing, Robert Davidson, Norval Morrisseau, Kiawak Ashoona, Johnnie Inukpuk. See page 86, "Hispanic Influences," for Mexican artists.

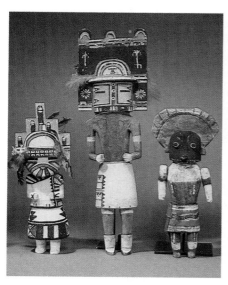

Hopi and Zuni Katchina dolls, Southwest American Indian. Painted on carved wood. Largest figure, 24 ¹/₂" (62 cm) high.

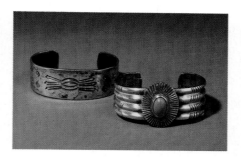

Navaho Bracelet, 1920-1930. The Navaho and other people of the southwest have traditions of fine work in metal, clay and fiber. Silver with turquoise, 1 ¹/₄" (3 cm). wide. Museum of New Mexico.

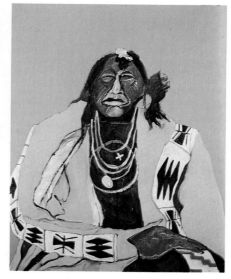

Fritz Scholder, *Dartmouth Portrait #10*, 1973. Many Native American artists create art about their past and present experiences. Their styles of art are not always clearly linked to their traditional forms of art. Oil on canvas, 68" x 54" (173 x 137 cm). Courtesy of the artist.

Apache Girl's Fringed and Beaded Hide Dress. Skirt, 42" (107 cm), blouse 19" (48 cm).

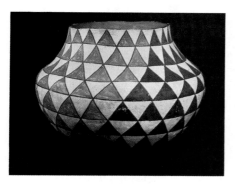

Acoma Pueblo, New Mexico, Jar, 1910. Polychromed pottery, 9 ¹/2" (24 cm) high. Museum of the American Indian. Heye Foundation.

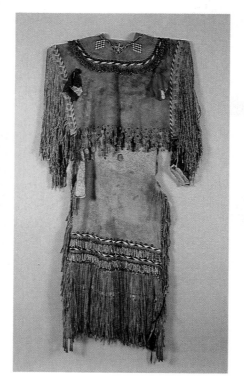

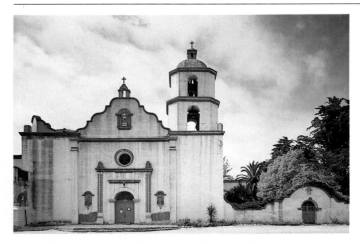

Hispanic, San Luis Rey Mission, 1811. Mission architecture often combines ideas from Spain, Mexico and traditions of construction in the Southwestern states. San Luis, California.

Jose Ines Herrera, *Death Cart or La Dona Sebastiana*, El Rito, New Mexico, late 1800's. Religious themes are a prominent part of Mexican and Hispanic artwork. Wood, gesso, polychrome, animal hair, rawhide, 54 ½" x 26" x 36" (138 x 66 x 91 cm). Denver Art Museum. Anne Evans Collection.

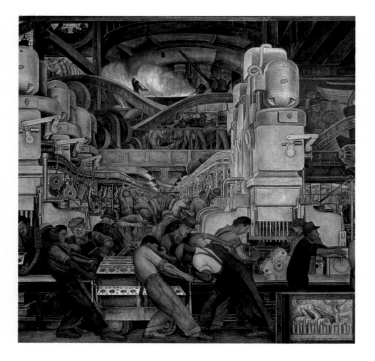

Hispanic Influences

Hispanic refers to Spanish influences in a culture. You see Hispanic influences on art in Mexico and much of the southwestern United States. This region was once called New Spain. Spain ruled Mexico for about 300 years.

Around 1530, the Catholic religious leaders in New Spain began to set up missions to teach their religion to the native people. Some of the earliest buildings in Mexico are similar to the elaborate Gothic and Renaissance churches in Spain. Small churches were built from adobe – sun-baked – clay brick. They had Spanish elements, such as bell towers to call people to worship.

Around 1900, Hispanic styles of homes became popular in the United States and southern Canada. These homes have adobe-type walls, curved clay-tile roofs, thick interior beams and patio gardens.

In the early twentieth century, a new form of political art developed. José Clemente Orozco, Diego Rivera and David Alfaro Siqueíros lead this *Mexican mural movement.* These artists revived the art of fresco painting. Using dramatic shapes and colors, they portrayed the history of the Mexican people's struggle for freedom. Rivera and Orozco also painted murals in the United States. Their work inspired mural-making projects by United States artists during the Great Depression of the 1930's.

Many people of Mexican heritage live in the United States. Some call themselves *Chicano* – a short term for *Mexicano.* In the 1960's, Chicano artists began to set up cultural centers and exhibit their work together. Artists in this *Chicano art movement* are expressing their special customs, folklore and feelings about their life in the United States. You might want to find out more about these artists: Judith Baca, Luis Jiménez, Mario Castillo, Carmen Garza, Melesio Casas, Leonard Castellanos, Eduardo Carillo.

Other Hispanic artists, including artists from Cuba and the Carribean, have also become well-known. Among them are; (*Mexico*) Rufino Tamayo, Frida Kahlo, José Cuevas, Helen Escobedo, José de Rivera; (*Puerto Rico*) Rafael Tufiño, Myrna Báes, Rafael Ferrer; (*Cuba*) Amelia Paláez; (*Haiti*) Jean-Michel Basquiat.

Diego Rivera, *Detroit Industry*, 1933 (detail from south wall). This is a detail of a large group of murals created in the United States by one of Mexico's most well-known artists. Fresco. The Detroit Institute of the Arts. Founders Society Purchase, Edsel B. Ford Fund and Gift of Edsel B. Ford.

African Influences

African people were first brought to North America as laborers. Many were highly skilled artists and craftsworkers. In Africa they had created art for their royal families and for daily or ceremonial needs. In North America, some of these craftsworkers built the homes of the slave owners, adding carvings, ceramic details and ironwork.

With the end of slavery in the United States in 1865, there were more opportunities for African-Americans to study painting and sculpture. Among the first artists who became well-known were painters Robert Duncanson and Henry O. Tanner, and sculptor Edmonia Lewis.

In the 1920's, a group of artists, writers, photographers and entertainers gathered in Harlem, a section of New York City, to express their heritage as African-Americans. Among the artists in this *Harlem Renaissance* were painter and printmaker Aaron Douglas, photographer James Van der Zee, sculptor Meta Fuller, and painters Palmer Hayden and William H. Johnson.

Others who formed a community of African-American artists were sculptors Augusta Savage, Selma Burke, Richmond Barthé, Elizabeth Catlett and Sargent Johnson. Painters included Lois Mailou Jones, Laura Wheeler Waring and Hale Woodruff.

During the 1930's, Jacob Lawrence, Romare Bearden and Charles White were among well-known artists employed on government art projects. After World War II and the beginning of the United States civil rights movement in the 1950's, more African-Americans studied and exhibited art.

Today, there are museums of African art and African-American art. Art historians such as Samella Lewis are doing research on African-American art.

African-American artists work in many styles and explore their individual interests. You might do research on such well-known artists as; PAINTERS: Sam Gilliam, Alma Thomas, Howardena Pindell, John Biggers; SCULPTORS: Richard Hunt, Betye Saar, Faith Ringgold, Barbara Chase-Riboud and PHOTOGRAPHER/FILMMAKER Gordon Parks.

Henry O. Tanner, *The Banjo Lesson*, 1893. This African-American artist drew inspiration from his heritage and from the European art style known as Impressionism. Oil on canvas. 48" x 35" (122 x 89 cm). Hampton University Museum, Hampton, Virginia.

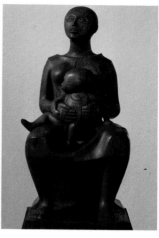

Elizabeth Catlett, *Mother and Child.*. Elizabeth Catlett's sculptures reflect her deep interest in people including their hopes and problems in today's world. Pecan wood, 23" (58 cm). Museum of African American Art, Los Angeles.

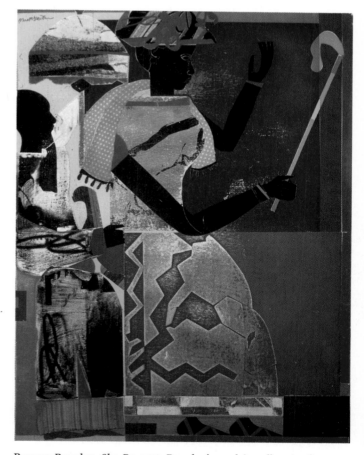

Romare Bearden, *She-Ba*, 1970. Bearden's work in collage is often based on African themes or the experiences of African-Americans living in large cities. Collage of paper, cloth, synthetic polymer paint on composition board, 48" x 35 $^7/_8$" (122 x 91 cm). Wadsworth Atheneum, Hartford. The Ella Gallup Sumner and Mary Catlin Sumner Collection.

Asian Influences

North American art has also been enriched by people from Asia, especially from China, Japan, Korea and Indochina (Laos, Vietnam, Cambodia, Thailand, Malaysia).

In the early 1600's, Spanish sailing ships brought Asian silks, ceramics and artwork to Mexico. Some of the Asian designs were used in Mexican religious art. For example, saints were sometimes portrayed in silk robes with Asian floral designs.

In the eastern colonies of North America, trade with China began in the 1700's. Trade with Japan increased after the 1860's. Imported furniture, ceramics and textiles from these nations became popular.

A deeper understanding of Asian art began to develop in the 1890's. It came from new research and teaching about Asian art in North America. This helped many people appreciate Asian art and want to collect it. Arthur Wesley Dow used this new research in his theory of the elements and principles of design. He wanted his theory to apply to the art of Asia, not just to art from European traditions.

Asian religions and art have inspired many artists to explore new directions. For example, Asian calligraphy (beautiful writing with a brush) inspired the work of painters Morris Graves, Mark Tobey and Jackson Pollock. The wonderful integration of landscapes and buildings in Japan inspired some of the architecture of Frank Lloyd Wright (*United States*) and Arthur Erickson (*Canada*).

Many artists of Asian heritage are known as leaders of new directions in twentieth century art. Their cultural heritage is often a source of inspiration for art. You might want to find out more about these artists; PAINTERS: Dong Kingman, Yasuo Kuniyoshi; PRINTMAKER: Seong Moy; SCULPTORS: Isamu Noguchi, Ruth Asawa; ARCHITECTS: Minoru Yamasaki, I.M. Pei, Maya Lin; VIDEO ARTISTS: Nam June Paik, Shigeko Kubota and Tomiyo Sasaki.

Helmuth, Yamasaki and Leinweber, Airport Terminal Building, 1954. Yamasaki's design for the St. Louis airport is still considered one of the most graceful and functional in the world. St. Louis, Missouri.

Ruth Asawa, *Number 9*, 1955. Ruth Asawa works in a variety of sculptural media including clay and bronze. Brass wire, 66" high. Courtesy of The Whitney Museum of American Art, New York. Gift of Howard Lipman.

Dong Kingman, *The El and Snow*, 1946. Dong Kingman's watercolor reflects his early and strong interest in Asian traditions of calligraphy. Watercolor, 21" x 29 ³/₄" (53 x 76 cm). Collection of Whitney Museum of American Art. Purchase.

Women Artists

Many artworks by women are included in this book. Others can be found in galleries and museums in your community. If you travel to Washington, DC, you might visit the National Museum of Women in the Arts.

Today, artwork created by women is being recognized as never before. In the 1970's, art historians such as Linda Nochlin and Anne Sutherland Harris began doing research on women artists. Many other scholars are discovering that women were leaders in art. Here are just a few highlights from this research.

Native North American women have a deep heritage of art. In many groups, women artists create fine weaving and stitchery. They also create pottery and work with leathers and metals.

During the Colonial period (1500-1776) few women had the opportunity to study art. Many created hand-made quiltwork, stitchery and other crafts. North America's first professional sculptor, Patience Wright, created realistic portraits in wax.

During the quest for independence (1776-1860), well-known painters included Lilly Spencer and Fidelia Bridges. Fine portraits and still lifes were painted by sisters Sarah, Anna and Margaretta Peale. Leading sculptors were Harriet Hosmer, Anne Whitney and Emma Stebbins. The famous printing firm Currier and Ives published over 200 illustrations by Frances Palmer.

In the era of industrialization and growth (1860-1900) more women studied and exhibited art in major European shows. Among them were painters Elizabeth Gardner, Anna Merritt and Elizabeth Nourse. Janet Scudder pioneered the art of garden sculpture. Bessie Vonnoh, Helen Mears, Evelyn Longman and Elisabet Ney received commissions for large sculptures.

In the early twentieth century, more women became self-employed in art. United States painters Cecilia Beaux and Mary Cassatt, and Canadian Emily Carr became internationally known. Architects Julia Morgan and Marion Mahony received major commissions. Candace Wheeler created textile designs for the Tiffany Company in New York City. You will learn more about other women artists in this and other chapters.

Marion Mahoney Griffin, Rendering of two houses in Evanston for Hurd Comstock. Photograph courtesy of Northwestern University.

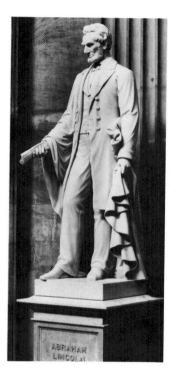

Vinnie Ream Hoxie, *Abraham Lincoln*, 1871. In the late 19th century, women had opportunities to create large sculptures for public buildings. Marble. Statuary Hall, United States Capitol. Photograph: Architect of the Capitol. Courtesy of the United States Capitol Art Collection.

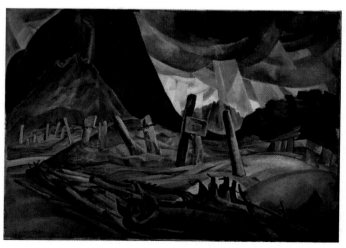

Emily Carr, *Vanquished*. Emily Carr is one of Canada's most well-known artists. What does the title of her painting mean? Oil on canvas, 36" x 51" (92 x 129 cm). Collection of the Vancouver Art Gallery. Emily Carr Trust, 1942.

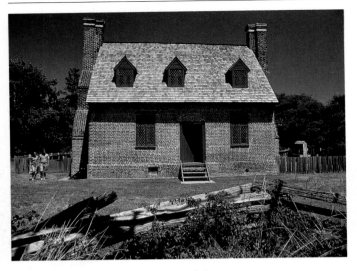

Courtesy of the National Audio-Visual Center.

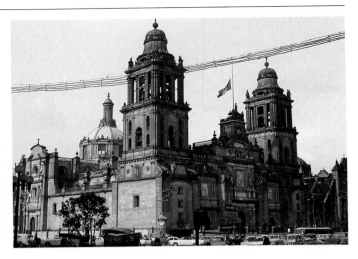

Zocalo Cathedral, 1563-1667 Mexico City. Photograph courtesy of George Barford.

Early Colonial Period 1500-1700

Around 1500, many European nations began to send ships across the oceans to Asia, Africa and the Americas. In North America, they set up three major colonies: New Spain, New France and New England.

The Spaniard Hernando Cortés planned New Spain's first major colonial city in 1521. It is present-day Mexico City. The colony of New Spain grew rapidly. Fleets of ships brought craftsworkers and tools for constructing buildings, especially churches. Religious artworks were created to help teach the Catholic religion to the native people.

In Canada, a fur trading settlement in Quebec was started in 1608. It grew to be the colony of New France. Most of the settlers were Catholics, who wanted their churches to be richly decorated. The first art school in New France, set up in 1675, trained artists to meet this need.

New England included thirteen colonies along the Atlantic coast. Virginia was the first colony, founded in 1607. Massachusetts became a Pilgrim settlement in 1620. The Dutch colony in the region of New York, originally founded by the French, soon became an English colony too. Before long, colonists from Germany, Sweden and other northern European countries arrived. Many of the settlers were Puritans and other Protestents seeking religious freedom.

The major influences on art in the thirteen United States colonies came from England. Most Protestants worshipped in simple meeting houses and churches. In early New England, paintings and decorative items were created primarily for homes, not for churches.

Architecture

Early settlers in the New England colonies and in New France created makeshift cabins and log cottages. Later, they built homes from stone, brick and hewn planks. Windows were made from imported glass. The builders of churches, homes and stores often added style details from their homelands in England and other countries.

In New Spain, architecture was more advanced. Mexico City and other urban centers had large cathedrals and government buildings. The style was similar to the Renaissance and Baroque styles of architecture in Spain.

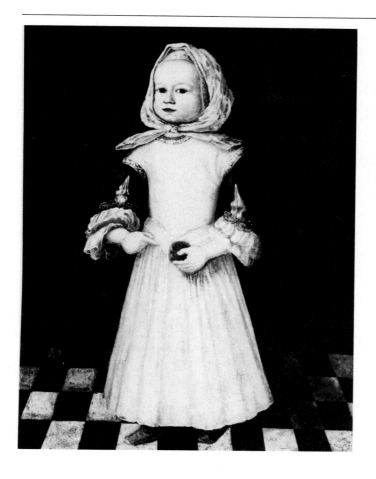

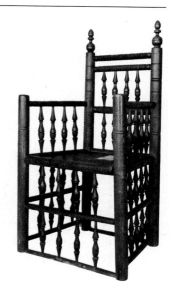

Unknown, *Alice Mason*, ca. 1670. Few of the first settlers had formal training as artists. They were self-taught. U.S. Department of the Interior, National Park Service, Adams National Historic Site, Quincy, Massachusetts.

Unknown, Turned Chair (Bradford), ca. 1640. Chairs were a luxury item in many homes. This was owned by William Bradford, Governor of the Plymouth Colony. Ash, 45 1/4" (115 cm) high. Courtesy of the Pilgrim Society, Plymouth, Massachusetts.

Design

The furnishings in the early homes of New England and New France were simple handmade stools, tables and the like. As more settlers arrived with special skills, craft-workers built finer furniture. Silversmiths found work in the large cities. Most household items were still imported.

In New Spain, native artists had created fine work in ceramics, metals and textiles before the Spaniards arrived. These artists created new designs to please the Spanish and to decorate the many new churches.

Painting

In the New England colonies, portraits were the most common form of painting. Most painters were self-taught *limners*–people trained to paint signs and houses. Many paintings show the settlers in fine clothes, posed as if they were European aristocrats.

In New France and New Spain, the most advanced painting was created for churches. French artist Frère Luc created religious paintings in a Baroque style for churces in Quebec.

In New Spain, artists were organized into *guilds*, like labor unions, to create religious murals and smaller paintings. They often copied designs from prints of European art. They added bold colors and patterns to brighten the mood of the works.

Sculpture

Sculpture in the New England colonies was limited. Carved gravestones included medieval symbols for death: skulls or skeletons, crossed bones and hourglasses.

In New France, Noël Levasseur and his family began a tradition of elaborate carving for churches and homes in Quebec. In New Spain, sculptures of saints and elaborate altarpieces were carved for churches.

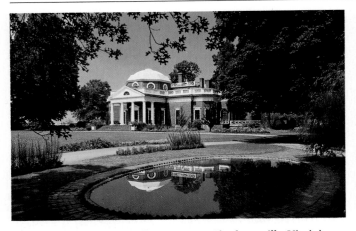

Thomas Jefferson, Monticello, 1768-1809. Charlottesville, Virginia. Jefferson designed his own house. His ideas for the home came from an Italian architect of the Renaissance, Andrea Palladio, as well as from English villas in the Palladian style.

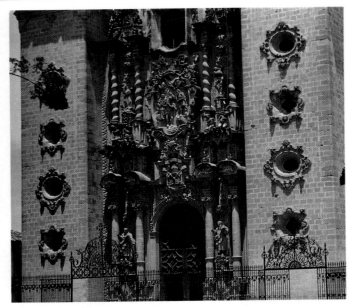

Santa Prisca Church in Taxco, Mexico. Colonial design ideas for churches in New Spain were very ornate. Can you explain why? Photograph courtesy of George Barford.

Late Colonial Period 1700-1776

By 1700, there were about a quarter of a million settlers in the New England colonies. Many of the people who lived in towns were merchants, traders and craftsworkers.

New France had grown to include about 70,000 people. From Quebec, French explorers traveled west and south along the Mississippi River to present-day New Orleans. English-speaking people were also arriving in Canada. Conflict lead to a war between the French and English (1757-1763). The English won and became dominant in much of Canada. The older French culture is stilled preserved in the region of Quebec and parts of the United States' Midwest down to New Orleans.

From New Spain, soldiers and church leaders moved north into California and parts of Arizona and Colorado. They set up forts and missions to teach their religion to Native North Americans.

Architecture

In the New England colonies and English-Canada, most people constructed buildings by following plans in books from Europe. The *Georgian* style, named for kings in England, was popular. This style borrows ideas from ancient Greek and Roman temples, and a Renaissance villa by Palladio.

Georgian buildings are symmetrical. They often have columns near the front door. They have windows with rounded tops, and hip-type roofs with windows projecting out from the roof. Churches and large public buildings had tall steeples.

In French-Canada, churches resembled the fancy Baroque and Rococo churches in France. Homes of the wealthy resembled French mansions, called *châteaux*.

In New Spain, the earlier Baroque style of cathedrals became much more elaborate. Carved altarpieces had intricate twisting designs gilded with gold. Colorful paintings of saints filled the open spaces. This style came from a family of architects in Spain named Churriquera. The style is called *Churriqueresque* (chur-IG-er-esk).

Design

In the larger settlements, people had more time for relaxation. Homes for wealthy people often had many rooms. In the New England colonies and English-Canada, furniture designs by Thomas Chippendale were popular. The *Chippendale* style was a variation on the fancy Rococo style in Europe. A light, graceful style of furniture called *Queen Anne* was also popular. Workshops for glassmaking and ceramics were started.

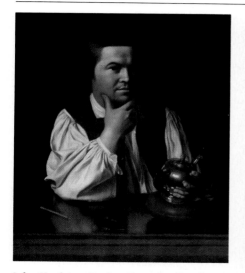

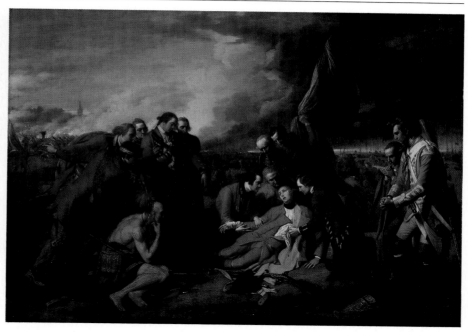

John Singleton Copley, *Portrait of Paul Revere*, 1765-1770. West and Copley were among the first American-born artists to study in Europe. Both became famous, in Europe and America, for their portraits and paintings about history. Oil on canvas. Museum of Fine Arts. Gift of Joseph W., William B. and Edward H. R. Revere.

Benjamin West, *The Death of General Wolf*, 1770. Oil on canvas, 60" x 84" (154 x 213 cm). National Gallery of Canada, Ottawa. Transfer from the Canadian War Memorials, 1921. Gift of the Second Duke of Westminster, Eaton Hall.

Unknown, Chippendale Side Chair, Charleston, South Carolina, ca. 1770. Upholstered chairs with fancy carving were popular in homes for the wealthy. The styles were adapted from Europe and have some elements from new trade with China. Mahogany, 39 ¹/₄" (102 cm) high. Greenfield Village and Henry Ford Museum.

Unknown, Queen Anne Side Chair, 1730-1760. Walnut and maple, 40" (102cm) high. Historic Deerfield, Inc., Deerfield, Massachusetts.

In the larger colonial towns, artwork in silver and other metals became more elaborate. Silversmith and United States patriot Paul Revere worked in Boston. Many women created fine quilts, needlework and homespun weaving

Painting

Most Colonial painters were still self-taught. Some artists had moved beyond the stiff paintings of limners. British-born John Singleton Copley and Benjamin West created portraits and historical paintings. Both of these New England colonists went to England and became well-known. Copley was accepted as a member of the Royal Art Academy of England. West became a painter for King George III.

In New Spain, portraits were similar to European paintings of aristocrats. They often included jewelry and details to show the person was rich and Catholic. For example, women were shown with lacy veils traditionally worn to church.

Sculpture

Throughout the colonies, sculpture was still a craft related to wood carving, stonecutting, or metalworking. In New France, Jean Baillairgé and members of his family of began a 200 year tradition of fine carving for churches and mansions.

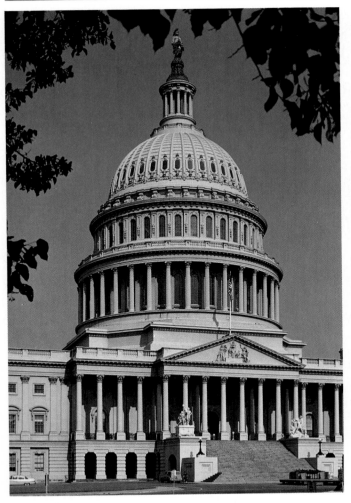

Thomas Ustick Walter, United States Capitol Dome, 1856-1863. Washington, DC. This building has many variations on Classical ideas. Neoclassical art and architecture were also popular in Europe.

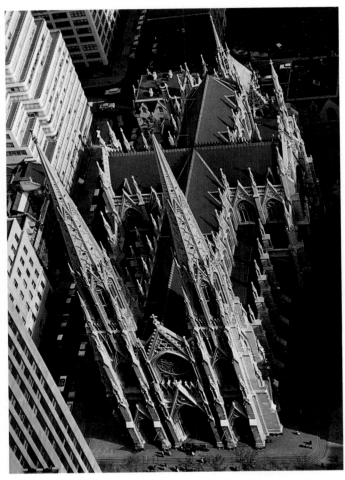

James Renwick, Saint Patrick's Cathedral, 1858-1879. New York.

Quest for Independence 1776-1860

During this period, North Americans sought and won independence from Europe. The United States became independent from the English in 1776. Mexico became a nation in 1821, and the region of New Spain north of the Rio Grande River became part of the United States. Canada's national government was set up in 1867.

Even though three new nations were formed, there were important similarites in North American art, for two main reasons.

First, most of the wealthy and well-educated people still thought that all good art came from Europe or the classical time of ancient Greece and Rome. A *Neoclassical* style of art captured this idea about good art. You can find artistic variations on this style throughout North America.

Second, most artists in Canada and the United States went to Europe to study in art academies. In these academies they learned to create work in the Neoclassical style. Most Mexican artists studied at an art academy in Mexico City. Set up in 1785, this academy also taught artists the Neoclassical style.

Architecture

Most buildings in the Neoclassical style are symmetrical and look like Greek or Roman temples. In the United States, this style was promoted by Thomas Jefferson, architect and president. Jefferson chose Benjamin H. Latrobe to construct the United States Capitol. Latrobe's plan included many Neoclassical features. You can see similar features in many public buildings.

George Hubener, Dish, Montgomery County, Pennsylvania, 1786. Red clay with lead glaze and sgraffito decoration, 2 ⅛" x 12 ¼" (5 x 31 cm). Philadelphia Museum of Art. Gift of John T. Morris.

Gothic Revival House, Toronto, Canada. Some architects drew inspiration from the Gothic style in Europe. Variations on the style were developed for many churches as well as cottages.

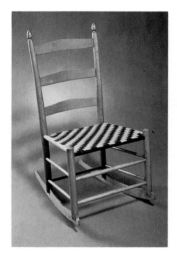

Shaker Rocking Chair. The Shakers, a religious group, lived by themselves. They created simple, superbly crafted furniture for their own use and for sale to others. Yale University Art Gallery. Gift of Mrs. A. Duer Irving.

In Canada, Jérôme Demers and Thomas Baillairgé developed a variation on this style called *Louis XVI,* named for the French king. Mexican variations for schools and government buildings were designed by Nicolas del Casillo, Pedro Bueno and others.

Greek revival is a fancy version of the Neoclassical style, with large Doric, Ionic or Corinthian columns. Thomas U. Walter used this style when he added the dome and side wings to the United States Capitol. Large Greek revival homes were designed by John Haviland, Isaiah Rogers and others. The homes became popular in Canada as well as in the United States' South and Midwest.

Around 1830, United States architects Richard Upjohn and James Renwick, Jr. popularized a *Gothic revival* style with pointed windows, chateau-like turrets, peaked roofs and fancy, open details. Canadians John Ewart, James O'Donnell and others also designed buildings in this style.

Design

In the United States and Canada, factories were being built. Cheap nails and lumber in standard sizes made it easier to build houses and furniture quickly.

In the city, many homes had gas lights, toilets and kitchen equipment. Factory-made furniture, pressed glassware and textiles were more common. A popular furniture style in Neoclassical homes was *Hepplewhite,* with tapered legs and contoured backs.

In rural areas, people made their own furniture. Some decorated the walls of their homes with stencil paintings. Designs were often adopted from folk art traditions in Holland, Germany, Sweden, Denmark and other countries. The simple elegance and fine handcrafting of Shaker furniture is still admired by many designers. The Shakers are a religious group.

Painting

Portraits and paintings about history were popular subjects throughout North America. In the United States, Benjamin West and John S. Copley were still major painters of these subjects. They were joined by Thomas Sully, who created about 2,000 portraits during his long career. Gilbert Stuart and Charles W. Peale created portraits of George Washington and other patriots. Peale also set up the first United States art museum, art school, and major exhibitions. Five of Peale's children became painters.

John Trumbull and Emanuel Leutze painted pictures about events in the United States' Revolution. In Canada, Antoine Plamondon and Théophile Hamel created portraits of civic leaders and patriots.

Throughout North America, painters began to explore new subjects. In the United States, Washington Allston and John Quidor created imaginative work based on legends or dreamy landscapes.

Some painters interpreted everyday activities in cities and life in frontier towns. Among them were United States artists William S. Mount, George C. Bingham and Lily M. Spencer, and Canadian Cornelius Krieghoff. In Mexico, José Arrieta began to portray rural and city life.

Landscape paintings were done in various styles. United States artists Thomas Cole, Asher B. Durand, Samuel F. B. Morse and George Inness created paintings of vast, idealized landscapes in New York and nearby regions. Canadian landscape painters James Cockburn, Daniel Fowler and Mary H. Meyer became well-known.

The western frontier fascinated many artists. Paintings of the Rocky Mountains and other majestic western landscapes were created by United States artist Frederich E. Church and others. Some of the first paintings of Native North Americans were created by George Catlin and John M. Stanley of the United States and Canadians Joseph Légaré and Paul Kane.

Many people have seen the work of John J. Audubon. He traveled along the Mississippi River recording wildlife. His 435 colored engravings of birds are still popular.

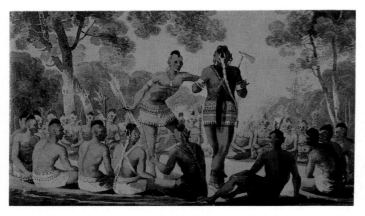

George Heriot, *War Dance, Performed by One or Two Persons*, ca. 1804. Watercolor and graphite, 172 x 294 mm. The Art Gallery of Windsor, Ontario. Purchased 1967.

John James Audubon, *Common Raven*, 1829. Watercolor on paper. Courtesy of the New York Historical Society.

Unknown Mexican Artist, *Dona Maria de la Luz Padilla y Cervantes*, ca. 1735. Courtesy of the Brooklyn Museum, New York.

Gilbert Stuart, *Athenaeum Portrait of George Washington*, 1796. Oil on canvas, 39 1/8" x 34 1/2" (99 x 98 cm). Jointly owned by the Museum of Fine Arts, Boston and the National Portrait Gallery, Smithsonian Institution, Washington, D.C.

Sculpture

Sculpture became more professional in quality, especially in the United States where there were many large cities. People were ready to have sculpture in parks and public buildings.

Many United States artists began to travel to Rome to learn how to carve and cast sculpture. Most worked in the Neoclassical style. Horatio Greenough and Hiram Powers created sculptures of George Washington and other national leaders. Some artists created sculptures with human figures posed to express ideals such as truth and justice. Among these artists were Erastus D. Palmer and Margaret Foley.

Naturalistic sculpture also developed in the United States. This style was developed by Thomas Ball, Henry K. Brown and Clark Mills. Brown and Mills set up the first foundries for creating large bronze sculpture. They created some of the first life-size sculpture for parks and monuments.

In Canada, Samuel Gardner and John Cochrane created Neoclassical sculptures of well-known civic leaders. François Baillairgé continued his family's tradition of elaborate carving for churches and mansions.

In Mexico, Francisco Miguel excelled in carving statues for churches. Manuel Vilar and Miquel Noreña created public sculpture with a mixture of heroic themes from pre-Columbian and Mexican history.

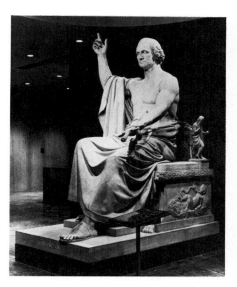

Horatio Greenough, *George Washington*, 1832-1841. Can you explain why this sculptor (and others) of this era often portrayed national leaders in Roman togas? Marble, approximately 11'4" (347 cm). Courtesy National Collection of Fine Arts, Smithsonian Institution.

Clark Mills, Major General Andrew Jackson. After Clark Mills and others set up foundries, large works in bronze could be created. Before the 1850's artists had to go to Europe to cast their works and then ship the work back home. Lafayette Park, National Park Service, Washington, DC.

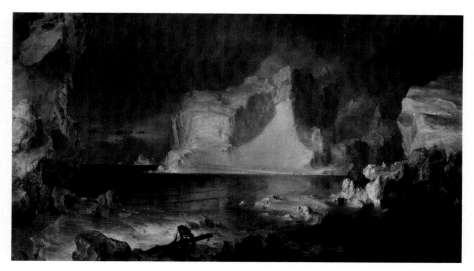

Frederic Edwin Church, *The Icebergs*, 1861. Oil on canvas, 64 ¹/₂" x 112 ³/₈" (164 x 286 cm). Dallas Museum of Art. Foundation for the Arts Collection, Anonymous Gift.

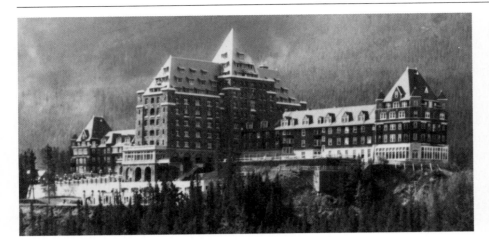

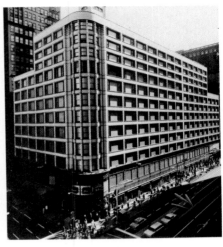

Byron Harmon, *Banff Springs Hotel and Bow Falls from Tunnel Mountian*, ca. 1920. Chateau-like hotels for tourists became popular in Canada. Courtesy of the Whyte Museum of the Canadian Rockies.

John Roebling and A. Washington, Brooklyn Bridge, tower and cables, 1867-1873. New York. Roebling, a gifted engineer, invented this system of bridge-building. He also invented many of the machines needed to construct them.

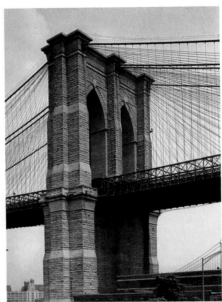

Louis Sullivan, Carson-Pirie-Scott Store, 1899. Chicago, Illinois. Cities grew rapidly after the Civil War. Architect Louis Sullivan pioneered the development of skyscrapers.

Industrialization and Growth 1860-1900

Many North American artists still went to Europe for training. Their international exhibitions and prizes were often reported in newspapers. This helped them achieve recognition when they returned home.

Many artists who were trained in Europe became leaders of art schools and cultural groups. Around 1870, the first art museums were set up in large cities such as New York, Boston, Philadelphia and Chicago. By 1900, others could be found in many Canadian and Mexican cities.

Architecture
Architecture of this period is often called the *"battle of styles."* Architects continued to borrow ideas from the Renaissance and ancient Greece and Rome. Design ideas were also introduced from Turkey, India, China, Japan and ancient Egypt. This technique of putting different ideas together is called *eclecticism*. Noted eclectic architects included Henry H. Richardson and Richard M. Hunt from the United States, and Canadian E. J. Lennox.

By 1880, there were more buildings with metal frames. The invention of elevators also made it possible to create buildings more than five stories tall. Engineering had improved. For example, John Roebling developed a new system for building suspension bridges.

These trends can be seen in the *Chicago School of Architecture*, lead by Louis Sullivan, Daniel Burnham and others. They developed a new form of building called a skyscraper—a structure over ten stories tall. Their innovative work and teaching influenced many other architects.

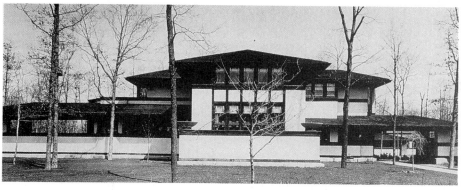

Frank Lloyd Wright, Ward Willits House, 1902. Highland Park, Illinois.

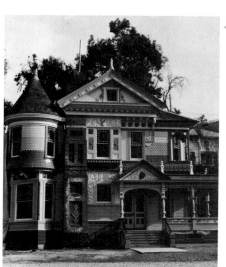

S. and J. Newsom, Residence of William Carson 1885. Eureka, California.

George Hunzinger, Patent Chair, ca. 1869. Walnut, 33" (84 cm) high. Gift of Lyndhurst, National Trust for Historic Preservation, 1985. Courtesy The Hudson River Museum, Yonkers, New York.

One of the most famous architects, Frank Lloyd Wright, first worked for Louis Sullivan. Wright is known for his philosophy of *organic architecture*, or the belief that the design of a building should be related to nature and to the functions of that building.

You can see Wright's ideas in his *prairie style* houses. These houses are horizontal and have very little decoration. They have open, flowing spaces like the open, flat prairie of the Midwest. A student of Wright, Frances C. Sullivan, designed prairie style homes in Canada.

Design

In many items for everyday use, you can see the same "battle of styles" that you see in architecture. In household items, this "battle of styles" is often called *Victorian* design, because it developed during the reign of British Queen Victoria (1837-1901).

During the Victorian era, trade with other cultures increased. Scholars learned about art in different cultures by doing research in the new subjects of art history, anthropology and archaeology. These trends made artists eager to explore new styles.

Around 1870, many North Americans became interested in their colonial history. This interest helped start a *Colonial Revival* style. Many crafts and manufactured items included the flag or other national symbols. Mexican folk art, especially ceramics and metalwork, became so popular that many items were created just for tourists.

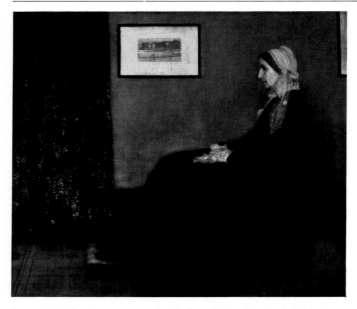

James Whistler, *Arrangement in Black and Gray: The Artist's Mother*, 1871. The title of this painting reflects Whistler's belief that the abstract design of a painting was just as important as the subject matter. Oil on canvas, 57" x 64 ¹/₈" (145 x 163 cm). The Louvre, Paris.

Painting

North American painting began to reflect three major styles in Europe: *Realism, Impressionism*, and *Romanticism.*

Impressionist painters use quick brushstrokes to capture light and color. The asymetrical design is often similar to a snapshot. United States Impressionist painter Mary Cassatt became internationally known. Other Impressionists include; (*United States*) John H. Twachtman, Childe Hassam, Maurice Prendergast; (*Canada*) Maurice Cullen, Clara Hagerty, George A. Reid; (*Mexico*) Joaquín Sorolla y Bastida, Ignacio Zuloaga and Gilberto Cháves.

United States artist James A. M. Whistler extended Impressionist ideas toward abstract art. He thought that the overall design of a painting was more important than the subject. Other artists such as John S. Sargent and Cecilia Beaux explored the abstract design qualities of colors, shapes and brushstrokes.

C.W. Jeffreys, *Autumn Oak and Beech*, 1896. This Canadian artist dramatizes the haunting beauty of nature. Watercolor on paper, 18" x 12" (46 x 30 cm). The Corporation of the City of Toronto. Gift of the Toronto Industrial Exhibition, 1902.

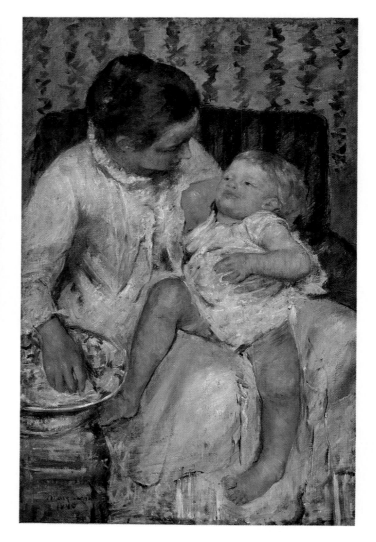

Mary Cassatt, *Mother About to Wash Her Sleepy Child*, 1880. Cassatt became one of America's best-known Impressionist painters. Oil on canvas, 39" x 26" (100 x 65 cm). Los Angeles County Museum of Art. Bequest of Mrs. Fred Hathaway Bixby.

Romanticism refers to art about myths, legends, and foreign or imaginary events. Well-known painters who worked in this style include; (*United States*) Albert P. Ryder, Ralph A. Blakelock; (*Canada*) Henri Julien, Gertrude Cutts; (*Mexico*) Juan Cordero and Pelegrín Clavé.

Realism means that artists portray people, scenes and events of their own time. Accuracy is a goal in this work. Leading this style in the United States were Thomas Eakins and Winslow Homer. William Harnett and John F. Peto created *trompe l'oeil* (fool-the-eye) paintings of still life. Charles Hout and Paul Peel are well-known Canadian realists in painting. In Mexico, this style was developed by Hermenegildo Bustos.

Painters continued to be fascinated with western landscapes, Native Americans and frontier life. These are major themes in the work of United States artists Alfred Bierstadt, Frederick Remington and Charles Russell, and Canadians Lucius O'Brien and William Hind.

Jose Maria Velasco, *Hacienda of Chimalpa*, 1893. This Mexican artist was among the first to create paintings of vast landscapes in his country. Museo de Arte Moderno, Mexico.

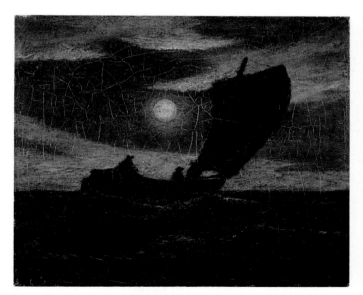

Albert Pinkham Ryder, *The Toilers of the Sea*, 1928. Oil on canvas, 10 ¼" x 12 ¼" (26 x 31 cm). Collection the Addison Gallery of American Art, Phillips Academy, Andover, Massachusetts. Gift of Miss L.P. Bliss.

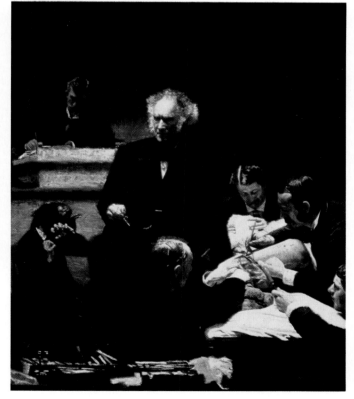

Thomas Eakins, *The Gross Clinic*, 1875. Eakins was a leader of a new kind of realism in which artists portrayed subjects that were not considered "beautiful." What is the subject matter in this painting? Oil on canvas, 96" x 78" (244 x 198 cm). Jefferson Medical College, Philadelphia.

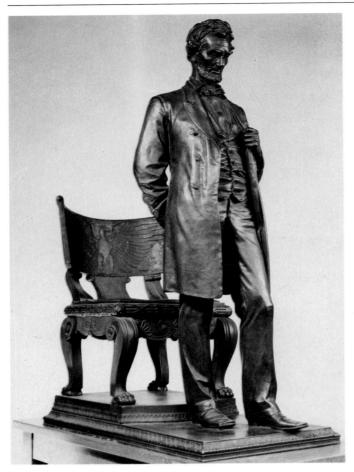

Augustus Saint-Gaudens, *Standing Lincoln*, 1886. Bronze, 40" (102 cm) high. The Newark Museum.

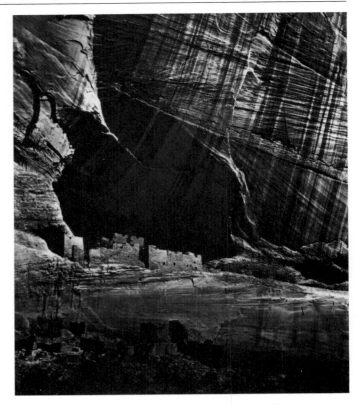

Timothy O'Sullivan, *Ancient Ruins in the Canyon de Chelle* (New Mexico), 1873. Photographers recorded the unspoiled grandeur of the west. Their photographs helped create national parks to preserve the beauty of the land. Albumen print. Courtesy of the International Museum of Photography at George Eastman House.

Sculpture

From Canada to Mexico, many sculptors created work about important historical events. Portraits of leading citizens, soldiers and government leaders became popular. Other important themes were ancient Greek myths, animals and frontier life.

Augustus Saint-Gaudens, Daniel C. French and Anne Whitney combined realism with heroic qualities in sculpture for parks and federal buildings in the United States. Many of their works were patriotic memorials for Abraham Lincoln and Civil War leaders. Portraits and patriotic sculpture were created by Canadians Charles Birch, Robert Reid and Mildred Peel, and Mexican sculptor Jésus F. Contreras.

Many artists created idealized sculptures in a *Beaux Arts* tradition popular in Europe. This complex style usually includes an allegory. In an allegory, a figure holding a lamp might represent the idea of hope or knowledge. This style also combines smooth surfaces with active, swirling forms. Well-known artists include; (*United States*) Frederick MacMonnies and (*Canada*) Walter Allward.

In the United States, western themes such as cowhands and Native North Americans were the favorite subjects of Solon and Gutzon Borglum and Frederic Remington. Animals are a major subject in the work of Herbert Haseltine. John Rogers created small "parlor" sculptures cast in plaster. People bought his inexpensive sculpture for their homes.

Photography

Samuel F. B. Morse, painter and inventor, introduced North Americans to photography. Morse had seen photographs in 1839 on a trip to Paris.

Early masters of the new art form in the United States included Alexander Gardner and Mathew Brady. They took pictures of the Civil War, Abraham Lincoln and other famous people. Timothy O'Sullivan artfully photographed the Western frontier. Eadweard Muybridge created the first photographs showing the motion of people and animals.

In Canada, William Notman and James Inglis combined photographs and paintings in an early form of montage. Photography began to change the way artists thought about Realism in painting. It helped set the stage for new styles of painting in the twentieth century.

Charles B. Atwood, Columbian Exposition Art Building (now the Museum of Science and Industry), 1893. Chicago, Illinois. This historically important building in Chicago is one of the few remaining from the World's Columbian Exposition. The Exposition was one of the last opportunities for many artists and architects to work in the complex Beaux Arts style (a blend of Neoclassicism, Roccoco and Romantic art ideas).

Daniel Chester French, *Republic* (destroyed World's Columbian Exposition), 1892. Guilded plaster, 64" (163 cm) high. Courtesy of Avery Library, Columbia University.

Daniel H. Burnham, *General View, World's Columbian Exposition*, 1893. Courtesy of Avery Library, Columbia University.

Ending One Era, Beginning Another

Two major exhibitions helped many people see that North American artists were as skilled as artists in Europe. The first major show, at the 1876 Centennial Exposition in Philadelphia, included several thousand artworks. There were so many kinds and styles of art that critics had to invent new categories. For the first time, critics began to talk about subtle differences in artists' styles.

The second great exhibition was the 1893 Chicago World's Columbian Exposition. It had a unified Beaux Arts style–a complex mixture of Neoclassical and Rococo ideas, allegories and fantasy. Thousands of artists, including women, worked on parts of the total design. The exposition also featured new products, including a kitchen with electrical appliances.

Before the end of the century, many North American artists began to think of themselves as professional artists. They felt they were as skilled as artists in Europe.

Major Trends: North American Art to 1900

	General	Architecture	Design	Painting	Sculpture

Industrialization and Growth — *Am. Civil War 1860–1865*

(1900–1860)

- **General:**
 - ▶ Art history first taught.
 - ▶ Growth of art museums.
 - ▶ Art journals.
 - ▶ 1839 Photography invented.
 - ▶ 1876 Centennial Exhibition
 - ▶ 1893 Chicago World's Columbian Exhibition

- **Architecture:**
 - ▶ BEAUX ARTS
 - ▶ CHICAGO SCHOOL — Louis Sullivan
 - ▶ PRAIRIE STYLE — Frank Lloyd Wright

- **Design:**
 - ▶ Electricity in homes.
 - ▶ VICTORIAN ENGLAND 1837–1901
 - ▶ REVIVAL–COLONIAL

- **Painting:**
 - ▶ REALISTS varied subjects, accuracy.
 - ▶ ROMANTICS color, design for mood; story-telling.
 - ▶ IMPRESSIONISTS – airy color, unusual compositions.

- **Sculpture:**
 - ▶ BEAUX ARTS myths, idealized figures.
 - ▶ HISTORY monuments, life-size statues.
 - ▶ REALISM character, detail; everyday life, animals.

Quest for Independence — *Am. Revolutionary War 1775–1780*

(1850–1780)

- **General:**
 - ▶ Growth of art collecting.
 - ▶ North American-born artists study in Europe.
 - ▶ Growth of art schools.

- **Architecture:**
 - ▶ REVIVALS– Greek, Gothic, others. "Battle of Styles"
 - ▶ cast iron /steel and glass elevators
 - ▶ NEOCLASSICAL Hepplewhite furniture

- **Design:**
 - ▶ Standard lumber, low cost nails, gas lighting, toilets.
 - ▶ "Battle of Styles" Eclectic-Victorian.
 - ▶ Factory-made furniture, decorative items.

- **Painting:**
 - ▶ New subjects and themes; Landscapes – majestic Western, idealized, moody; Everyday life – city, frontier. Also still life, Native Americans, birds, portraits, history.

- **Sculpture:**
 - ▶ GREEK REVIVAL – allegory, moral themes. Casts in plaster – "parlor sculpture." Interest in anatomy.
 - ▶ NEOCLASSICAL – portraits of leaders in Greek clothing, poses.

Late Colonial

(1770–1690)

- **General:**
 - ▶ European artists in New France, New England.

- **Architecture:**
 - ▶ BAROQUE/CHURRIGUEREQUE in New Spain.
 - ▶ GEORGIAN Chippendale, Queen Anne furniture
 - ▶ Elaborate churches in New France
 - ▶ Regional differences in architecture (Dutch, French, German, etc.)

- **Design:**
 - ▶ Workshops make furniture, decorative items.
 - ▶ Regional styles in art – Dutch, German, Shaker, etc. Currier & Ives prints.
 - ▶ Pursuit of comfort. Handmade and imported furnishings based on European court styles.
 - ▶ Simple comforts in rural areas.

- **Painting:**
 - ▶ European artists paint portraits, religious themes.
 - ▶ North American-born painters begin work.

- **Sculpture:**
 - ▶ Sculpture based on skills in woodcarving, stone-cutting, metalwork.
 - ▶ Religious statues in New France.

Early Colonial — *Spanish influence in Mexico to 1821*

(1690–1500)

- **General:**
 - ▶ Artists from Spain arrive in Mexico.

- **Architecture:**
 - ▶ RENNAISSANCE churches, adobe missions in New Spain.
 - ▶ COLONIAL Functional buildings.

- **Design:**
 - ▶ Handmade furniture a few imported items.

- **Painting:**
 - ▶ Self-taught painters of portraits.
 - ▶ Religious paintings in New Spain.

- **Sculpture:**
 - ▶ Religious statues in New France.
 - ▶ Carved gravestones in New England, New France.
 - ▶ Religious statues in New Spain.

Timeline dates (left axis): 1900, 1890, 1880, 1870, 1860, 1850, 1840, 1830, 1820, 1810, 1800, 1790, 1780, 1770, 1760, 1750, 1740, 1730, 1720, 1710, 1700, 1690, 1680, 1670, 1660, 1650, 1640, 1630, 1620, 1610, 1600, 1500

European settlers in Mexico from 1521

Native American Cultures (Pre-Columbian) from 10,000 BC

Summary

North American art goes back in time thousands of years. It includes art of Native North Americans before and after the land was settled by Europeans. It includes influences from England, France, Spain and other European countries. It includes art by people from Africa and Asia. It includes the contributions of women artists.

There were three major periods of artistic development in North America from about 1500 to 1900.

The Colonial period (1500 to 1776) was dominated by European art styles, especially those from England, France and Spain. Few colonists had training in art.

During the quest for independence (1776-1860) most artists went to Europe for art training. They explored North American subjects and themes but often used European art styles. In architecture and sculpture, the dominant style was Neoclassical art.

In the period of industrializtion and growth (1860-1900), there was a "battle of styles" in architecture and design. Because many artists still studied in Europe, the styles of painting and sculpture followed the main trends in Europe. Photography became a new form of art.

By 1900, most North Americans still looked toward Europe for standards in judging art. Many artists felt they had developed skills that were equal to the skills of artists in Europe.

Using What You Learned

Art History

1 Identify at least two influences on North America's art heritage from the following cultures or groups: *Native North Americans, Asians, Africans, Europeans, Hispanics, women*

2 Select one of the following topics: architecture, design, painting, sculpture. Identify two major characteristics of this kind of art during each of the following periods: 1500-1776, 1776-1860, 1860-1900.

3 Why was the Harlem Renaissance important?

4 Explain why styles of colonial art in New Spain, New France and New England were different. In what ways were the art styles similar?

5 Why did the Neoclassical style become so dominant in North America between 1860 and 1900?

Aesthetics and Art Criticism

1 During what period were art critics forced to find new ways to describe art? Why did they have to expand their vocabulary?

2 Art critics and other experts invent short names for art styles. Why? Choose several style names from this chapter. Invent a new and short name for each one. Tell why you think it fits the style.

Creating Art

1 In this chapter, you learned that North American architects borrowed ideas from many styles of art. Lightly sketch the front view of your school or home as it now looks. Redesign it so it resembles a style of architecture in this chapter. Change or add features to the basic structure of the building. Find out if your classmates can guess the style of your redesigned building.

2 Create an architectural model based on one of the styles in this chapter. Use materials inventively. You might start with materials such as discarded foam packing material, cardboard (sheets, tubes, boxes), straws, tongue depressors, pipe cleaners and the like. What other materials can you use?

3 Create an artwork based on this theme: What is best about my nation. As you develop your idea, imagine your work will be seen by an international audience.

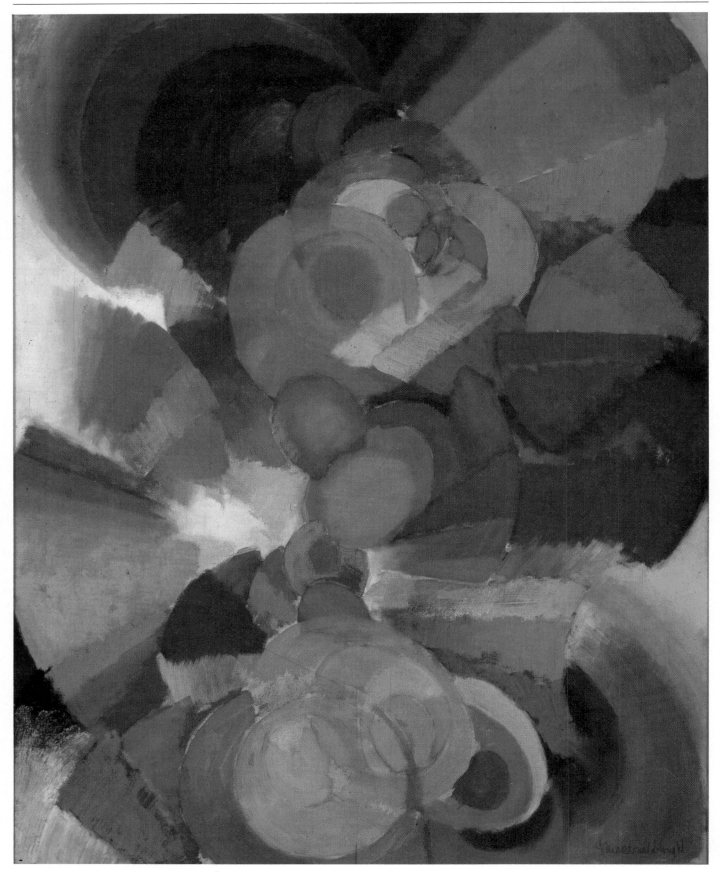

Stanton MacDonald-Wright, *Conception Synchromy*, 1914. Oil on canvas, 36 $^1/_4$" x 30 $^1/_4$" (93 x 77 cm). Hirshhorn Museum and Sculpture Garden, Washington, DC.

Chapter 6
North American Art: Twentieth Century

Chapter Vocabulary

pluralistic
Post-modern
Art Moderne
Precisionism
Abstraction
Abstract Expressionism
Pop art
Op art
Photo Realism
Semi-abstraction
assemblage
kinetic sculpture
happening

When the twentieth century began, few people could have imagined that automobiles, television sets, telephones, refrigerators and computers would be common. These and many other inventions are just part of the reason why life and art of this century are so different from other times in history.

Many new styles have been created by North American artists during this century. These new directions have been influenced by three important trends: immigration, innovation and information about art.

In the early part of the century, many immigrants came to America to escape poverty in their homelands. Political refugees came from Europe just before and after World War II. In the 1970's and 1980's others came to escape political problems in Southeast Asia and other lands. Today, North American art is often called ***pluralistic***, which means that the art traditions of people from many cultures are present.

Twentieth century artists have used new materials such as plastic and strong lightweight metals to create many new art forms. Motion pictures, television and satellites have changed how we see and think about time, space and distance in our world. These changes have fascinated artists.

Information about art has grown tremendously in the twentieth century. Early in the century, Paris became an international center for inventive art. After World War II, New York City became an international center for inventive art, with many galleries, art critics and other ways to promote art. Today, most large cities have art schools, art programs, art museums and galleries. Artists, art critics and other experts often share information about new trends in art.

At no time in history has there been so much organized activity and information about art. This also means that similar trends and styles in art can often be found in more than one country. In this chapter, you will learn more about North American Art of the twentieth century.

After you study the chapter, you will be better able to:

Art History and Creating Art	• appreciate and apply knowledge about the history of art when you create and study art
Aesthetics and Criticism	• use appropriate art terms and insights from art history in judging art

Architecture 1900-1950

Between 1900 and 1950, everyday life changed rapidly. Many people's lives were interrupted by World War I (1914-1918), the economic Great Depression of the 1930s and the events that lead to World War II (1938-1945).

Revival Styles In the early part of the century, many architects continued to plan buildings in the revival styles from the 1800s. For example, many of the skyscrapers designed before 1950 still had Gothic, Greek or other details from styles of the past.

International Style The most important new trend in architecture was the International Style. It started in the famous German art school, the *Bauhaus* (1913-1933). Bauhaus leaders believed that design for an industrial age should use new industrial materials like steel beams and plate glass. They thought that simple, machine-like forms were elegant.

In the International Style, there are few or no decorations on the outside of buildings. Most buildings have simple grid-like frames of steel or concrete posts that support large windows. These design ideas influenced architecture in many nations from about 1920 to 1970.

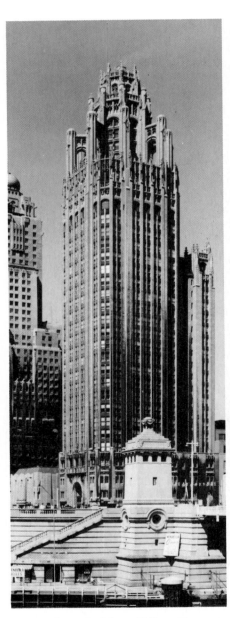

Raymond Hood, *Chicago Tribune Tower*, 1922. The growth of cities lead to many design concepts for high-rise buildings. What are some of the main differences in this building and the apartments on the next page?

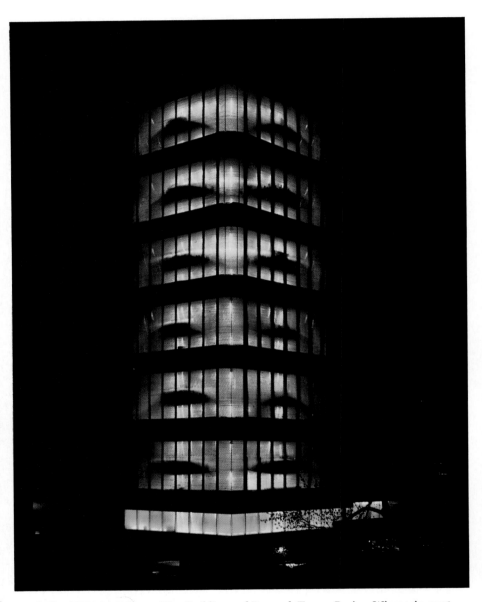

Frank Lloyd Wright, *Johnson Wax Building and Research Tower*, Racine, Wisconsin, 1936-1939, and tower 1946-1949. Wright continued to create innovative architecture. Notice how his design for the Johnson Wax Building includes smooth, streamlined corners on the tower.

Leaders of the International Style included Walter Gropius, Ludwig Miës van der Rohe, Eliel Saarinen, Marcel Breuer and Richard Neutra. They came to the United just before World War II. Gropius, Breuer and van der Rohe taught architecture in the United States. Some of their students and followers became leading architects. Among them are *(United States)* Phillip Johnson and *(Canada)* John C. Parkin.

Organic Architecture Frank Lloyd Wright continued to develop his philosophy of organic design for homes. He planned them so the outdoor and indoor environments seemed to flow together. Sometimes he used natural materials or forms in the surrounding landscape as part of the design. In Canada, Wright's influence can also be seen in homes designed by the firm of Thompson, Berwick and Pratt, and others.

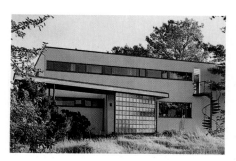

Walter Gropius and Marcel Breuer, James Ford House, 1939. Lincoln, Massachusetts. Photograph courtesy of Dartmouth College.

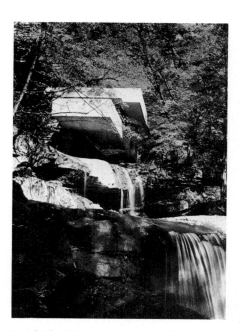

Frank Lloyd Wright, Kaufmann House, 1936. Bear Run, Pennsylvania.

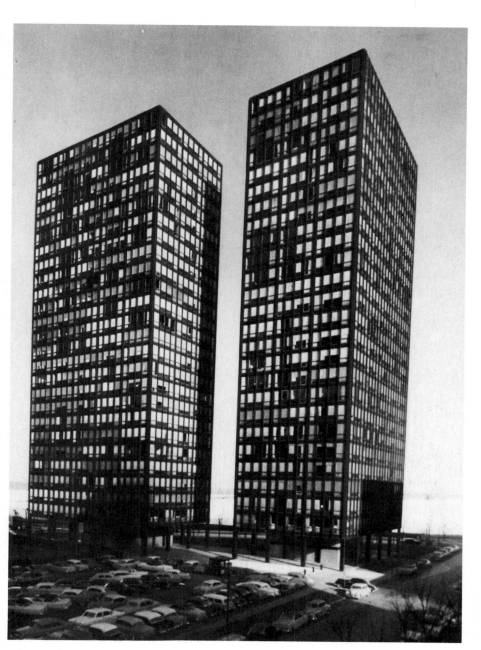

Mies van der Rohe, Lake Shore Drive Apartments, Chicago, 1951. Photograph courtesy Hedrich-Blessing, Chicago.

109

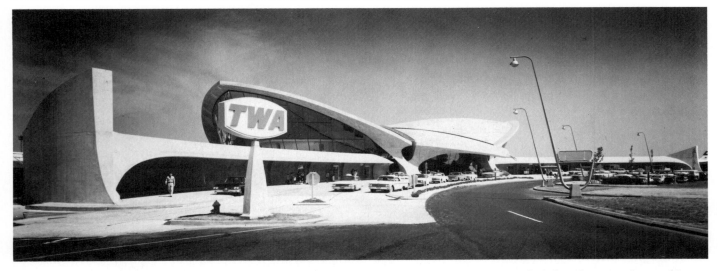

Eero Saarinen, TWA Terminal, Kennedy International Airport, New York. Saarinen's rising, soaring use of reinforced concrete is an architectural metaphor for the function of this structure. Photograph courtesy of TWA.

Central Library, National University of Mexico, Mexico City 1952. The simple forms in this International style building have been made lively with a complex mosaic mural about Mexico's culture.

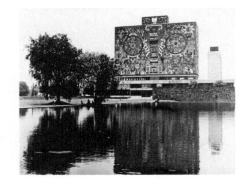

Paolo Soleri, *Arcology-Babel II*, C Section. Soleri is one of many visionary architects. A visionary architect proposes plans for buildings and cities of the future. Archology is the name Soleri has given to the ideas of combining architecture and ecology. Courtesy of the architect.

Architecture 1950-Present

Since World War II, cities have grown rapidly. Freeways and large shopping centers have been built to serve people in the suburbs. Four main trends have developed in architecture.

Post-War Construction Boom In this trend, standard plans are used so that many buildings can be put up quickly. Many buildings of the same type and price look like others. By 1970, suburbs, freeways and unplanned growth had created major problems in the quality of city life. Cities planned and began huge construction programs. They were intended to help bring the cities back to life.

Philosophy of organic architecture Frank Lloyd Wright died in 1959, but many architects still follow his philosophy of relating architecture to nature. For example, in Canada, Arthur Erickson designed a large downtown civic center so it includes the experience of nature. The buildings have many terraces for parks and trees. The large terraces are cliff-like supports for dramatic human-made waterfalls.

In many large projects, such as ideal communities, architects try to integrate park-like elements with the buildings. A related direction is explored in ecological designs for the future. For example, Paolo Soleri believes that people can live in large cities but preserve nature. Soleri calls his philosophy of architecture *arcology*– architecture plus ecology.

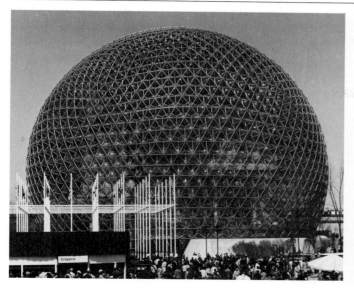

R. Buckminster Fuller, American Pavilion, Expo 1967. The geodesic dome is a unique structural system invented by Buckminster Fuller. He envisioned the possiblity of enclosing whole cities with domes to help solve problems of pollution and to conserve energy. Courtesy Montreal Chamber of Commerce.

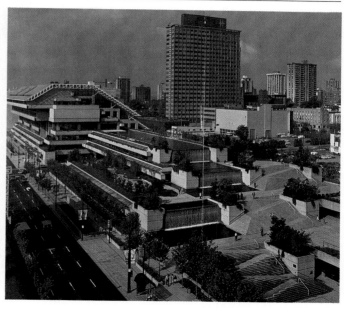

Vancouver Government Center, British Columbia, 1980. Designed by Arthur Erickson Associates.

International Style This sleek-looking style continues to be a dominant style for skyscrapers and the other large office or industrial buildings around the world. Well-known architects working in this style include *(U.S.)* I.M. Pei and the firm of Skidmore, Owings and Merrill; *(Canada)* John Andrews, Victor Prus; *(Mexico)* Mario Pani, Luis Barragán, and Enrique de Moral.

Variations in this style, with more complex rythmic forms were developed by *(U.S.)* Louis Kahn, Eero Saarinen, Minoru Yamasaki, Kevin Roche; *(Canada)* Douglas J. Cardinal and others.

United States engineer R. Buckminster Fuller invented a dome-like structure to enclose a space without using posts to hold it up. Fuller's geodesic dome is built from a network of rods and connectors. The open spaces between the rods are covered with glass, metal, thick plastic or the like.

Post-Modern Architecture Around 1960, some architects were ready to move away from the modern, grid-like International Style. These architects thought that buildings should have special meanings to people who use them. In this trend, called *Post-modern* architecture, you often see unexpected colors, materials and elements from older styles of buildings.

In the related historic preservation movement, architects work to preserve historically important buildings and other landmarks. Leading architects include *(U.S.)* Robert Venturi, Denise Scott Brown, Charles Moore, Michael Graves, Maya Lin; *(Canada)* Geoffrey Massey, Allen Duffus, Barton Myers; *(Mexico)* Juan O'Gorman and Luis Barrigán.

Charles Moore, Piazza D'Italia, New Orleans, Louisiana, 1975-1980. Post-modern is a style name for the renewed interest in color, decoration, and the use of historical styles in architecture. These architects are dissatisfied with the geometric sameness of environments produced by the dominant International style. Courtesy of Perez Architects.

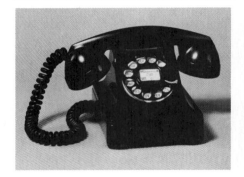

Raymond Loewy, Telephone, 1936-1937. This telephone design, as well as the chair designs, reflect a growing interest in sleek, smooth, streamlined forms in product design. Plastic, 5 ⅝" (14 cm) high. Bell Telephone Co., New York.

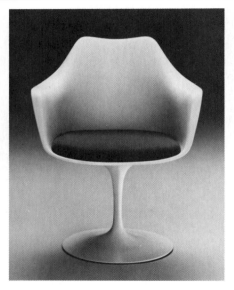

Eero Saarinen, Pedestal Chair, 1956. Molded plastic with cast metal base. Courtesy, Knoll International.

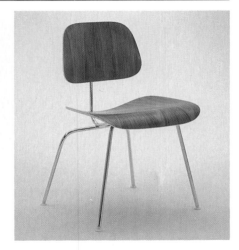

Charles Eames, LCM Chair, 1946. Courtesy Herman Miller, Inc.

Design 1900-1950

Three main trends developed in art for the home and community.

Colonial Revival Early in the century, interest in America's past developed. It continues today. Many people collect Colonial furniture, quilts and Native North American art. Symbols from the past such as early national flags are used on many decorative items, including new ones.

Art Moderne This design trend combines smooth curves and the sleek machine-like surfaces of geometric forms. Streamlined forms–curves similar to airplane wings–are one example of visual qualities in this style. These style elements fitted into the new, simple forms and surfaces of the International Style. Industrial designers such as Raymond Loewy and Henry Dreyfuss made elements of this style popular in designs for cars, refrigerators, radios and other mass-produced items.

Organic Design In this trend, led by Frank Lloyd Wright, the interior furnishings and details of a building are planned at the same time as the building. Architects and interior designers work together so all elements of buildings became part of total organic designs. For example, when Wright designed a home, he often designed some of the furniture, cabinets, lights and fabrics, too.

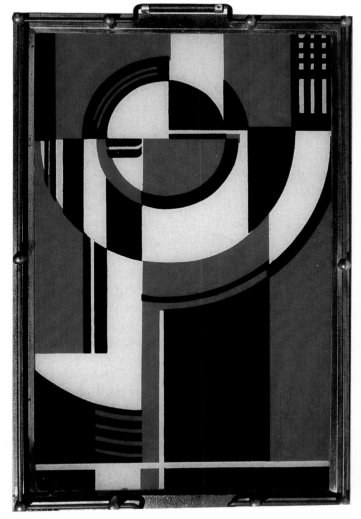

Cocktail Tray, manufacturer unknown, ca. 1930. The design of this Art Moderne tray is based on simple interlocking geometric shapes. Chromium and glass, 18" x 12" (46 x 31 cm). Collection of Robert Heide and John Gilman.

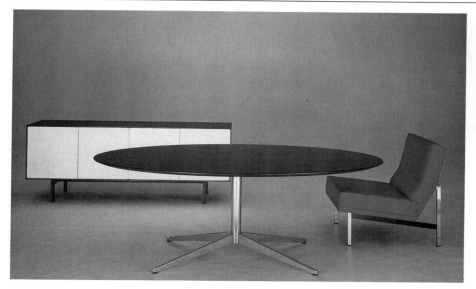

Andy Warhol, *Cow Wallpaper*, 1966. Ideas from painting and other art forms can influence interiors and architecture, as seen in this Pop art wallpaper. Silkscreen ink on paper, each image is 44" x 30" (112 x 76 cm). Courtesy Leo Castelli Gallery, New York.

Florence Knoll, Cabinet, Oval Table/Desk and Lounge Chair. Florence Knoll became one of the most respected designers of comfortable furniture with very simple forms. Wood and steel. Courtesy, Knoll International.

Design 1950-Present

Since World War II, design for mass-production has become a major field for artists.

International style Large design companies such as Herman Miller, George Nelson and Knoll International employ many people trained as artists, architects and designers. These large companies usually feature designs that fit in with the simplicity of the International Style. The leaders of this style include Florence Knoll, Charles and Ray Eames (furniture, textiles), Eero Saarinen, Marcel Breuer (chairs), Jack Lenor Larson, Louise Todd-Cope (textiles) and Isamu Noguchi (lamps, furniture).

Post-modern Design Post-modern design is varied. Some designers have been influenced by trends in painting and sculpture to create Pop furniture or Op textiles. Other designers have been inspired by new materials to create products like fiberglass chairs and molded plastic shoes. In Post-modern design, ideas from many sources are combined creatively by designers and consumers.

Post-modern also means that customers often participate in the process of design. For example, an automobile designer uses research to find out what people like and dislike about the existing design. The designer then tries to improve the car. In this way, designs for products are more likely to satisfy customers.

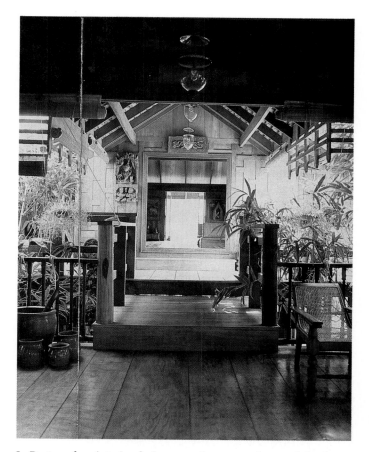

In Post-modern interior design, you often see a mixture of simple contemporary furnishings and older furnishings. What elements of this interior appear to be old? Which appear to be of recent design?

Tom Thomson, *Spring Ice,* 1916. This artist was a leader of a new style of painting in Canada. What are some of the important features of this style? Oil on canvas, 28" x 40" (72 x 102 cm). National Gallery of Canada, Ottawa.

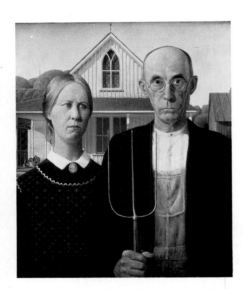

Grant Wood, *American Gothic,* 1930. Grant Wood was one of the leaders of the Regional movement. What themes were of special interest to the American Regionalists? Oil on beaver board, 30" x 25" (76 x 63 cm). The Art Institute of Chicago. Friends of American Art.

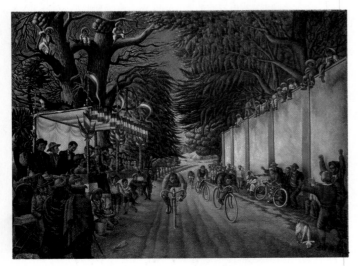

Antonio Ruiz, *The Bicycle Race,* 1938. This Mexican artist has interpreted an important community activity. What are some of the visual details and design elements he wants you to see? Oil on canvas, 14 ½" x 16 ½" (37 x 42 cm). Philadelphia Museum of Art. Purchase: Nebinger Fund.

Painting 1900-1950

Before World War I, artists traveled to Europe to study and work. In Paris, they saw new, exciting styles of painting. When they came home, some helped to organize the famous *1913 Armory Show,* held at the Armory building in New York City. It was the first large show of modern European art in America.

The Armory Show included work by Post-Impressionist artists such as Paul Cézanne, Henri Matisse, Vincent van Gogh and Paul Gauguin. It included Cubist work by Pablo Picasso and Futurist work by Marcel Duchamp. After the Armory Show, there were three main trends in American painting: varieties of realism, art that explored fantasy and the future, and abstract and nonobjective art.

Varieties of Realism

Realism means that artists interpret their experience and the world around them. There are many varieties of realist painting.

In the United States, a group known as *The Ashcan School* painted scenes of alleys, slum dwellers and nightlife in cafes or on the street. Artists in this group included Robert Henri, John Sloan and George Bellows.

Other painters concentrated on the expressive qualities of the landscapes, people and activities in rural areas and cities. Their work often centers on one main theme in a realistic or *semiabstract* style. In the United States, these themes interested Charles Burchfield, Isabel Bishop, Edward Hopper and others. In Mexico, artists such as Eduardo Chavez and Antonio Ruiz portrayed village scenes and festivals.

American Regionalists – including Thomas Hart Benton, John Steuart Curry and Grant Wood–believed that American values could be expressed through paintings about life in small towns and rural areas in the Midwest. Self-taught folk artists such as Horace Pippin and "Grandma Moses" (Anna Mary Robertson) worked on related themes.

A style unique to Canada, started by artists called the *Group of Seven,* included many artists who interpreted the Canadian landscape. Their subjects were the changing seasons and moods of the lake country, mountains, deep forests and prairie lands. Many used intense or contrasting colors and expressive brushstrokes. A few of the artists were Tom Thomson, Lawren Harris, A.Y. Jackson, Arthur Lismer, Fredrick Varley, J.E.H. Macdonald and Emily Carr.

Social Realists expressed their feelings about poverty and other social problems. The most well-known artists were part of the Mexican mural movement, especially Diego Rivera, José C. Orozco and David A. Siquerios (See Chapter 5). These painters dominated Mexican art until about 1950. In the United States, themes such as injustice, poverty and greed were explored by Ben Shahn, George Tooker, Jacob Lawrence, Romare Bearden, Jack Levine and others.

The Future, Fantasy and Change

Just before and after World War I, artists in Europe explored subjects and themes related to fantasy, the future and rapid changes in life. Some of these artists moved to North America. Others traveled to Europe and saw the new styles.

In a new style called *Surrealism*, developed by Spaniard Salvador Dali and others, dream-like images are portrayed as if you could actually see them. Other well-known Surrealist painters are *(U.S.)* Kay Sage, Arshile Gorky, Pavel Tchelitchew; *(Canada)* Alfred Pellan, Paul E. Borduas; and *(Mexico)* Frieda Kahlo.

Magic Realism is a style term for paintings with subjects you can recognize, such as birds or people, but interpreted with a technique or viewpoint that gives them a surrealistic quality. Artists working in this style include *(U.S.)* Loren MacIver, Mark Tobey, Yasuo Kuniyoshi, Ivan Albright; *(Canada)* David Milne and Alex Colville.

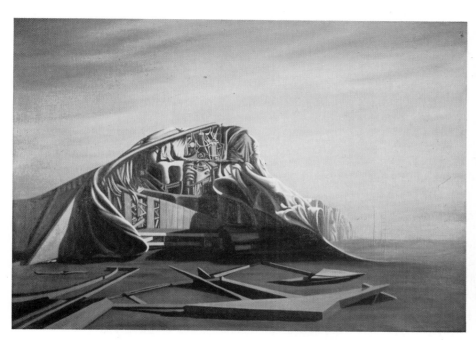

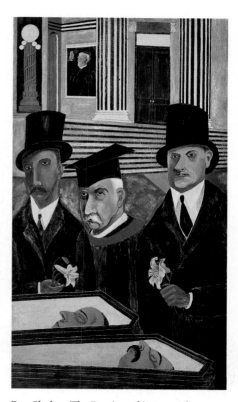

Kay Sage, *The Instant*, 1949. Sage, like many artists, explored style directions that started in Europe, such as Surrealism. Oil on canvas, 38" x 54" (97 x 137 cm). Courtesy The Mattatuck Museum, Waterbury, Connecticut.

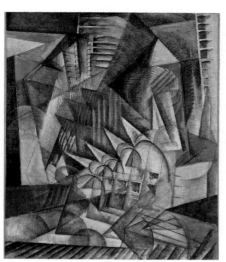

Max Weber, *Rush Hour, New York*. 1915. Canvas, 36 ¼" x 30 ¼" (92 x 77 cm). Max Weber was among the first to explore the European style known as Futurism. Courtesy of the National Gallery of Art, Washington, DC. Gift of the Avalon Foundation.

Ben Shahn, *The Passion of Sacco and Vanzetti*, 1931-1932. Shahn often created art to express his views on political and social problems. In this work he is critical of judges who sentenced two men to death as "anarchists." Shahn believed the men were not given a fair trial. Tempera on canvas, 84 ½" x 48" (215 x 122 cm). Collection the Whitney Museum of American Art, New York. Gift of Edith and Milton Lowenthal.

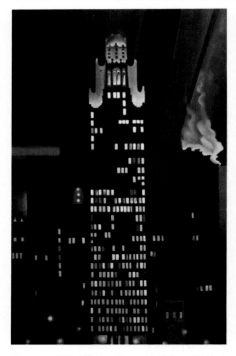

Georgia O'Keeffe, *Radiator Building-Night, New York,* 1927. Oil on canvas, 48" x 30" (122 x 76 cm). Alfred Stieglitz Collection, The Carl Van Vechten Gallery of Fine Arts, Fisk University.

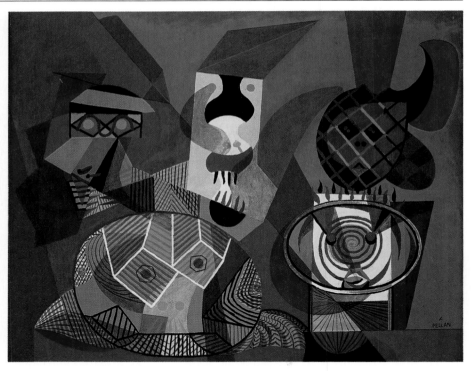

Alfred Pellan, *Mascarade,* 1942. Canadian Pellan's work shows the influence of Cubism and Surrealism on North American artists. Oil on canvas, 51" x 64" (130 x 162 cm). Musée d'art Contemporain de Montreal.

Abstract and Nonobjective Art

Many European artists of the twentieth century developed new concepts and goals for art. Some painters were inspired by the precise geometric forms of machine-made products. Cubism and other styles of abstract and nonobjective art were also explored by artists in Europe and North America.

Precisionism, for example, is a style name for paintings that focus on city or industrial buildings, machinery and related scenes. Artists were interested in using precise, smooth brushstrokes to suggest the beauty of these simple forms. Well-known artists included: *(United States)* Charles Demuth, Charles Sheeler, Niles Spencer, and Lyonel Feininger; *(Canada)* Lemoine Fitzgerald and Alfred J. Casson.

Abstractionists used bright colors, varied brushstrokes, and designs with simplified or rearranged elements. Among many abstractionists were: *(U.S.)* Max Weber, Joseph Stella, Georgia O'Keeffe, Stuart Davis, John Marin, Irene R. Pereira; *(Canada)* Bertram Brooker, Jack Humphrey, Jock MacDonald, Hortense Gordon; *(Mexico)* Rufino Tamayo and Carlos Mérida.

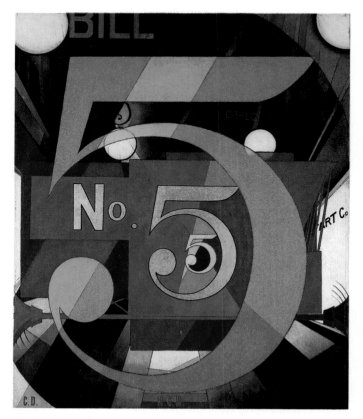

Charles Demuth, *I Saw the Figure Five in Gold,* 1928. Some of Demuth's work has been called Precisionist. What are some meanings of this style term? Oil, 36" x 29 ³/₄" (91 x 76 cm). Courtesy of the Metropolitan Museum of Art, New York. The Alfred Stieglitz Collection, 1949.

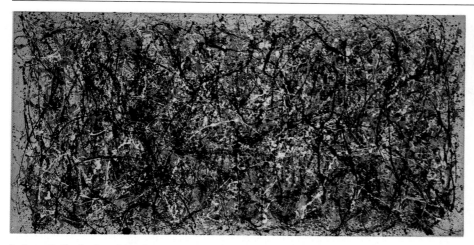

Jackson Pollock, *One (Number 31, 1950)*, 1950. In the Abstract Expressionist movement, artists often created large paintings which energetically record the process of applying paint. Jackson Pollock was a leader of this movement. Oil and enamel on unprimed canvas, 8' 10" x 17' 5 ⁵/₈" (269 x 532 cm). Collection, The Museum of Modern Art, New York. Sidney and Harriet Janis Collection Fund (by exchange).

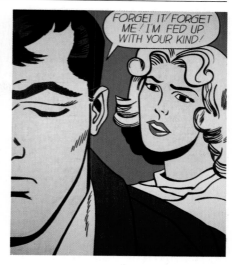

Roy Lichtenstein, *Forget It! Forget Me!*, 1962. Pop artists thought that images created for a mass audience could be reused as ideas for art. Magna and oil on canvas 79 ⁷/₈" x 68" (203 x 173 cm). Rose Art Museum, Brandeis University, Waltham Massachusetts. Gevirtz-Munchin Purchase Fund.

Painting 1950-Present

After World War II, the center of inventive art shifted from Paris to New York City. Around 1960, this dominance of New York City was replaced by an international community of artists, critics and other experts in art. Many galleries set up branches in large cities in North America as well as in Europe.

National and international shows have become larger and more frequent. Some are sponsored by governments and large corporations. Many style names are invented for new trends and forms of art. A few highlights are discussed here.

Abstract Expressionism, Pop Art

Abstract expressionists developed unique ways of applying paint to express feelings and moods. Most of these "action" or "gestural" paintings have no familiar subject or theme. The most well-known painter, Jackson Pollock, applied paint by dripping it on large canvases. Others who have explored this direction are: *(United States)* Hans Hofmann, Willem de Kooning, Franz Kline, Robert Motherwell, Hale Woodruff, Lee Krasner, Joan Mitchell; *(Canada)* William Ronald, Harold B. Town, Jack Shadbolt and Jean P. Riopelle.

Pop art refers to art based on the products and images of popular culture. Favorite subjects are brand-name products, comics, famous people and other items you often see or use without much thought. Leaders of Pop art in America were Robert Rauschenberg, Jasper Johns and Andy Warhol. Others include *(United States)* James Dine, James Rosenquist, Tom Wesselmann, Robert Indiana, Claes Oldenburg; and *(Canada)* Michael Snow.

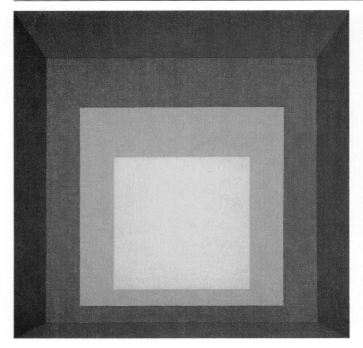

Josef Albers, *Homage to the Square: Apparition*, 1959. Albers spent much of his life exploring color interactions within very simple compositions. Oil on board, 47 ¹/₂" x 47 ¹/₂" (121 x 121 cm). Solomon R. Guggenheim Museum, New York. Photograph by David Heald.

Helen Frankenthaler, *Cravat*, 1973. Works like this are called soft-edged or color-field paintings. Do these style names seem appropriate to you? Why? Why not? Acrylic on paper, 62 ¹/₂" x 58 ³/₄" (159 x 149 cm). Collection of Mr. and Mrs. Gilbert H. Kinney. Courtesy of the Andre Emmerich Gallery.

Varieties of Abstract and Nonobjective Art

Around 1960, some artists became well-known for moving away from "action" painting and Pop art.

Soft-edged (color field) paintings have large fields or areas of color applied by staining canvases or using subtle brushstrokes. Many paintings have striking color interactions. Well-known artists include *(United States)* Mark Rothko, Helen Frankenthaler, Morris Lewis, Sam Gilliam, Alma Thomas; and *(Mexico)* Vincente Rojo.

Hard-edged paintings have geometric shapes, clear "hard" edges and subtle color interactions. Most painters use smooth, flat brushstrokes. Some of these artists are *(United States)* Ellsworth Kelly, Helen Lundeberg, Frank Stella, Ad Reinhardt, Kenneth Noland; *(Canada)* Roy Kiyooka, Jack Bush, Kathleen Graham and *(Mexico)* Gunther Gerzo.

Op artists create illusions of motion or illogical space in paintings. *Op* is a short form of *optical illusion*. Leading artists include *(United States)* Josef Albers, Larry Poons, Richard Anuszkiewicz; *(Canada)* Claude Tousignant, Ralph Allen and Guido Molinari.

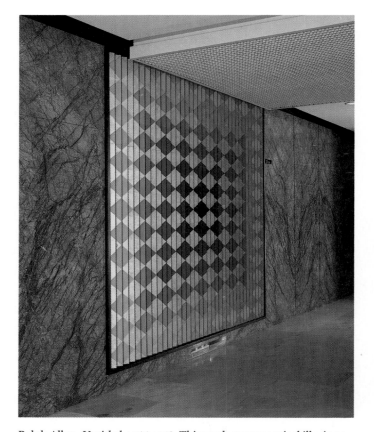

Ralph Allen, *Untitled*, 1966-1968. This work creates optical illusions. It is an example of Op art by a Canadian artist. Can you find other examples of Op art in this book? Wood, gesso, sheet plastic gold leaf, copolymer. Macdonald Block Complex, Queen's Park, Toronto. Courtesy of the Government of Ontario Art Collection. Photograph by Thomas Moore.

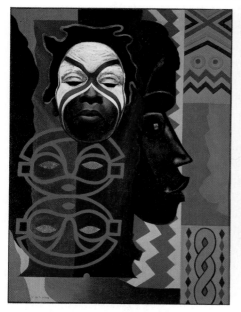

Lois Mailou Jones, *Ubi Girl from Tai Region*. Lois Mailou Jones is an African-American artist. This work is inspired, in part, by her African heritage. Oil on acrylic, 43" x 59" (110 x 150 cm). Courtesy The Museum of Fine Arts, Boston. Charles Henry Hayden Fund.

Richard Estes, *Drugstore*, 1971. This photorealist artist is fascinated with the reflections and the lighting in urban environments, especially as they are recorded in color photographs. How is his work unlike a color photograph? Oil on canvas, 44" x 60" (113 x 152 cm). The Art Institute of Chicago.

Alejandro Colungo, *Children Playing St. George*, 1981. What famous story is the theme in this Neo-Expressionist work? Why do think it is of interest to this artist from Mexico? Oil on canvas, 79" x 63" (200 x 160 cm). Collection Sra. Margara Garza Sada de Fernandez, Garza Garcia, Mexico.

Realist and Heritage-Based Art

Since about 1970, artists and the larger art world have shown a growing interest in realistic art about people, the environment and the past. Artists who work in the tradition of realism have become well-known.

Photo Realist painters render the exact details and distortions often seen in photographs. Variations on this style are sometimes called *Super Realism*–creating the illusion of a reality through paint qualities. Artists working in this way include *(United States)* Richard Estes, Chuck Close, Audrey Flack, Janet Fish; and *(Canada)* Ernest Lindner.

Many painters include recognizable subjects such as portraits, landscapes or figures in their work. Some interpret their subjects in highly detailed ways. Others work more abstractly or strive for dramatic interpretations. Among many artists are *(United States)* Alice Neel, Andrew Wyeth, Richard Diebenkorn, Alfred Leslie; *(Canada)* Toni Onley, Jean Lemieux, Robert Bateman; and *(Mexico)* José Luis Cuevas.

Heritage-based artists are inspired by their special heritage or quest for recognition in today's culture. Many of these artists were introduced in Chapter 5. In addition, artists such as *(United States)* Judy Chicago, Lynda Benglis, Lucy Lippard and *(Canada)* Krystyna Sadowska have begun to express their unique experiences as women.

Present-Day Directions

Since 1980, art galleries and critics have identified several new styles of art. Most of these style names are still not set and come from trends in major cities.

New abstraction refers to paintings based on new combinations of brushstrokes and other visual elements, usually without any clear subject you can recognize. A few of these artists are *(United States)* Elizabeth Murray, Susan Laufer, Gary Stephan, Will Mentor, Dorothea Rockburne; *(Canada)* Agnes Martin, and Vera Frankel.

Neo-expressionism is influenced by the earlier styles of Expressionism, Dada and Surrealism. The subject matter is often about historical events, myths and heroic symbols. A few of these artists are *(United States)* Julian Schnabel, David Salle, Tom Otterness and John Ahern; *(Canada)* Graham Coughtry, Stephen Arthurs. This direction is especially strong in Mexico. Leading Mexican artists are Luis López-Loza, Rocío Maldonado and Alejandro Colunga.

New Image refers to artists who usually choose a single theme or subject–people, ordinary objects, an animal–and explore it in many related paintings. Some of these artists are *(United States)* Susan Rothenberg, Joe Zucker, Pat Steir, Keith Haring; *(Canada)* Claude Breeze; and *(Mexico)* Carlos Almaraz.

e 1900 – 1950

and 1950 many of the sculptors who ~~became well-known~~ came to North America from Europe and other lands.

Many sculptors worked in the traditional materials of stone, wood and bronze. Some began to work with new materials such as welded steel and wire.

Realism Many sculptors explored special subjects in sculpture. Sometimes their subjects are symbols for abstract ideas such as beauty, childhood or strength. In the United States, sculptures in bronze were created by Mahonri Young (workman, prize fighters), Abastenia Eberle (slum children), Anna H. Huntington (animals) and Paul Manship (graceful curved forms). Augusta Savage, Malvina Hoffman and Richard Barthé created character studies of people.

Semi-abstraction Many leaders of the semi-abstract direction were immigrants from Europe. *Semi-abstract* means that the forms of the sculpture are usually simplified and lack fine detail. In the United States, Ivan Mestrovic and Alexander Archipenko created semi-abstract sculptures with angular, Cubistic qualities. The human figure is often a major subject. Related work was created by *(Canada)* Louis Archambault; *(Mexico)* José Morado, Louis Monasterio and Octavio Medellín.

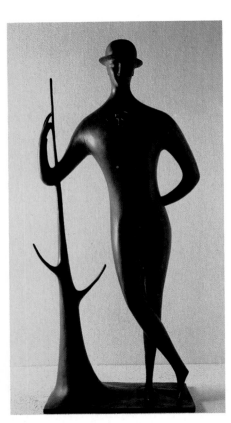

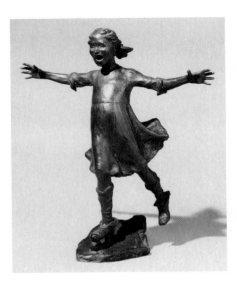

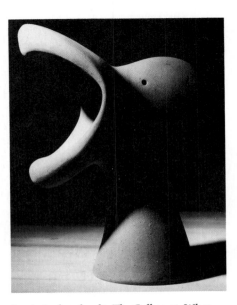

Abastenia St. Leger Eberle, *Roller Skating*, ca. 1906. One critic said the theme of this work is "freedom." Do you agree or disagree? Why? Bronze, 12 ¹³/₁₆" x 11 ¹/₄" x 6 ¹/₂" (32 x 29 x 16 cm). Collection of Whitney Museum of American Art, New York. Gift of Gertrude Vanderbilt Whitney.

Louis Archambault, *The Call*, 1946. What forms has this Canadian sculptor exaggerated and simplified to express his theme? Terra-cotta, 15 ¹/₂" x 7 ¹/₂" x 11 ¹/₂" (64 x 19 x 29 cm). Musée de Quebec. Photograph courtesy of the artist.

Elie Nadelman, *Man in the Open Air*, ca. 1915. Which qualities in this work are similar to the forms in *The Call?* Can you explain why they are similar? Bronze, 54 ¹/₂" x 11 ³/₄" x 21 ¹/₂" (138 x 30 x 55 cm). Collection, The Museum of Modern Art, New York. Gift of William S. Paley.

In the United States, Gaston Lachaise, Carl Milles and Elie Nadelman created sculptures of people and animals with thin, graceful curves and simple forms. William Zorach, José de Creeft and John Flannagan often carved stylized figures from natural rocks. In Canada, Florence Wyle carved elegant smoothly finished sculpture in wood.

Many large outdoor sculptures were done in the semi-abstract *Art Moderne* style. A well-known example at Rockefeller Center in New York City includes work by John Storrs, Isamu Noguchi, and others.

Abstraction Around 1932, United States artist Alexander Calder invented two kinds of sculpture. One type is a *mobile* –forms hung from the ceiling so they move in space. The second type is a *stabile*, a sculpture made of large forms that do not move or hang.

Other artists began to work with metal in an abstract style. In the United States, José de Rivera created highly polished forms that spiral in space. George Rickey suspended pieces of sheet metal on wire so they shimmer. Richard Lippold used wire-like forms to imply interactions of light, space and movement.

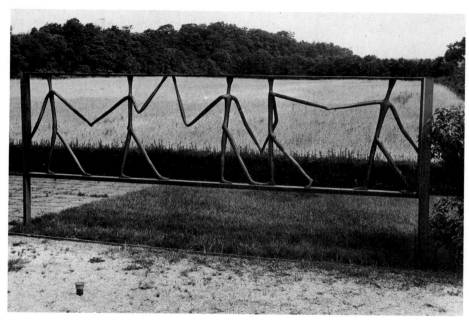

Mary Callery, *Amity*, 1947. Linear sculptural forms are not often seen in bronze. What is the meaning of the title of this sculpture? Bronze, 5' x 16' (152 x 488 cm). Courtesy of Washburn Gallery, New York.

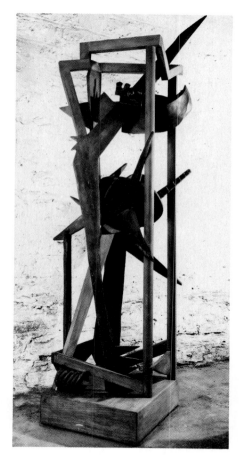

Seymour Lipton, *Imprisoned Figure*, 1948. Combinations of materials for sculpture were being explored by many artists. Do you think the theme of this work might be related to events in the 1940's? What events? Wood and sheet-lead construction 7' 3/4" x 30 7/8" x 23 5/8" (215 x 79 x 60 cm). Collection, The Museum of Modern Art, New York. Gift of the artist.

Alexander Calder, *Fish*, ca. 1950. Calder is known as the inventor of mobiles. A mobile is one of many forms of kinetic sculpture. Metal and glass, 16 1/4" x 46 1/2" (42 x 118 cm). Hirshhorn Museum and Sculpture Garden.

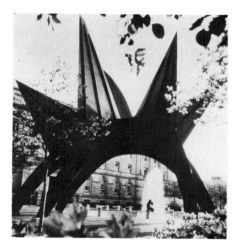

Alexander Calder, *Stegosaurus*. Steel plate, 50'. Burt McManus Memorial Plaza, Hartford, CT.

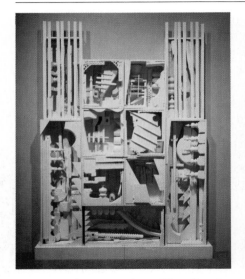

Louise Nevelson, *Dawn's Wedding Chapel II*, 1959. White painted wood, 9' 7 7/8" x 6' 11 1/2" x 10 1/2" (295 x 212 x 27 cm). Collection of Whitney Museum of American Art. Purchased with funds from the Howard and Jean Lipman Foundation, Inc.

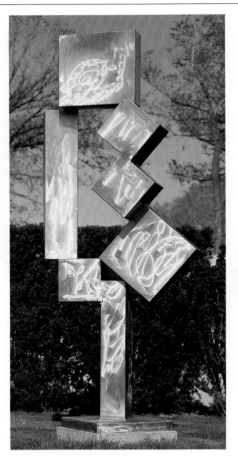

David Smith, *Cubi XII*, 1963. Sculptures from welded stainless steel are a 20th century development. Stainless steel, 109 5/8" x 49 1/4" x 32 1/4" (278 x 125 x 82 cm). Hirshhorn Museum and Sculpture Garden, Smithsonian Institution. Gift of Joseph H. Hirshhorn, 1972.

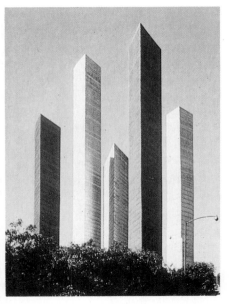

Mathias Goeritz, *Towers without Function*, 1957-1958. This large environmental work combines architectural ideas and sculptural forms. Mexican artist Mathias Goeritz influenced many other sculptors in North America. Satellite City, Mexico City.

Sculpture 1950-Present

Since 1950, sculptors have continued to combine expressive and abstract forms in a variety of media.

Constructed sculpture Since World War II, industrial materials such as plastic and metal sheets or rods have become more common as media for sculpture. Innovative welded forms can be seen in the work of *(United States)* David Smith, Theodore Roszak, Ibraham Lassaw, Mark di Suvero; *(Canada)* Haydn Davies and Kosso Eloul. In Mexico, Manual Felguérez was among the first artists to do related work.

Some artists join ready-made or salvaged items to create *assemblages.* Others explore new forms or media such as cloth or foam rubber. Among well-known artists are *(United States)* Joseph Cornell, Louise Nevelson, John Chamberlain, Lee Bontecou, Nancy Graves; *(Canada)* Jackie Winsor.

In Minimal sculpture, artists create subtle, quiet work by using very few art elements, such as cubes or cylinders. Many of these sculptors assemble or combine ready-made materials such as sheets of plastic or metal. Among these artists are *(United States)* Donald Judd, Robert Morris, Anne Truitt, Tony Smith, Sol Lewitt, Carl Andre; *(Canada)* Mia Roosen and Ronald Bladen.

New abstraction to sculpture is based on a special interest in the symbolism of forms, spaces and materials. The artist often includes a recognizable subject or theme. Among many artists working in this style are *(United States)* Scott Burton, Richard Hunt, Louise Bourgeois; *(Mexico)* Guillermo Ruiz and Ignacio Asúnsolo.

A kind of *Super Realism* in sculpture was developed in the late 1960's. Sometimes the figures are so life-like that they startle people. Artists include *(United States)* Duane Hanson, John De Andrea and Bob Graham. In Mexico, realism and heroic qualities are present in the work of Francisco Zúñiga and Rodrigo Betancourt.

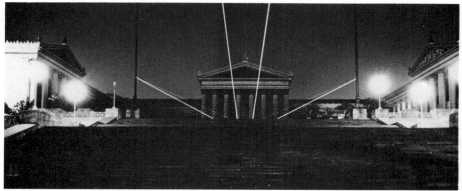

Rockne Krebs, *Sky Bridge Green*, 1973. New technologies, motion, and light are being explored as sculptural media. Photograph. Philadelphia Museum of Art.

Duane Hanson, *Tourists II*, 1988. Super-realism in sculpture developed at about the same time that photorealism developed in painting. Hard plastic, oil paint, mixed media, life-size. Collection of the artist.

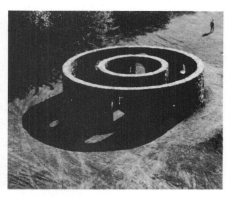

Sally Cooley, *Skunk Cabbage*. The Pop Art movement included sculpture, sometimes made from "soft" materials. Cotton stuffed with fiberfill, 18" x 12" x 2" (46 x 30 x 5 cm). Photograph courtesy of the artist.

Nancy Holt, *Stone Enclosure: Rock Rings*, 1977-1978. Earthworks and related sculpture are based on artists' enduring interest in nature and our relationship to it. Hand quarried schist, outer ring 40' diameter, inner ring 20" diameter, height of ring walls 10'. Western Washington University. Photograph courtesy the John Weber Gallery.

Environmental Sculpture *Land* or *earth art* refers to several directions in sculpture. Some artists use the earth, wind and water as sculptural media. Many create spaces that include fountains, gardens and the like. Others create environmental work that people can walk through or sit on. Well-known sculptors include *(United States)* Siah Armajani, Judy Pfaff, Robert Smithson, Dennis Oppenheim, Alice Aycock, Nancy Holt, Jennifer Bartlett; *(Canada)* Colette Whiten, Nobuo Kubota; *(Mexico)* Mathias Goeritz and Helen Escobedo.

Some artists create theater-like environments with sculptural elements. Among these artists are *(United States)* Red Grooms, Marisol, Edward and Nancy Kienholz, George Segal; and *(Canada)* Phil Richards.

Motion and Technology *Kinetic* refers to sculpture with parts set in motion by natural or mechanical energy. Alexander Calder was the first well-known kinetic sculptor. Others are: *(United States)* George Rickey, Lin Emery, Len Lye; and *(Canada)* Gray Mills.

High tech sculptors create images with computers, television, lasers and other forms of technology. Leaders are: Chryssa, Dan Flavin, Robert Irwin, Keith Sonnier, Charles Csuri and Nam June Paik.

Happenings are events that include planned and unplanned activities and audience participation. Happenings were first developed by United States artists Allan Kaprow, Claes Oldenburg and James Dine. More recently, performance artists have worked together on projects similar to films, television or theatrical events. Leaders in performance art are John Cage, Twyla Tharp and Laurie Anderson.

Photography 1900–1950

Between 1900 and 1950, photography developed as a fine art. In New York City, Alfred Stieglitz set up a magazine and gallery to promote photography. Other leaders of photography as a fine art were Gertrude Käsebier and Edward Steichen.

After the 1913 Armory Show, many artists began to focus on the abstract design qualities of their subjects. Among these were United States photographers Paul Strand, Edward Weston, Ansel Adams, and Imogen Cunningham. Man Ray experimented with photograms (images made without a camera) as well as montage.

Early photographers who reported on social problems and special groups in America were Lewis W. Hine (child labor), Doris Ulmann (poverty) James Van Der Zee (Harlem, New York City), Edward S. Curtis, Adam Clark Vroman (Native North American cultures) and Walker Evans (urban life). In Mexico, Augustín Casasola photographed the Mexican revolution. Manuel and Lola Bravo began to record everyday life.

In the United States, leaders in documentary photography about the Great Depression of the 1930's were Dorthea Lange, Arthur Rothstein, Margaret Bourke-White, Berenice Abbott and Ben Shahn. The work of these and other artist-photographers was often published in books or as photo essays for two new picture magazines, *Look* and *Life*.

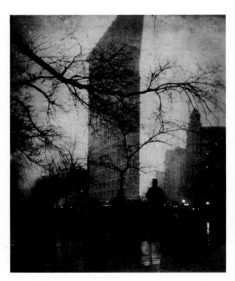

Edward Steichen, *The Flatiron*, 1909. Photograph. The Metropolitan Museum of Art. Gift of Alfred Stieglitz, 1933.

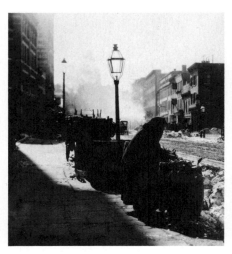

Alfred Stieglitz, *The Rag Picker, New York.* Stieglitz had faith that photography would become a major form of art. Courtesy Sotheby's, Inc. 1987.

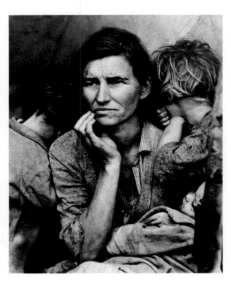

Dorothea Lange, *Migrant Mother, Nipomo, California*, 1936. One critic called this photograph "The Madonna of the Depression." Can you interpret the meaning of this phrase? Photograph. Dorothea Lange Collection, The Oakland Museum.

Photography 1950-Present

Since World War II, photographers have explored many subjects and ways of using new photographic equipment and techniques. Photography as a fine art has been accepted by more museums, critics and art historians.

Contemporary culture became a major theme in the work of *(United States)* Robert Frank, Diane Arbus, Les Krims, W. Eugene Smith and Gordon Parks; *(Canada)* Lynn Cohen, Robert Bourdeau, Gabor Szilasi; *(Mexico)* Enrique Bostlemann and Graciela Iturbide. Fashionable photographs of celebrities were created by United States artists Arnold Newman, Irving Penn, Richard Avedon, Phillippe Halsman and Canadian Joseph Karsh.

Elegant close-ups, altered photographs (two negatives, one print), abstract design concepts and other experimental approaches were explored by Lazló Moholy-Nagy, Gyorgy Kepes, Minor White, Harry Callahan, Barbara Morgan and Jerry Uelsmann.

Color films are more permanent than they once were. Since the 1960's, more photographers have become interested in color. Outstanding color photographers include Eliot Porter, Ernst Haas, Helen Levitt and Marie Cosindas.

Marie Cosindas, *Conger Metcalf Still Life,* 1976. What photographic process did this artist use? What is the theme of her photograph? Polacolor photograph, 8" x 10" (20 x 25 cm). Courtesy of the artist.

Erika Davis Wade, *Tulips,* 1982. The first dyes for color photography were not very permanent. After the 1950's, these technical problems were being solved. Color photography became more attractive to artists. Courtesy of the artist.

Jerry Uelsmann, *Untitled,* 1976. Can you offer a hypothesis about the process used to create this photograph? What mood is created in this work? Photograph, 15" x 20" (38 x 51 cm). Copyright Jerry Uelsmann.

Major Trends: 20th Century North American Art

Column headers: General | Architecture | Design | Painting | Sculpture | Photo

New directions often combine ideas from earlier styles. Examples: New Abstraction, New Expression, New Image

Timeline axis (right side): Present, 1980, 1978, 1976, 1974, 1972, 1970, 1968, 1966, 1964, 1962, 1960, 1958, 1956, 1954, 1952, 1950, 1948, 1946, 1944, 1942, 1940, 1938, 1936, 1934, 1932, 1930, 1928, 1926, 1924, 1922, 1920, 1918, 1916, 1914, 1912, 1910, 1908, 1906, 1904, 1902, 1900

W.W. II (marked ~1942) | **W.W. I** (marked ~1917)

General
- EUROPEAN INFLUENCES
- Art Nouveau
- Post-Impressionism
- Cubism
- Futurism
- Expressionism
- Nonobjective/Geometric
- Dada
- Surrealism
- Bauhaus 1919–1933
- INNOVATION IN NORTH AMERICA
- INTERNATIONAL ART COMMUNITY
- New York City – main art center
- Growth of art criticism
- Many new galleries
- International network of critics, galleries
- Art history about women, minorities
- Corporations collect art

Architecture
- BEAUX ARTS CLASSICISM
- CHICAGO SCHOOL — Louis Sullivan
- PRAIRIE STYLE — Frank Lloyd Wright
- Growth of INTERNATIONAL STYLE
- POST-WAR CONSTRUCTION BOOM
- POST-MODERN ERA
- Eclecticism
- Historic Preservation
- Urban Renewal

Design
- Electricity in homes.
- "Battle of Styles" Eclectic-Victorian
- Growth in the use of modern appliances
- ORGANIC DESIGN-Wright
- ART MODERNE
- COLONIAL REVIVAL
- Frank Lloyd Wright (1867–1959) — Philosophy of ORGANIC DESIGN
- Ecological Design
- Tradition of ORGANIC DESIGN
- Design for INTERNATIONAL STYLE
- Design for a CONSUMER-ORIENTED SOCIETY
- POST-MODERN DESIGN CONCEPTS – consumer and designer are free to choose and combine styles

Painting
- REALISTS
- ROMANTICS
- IMPRESSIONISTS
- ASH CAN SCHOOL
- REALISM
- FUTURE, FANTASY, CHANGE
- ABSTRACTION
- New style directions from Europe and 1913 Armory Show
- ABSTRACT EXPRESSIONISM
- Combines / Assemblage
- Soft-edge
- Hard-edge
- POP
- OP
- MINIMAL
- PHOTO-REALISM
- HIGH TECH

Sculpture
- BEAUX ARTS CLASSICISM
- HISTORY
- REALISM
- ABSTRACTION
- SEMI-ABSTRACTION
- REALISM
- Constructed sculpture (welding, etc.)
- Mobiles and early kinetic sculpture
- Happenings
- Performance art
- Land/Earth Works
- Environments
- HERITAGE-BASED
- SUPER-REALISM

Photo
- Documentary photography
- Abstract and experimental photography
- Contemporary culture
- Greater use of color

Note: The beginning dates and ending dates for each development in art becomes less precise after World War II.

Summary

North American art of the twentieth century has been influenced by immigration, innovation and increased information about art.

Before 1950, European styles of art such as Surrealism, and varieties of abstraction had a major influence on North American art. This influence increased after the 1913 Armory Show and the arrival in North America of artists who develped new styles in Europe.

After 1950, New York City became the main center for innovative art. Around 1960, the art world became increasingly international. Throughout this century, critics and other experts have invented style names and special phrases to describe the many new directions in art.

The names and phrases to describe different art forms are sometimes related, such as Photo Realist painting and Super Realist sculpture. New terms have also been invented for nontraditional forms of art. Examples include happenings, mobiles and earth art.

Since 1970, there has been a new appreciation of pluralism. Pluralism means that many forms, styles and traditions of art are used at the same time by artists. This trend is continuing. It is often called the post-modern movement in art.

Using What You Learned

Art History

1 List at least one influence of the following on American art before 1950:

- *1913 Armory Show*
- *Bauhaus*
- *Dada and Surrealism*

2 Name four varieties of Realism in painting in the period between 1900 and 1950.

3 Briefly define:

- *abstract expressionism*
- *Pop art*
- *Op art*
- *kinetic sculpture*
- *assemblage*
- *happening*
- *historic preservation*

Aesthetics and Art Criticism

1 What is meant by the term *pluralism*?

2 Briefly define the following terms. You may choose to make simple drawings to explain their meanings.

- *soft-edged*
- *hard-edged*
- *grid-like structure*
- *Realism*
- *abstraction*
- *Semi-Abstraction*

Creating Art

1 Choose two styles of painting introduced in this chapter. Create an original artwork (not copied or traced) that combines ideas from both of the styles.

2 Identify a new type of sculpture introduced in this chapter. Create an original artwork of that type. For example, you might create a mobile or an assemblage. What other possibilities can you identify?

3 Create a form of environmental art. It might be an architectural model in which you use some ideas about organic or ecological design. You might collect some natural materials and create a sculpture. What other forms of environmental art could you consider as possibilities?

Charles Sheeler, *Rocks at Steichen's*, 1937. Have you ever tried drawing part of a larger scene? What details did Sheeler include? How did he suggest light and shadow? Conte crayon on off-white wove paper, 161" x 120" (408 x 305 cm). The Baltimore Museum of Art.

Chapter 7
Drawing

Chapter Vocabulary

contour
gesture
whole-to-part
wet media
dry media
mixed media
positive shape
negative shape
stipple
hatch
crosshatch
highlight
cast shadow
proportion
three-quarter view
foreshortening
linear perspective
horizon line
vanishing point
calligraphic drawing
computer draw programs

How many times have you looked in a mirror: 100 times? 1,000 times? 10,000 times? You look at yourself every day, but what do you really see?

Look in a mirror and draw your face. The way your eyebrows arch, the slope of your nose, the angle of your chin – take your time and carefully draw all the details. You may find that you see yourself in a totally new way. Think of drawing as a way of looking at the world. It is an adventure in seeing.

Drawings have many purposes. They can be a quick record of things you observe and want to remember. They can be a way to explore and try out ideas for paintings, posters and other kinds of artwork. Drawings can also be planned as finished works of art. Many artists use drawing tools and materials to express feelings and ideas. When they are successful, we say they have used their medium expressively.

Many artists draw or sketch on a daily basis, just as some writers keep a diary or notes to refer to later. Some artists value drawing as a process more than a product. They approach drawing in the way that an athlete might approach a work-out: drawing becomes a form of exercise to strengthen their artistic skills. You can develop your skill in the same way. As your skills develop, you will discover that drawing can be a medium for expression, just as it is for artists.

In this chapter, you will explore drawing as artists do. You will make drawings for several purposes: to learn to see, to understand design and to express your ideas, feelings and imagination.

After you have studied this chapter and completed some of the activities, you will be better able to:

Creating Art • create drawings in a variety of media using different approaches and design concepts.

Art Criticism • evaluate varieties of drawings in relation to their expressive qualities.

Aesthetics • understand terms for describing media and approaches to drawing.

Art History • understand traditional and experimental approaches to drawing.

Gallery

Drawings can be done in many media and on different surfaces such as rough paper, smooth paper, silk or canvas.

Some of the drawings shown here were created with dry media. Dry media include pencils, charcoal, chalk (pastels) or crayons.

Wet media for drawing include black or colored inks applied with a pen or a brush. A pen and wash drawing combines thin lines and watery ink to create a "painterly" effect.

In a mixed media artwork, artists may combine drawing with painting, collage or printmaking.

Because drawings in wet and mixed media may resemble paintings, many experts call these combinations "works on paper."

Critical Thinking All of these drawings show people. Which ones are linear? Which include shading? Do some combine both techniques? How? What moods and expressions have these artists captured? How?

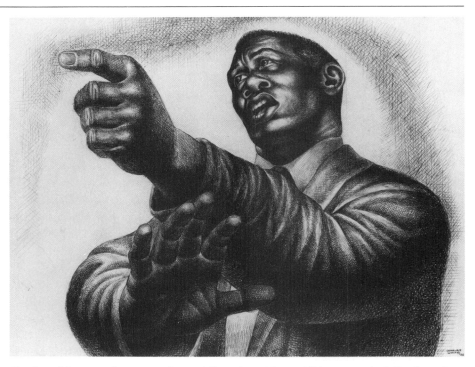

Charles White, *Preacher*, 1952. Ink on cardboard, 21 ³/₈" x 29 ³/₈" (54 x 75 cm). Collection of The Whitney Museum of American Art.

Chuck Close, *Phil/Fingerprint II*, 1978. Stamp pad ink and pencil on paper, 29 ³/₄" x 22 ¹/₄" (76 x 57 cm). Collection of Whitney Museum of American Art, New York. Purchased with funds from Peggy and Richard Danziger.

Käthe Kollwitz, *Self-portrait*, 1934. Charcoal and crayon, 17" x 13 ¹/₄" (43 x 34 cm). Los Angeles County Museum of Art. Los Angeles County Funds.

Nyoirin Kannon, 12th century, Heian period. Ink and colors on silk, 39" x 18" (98 x 44 cm). The Museum of Fine Arts, Boston. Fenollosa Weld Collection.

Ben Shahn, *Dr. Robert J. Oppenheimer*,
1954. Brush and ink, 19 ¹/₂" x 12 ¹/₄" (50 x 31
cm). Collection, The Museum of Modern
Art, New York. Purchase.

Albrecht Dürer, *Four Heads.* Brown ink,
8 ¹/₄" x 7⁷/₈" (21 x 20 cm). The Nelson-Atkins
Museum of Art, Kansas City, Missouri,
Nelson Fund.

Rosalba Carriera, *Self-Portrait Holding
Portrait of Her Sister*, 1715. Pastel on paper.
Galleria delgi Uffizzi, Florence.

Gian Lorenzo Bernini, *Portrait of a Young
Man,* ca. 1625-1630. Red and white chalks,
13" x 8 ¹/₂" (33 x 22 cm). The J. Paul Getty
Museum, Malibu, California.

Katsushika Hokusai

1760-1849

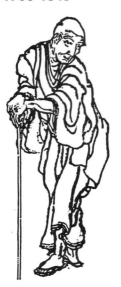

Katsushika Hokusai, *Self-portrait*, 1840. Paris, Guimet.

He lived to be eighty-nine, used fifty names, and resided in about ninety different places during his lifetime. He once wrote: "From the age of six I had a mania for drawing. At seventy-three I had learned a little…and when I am a hundred and ten, everything I do…will be alive."

During his lifetime, Hokusai published a 13-volume book called Manga (sketches or drawings). Many of the sketches show people and scenes in and around his hometown of Edo (now Tokyo, Japan). He sketched people at many kinds of work and play. He drew objects, plants and landscapes, as well as both real and imaginary animals. He loved doing caricatures and drawings based on legends.

Hokusai was famous for working quickly and giving public demonstrations of his skill in drawing. There are many legends about him. It is said that he once drew birds on a tiny grain of rice. At another time, he gathered a large audience outside a temple. There he drew a huge picture of Buddha using a broom-sized brush.

The most well-known story tells of his drawing at the palace of the Shogun (the military ruler of Japan). There Hokusai spread a long piece of paper on the floor. Quickly he painted blue waves across it. Then he dipped the feet of a live rooster in red paint and let it run across the painting. To the amazement of all, he said the work was finished and called it "red maple leaves floating down a river."

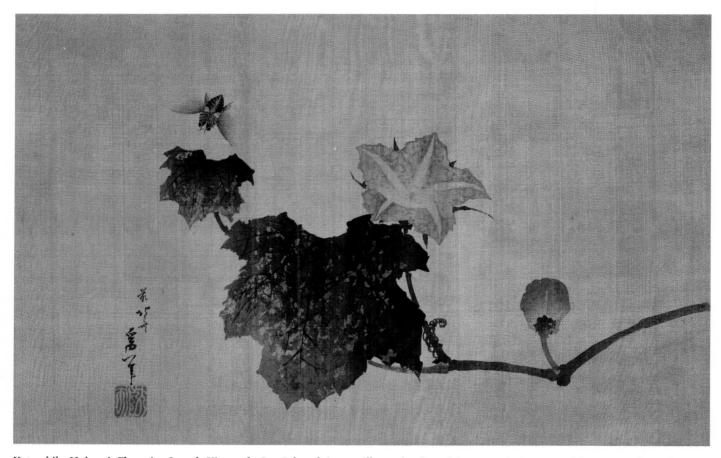

Katsushika Hokusai, *Flowering Squash-Vine and a Bee.* Ink and tint on silk panel, 14" x 22" (35 x 55 cm). Courtesy of the Freer Gallery of Art, Smithsonian Institution.

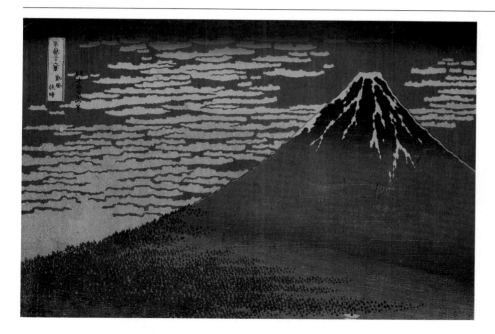

Katsushika Hokusai, *South Wind and Fair Weather*, Edo period. 10 ⅛" x 18" (26 x 46 cm). Woodblock print. Copyright 1990 Indianapolis Museum of Art. Carl H. Lieber Memorial Fund.

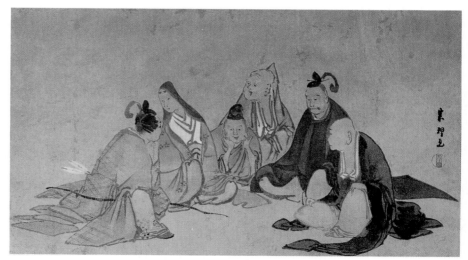

Katsushika Hokusai, *The Six Poets*, Edo period (Tokugawa). Ink and color on paper, 13" x 22" (33 x 56 cm). Courtesy of the Freer Gallery of Art, Smithsonian Institution.

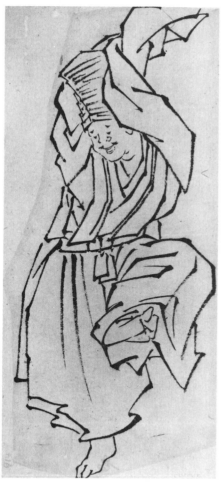

Katsushika Hokusai, *Dancing Man*. Ink on paper, 10¾" x 4¾" (27 x 12 cm). One of a set of 16 original sketches and drawings on paper. Courtesy Freer Gallery of Art, Smithsonian Institution.

Hokusai's reputation in drawing is great, but his work as a print-maker and painter is also well known. Some of his finest work is the series of woodcuts called *Thirty-six Views of Mount Fuji*. Each one shows the mountain from an unusual view and in different weather, often with figures in the foreground.

Critics say that Hokusai's rich imagination, sure technique, sense of humor and endless search for perfection make him one of the greatest artists in art history.

Critical Thinking Suppose that the legend about Hokusai's use of paint on the feet of a live chicken is true. What are the main lessons about artistic drawing that this legend includes?

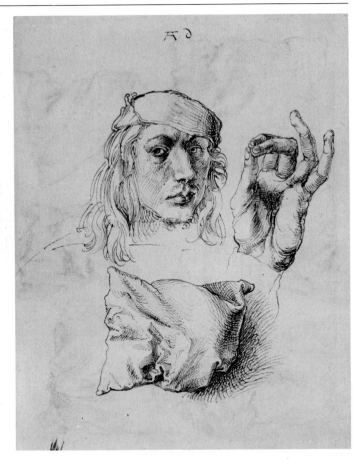

Alexander Cozens, *Landscape from a New Method of Assisting the Invention in Drawing Original Compositions of Landscape*, 1784-1786. Cozens developed a new technique for getting ideas for landscape compositions. You begin using a fluid medium for quick sketches. You then look at the edges and forms as if they were trees, mountains, clouds and the like. Aquatint. The Metropolitan Museum of Art, New York. Rogers Fund, 1906.

Albrecht Dürer, *Self-portrait*. Dürer's sketches, created when he was 22, focus on the contours of the subjects. Dürer became one of the finest artists of the Renaissance (1400-1600) in Northern Europe. Museo del Prado, Madrid.

Ideas for Drawing

One of the best ways to get ideas for imaginative drawing is to experiment. Try using your drawing materials on different surfaces. Use your hand and arm in a variety of ways as you draw. Try using different pressures when you apply pencil, chalk and other media. Look at your experiments. Which of the techniques might be changed or used for another drawing?

Sketching things you observe is also one of the best sources of ideas. Try to make a visual record of the most important or interesting parts of your subjects. Try filling a page with *thumb-nail sketches* – small drawings. Sketch one subject from different views or with different amounts of detail.

Draw the people you know or see. Draw scenes in your neighborhood. Sketch landscapes, animals and any other ideas that come to mind.

There are other ways to get ideas for drawings. You might recall some of the most unusual events in your life or fascinating places you have been. You might think about your beliefs and feelings to get ideas for drawing. Perhaps you care deeply about preserving the beauty of the natural world, helping poor people or working for peace in the world.

Sometimes you can get ideas by using your imagination. For example, draw a mechanical object such as a car or airplane. Then add other shapes and lines to transform it into an imaginary creature.

Can you develop ideas for drawings in other ways?

Student art.

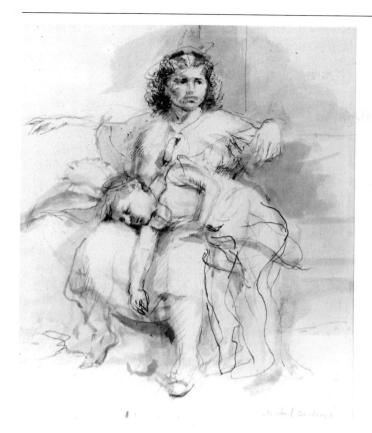

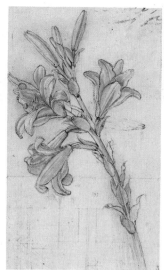

Leonardo da Vinci, *Lily*, 1475. Da Vinci's drawing captures the organic contours of each part of the lily. A thin wash was added after the drawing was completed. Leonardo is remembered for his scientific and artistic achievements during the Italian Renaissance. Pink and brown wash over black chalk-white heightener, 12" x 7" (31 x 17 cm). Windsor Royal Library. By Gracious Permission of Her Majesty the Queen.

Isabel Bishop, *Waiting*, 1935. Gestures are captured in this drawing. Ink on paper, 7 ¹/₈" x 6" (18 x 15 cm). Collection of Whitney Museum of American Art, New York. Purchase.

Approaches to Drawing

Drawing is a record of how well your senses, mind and feelings work together. With practice, drawing is easy, natural and creative.

One of the best-known practice methods is *contour* drawing. A contour is an edge, ridge or groove of a form. In contour drawing, the main idea is to slowly record every slight change in the edges of a form.

Draw lines as if your pencil was slowly moving along the edge of the object, like a snail. Do not stop to erase or correct lines. Look at the object more than your paper. Do not worry about how your drawing looks. The more you practice this method, the more observant you will become.

Gesture drawing is almost the exact opposite of contour drawing. A gesture is an expressive movement. In gesture drawing, you work quickly to capture the overall movement in something you see.

To begin, you need four or five sheets of paper. Draw with the flat side of a short piece of chalk or crayon.

Move your eyes and hand quickly. Draw just the main curves and angles that you see. Feel the flow of action and record it quickly. Do not try to draw outlines or details. For action poses with one or two people, draw for about two or three minutes.

Take turns posing with props like chairs, brooms and sports equipment. Do gesture sketches of people in shopping malls, at work, dancing or playing. Sketch pets, flowers and other forms. For a variation, try gesture drawings of the negative spaces around the human figure or other subject.

Sketches can also help you plan well-balanced compositions. Artists usually begin by using the following *whole-to-part* approach. These are the main steps:

1. Sketch very light lines to show the position of the largest shapes and their proportions.

2. Compare the sizes of objects and observe how shapes overlap.

3. Observe and add other features, such as shadows or patterns.

4. Add details and textures.

Can you explain why this method can help you compose a drawing?

Media for Drawing

Wet Media

Ink is the oldest fluid medium. India or China ink is a mixture of carbon black and water. Today, inks are made in a variety of colors and consistencies for use on paper, plastic and other surfaces.

Pens for ink can be hollow reeds, quills or metal nibs inserted in a handle. A variety of fountain or cartridge pens with different tips – felt, plastic, roller balls – are also available. Rigid points give a uniform width to the line.

A *wash* is diluted ink applied with a brush or swab. Many subtle tones can be created with diluted ink on a moist surface. By choosing different brushes, you can vary line and tonal qualities. Many artists combine linear pen or brush drawing with wash to suggest form, movement and atmosphere.

Other fluid media are watercolor and water-based markers. Both can be used on wet or dry paper. Other tools for applying fluid media include twigs, bits of sponge and other found objects.

Safety Note Most permanent felt-tip markers contain fume-producing solvents. Because the fumes can be extremely hazardous to your health, they are not recommended for use in any art activity.

Dry Media

Dry media for drawing include pencil, charcoal, pastel, wax crayon and silverpoint.

The relative hardness of art pencils is usually shown in a code. A pencil coded 6-H is very hard, a 6-B is very soft. Areas of tone or value can be created by smudging or building up strokes of various kinds. Colored pencils can be used to create "painterly" drawings.

Charcoal is burnt wood in the form of thin vines, pencils or compressed sticks. Charcoal sticks vary in hardness. They can be sharpened to a fine point, dragged and smudged. Textured papers are usually best for creating charcoal drawings.

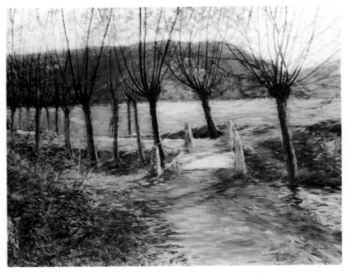

Lila Cabot Perry, *Bridge-Willow-Early Spring*, 1905. Pastel, 25 1/4" x 31 1/4" (64 x 79 cm). Private Collection. Courtesy Hirschl & Adler Galleries, New York.

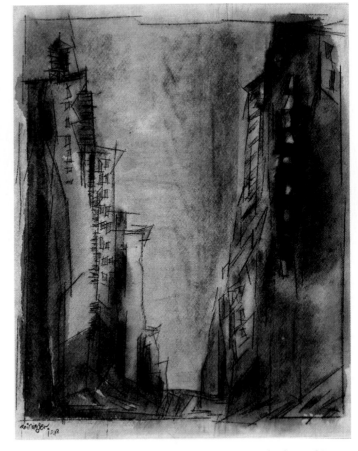

Lyonel Feininger, *Manhattan Canyon*, 1948. Pen and ink on white laid paper, 18 7/8" x 14 3/4" (48 x 37 cm). The Baltimore Museum of Art. Frederic Cone Contemporary Fund.

Chalk and pastels are sticks of colored pigments mixed with a binder such as gum arabic (a glue) or an oil (oil pastels). These media are often selected for "color studies" and finished drawings. A transparent fixative is usually sprayed on finished charcoal and chalk drawings to prevent the dust from smearing.

Wax crayons can be built up in shiny layers, scratched into, or combined with fluid media for a resist effect. Conte crayons combine chalk and wax. They allow you to create very fine detail or soft velvety tones.

Silverpoint drawings are made with a silver wire on special paper. The drawing is finished when the silver lines become tarnished and dark.

Safety Note Chalk, pastels and charcoal produce dust. Follow safety and health precautions. Use spray fixative only in well-ventilated areas outside of the classroom. Follow all directions.

Mixed Media and Collage

The combinations of traditional wet and dry media are almost limitless. Artists combine drawing with painting, collage and printmaking. Some have created drawings on sculpture. Drawings can be made in sand, plaster, foil, clay and many other surfaces.

A collage may include elements drawn in charcoal or another medium. A collection of drawings might be cut up and re-composed as a collage.

Explore these and other possibilities. Try using sticks or twigs, found objects or the edge of cardboard for drawing. Try drawing on wet surfaces, blotters, or old window shades.

Try combining dry media such as chalk and crayon. What happens when you use chalk on wet paper? Try combining wet media. For example, find out what happens when you spread diluted watercolor on paper and then draw on top of it with ink.

Combine wet and dry media. Try crayon resist: Draw heavily with wax crayon, then cover the drawing with a wash of ink or watercolor. Explore other ways to combine drawing media.

Robert Indiana, *The Great American Dream: New York,* 1966. Frottage is a French name for a texture rubbing. Indiana became well known as a Pop artist. Colored crayon and frottage on paper, 39 ¹/₂" x 26" (100 x 66 cm). Collection of Whitney Museum of American Art, New York. Gift of Norman Dubrow.

Student art.

Paul Klee, *Twittering Machine,* 1922. Klee's masterful use of mixed media is seen in this whimsical work. Does the title of the work seem to go with the image? Why or why not? Watercolor and pen and ink on oil transfer drawing on paper, mounted on cardboard, 25 ¹/₄" x 19" (64 x 48 cm). Collection, The Museum of Modern Art, New York. Purchase.

Jimmy Ernst, *Face*, 1960. How do the qualities of line in this drawing differ from those in the other drawings on this page? How do these differences help express the theme in each work? Ink on paper, 22" x 29 ³/₄" (56 x 76 cm). Collection of Whitney Museum of American Art, New York. Purchase.

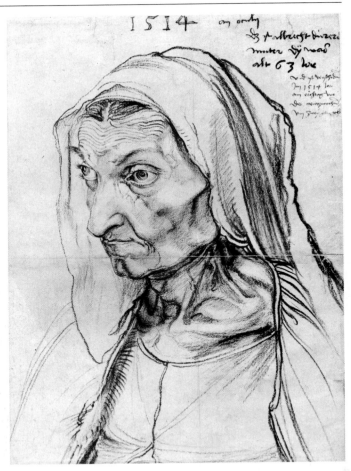

Albrecht Dürer, *Dürer's Mother*, 1514. Kupferstichkabinett, Berlin.

Contour drawing. Student art.

Using Design Concepts: Line

Lines can be drawn in ways that remind us of human feelings such as joy or sorrow; strength or weakness; calmness or nervousness. They can be drawn to show the sensory qualities of objects such as brittleness or transparency.

Lines have qualities that depend on your choice of medium. Stiff pen points give uniform "hard" lines, especially on smooth paper. Charcoal lines on rough paper are "soft" and fuzzy. You can select a medium for the idea you want to express.

Line variations can be described in many other ways — long or short, wide or thin, rough or smooth, straight or curved. The dominant direction of lines can be vertical, horizontal, diagonal or multi-directional. We can also describe lines as active or static, flowing or irregular.

Explore the expressive use of line. For example, with classmates, list on the board about ten moods or feelings. Include traits of people, such as strong or nervous, that might be expressed with line qualities. Choose one of the words. Create an abstract drawing with qualities of line that match the meaning of the word. After your drawings are completed, see if classmates can guess the mood you captured.

Try this same kind of drawing with other subjects. For example, as you draw a flower, look closely at its most delicate parts. Draw these parts with a thin, light line. Draw the stronger parts with a darker, wider line. If you are drawing a hand, vary the width and darkness of the lines to suggest smooth skin and fleshy wrinkles.

Patricia Renick, *Untitled*, 1989. Colored pencil. Courtesy of the artist.

Richard Diebenkorn, *Sink*, 1967. Can you create drawings based on very simple shapes in your environment? How does this artist emphasize shapes? What is the center of interest in this work? Is it in the center of the drawing? Charcoal and gray wash, 24 ³/₄" x 18 ³/₄" (56 x 76 cm). The Baltimore Museum of Art. Thomas E.. Benesch Memorial Collection.

Shape

Most of your line drawings have also included shapes. A shape is made when a line encloses a space.

Geometric shapes can be measured precisely or look very precise. Squares, circles, triangles and rectangles are examples. Related shapes are often seen in manufactured objects.

Organic or free-flowing shapes remind us of living, growing things such as leaves, faces and figures. *Free form* is a term used for irregular shapes. Free form shapes often combine geometric and organic qualities. The edges of shapes can be blurred and "soft" or very precise and "hard." The contours can seem to be active or passive.

Study and draw the *planes* (flat areas) and edges of shapes from different angles (top, side, front, back). For example, wrap rubber bands, string or yarn around a clear plastic cup or other small objects (your shoe or a handbag). Observe and draw the edges of the bands as they go around the edges of the form.

Artists also plan their use of positive and negative shapes. The *positive* shapes are those you see first. These are often called the main shapes. The *negative* shapes are background areas. These shapes are usually unnoticed until you learn to see and plan them.

For practice in seeing positive and negative shapes, try some drawings of silhouettes. A *silhouette* is the outline of a shape that you fill in with one solid color. You might try cutting or tearing paper shapes and arranging them in a composition.

Try drawing geometric shapes. Combine or repeat four or five of them. See if you can create one symmetrical design and one asymmetrical design. Perhaps you can draw an allover design using stencils (cutouts) of geometric shapes.

Value: Light and Dark

Create two drawings on the same subject, one based on very light values and the other based on very dark values. Can you see a difference in mood between them?

Your drawing might have many different values, from white to black with many grays in between. If you change the values gradually, you can suggest forms, textures and space. Gradual changes like this are called shading. You might introduce very sharp contrasts in value for a dramatic effect.

Pencil, charcoal and chalks can be blended with a tissue to create smooth shading. With ink, the effect of gray can be created by placing dots or thin lines close together or farther apart. The dot technique is called *stippling*. The line method is called *hatching* (parallel lines) or *crosshatching* (lines that cross each other).

You can learn to see and use values creatively in drawings. Try some of these methods.

Draw a classmate or objects in the room. Make sure there is only one main source of light. Record the lightest and darkest surfaces first, then add grays.

Select one of your line drawings. Shade it to suggest a definite source of light and shadow (above, below; left, right). Include the *highlights* and *cast shadows*.

Do a three-tone drawing on gray paper using white for strong highlights and black for deep shadows. Let the gray paper serve as the third value.

Try creating a two-tone drawing of an object. Use black and record only the deepest shadows on white paper. Try drawing on black paper with chalk. Focus on the highlights in your subject.

Find an object with bumps and hollows. You might use a mirror and draw your nose and lips or nose and eyes. Study and draw the light and shadow of concave and convex forms.

Cast shadows.
A low light source casts long shadows.

A high light source casts short shadows.

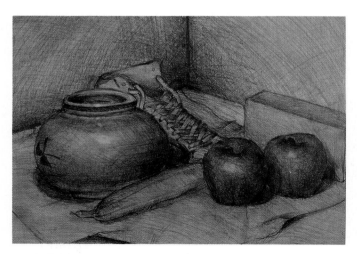

Gradual changes in value can be used to suggest the form of objects. Student Art.

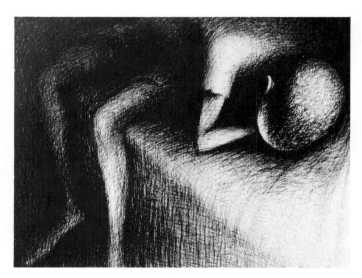

John Biggers, *Sleeping Boy*, 1950. Conte crayon. Dallas Museum of Art, Neiman-Marcus Company Prize for Drawing, Fifth Southwestern Exhibition of Prints and Drawings, 1952.

Texture and Pattern

Texture refers to how something feels when it is touched–such as rough, smooth, pebbly or silky. In drawing, artists usually create the illusion of textures. They can also include actual textures such as string or other collage materials glued to the paper.

Discover how textures might be created in a variety of drawing media. Here are some examples. Create textural qualities with the techniques of crayon etching and crayon resist. Draw with a brush. Spread out the hairs of a paint brush and put a small amount of ink on the brush. Unusual drawing tools such as the tip of a stick can be used to suggest textures.

Try different techniques to suggest the texture of cotton, wood, hair and other materials. Find a small natural form with an interesting texture. Draw it so the textural qualities stand out.

Patterns and textures are often related in a drawing. Invented patterns are an important way of creating the illusion of texture. For example, if you draw a brick building, you might give the impression of pattern by drawing lines between the bricks. Some of the bricks might have small dots or thin lines to suggest their texture.

Try creating a line drawing unified by details, patterns or textures. Use waterproof ink on a smooth surface such as bristol board or a large index card. You might begin with a still life with overlapping shapes. You might start with a maze-like composition, then fill it with colorful patterns and unexpected details.

Dots in this work create a texture and many values. Student art.

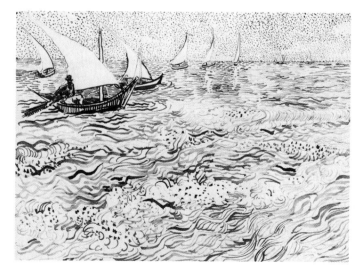

Vincent Van Gogh, *Boats at Saintes-Maries*, 1888. Van Gogh often used a flexible reed pen to create intricate patterns. These small patterns create a rich feeling of textural changes throughout the work. Pencil and ink on wove paper, 9 9/16" x 12 9/16" (24 x 32 cm). Solomon R. Guggenheim Foundation, New York. Photograph by Robert E. Mates.

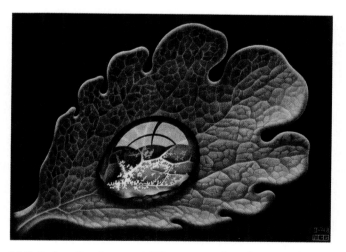

M.C. Escher, *Dewdrop*, 1948. What textures have been simulated in this work? How has the artist suggested the clear smoothness of the dewdrop? Mezzotint, 70" x 91" (179 x 245 cm). Collection Haags Gemeentemuseum, The Hague.

Proportion

A knowledge of proportions will help you any time you include people in a drawing. It will help you create portraits that show a person's uniqueness and mood. Even exaggerated character studies of people are based on an understanding of proportions.

Faces

There are a number of ways to learn about proportions in a face. One method for a *front view* is to draw an oval with lines for the eyes, nose, lips and ears. This drawing is done lightly, as a guide.

After the guidelines are set up, observe the person you want to draw. Notice whether the person has a wide or skinny face, a long or short nose, a high forehead or one with hair close to the eyebrows. Change your lines to show these differences.

Next, work on the "character" or special qualities you want to show. For example, you might use thin, wiry lines for a thin, nervous person. Capture important details. These might include the shape of the eyebrows, a dimple in the chin, a sparkle in the eyes or a unique hairstyle.

You might try shading the drawing. Set up a definite source of light so you can see the highlights and shadows clearly.

Try drawing a *profile* or a *three-quarter view* of a face. A three-quarter view of a face is about midway between a profile and a front view. If the head is level, the shapes of the eyes, nose and mouth are easy to see.

Ask someone to pose so you can draw a three-quarter view. Lightly draw the shape of the head. Then sketch guidelines for the eyes, nose, lips and ear.

Typical proportions: face

1. The eyes are about halfway between the top of the head and chin.

2. The forehead is partly covered with hair.

3. The bottom of the nose is about halfway between the eyes and chin.

Edgar Degas, *Head of a Roman Girl*, ca. 1856. Can you draw a three-quarter view of a face that is tilted up or is seen from slightly below the person? Black crayon, charcoal and estompe on off-white wove paper, 14 ³/₄" x 10 ¹/₄" (38 x 26 cm). The Baltimore Museum of Art. The Cone Collection.

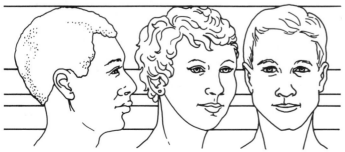

Typical face proportions.

Juan Gris, *Portrait of Max Jacob*, 1919. Notice the edge of the nose. It begins at the bridge near the distant eye, goes down and curves under. The shapes of the eyes and lips are no longer symmetrical. Pencil, 14 ³/₈" x 10 ¹/₂" (37 x 27 cm). Collection, The Museum of Modern Art, New York. Gift of James Thrall Soby.

4. The ears are about parallel to the eyebrows and bottom of the nose.

5. The neck flows down from the jaw.

6. The mouth is slightly higher than halfway between the chin and nose.

7. The width between the eyes is about the same as the width of an eye.

8. The mouth extends to a line directly under each eye.

9. The colored part of the eye (iris) is partly covered by the eyelid.

The proportions for a profile are the same as for the front view. Notice these differences.

a. The lower part of the ear is about halfway between the top of the nose and back of the head.

b. The bridge of the nose and front of the chin are nearly parallel (in a vertical line).

Full Figures

The height of most adults is about seven or eight times the length of the head. Find in your own body some of the other proportions listed in the next section.

Typical proportions: figure

1. The knees are about halfway between the heel and the hip.

2. The hip is about halfway between the heel and the top of the head.

3. The elbows are about parallel to the waist.

4. The hands are about as large as the face.

Similar proportions apply when you draw the side view and people who are active – dancing, playing sports, or in other positions (stretched out, lying down, sitting).

Foreshortening is the name for a perspective technique that you apply when parts of the body move toward you or away from you.

In foreshortening, you show that the nearest part of a form (such as a hand coming toward you) looks larger than a distant part (such as the upper arm and shoulder). The distant parts are always shorter (compressed) and smaller in size. Often, the nearest part will overlap and block out a full view of the parts behind it.

Typical proportions can be exaggerated to show a definite mood. Student art.

Paul Signac, *Stonebreakers*, 1896. Lithograph, printed in black, 18 ¹/₂" x 12" (47 x 30 cm). Collection, The Museum of Modern Art, New York. Purchase Fund.

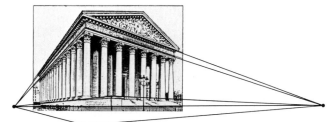

In linear perspective, the parallel edges of forms appear to become narrow and converge at one or more vanishing points. The lines in this diagram illustrate two-point perspective (two vanishing points).

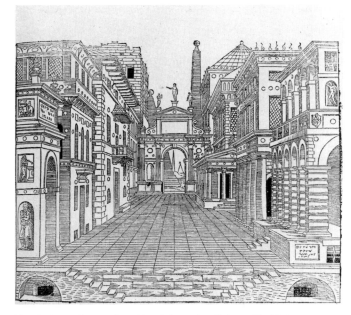

Tragic Scene from Jehan Martin's Paris edition of Serlio's, "De Architettura,"1545. This drawing of a stage set has one-point perspective. The vanishing point is in the middle of the central arched doorway. Woodcut. The Metropolitan Museum of Art, Harris Brisbane Dick Fund, 1937.

This perspective drawing is based on careful observation. Student art.

Space and Perspective

Perspective is the illusion of space and distance on a flat surface. There are many ways to create this kind of illusion.

One of the most challenging problems is drawing objects or scenes that you see from a corner or angle. This problem, called two-point *linear perspective,* can be solved if you observe carefully and practice drawing with the aid of a ruler.

To begin, set up a straight line across your paper. This represents a *horizon line* at the level of your eyes when you look straight ahead at the scene. Above your eye level, you may see horizontal lines in a building. These horizontal lines will slant *downward* to a *vanishing point* (where the lines converge to one point on the horizon line). All of the horizontal lines below your eye level slant *upward* to the vanishing point.

Practice drawing some box-like forms in perspective. Combine them with other forms such as cylinders. You might try a maze-like perspective composition and include some shading. To learn more about perspective, find a photograph of buildings and paste it on a piece of paper large enough to leave a wide border around the photograph. Use a long ruler to find the vanishing points beyond the border.

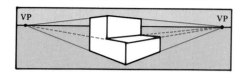

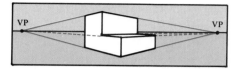 Linear Perspective: Two Point

The horizon line is high

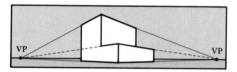 The horizon line is average

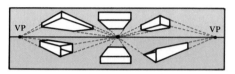 The horizon line is low

Try some perspective experiments

VP=Vanishing Point

Charles-Francois Daubigny, *Landscape*. What perspective techniques did this artist use? Charcoal and crayon on tan laid paper, 17" x 24 1/4" (45 x 63 cm). The Baltimore Museum of Art. Fanny B. Thalheimer Fund.

Observe and draw a variety of scenes in two-point perspective. You might begin with the corner of your street or school. Choose other subjects that interest you. Complete your drawing by using some of the other perspective techniques.

Perspective Techniques

1. Overlap: Complete forms appear to be near you.
2. Shading and shadow: Add these to suggest space.
3. Placement: objects near the top seem to be distant.
4. Size: To show the distance between objects of the same actual size (such as telephone poles), draw the nearest ones larger than the ones farther away.
5. Color and value: Light values and cool, dull colors suggest distant features.
6. Focus: Sharp edges and detail suggest nearness.
7. Linear perspective: Parallel edges of forms appear to narrow as they go toward one or more vanishing points on a horizon line.
8. Foreshortening: The nearest part of a form is large. Distant parts are shorter (compressed) in size.

Georges Seurat, *Two Men Walking in a Field*, ca. 1882-1884. Which of the figures in this landscape appear to be nearest to you. Why? Conte crayon on laid paper, 125" x 96" (318 x 243 cm). The Baltimore Museum of Art. The Cone Collection.

Inventive perspective

We usually think of perspective techniques as a way to create realistic art. Perspective techniques can also be used to create illusions within an unrealistic world.

This approach to perspective was often used by Surrealist artists early in the twentieth century. It still appeals to many artists today.

You might try applying your knowledge of perspective techniques to create the illusion of reality in an unrealistic world. Your drawing might have a mysterious quality or a science fiction theme.

You might create a maze-like environment or one with creatures floating in the sea or space. What other ideas could you explore?

Hands and Muscles

We think of the face as the most expressive part of a person, but hands are expressive also. Hands can point up or down. They can hold tools, flowers or other objects. They can be relaxed or tense. In portraits and many other artworks, hand gestures may be symbols for prayer, respect, strength or weakness.

Try drawing your own hand. Keep it in one position so you can draw it in detail. Choose an expressive pose. Lightly sketch the largest shapes, then work on the contours.

Vary the width of lines to suggest deep folds with shadows. When the contour is accurate, you might shade the drawing to show the form and bring out the expressiveness of the hand.

Practice drawing other parts of the body. Study the forms of muscles when they are relaxed and tense. Draw details of fat and skinny people, young and old people, super-strong and weak people. Do you know why this kind of practice can be important to an artist?

Edward Ruscha, *Motor*, 1970. Linear perspective and shading make the letters seem to float in space. Gunpowder and pastel on paper, 23" x 20" (58 x 51 cm). Collection of Whitney Museum of American Art, New York. Purchase with funds from the Lauder foundation.

Michelangelo, *Studies for the Libyan Sibyl.* Artists of the past and present have created drawings to understand the human figure and try out ideas for compositions. Red chalk on paper, 11 3/8" x 3 3/8" (29 ...politan Museum of Art. Purchase, 1924. Joseph

Three-Dimensional Drawings

Drawings are usually created on flat surfaces. They can also be created on three-dimensional forms such as boxes or cylinders. They can be made on flat shapes and assembled into three-dimensional forms.

The most interesting part of drawing on a three-dimensional form is composing the whole drawing so it continues around or across all sides of the form.

Find a small but strong box or cylinder on which you can create a drawing. You might paint the whole box white or a light color first to prepare the surface for drawing.

You might prefer to cut shapes of heavy paper or poster board. Create related drawings on each shape and then assemble the shapes into a sculptural form.

Geometry and Drawing

Many artists gain insight into drawing by studying the geometry in complex forms. About 100 years ago, almost all artists learned to draw and shade geometric forms such as spheres, cylinders, cubes and pyramids.

This kind of practice helps you analyze and draw complex forms. It also helps you discover the "hidden" geometry in many natural forms. For example, most tree limbs are curved cylinders. The human eye is a sphere locked in a concave socket, partially covered with two flaps of skin.

Try drawing some of the geometric forms "hidden" in organic forms. Draw a plant, your hand or an action figure. Approach your drawing with the idea of understanding its geometric features.

Many machine-made forms are also geometric. They often have flat planes along with convex or concave forms. Their surfaces are often smooth or evenly textured. They can be beautiful when carefully composed and drawn.

Find some geometric forms to draw. They might be boxes, balls, cylinders or pyramids. Tools, old appliances or parts of machines have geometric forms.

Tom Wesselmann, *Drawing 1964 for Still Life No. 42,* 1964. This drawing includes some three-dimensional objects. These objects have highlights and shadows that interact with the highlights and shadows created with charcoal. Construction, 48 ¹/₈" x 60" x 10" (122 x 152 x 25 cm). Archer M. Huntington Art Gallery, The University of Texas at Austin, Lent by Mari and James Michener.

Alan Dworkowitz, *Bicycle II,* 1978. This finely-shaded drawing includes many geometric, machine-like parts. Do you know how to create gradual changes in shading on machine-like forms? Graphite on paper, 20" x 18" (51 x 46 cm). Louis K. Meisel Gallery, New York.

Interpreting What You See

You have learned that many drawing skills are related to careful observation and the use of the elements and principles of design. In all drawing there is also a process of interpreting what you see.

Interpretation means that you select certain visual elements and media to use when you draw. When these choices are appropriate, your drawing is usually effective.

Try out your interpretive skills by drawing some natural objects, machine-made objects or a scene. Make separate drawings. Select your media and design elements to bring out the main visual differences in the objects. Study the object or scene carefully before you make your decisions.

Plan your composition by using the principles of design. What will you emphasize? Are there rhythms you can set up? Will you use normal, ideal or exaggerated proportions? Why? What other principles of design should you consider to capture a definite mood or feeling?

Social Commentary

Every day you can see a new expressive drawing in your newspaper. These drawings are editorial cartoons. Editorial cartoonists often use humor to help people think about important events. However, many editorial cartoons are not really funny. They are a powerful expression of a point of view.

Artists such as William Hogarth, Honoré Daumier, Käthe Kollwitz and Ben Shahn are among many who have created drawings to express a strong point of view about society, politics, peace and war. Works of this kind are called social commentary art.

Think about a social or political issue that is important to you. It might be an issue in your community or a national problem. It might be an international topic.

Create a drawing that shows your point of view. Think about visual symbols you might include. What design elements and principles will help you express your point of view? What medium will you use? Why?

You might plan your drawing as an editorial cartoon. Keep the drawing simple and clear. Study some editorial cartoons to find out why, when and how lettering may be included.

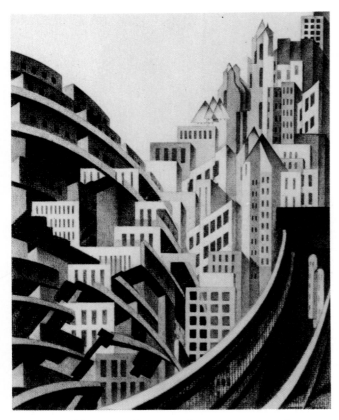

Louis Lozowick, *New York*, ca. 1923. Strong contrasts and simplified shapes have been used in this drawing. The artist has not simply recorded a scene but interpreted it. Carbon pencil, 12 1/2" x 10" (32 x 25 cm). Collection of Whitney Museum of American Art, New York. Purchase with funds from the Richard and Dorothy Rogers Fund.

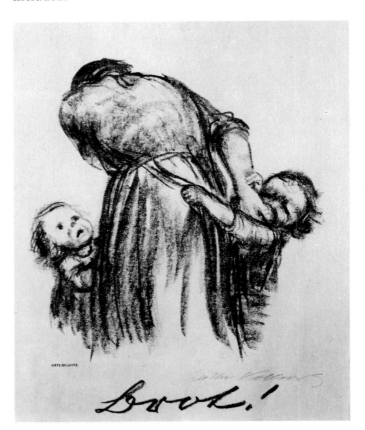

Käthe Kollwitz, *Bread!*, 1924. Hungry children, begging for bread, are portrayed in this powerful drawing. Lithograph. Courtesy Galerie St. Etienne, New York.

Imaginative Drawing

Imaginative drawings can take many forms. In an imaginative drawing, you can combine unrelated ideas. These can be found by thinking of opposites.

For example, you might combine parts of different kinds of animals (bird, fish, insect) into an imaginative creature. Suppose that people were small and insects were large. Imagine a world where soft, smooth surfaces were prickly or jagged.

Dreamlike landscapes and odd combinations like these have interested artists for hundreds of years. In the twentieth century, artists working in styles known as Dada and Surrealism explored these and other ideas for imaginative art.

Use a medium that will help you express an imaginative idea. Your work might be bold and startling or highly detailed. It might have fluid qualities or precise, even lines.

Calligraphic Drawing

Calligraphy means beautiful handwriting. A *calligraphic drawing* is done with a soft brush along with ink or thin watery paint.

The art of calligraphic drawing is highly developed in China, Japan and many other Asian cultures. It is still practiced by many Asian people as a form of self-discipline and meditation and as an art form. Each stroke is mentally planned first. It is often rehearsed several times by making gestures over the paper without touching the surface.

To create a calligraphic drawing, practice first. Dip your brush in ink. Slowly wipe the brush on the edge of the bottle to shape the hairs of the brush into a point.

Rest your little finger on the paper and hold the brush vertically. Now make calligraphic lines. Begin with a thin line and gently press down to make the same line thicker. Practice making a line change from thick to thin in one stroke. Press down on the brush and lift it straight up. What shape do you see? Try other combinations of brushstrokes.

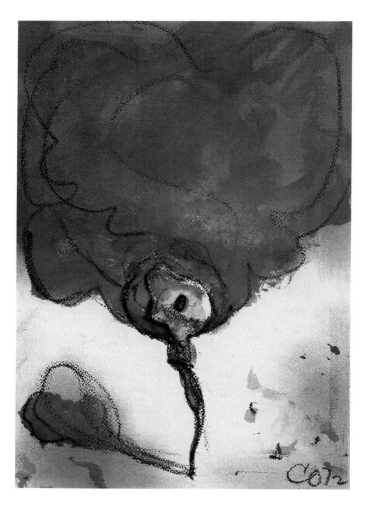

Claes Oldenburg, *Typewriter Eraser as Tornado*, 1972. Imaginative drawings can be serious or humorous. Watercolor and crayon, 20" x 14" (51 x 36 cm). Collection of the Modern Art Museum of Fort Worth. Museum Purchase, The Benjamin J. Tillar Memorial Trust.

Musashi Miyamoto, *Bird and Branch*, late 16th – early 17th century. Calligraphic drawing is based on intense concentration before you begin, then quick sure strokes with a brush or pen. Ink on paper. Philadelphia Museum of Art. Fiske Kimball Fund.

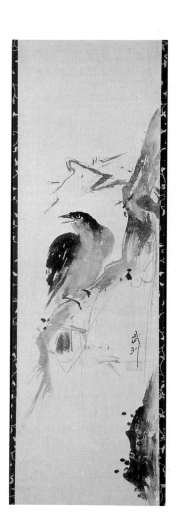

149

GEOCAD is a registered trademark of Rudolph Horowitz and Associates, Architects.

Student art.

Computer Drawing

Computers are used as drawing tools by many architects, graphic designers and illustrators. Most drawing software programs have a tool palette which is a set of illustrated codes, called *icons*. Each icon shows a drawing task the computer can help you accomplish when you activate an external control.

There are different types of external controls (a mouse, a joy-stick, a pen-like rod and pad). The movement you make with the external control can be seen on the computer screen. For example, you might select the icon or tool for drawing straight lines. You can then draw straight lines by pressing an external control and moving a pointer in the direction you wish.

Computer drawings can be made by choosing and activating different icons. You might combine straight and curved lines of varying widths. Basic geometric forms – circles, squares, ellipses – can be drawn in any size and overlapped. Some tools allow you to simulate values, textures and regular patterns. Some programs can make symmetrical designs and distort shapes.

Many drawing programs include rulers and grids so that you can make architectural plans with measurements. Advanced programs assist you in creating the illusion of form and space.

Critical Thinking If you could design a set of computer drawing tools, what tools would you want included? For example, would you want a simple way to "erase" lines? A way to create fuzzy lines?

Student art.

Student art.

Student art.

Student art.

Student art.

Student art.

Student art.

Student art.

Summary

Drawing is a way to record what you see and try out ideas for other artwork. It is a way to develop skills in seeing and using the elements and principles of design. Drawings can also be finished artworks. The various media for drawing – dry, wet, mixed – all have special possibilities for expressive use. Drawings can be linear, painterly or assembled (as in collage).

Contour, gesture and whole-to-part planning are three traditional methods of learning to draw. Others include studies in line, shape, value, texture and pattern, proportion and perspective. These studies and skills are a foundation for many varieties of creative and expressive drawing. They are also a foundation for creative work in many other forms of visual art.

Using What You Learned

Aesthetics and Criticism

1 Select one of your best drawings. Explain why you think it is one of your best by (a) giving criteria for your judgment and (b) pointing out qualities of the drawing that meet the criteria.

2 Identify in this chapter, two drawings created in the same medium. Use your art vocabulary to describe the main differences in how the artists used their media.

3 Look again at the Gallery section. Identify the drawing you most admire. Explain the qualities you admire in these areas: (A) the subject or theme, (B) the sensory qualities, (C) the technical qualities, (D) the formal (design) qualities, (E) the expressive (mood) qualities

Art History

1 Briefly describe three reasons why Hokusai is widely regarded as a great artist.

2 Which three drawings reproduced in this chapter are the oldest? Which three drawings have the most recent dates? What are some of the main differences you can see in the two sets of drawings? How might an art historian explain these differences?

Creating Art

1 Select one of your best sketches. Enlarge it on another paper and develop it into a finished drawing. Complete it in your own individual style. Use a medium of your choice. Demonstrate at least three of your best artistic skills in completing it.

2 Identify two careers in which drawing skills could be helpful. Create a sketch or drawing of a kind that might be useful in that career. (Example: For the career of an auto designer, you might sketch a whole car or details).

Vincent Van Gogh, *The Yellow Chair*. Van Gogh's painting glows with color and the textures of brushstrokes. It is clearly a painting of a chair, not a drawing or a photograph. The National Gallery, London.

Chapter 8
Painting

Chapter Vocabulary

fresco mural
easel painting
soft-edge
hard-edge
linear style
painterly style
chiaroscuro
analogous
Pointillism
trompe l'oeil
atmospheric perspective
monochromatic
complementary
split complementary
opaque
transparent

What color is a chair? A floor? A wall? Vincent Van Gogh's painting almost shouts the answer. In a painting, the color of anything is up to the artist. Do you know why?

Painting is about the creative, inventive use of color. Even when an artist tries to make his or her paintings very realistic, the whole process of mixing colors is an adventure. And that's just the beginning. In painting, you can also be inventive in applying paint, composing your work and expressing your ideas, feelings or fantasies.

The versatility of painting may explain why it has been a major art form throughout history. Unknown artists created remarkably realistic paintings in caves over 20,000 years ago. Ancient Egyptian paintings in tombs are abstract but detailed records of life over 2,000 years ago. The homes of ancient Romans were decorated with *fresco murals* – large paintings in fresh plaster.

During the Renaissance, artists developed more interest in realistic detail. Oil paints and canvas stretched on frames made easel paintings possible. *Easel paintings* are portable and can be displayed in a variety of places.

Since the Renaissance, artists have explored many themes. They have created paintings about political events, still lifes and everyday scenes in the city and country. They have painted subjects such as adventures in foreign lands, animals and powerful forces in nature. The Impressionists captured the subtle qualities of outdoor light and color.

Since the Post-Impressionist period, many artists have thought about paintings as objects with colorful, lively surfaces rather than scenes. You can see this idea in Van Gogh's painting. The subject matter is simple – a chair in a room. But the painting is filled with color and textured brushstrokes.

In the twentieth century, artists have experimented with new ways to paint and new sources of inspiration for painting. Today, painting is more varied and personal than it has ever been.

In this chapter, you will learn more about the art of painting. After you study this chapter and try some of the activities, you will be better able to:

Creating Art
- create original paintings using a variety of ideas and approaches.
- use painting media, tools, and techniques expressively.
- effectively design your paintings.

Aesthetics and Art Criticism
- use art terms to describe, analyze, interpret and judge your own and others' paintings.

Art History
- discuss some of the major subjects, purposes and styles in the history of painting.

Art Criticism
- apply your skills in art criticism to evaluate your own and others' paintings.

155

Gallery

Since the Renaissance, artists have interpreted subjects in their own way. This is true even when artists choose similar subjects for painting, such as cityscapes or people. Study the paintings in this gallery. How have the artists captured definite moods and feelings?

Artists also develop their own methods of painting. Some plan their paintings by making drawings and then slowly building up the painting. Others work directly with paint and develop a plan while they are working.

When you create paintings, try to interpret your subject in a personal way. Explore different subjects and methods of painting. These steps will help you discover your own style of painting. Activities later in this chapter will help you explore various methods and themes for painting.

Critical Thinking In which of the eight paintings is the subject idealized? Why do you think so? Which paintings are not beautiful but express a definite idea and mood? Which paintings do you find most intriguing? Why?

Abraham Walkowitz, *Cityscape Abstraction.* Watercolor, charcoal and pencil, 31" x 22" (77 x 56 cm). Museum of Art and Archaeology, University of Missouri-Colombia. Gift of the artist.

Richard Estes, *Drugstore*, 1970. Oil on canvas, 60" x 44" (152 x 113 cm). The Art Institute of Chicago. Edgar Kaufmann Restricted Fund, 1970.

John Marin, *Lower Manhattan*, 1920. Watercolor and charcoal on paper, 21 ⁷/₈" x 26 ³/₄" (56 x 68 cm). Collection, The Museum of Modern Art, New York. The Philip L. Goodwin Collection.

Jacob Lawrence, *Tombstones*, 1942. Gouache on paper, 28 ³/₄" x 20 ¹/₂" (73 x 52 cm). Collection of Whitney Museum of American Art. Purchase.

Jan Vermeer, *The Little Street in Delft*, ca. 1700. Oil on canvas. Rijksmuseum, Amsterdam.

Henri Matisse, *Purple Robe and Anemones*, 1937. Oil on canvas, 28 ³/₄" x 23 ³/₄" (73 x 60 cm). The Baltimore Museum of Art. The Cone Collection.

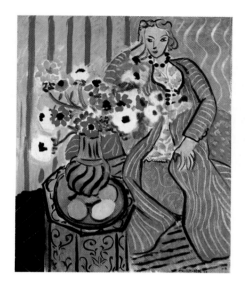

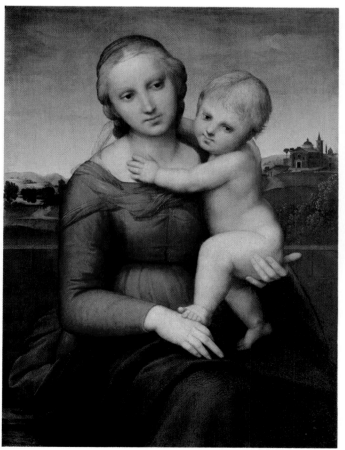

John Nieto, *Turquoise Fancy Dancer*. Acrylic on canvas, 60" x 72" (152 x 183 cm). Courtesy of J. Cacciola Galleries.

Raphael, *The Small Cowper Madonna*, ca. 1505. Tempera on wood, 23 ³/₈" x 17 ³/₈" (59 x 44 cm). Courtesy of The National Gallery of Art, Washington, DC. Widener Collection, 1942.

Claude Monet
1840–1926

It is dawn. Claude Monet is already at work. He is in a field getting set up for his first painting of the day. His large box holds several canvases and the latest equipment – oil paints in tubes and a lightweight easel.

On an early morning in 1891, at the age of 51, he knows that his subject matter is not the field; it is not even the haystacks. His subject is light – the shimmering light and color of the moment. He works quickly to capture his impression of the sun-dappled field.

At sunset, he paints his last painting of the day. Gone is the contrast in light and shadow. Colors are muted but still glowing. He paints until the light fades completely and it is dark.

Monet created other series of paintings in the same way – paintings of poplar trees by riverbanks and light on the front of a cathedral. In his later years, though nearly blind, he painted large glowing murals of his beloved garden and lily ponds.

As a child, Monet loved to draw caricatures. When he was a teenager, an artist in his hometown of Le Havre, France introduced him to the new idea of painting outdoors.

At the age of 19, he went to Paris to study art. With some classmates and friends, including Pierre Renoir, Monet developed a style of painting that a critic of the time called "Impressionism." Later, many artists would praise Monet as one of the founders of a modern way of painting.

Paul Cézanne, an artist of the same time, said, " Monet is no more than an eye – but, what an eye!"

Critical Thinking Why is it correct to say that Monet's true subject matter is light and color rather than haystacks, cathedrals or gardens? Think about the skills and interests of an artist who draws caricatures. Think about the skills and interests of Impressionist painters. How are the two forms of expression alike? How are they different?

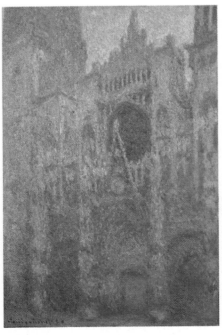

Claude Monet, *Rouen Cathedral, West Facade,* 1894. Canvas, 39 ¹/₂" x 26" (100 x 66 cm). Courtesy of the National Gallery of Art, Washington, DC. Chester Dale Collection.

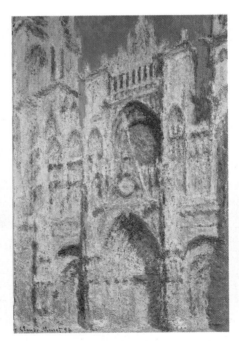

Claude Monet, *Rouen Cathedral,* 1894. Oil on canvas, 39 ¹/₄" x 25 ⁷/₈ (100 x 66 cm). The Metropolitan Museum of Art. Bequest of Theodore M. Davis, 1915. Theodore M. Davis Collection.

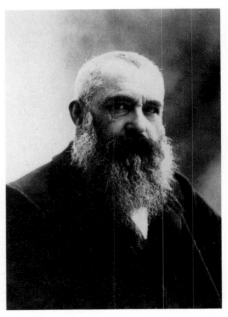

Félix Nadar, *Claude Monet,* 1899. Photograph. Caisse Nationale des Monuments Historiques et des Sites.

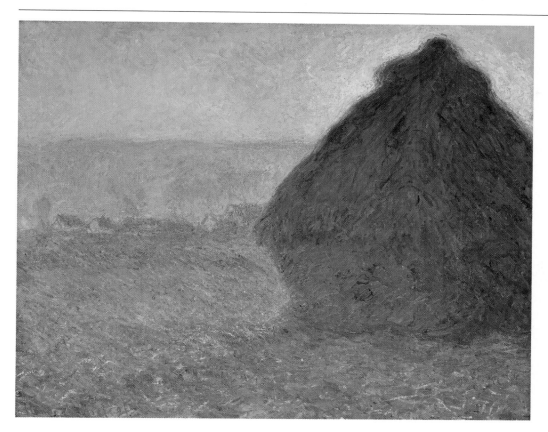

Claude Monet, *Grainstack Sunset*, 1890-1891. Oil on canvas, 28 7/8" x 36 1/2" (73 x 93 cm). Museum of Fine Arts, Boston. Julia Cheney Edwards Collection.

Claude Monet, *Haystacks, End of Day, Autumn*, 1891. Monet was especially interested in the changing quality of light at different times of day. The paintings of Rouen Cathedral reflect the same interest. Oil on canvas, 26" x 40" (66 x 101 cm). The Art Institute of Chicago, Mr. and Mrs. Lewis Larned Coburn Memorial Collection, 1933.

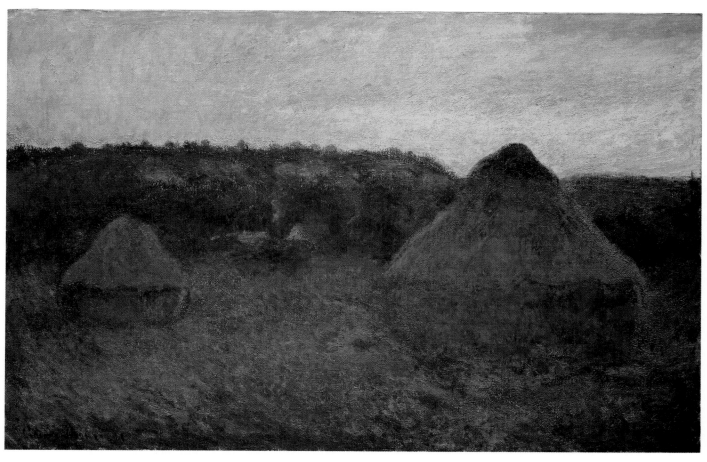

The Visual Elements of Painting

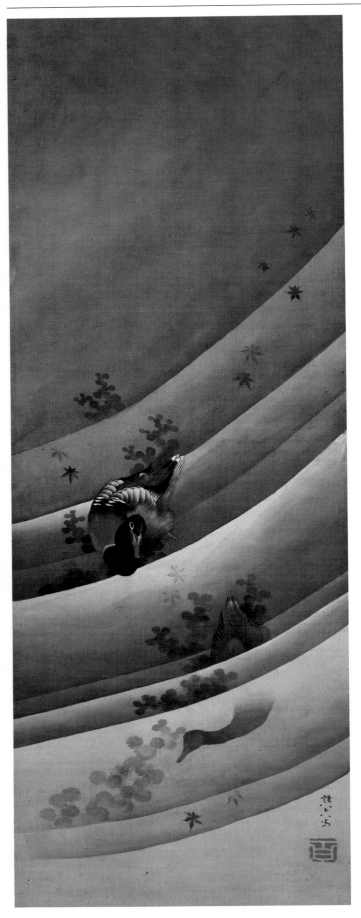

Do you recall the visual elements of art? They apply to all kinds of art, but each art form uses them in special ways. Here are a few things to remember as you create paintings and look at them.

Lines in paintings can be the outlines or just edges where two colors meet. The painted lines or edges can be sharp and clear or soft and blurred. Critics refer to this difference as soft-edge or hard-edge painting. Some paintings are dominated by outlines and linear detail. Others are dominated by color and free brushstrokes. Art historians speak of these differences as a *linear* style versus a *painterly* style.

Color and *value* can vary in many ways. Paintings may have few or many different hues. Colors can range from light to very dark in value. A painting with dramatic lighting and shadows can differ in mood from one with closely related values. *Chiaroscuro* (say ki-ar-roh-SKUH-roh) is an Italian term for the dramatic use of light and dark.

Colors can be used to create a flat, abstract design or to capture shimmering qualities of light and space. When *analogous* colors (next to each other on the color wheel) are placed close together, a painting "glows" with color. If you put small dots of pure colors next to each other, the eye will tend to see them as mixed. This technique, called *Pointillism*, was developed by the French painter Georges Seurat.

Textures in paintings can be uniform or varied, smooth or rough. Acrylic and oil paints can be built up in thick layers to create actual textures. Paintings with very realistic details and textures are called *trompe l'oeil* (say tromp LOY), French for "fool the eye."

Space in paintings, as well as *shapes* and *forms* can be flat and abstract or give the illusion of a three-dimensional world. Highlights, shadows and overlapping shapes also help to suggest distance.

To create the illusion of space and distance, artists master the use of color for *atmospheric perspective.* Atmospheric perspective shows the idea of a hazy distance. Background areas are painted with light, cool hues and only a little detail. Colors in the middleground and foreground are brighter, warmer and darker. More detail is added to the foreground than the middleground. What other techniques can you use to create the illusion of depth?

Katsushika Hokusai, *Ducks in Stream.* The sweeping curves are placed at intervals that lead your eye upward through the stream in which the ducks are swimming. British Museum, London.

Ways to Design Paintings

Think about the *principles of design* when you organize your paintings. For example, you might want to create the illusion of reality. To do that, you will think about proportions, patterns and movement in a naturalistic way. On the other hand, you might want your painting to express a definite, intense feeling, or some unusual, imaginative idea based on fantasy.

When you decide on a general approach to your painting, you can make choices of the principles of design. You can ask, for example, whether the *balance* should be asymmetrical or symmetrical for your idea. You can decide whether to use exaggerated, normal or ideal *proportions*. Your idea can also help you make decisions about *movement, pattern,* and *emphasis* in your painting. Think about the principles you might use and how they can make your painting even better.

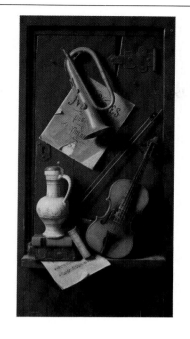

William Harnett, *Old Models*, 1892. How is this composition unified? What similarities can you find in this composition and the overall design of Jacob Lawrence's painting? What kind of balance do you see in both paintings? Oil on canvas, 54" x 28" (137 x 71 cm). The Museum of Fine Arts, Boston. Charles Henry Hayden Fund.

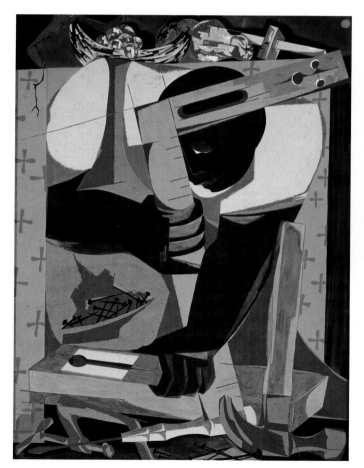

Jacob Lawrence, *Cabinet Maker*, 1957. Casein on paper, 30" x 22" (77 x 57 cm). Hirshhorn Museum and Sculpture Garden, Smithsonian Institution, Gift of Joseph H. Hirshhorn.

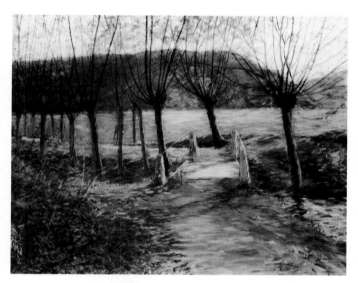

Lila Cabot Perry, *Bridge-Willows–Early Spring*, 1905. Pastels are often considered a medium for drawing. They become a "painterly" medium when color is dominant and unifies the work. Pastel, 25 ¼" x 31 ¼" (64 x 79 cm). Private collection. Courtesy Hirschl & Adler Galleries, New York.

Studies in Color

Most young artists learn to mix colors by doing experimental paintings. Your experimental painting can be in any style with any subject. Because the main idea is to learn about color, you might choose a simple subject and do several variations on it.

Try a *monochromatic* painting – one dominated by many values of one hue. You might select a primary, secondary or neutral color.

Try a painting with analogous colors. Mix different values of each color you choose. Try creating one painting dominated with warm hues and one dominated by cool hues. Compare the expressive qualities.

Begin a painting with colors of high *saturation* – bright, intense, unmixed colors. Gradually complete it by mixing colors of low saturation – colors made dull by mixing them with their complements (for example, green with a small amount of red).

Try a *Pointillist* experiment, placing small dots of primary colors side by side. Turn it into an *Op Art* experiment by using *complementary* colors side by side.

Use a *split-complementary* color scheme with three colors. Choose one color. Find the complement on the color wheel. Use the two colors on each side of the complement together with the first color you chose.

What other color experiments can you set up? Do your experiments give you ideas for other paintings? Do you want to keep or display some of your color experiments? Why? Why not?

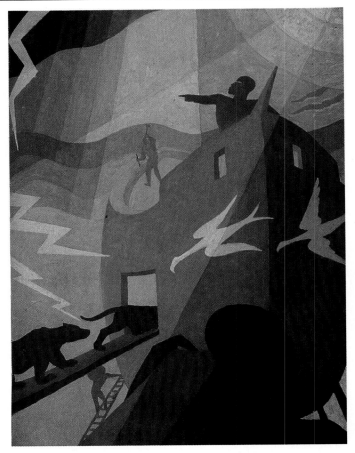

Aaron Douglas, *Noah's Ark*, ca. 1927. What color scheme unifies this work? What feeling and ideas seem to go with the dominant hue. Why? Oil on masonite, 48" x 36" (122 x 91 cm). Fisk University Art Museum, Nashville.

Mixing Secondary and Intermediate Hues.

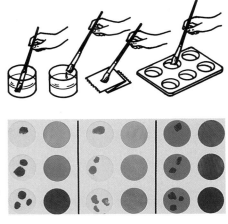

For practice, paint several circles of a primary color. Add a different number of dots of another primary color. Mix the paint in each circle. Wash, wipe, and blot the brush when you change colors.

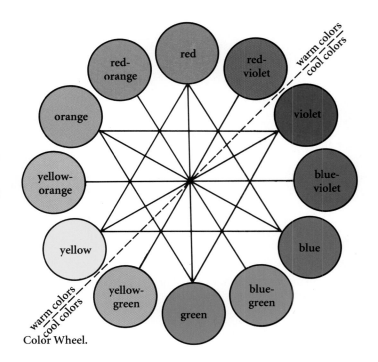

Color Wheel.

What colors do you see when small dots or strokes of colors are placed side by side? Student art.

A color study. Student Art.

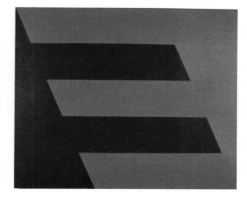

Carmen Herrera, *Green and Orange*, 1958. Which color seems to be advancing toward you in this work? Do the shapes also seem to be moving? Why? Acrylic on canvas, 60" x 70" (152 x 178 cm). Courtesy Rastovski Gallery, New York. Photograph by Tony Velez.

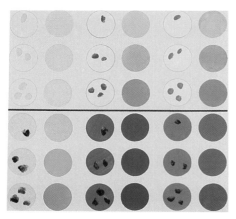

Mixing Values.

To mix a *tint*, begin with white. Add dots of a hue and mix the paint. Why is it usually best to begin with white?

To mix a *shade*, begin with a hue. Add dots of black and mix the paint. What happens if you begin with black instead of a hue?

Brushes.

Stiff bristle brush for thick paint.

Soft hair-type brush for fluid paints, washes, and details.

Stiff bristle brush for stencil work.

Improvised sponge brush.

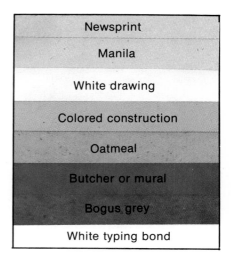

| Newsprint |
| Manila |
| White drawing |
| Colored construction |
| Oatmeal |
| Butcher or mural |
| Bogus grey |
| White typing bond |

Papers. Try a variety of papers for painting. You can also paint on other materials such as cotton cloth or canvas, gesso-covered masonite, thick cardboard, and many three-dimensional surfaces.

Media and Techniques

Types and Qualities of Paint

Most painting media are made from powdered *pigments*, coloring materials made from earth, crushed minerals, plants or chemicals. The bright colors you see in paintings after the 1800's came from new research on pigments and ways to manufacture paint. Pigments are bound together by a vehicle or *binder,* such as glue, egg, wax, oil, casein or resin. Chalk, oil and wax pastels are dry painting media. Paint is applied to a surface or *support.* Paper, canvas, wood and plaster are examples of supports.

Each painting medium has special qualities and limitations. Look at the samples of painting media and read the captions underneath them. Notice how differences in painting media are described by using terms such as matt or shiny, transparent or opaque, fluid and thin, or dense and thick. Some paints, such as acrylics, can be used in many ways. Others, such as watercolors, should be used in a particular way.

A variety of brushes are used for painting. Stiff, bristle brushes are often used for oil, acrylic and tempera. Soft, hair brushes are used for watercolor and ink. They can also be used for diluted oil, acrylic, and tempera. Brushes differ in size, shape (pointed or chisel) and quality. Palette knives can be used to apply thick paints.

Contemporary artists use unusual materials in addition to traditional painting media. Some have used house paints or combined thick paints with gritty materials such as sand and sawdust. To apply paint, some artists have used rollers, sponges, their hands, strips of cardboard or sticks. Some pour or drip paint onto a surface or squeeze it directly from the tube.

Mark Tobey, *Five A.M.,* 1953. The direction of brushstrokes can be an important part of a painting. Tempera on mat board, 39 ¹/₂" x 29 ¹/₂" (100 x 75 cm). The Baltimore Museum of Art. Edward Joseph Gallagher II Memorial Collection.

Tempera paint. Dilute with water as desired. Has a dull, chalky appearance when dry. Available in several forms: powder (mix with water), compressed cakes (dry or semi-moist) and liquid. Often called poster paint or gouache.

Acrylic paint. Available in jars or tubes. Has a thick consistency similar to oil paint and a slight sheen when dry. Dilute with water to create glazes—semi-transparent layers of colors (allow each coat to dry). Wash brushes before paint dries.

Watercolor. Colors in pans or tubes are diluted by using a water-filled brush. Apply light colors first. For white, let the white paper show. Try for a clear transparent quality in the whole painting.

In school, you will probably use water-based paints such as tempera, acrylic or watercolor. Tempera paints are thick and *opaque*. They are sometimes called poster paints. Wet tempera paint tends to mix with any dry paint underneath. Artists often use related water-based paints called gouache (say gwash), casein or designer colors.

Acrylic paints are similar to oil paints, but can be applied in thick layers or diluted with water to create transparent glazes. Wet acrylic paint will not mix with dry paint underneath. Acrylics usually have a slight sheen when they are dry.

Watercolors are *transparent*. They are diluted with lots of water and applied in a light-to-dark sequence. Leave the paper unpainted for white. Begin with light washes of color and gradually add darker values. You also begin with the largest background areas first, then gradually add details.

If you have not used watercolors before, try some experiments first. Begin with a watercolor *wash*. Lightly dampen the paper with your brush or a small sponge, then put a lot of water in your brush and just a little paint. Brush it on the paper quickly. Add more water and a small amount of a second, related color. Let the colors blend and fuse.

Paul Cézanne, *The Bridge of Trois-Sautets*, 1906. The transparent quality of watercolor is seen in this painting by Cézanne. Watercolor and pencil, 16" x 21" (41 x 54 cm). Cincinnati Art Museum. Gift of John J. Emery.

Watercolor tips

Press down for a wide line.

Use the tip for a thin line.

Make small shapes with one stroke.

Paint on dry paper.

Paint on wet paper.

Wash and ink. Dampen the entire paper with water. Brush well-diluted paint on the paper. Allow colors to blend. Blot the "pools" of paint and study the colors and shapes for an idea. Begin outlining some of the shapes with pen and ink. Add final details when the paint is dry.

Waterbased felt markers. Apply to damp or dry paper. Use a wet brush on top of lines, shapes, or textures to create effects similar to watercolor.

Chalk or pastels. A painting medium when colors are blended. Experiment. Blend with a tissue. Erase areas. Apply chalk to damp paper or paper covered with diluted liquid starch.
Safety Note *Do not use chalk if you have a dust allergy.*

Mixed Media and Processes

Many artists have explored techniques that combine drawing, painting and other media. The idea of painting is often extended to include collage, montage, mosaics and paintings with sculptural forms.

A *collage* is made by gluing down paper, fabrics or found objects. Sometimes paintings include montage elements. A *montage* is created by combining photo-graphs from magazines, newspapers and the like. Collage and montage materials are selected for many reasons. They may have comical, literary or political meaning. They may have appealing colors or textures. Parts are often combined, overlapped and painted.

You can create rich textural effects by using the tempera resist or crayon resist techniques shown here. Experiment with different brushstrokes to create textures, too.

Henry Moore, *Pink and Green Sleepers*, 1941. During WWII, people in England often had to spend long hours in bomb shelters. Moore created this and many studies of them using a crayon resist technique. The Tate Gallery, London. Photograph by John Webb.

What media can be used for bold lines and shapes? Student art.

Chalk or oil pastel with tempera. Create a tempera painting. Allow it to dry. Add details and additional colors with chalk or oil pastels.
Safety Note *Do not use chalk if you have a dust allergy.*

Oil- or wax-based pastels. Colors are easily mixed and blended without dust. You can build up textures and scratch into the surface with a pointed tool.

Tempera resist. Create a painting with thick tempera. Leave some of the paper unpainted. Allow the paint to dry. Apply waterproof ink to the entire surface. Allow the ink to dry. Wash the painting under running water, gently rubbing it with a soft brush.

Mosaic-like work can be created by painting small patches of light colors on top of a black or very dark background paper. Leave spaces between the patchwork so the color of the background shows. Real mosaics are made of small bits of colored glass, tiles or the like, called *tesserae*. The tesserae are glued down or placed in fresh cement or paster.

Paintings can also include three-dimensional objects. If they are created on three-dimensional objects, such as boxes, cylinders, or found objects, they are usually called combines or assemblages (an extension of collage). Paint is often used to unify the work.

Critical Thinking Experiments with painting are a major trend in twentieth-century art. This trend led one art critic to say that painters were setting up a new tradition in the twentieth century – "the tradition of the new." What do you think the critic meant?

Collage. Made from a wide range of papers often combined with paint or other media.

Montage. A collage created with photographic images.

Mosaic. Made by placing small bits of material (stones, glass, wood) next to each other.

A black paper background unifies this tempera painting. It also imparts a sparkling quality to the flat tints and shades.

Tissue collage. Cut or tear colored tissue paper for a collage. Brush diluted white glue on the entire paper and on each shape as it is glued down. Overlap shapes and allow colors to blend. Student art.

Crayon or oil pastel and etching. Color the paper with a thick layer of crayon or oil pastels. Use light colors. Apply a second layer of dark tempera paint mixed with a drop or two of liquid soap. Allow the paint to dry. Draw into the black layer with a nail or similar tool.

Crayon resist. Apply wax crayons or oil pastels with firm pressure, then cover the entire paper with diluted tempera or ink. Use a wide brush. The wax will "resist" paint and ink.

Other Ideas to Explore

Paintings of Still Lifes

Still lifes are artworks that show inanimate (non-living) objects. Seventeenth-century Dutch painters mastered this type of painting. In Dutch still lifes, objects were often visual symbols for ideas. A book might be a symbol for wisdom. A burning candle might be a symbol for life.

Cézanne and many twentieth-century artists chose still lifes as a subject for abstract art. Some twentieth-century painters have included real things or collage elements in still lifes.

Choose some objects for a still life arrangement. Shoes, coats, books and chairs are handy. Consider other things such as musical instruments or parts of old machines. Think about the general style of your painting.

Will you try for a very realistic painting? Will you try to abstract and simplify forms? Will you make an imaginative painting based on the still life arrangement, but with unexpected changes or collage elements?

Make a sketch of the still life that works well with the style of painting you have chosen. Now think critically before you begin: What general color scheme will you use? You might consider a monochromatic, analogous, or other scheme. Will you try for gradual changes in values or do you want strong contrasts? Would bold outlines work? What areas should you paint first? Why? Will you use one medium or a mixture of media?

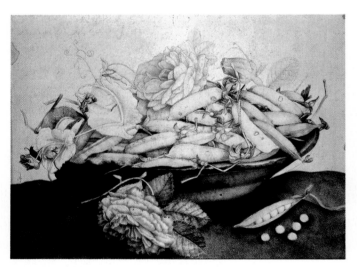

Giovanni Garzoni, *Dish of Broad Beans*. Tempera on parchment, 9 ³/₄" x 13 ¹/₂" (24.8 x 14.3 cm). Palazzo Pitti, Florence.

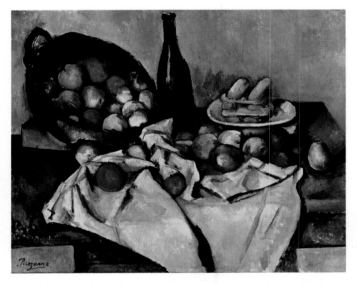

Paul Cézanne, *The Basket of Apples*, ca. 1895. Composing a still life is just as important as creating a painting based on it. How does the design of this still life painting differ from the Garzoni painting? Oil on canvas, 26" x 32" (65 x 81 cm). The Art Institute of Chicago. Helen Birch Bartlett Memorial collection, 1926.

Student artwork.

Your Environment

Do you live in the city, a small town, a suburb, or in the country? Environments like these can be a wonderful source of ideas for paintings. In the 1800's, American and English artists created majestic landscape paintings. Some specialized in cityscapes and seascapes. Since 1900, artists have continued to interpret the natural and human-made environment in a variety of styles and media.

You might try a realistic painting of a place you know very well. Make sketches, then paint the largest background areas using light, slightly dulled colors (add a small amount of a color's complement). As you work toward the foreground, brighten your colors and add more details.

How many different ways could you paint the city at night? Would you focus on the diamond-like brilliance of the city lights? Do you think of the city as a lovely place or somewhere scary with dark towers and cavern-like alleys? Does the word "city" suggest a special kind of action or mood?

You might paint on colored paper. Consider an action-filled painting of a tornado, earthquake, tidal wave, erupting volcano or explosion. Use colors and brushstrokes to suggest the energy and movement of the event.

You might try a Japanese technique of landscape painting. Here are the steps to follow: Use ink, watercolor or tempera with a soft brush. Practice some brushstrokes. Then close your eyes and try to picture exactly how you will create the painting using the "back-to-front" method. Open your eyes and quietly begin your painting. Keep your colors light and plan each brushstroke.

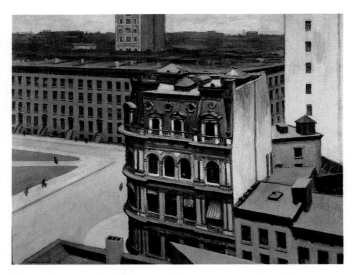

Edward Hopper, *The City*, 1927. Oil on canvas, 27 ¹/₂" x 37" (70 x 90 cm). University of Arizona Museum of Art. Gift of C. Leonard Pfeiffer.

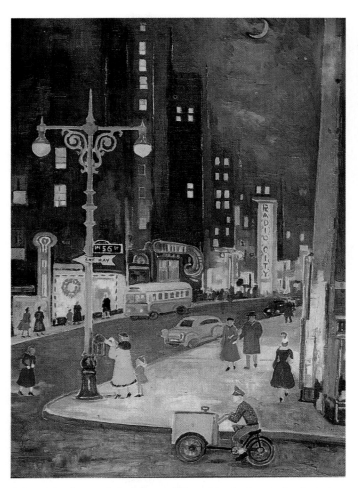

Palmer Hayden, *56th Street*, 1953. Palmer Hayden's painting includes important details and captures the quality of nighttime in the city. Watercolor on paper, 23" x 17 ¹/₄" (58 x 44 cm). Collection Evelyn N. Boulware, New York.

Interiors

Paintings of interiors first became popular in Holland during the 1600's. Since that time, many artists have used room interiors as a subject.

Think about the rooms in which you spend a lot of time. Have you ever really looked at the location of furnishings? Have you studied the changing colors of floors, walls, and ceiling at different times of day? What are the sources of light in a room? Are there definite moods or feelings that change from daylight to dusk, with natural or artificial light?

Choose a room and a mood you can recall or sketch. Then create an original painting of it. Try to capture a definite mood or feeling. If you have trouble thinking of an idea, talk to your classmates. Develop a "starter" list of types of interiors and ways of interpreting the mood of an interior.

Use your skills in art criticism to describe, analyze, and interpret the John and Van Gogh paintings. Compare the mood of both paintings. Note the differences in color, textures, brushstrokes and amount of detail.

In what ways are these paintings realistic? Where do you see evidence of the artists' inventive use of composition, lighting, color and detail? Interpret each painting in several sentences. Discuss your conclusions in class.

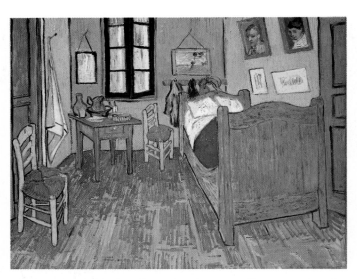

Vincent Van Gogh, *His Bedroom in Arles*, 1889. Oil on canvas. Musée D'Orsay, Paris.

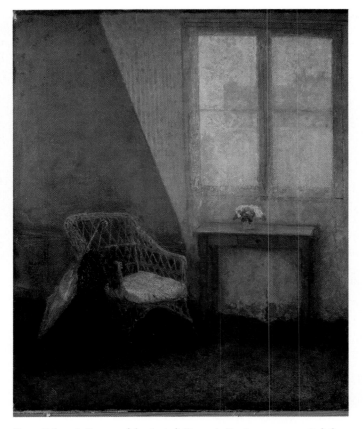

Gwen John, *A Corner of the Artist's Room in Paris*, 1907-1909. Subtle colors and values create a definite feeling in this work. How would you describe the feeling? Do you get the same feeling when you look at Van Gogh's painting of his bedroom? Why? Why not? Oil on canvas, 12 ³/₄" x 10 ³/₄" (32 x 27 cm). Sheffield City Art Galleries, Sheffield, England.

Action

A painting can seem as action-packed as any motion picture, television program or real-life adventure. How do artists capture a feeling of movement? They can use many techniques. Several are suggested in the two paintings shown here and in the diagram below.

Create an action-filled painting. You might plan it around an action word like the ones listed below. Do not tell anyone the word you have chosen. After your painting is finished, see of your classmates will agree on the kind of action you have captured. Here is a starter list of action words: exploding, splashing, breaking, falling, rippling, leaping, floating, and rising.

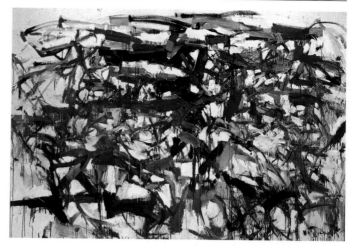

Joan Mitchell, *Ladybug*, 1957. Oil on canvas, 6' 5 ⁷/₈" x 9" (198 x 23 cm). Collection, The Museum of Modern Art, New York. Purchase.

Miriam Schapiro, *I'm Dancing As Fast As I Can.* Acrylic and fabric on canvas, 90" x 144" (229 x 366 cm). Courtesy Bernice Steinbaum Gallery, New York.

Suggesting Movement

1. Use diagonal lines and curves.

2. Place elements so they seem a) near or far, b) off-balanced or c) scattered randomly.

3. Set up a definite path of movement from one area to another.

4. Show the path of movement at one or several different time intervals or gradually change other elements.

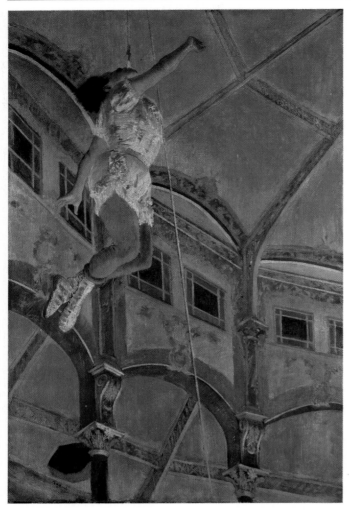

Edgar Degas, *La La at the Circus*, 1879. Paintings of people in action are almost always exciting. They can be very detailed or more quickly recorded, as you can see in *Kung Fu* by Zucker. Oil on canvas. National Gallery, London.

Paintings of People

People are always a good subject for paintings. Some artists paint portraits that show a specific person. Many artists create paintings of themselves – *self-portraits.* The challenge in this kind of painting is to capture the character or personality of the individual. The painting might show the face and shoulders or the full figure. Often a background environment suggests the interests of the person.

Artists also create paintings of people in action – at work or play, alone or with others. Crowds of people – the circus, downtown, battles, sports events – are among the many subjects artists have painted. You might try several ways to create paintings of people.

Create a painting of a classmate posing with a prop or costume in an action pose. Use one color of paint and a bristle brush. Emphasize the general shape. Then create another painting using the same materials, but painting only the negative space around the person.

Try an abstract painting of a crowd. Mix several colors to suggest flesh. Quickly paint shapes to suggest faces and necks. Vary the sizes. Then add hair, clothing and other details. Overlap the figures so they look like some are behind others.

Try mixed media. Use wax crayons or oil pastels to begin a portrait or self-portrait. Mix lighter colors for highlights (forehead, nose and cheek). Use darker colors to suggest shadowed areas. Complete it with watercolor, tempera or acrylics. Also try mixed media techniques to create realistic, abstract or funny paintings of people.

Joe Zucker, *Kung Fu (Tiger vs. Crane)*, 1984. Acrylic and aluminum foil on canvas, 2 panels, 96" x 96" (244 x 244 cm). Courtesy of Holly Solomon Gallery, New York.

Rufino Tamayo, *Self-portrait*, 1927. Gouache, 252 x 177 mm. The Cleveland Museum of Art. Gift of Malcolm L. McBride.

Paula Modersohn-Becker, *Self-portrait*, 1907. Folkwang Museum, Essen.

Imagination and Fantasy

Have you ever had a strange dream or imagined what the future might be like? Have you ever looked at cracks in a sidewalk or forms of clouds and seen them as faces or animals? Everyone has imagination.

Some artists create highly imaginative, fantastic paintings. Sometimes the paintings have illogical elements. Sometimes they may contain familiar things but with strange proportions, colors or patterns. Look at the paintings here and other imaginative artwork in this book. Then create an imaginative painting of your own. You could try the following techniques to help you find ideas.

Look for magazine photographs of unrelated things such as an automobile, a chair and a building. Cut them out and paste them down. Then unify them into a scene by adding painted elements. Dada and Surrealist artists used similar techniques early in the twentieth century. These artists were interested in random choices and dreams as sources of ideas for art.

Dampen two sheets of paper and place several thick colors of paint on each one. Place the painted surfaces face to face and rub them. This will spread and mix the paint in unusual ways. Pull the two sheets apart and study them from different directions. This Surrealist technique, called *decalcomania*, was developed by Oscar Dominques and Max Ernst.

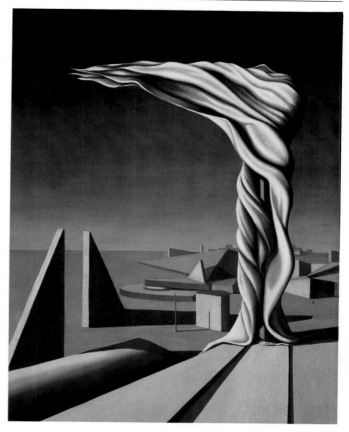

Kay Sage, *I Saw Three Cities*, 1944. Oil on canvas, 36" x 28" (91 x 71 cm). The Art Museum, Princeton University. Gift of the Estate of Kay Sage Tanguy.

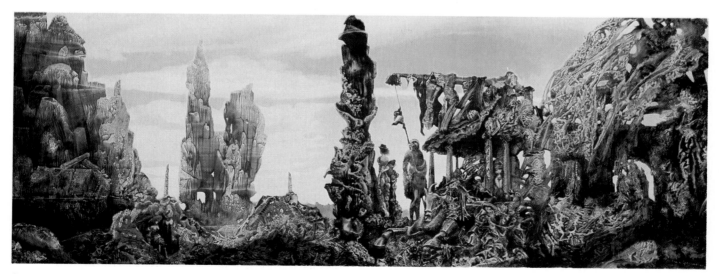

Max Ernst, *Europe After the Rain*, 1940-1942. Oil on canvas, 21 9/16" x 58 3/16" (55 x 148 cm). Wadsworth Atheneum, Hartford. The Ella Gallup Sumner and Mary Catlin Sumner Collection.

Painting and Technology

Have you created original artwork on a computer using a software "painting" program? If not, find out if a demonstration of such a program can be planned for the class. If you have created computer images using a software "painting" program, do you consider them true paintings or not? Why?

Creative and Critical Thinking Today, experts in art are still uncertain about whether computer-generated "paintings" should be a new category of art or just a subdivision of painting. Some say the computer is just a new kind of tool for artists. Other say the images are totally different and will become a new art form. Some of these same questions were asked about photography when it was invented in the early 1800's. Today, photography is considered a separate art form.

Study the examples of computer-generated images shown here. Do you think the term "painting" is correct for some of these computer images but not others? Why?

Brentano Haleen, *Ancient SW*. Computer-assisted fine art is still a new field. This artist has been exploring it since the early 1980's. Courtesy of the artist.

Charles Csuri, *Cosmic Matter*. Computer graphics. Courtesy of Nicolae Galleries.

David Hockney, *Untitled,* from Painting with Light Series. Courtesy Invision.

Diamond Scan 20 (model HL6905) microprocessor-based auto-tracking, 20" (19" viewable) color monitor. Mitsubishi Electronics.

Student art.

Student art.

Student art.

Student art.

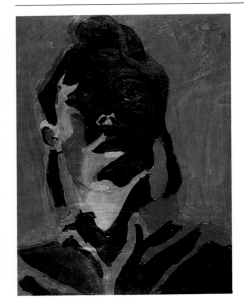

Student art.

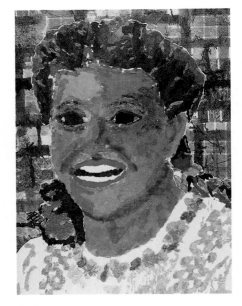

Student art.

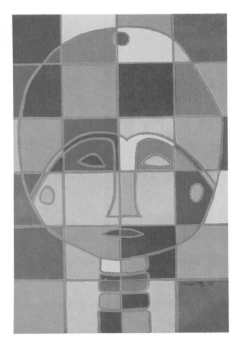

Student art.

Student art.

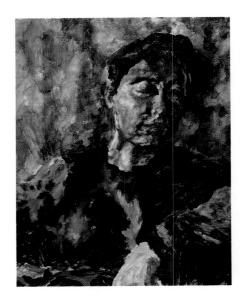

Summary

Painting is one of the oldest and most colorful forms of art. Throughout history, artists have created paintings for a variety of purposes. They have used a wide range of pigments, binders and surfaces for painting. Subjects, themes and styles of painting reflect the culture, artistic traditions and period in which the artist lives. Since the Renaissance, most artists in Western culture have tried to develop their own individual styles and methods of painting.

Using What You Learned

Art History

1 When were oil paints first available in tubes? Why was this important to the Impressionists?

2 What is the main subject in Monet's haystack paintings and his paintings of Rouen Cathedral?

Creating Art

1 List ten common subjects or sources of ideas for paintings. Then choose one and write a short paragraph explaining why you think it is often selected as a subject for painting.

2 Briefly describe two general methods of creating a painting.

3 Create an original painting on a subject of your choice. Demonstrate your ability to interpret the subject in a personal way. Develop an appropriate design and use painting media effectively.

4 What is a "mixed media" painting? How many mixed media paintings by artists are in this chapter?

5 List four ways to suggest the illusion of motion in painting.

Aesthetics and Art Criticism

1 Define the following terms.
- *chiaroscuro*
- *trompe l'oeil*
- *atmospheric perspective*
- *painterly style*
- *linear style*
- *soft-edge*
- *hard-edge*
- *monochromatic*
- *complementary*
- *split-complementary*
- *opaque*
- *transparent*
- *analogous*

2 Choose two paintings from the Gallery in this chapter. Work through the steps in art criticism for each painting. Write your interpretation of each painting and compare them with interpretations written by others in the class. Explain why interpretations of the same work may sometimes be very similar and sometimes very different.

3 Select one of your best paintings. Evaluate it using the steps in art criticism introduced in Chapter 3.

Careers

Today, most artists who exhibit paintings in museums and galleries are graduates of art schools or art programs in colleges. Many have their first exhibitions in shopping malls, art fairs and community centers. They usually prepare portfolios or make slides of their best paintings before they ask a gallery for an exhibition. Most painters have a second job, often art-related, which allows them to create paintings at their own pace and in their own way.

Many illustrators, designers, teachers and other experts in art were first trained as painters. Think of other occupations and daily activities in which a knowledge of color, design and painting media would be an asset.

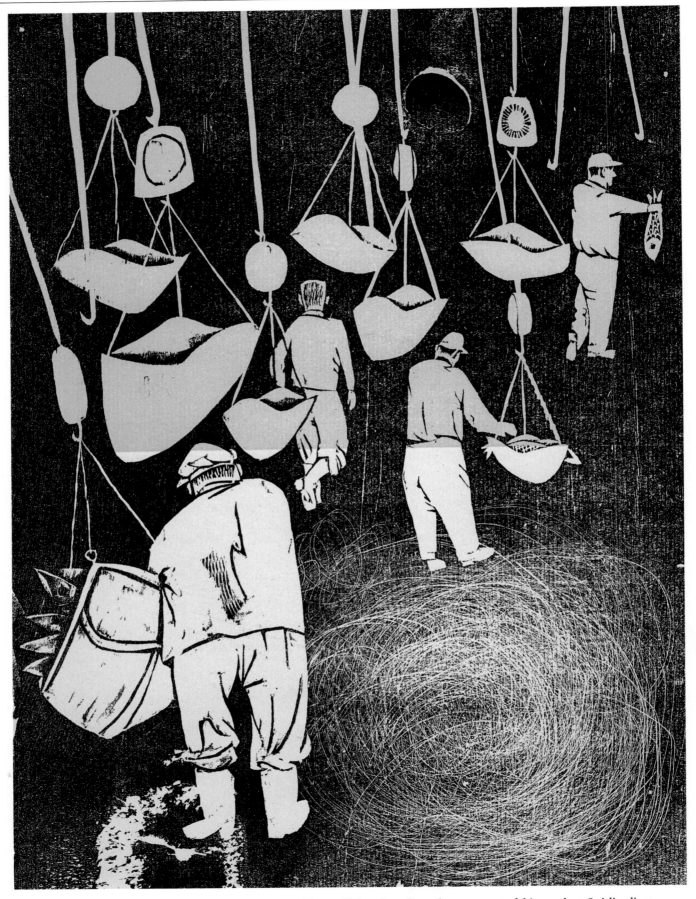

Antonio Fransconi, *Weighing Fish*, 1919. The odd shapes and lines of fish scales enliven the upper part of this woodcut. Swirling lines suggest water on the floor. Colored woodblock print, 10 ¹/₂" x 7 ³/₄" (27 x 20 cm). Norton Simon Museum. Gift of the Weyhe Gallery, 1953.

Chapter 9
Printmaking

Chapter Vocabulary

impression
edition
relief
intaglio
serigraphy
stencil
squeegee
brayer
inking slab
proof
collage
monoprint

Printmaking is a fine art. Graphic design is a commercial art. These two art forms are like two branches growing from one common tree – the invention of printing.

Printing is the process of making many copies of an original image. The first prints were seals and stamps made from clay or carved wood. The relief or raised part of the stamp was covered with ink or paint and pressed down on paper or cloth. The same image could be recorded again and again with only slight changes.

During the Middle Ages, carved blocks of wood were used to create pictures for books and printed playing cards. Sometimes the illustrations included words. The words or lettering had to be carved in reverse on the block in order to look correct when printed.

These early "duplicate pictures" were used for information. Printmaking as a fine art began during the Renaissance when artists such Albrecht Dürer wanted to create original works of art that many people could afford. Prints were a way for artists to sell one basic image to many people. Prints created by artists soon became popular. However, fine art prints were sometimes mistaken for commercial prints. To solve this problem, artists and art dealers set up guidelines for fine art prints. These guidelines are still in use.

A fine art print is original art if: a) the artist creates the image and prints it or supervises its printing; b) the total number of prints is limited in number; c) each print is numbered and signed by the artist in the lower right corner, under the edge of the image; d) the artist's signature is handwritten, not printed by the press.

A fine art print is called a "multiple original" because it is created from a printing surface the artist has prepared. Each print made and signed by the artist is called an *impression*. The total number of impressions made from one printing surface is called an *edition*.

Reproductions are images produced mechanically using cameras and large, machine-driven presses. Because these images are machine-made, they are not original impressions or prints, even if they are signed by the artist.

After completing this chapter and some of the activities, you will be better able to:

Art History and Creating Art	• appreciate and create prints using traditional and experimental methods.
Aesthetics and Art Criticism	• use appropriate terms to describe, analyze, interpret and evaluate your own and others' prints.
Creating Art and Art Criticism	• create and evaluate original prints with attention to their unique expressive, technical and sensory qualities.

Gallery

As a fine art, printmaking allows an artist to create many images from one original design. The prints in this gallery were created by different methods. Can you see the difference in the prints made by each method?

Relief Prints

Relief prints are made by carving into a block with a gouge or other chisel-like tools. Look at the relief prints shown here. Can you identify some of the shapes and edges that were created by carving away parts of the block?

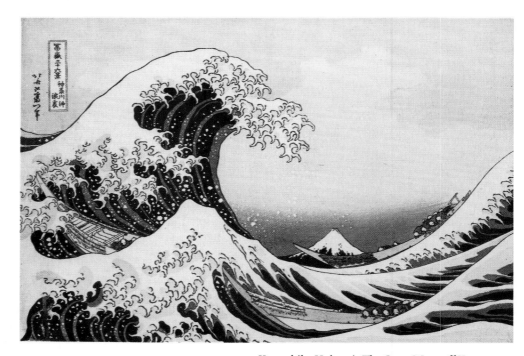

Katsushika Hokusai, *The Great Wave off Kanagawa*, from the series "Thirty-six Views of Fuju." Woodblock print, 10 ¹/₈" x 14 ¹⁵/₁₆" (26 x 38 cm). The Metropolitan Museum of Art. Bequest of H.O. Havemeyer, 1929. The H.O. Havemeyer Collection.

Roy Lichtenstein, *American Indian Theme II.* Woodcut, 32 ¹/₂" x 37 ¹/₂" (83 x 95 cm). Copyright 1980 Roy Lichtenstein/Tyler Graphics Ltd. Photograph by Steven Sloman.

Intaglio Prints

Intaglio prints are made by scratching lines into a smooth metal plate. Sometimes artists create tiny pitted and textured areas on the plate. Most intagalio prints have very fine, thin lines or soft, velvety shadows. They are usually more delicate and airy-looking than relief prints.

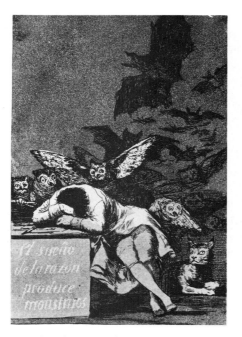

Jeremy Harrison, *Shower Bath*. Intaglio. Photograph courtesy of the artist.

Francisco de Goya, *The Sleep of Reason Produces Monsters*, 1797. Plate No. 43 from "Los Capricios." Courtesy of The Hispanic Society of America, New York.

Lithographic Prints

Many lithographs combine the qualities of drawing and painting. Look for painterly qualities achieved by the use of tusche, a thin, inky grease applied with a brush. Look for tonal qualities from the use of greasy pencils or crayons. These can be very soft and subdued or have high contrasts in light and dark areas.

Serigraphs or Silkscreen Prints

This printing method was first used to produce posters. A serigraph is based on a stencil process, usually with some overlapping of colors. Serigraphs often use color complements to produce vibrating color. A silkscreen stencil can be created with cutout film, crayon or a brush. The surface effects can be highly geometric and hard-edged (from film) or much like crayon or chalk drawings (from crayon) or quite painterly

Alexander Calder, *Untitled* (one of seven), 1964. Lithograph, 19 ¹/₂" x 25 ¹/₂" (50 x 65 cm). Solomon R. Guggenheim Museum, New York. Gift of the artist. Photograph by Robert E. Mates.

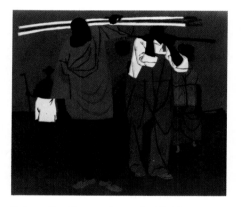

Robert Gwathmey, *Across the Fields*, 1944. Silkscreen. Philadelphia Museum of Art. Purchased: Harrison Fund.

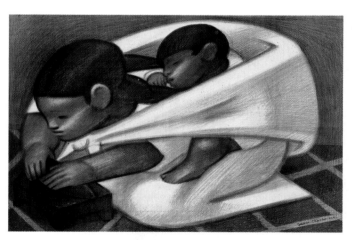

Jean Charlot, *Mother and Child*, 1941. Lithograph printed in color, 12 ¹/₂" x 18 ⁵/₈" (32 x 47 cm). Collection, The Museum of Modern Art, New York. Gift of Albert Carman.

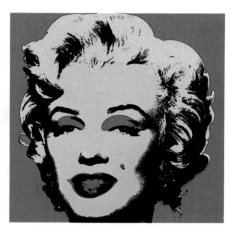

Andy Warhol, *Marilyn* 1967. Silkscreen print, 36" x 36" (91 x 91 cm). Courtesy of Ronald Feldman Fine Arts, New York.

Käthe Kollwitz

1867-1945

Käthe Kollwitz believed her art had a purpose. She wanted to show the dignity and strength of the poor, the beauty of the human spirit and the terrible horror of war. Her work – prints, drawings and sculpture – all grew directly out of her life experience.

Käthe Kollwitz was born in Prussia (now part of the USSR). She grew up in a family that encouraged her talents in art and her concern for political and social causes. In Munich she met and married a physician. They settled in a working class neighborhood in Berlin, near the clinic her husband supervised. In that neighborhood, she saw the daily hardships of the poor and cared deeply about them. She identified particularly with the mothers struggling in difficult, sometimes impossible, situations to protect their children.

Kollwitz's own son Peter was killed during the first weeks of World War I. His death had a deep and lasting influence on her art. Many of her prints and posters capture the grief of women and children whose lives are shattered by the death of loved ones in war. Her great gift was the ability to express – in a few bold, sure strokes – the grief, misery and agony of people who are victims.

There is a feeling of compassion and love in her work. She never gave up her plea for peace, justice and the end of hardship. Her last work, following the death of her grandson in World War II, is titled *Seed for Sowing Shall Not Be Ground*. It shows a mother protecting her three children. The title and date – she created it during the war – makes it a defiant plea for peace.

Käthe Kollwitz, Photograph by Lotte Jacobi.

Käthe Kollwitz's haunting works continue to stir the consciences of many. Critic Romain Rolland said her work is filled "with a solemn and tender compassion. She is the voice of the silence of the sacrificed."

Critical Thinking In your own words, interpret the meaning of the phrase: "She is the voice of the silence of the sacrificed."

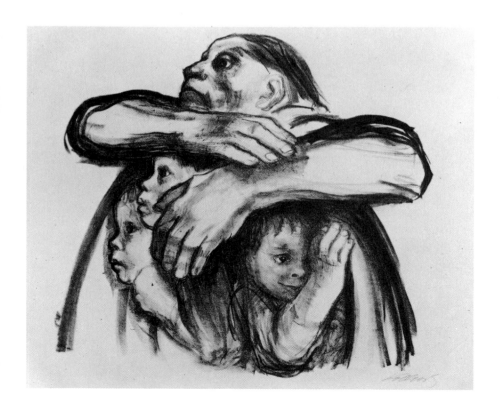

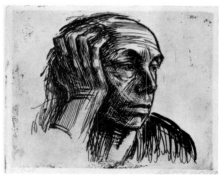

Käthe, Kollwitz, *Self-Portrait*, 1921. Etching. Frederick Brown Fund. Courtesy, Museum of Fine Arts, Boston.

Käthe, Kollwitz, *Seed for Sowing Shall Not Be Ground*, 1942. Lithograph on ivory wove paper. Courtesy Galerie St. Etienne, New York.

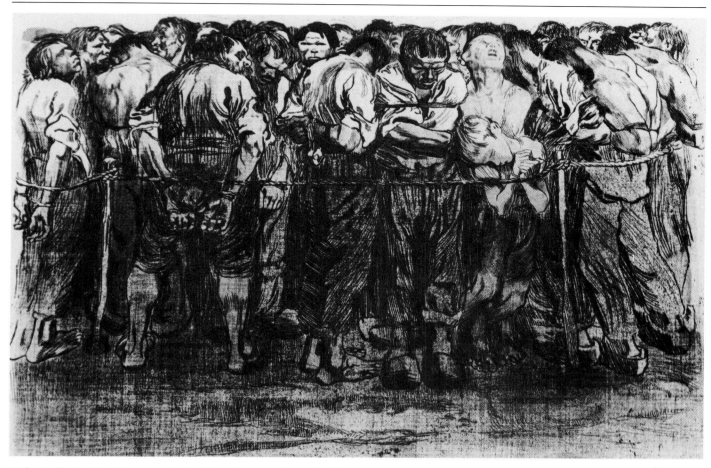

Käthe, Kollwitz, *The Prisoners,* 1908. Etching. Courtesy Galerie St. Etienne, New York.

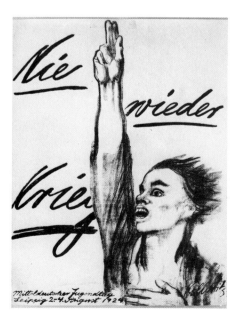

Käthe Kollwitz, *Never Again War!* Lithograph. Photograph courtesy Galerie St. Etienne, New York.

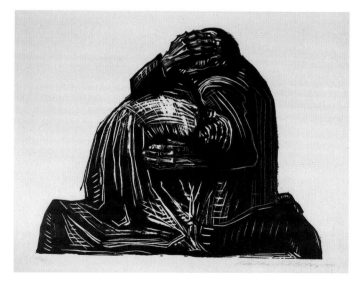

Käthe, Kollwitz, *The Parents.* Woodcut. Print Collection. Miriam and Ira D. Wallach Division of Art, Prints and Photographs. The New York Public Library. Astor, Lenox and Tilden Foundations.

Ideas for Prints

Ideas for printmaking can come from observation, imagination, personal feelings and the desire to communicate with others.

Look at the world around you for printmaking ideas. Sketch the delicate veins and organic shapes of leaves, the subtle contours of a feather, or the textures of tree bark.

Fantasy and imagination can be the source of ideas for prints. You might combine the printed impressions of various objects – a leaf, tin can rim, fork or scrap of wood – to create a strange landscape, animal or person.

Your prints might combine a poem and illustrations. You might create a print based on a theme such as friendship, happiness, anger or curiosity. You might develop serial prints – comic-book style – to express humor or a series of related events.

Think about printing as a way to create greeting cards, posters, stationery or another art form. For example, an "allover repeat" design can be printed on paper for wrapping a gift. Can you think of other ideas for prints?

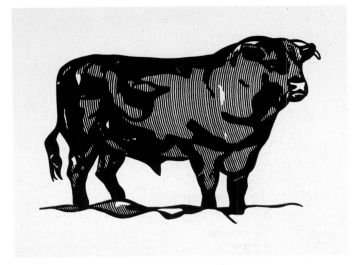

Roy Lichtenstein, *Bull I from Bull Profile Series.* One idea can often be explored and become the source of other ideas. The artist has abstracted and simplifed the shapes of this bull and *Bull II.* Another more abstract variation is seen in *Bull VI.*

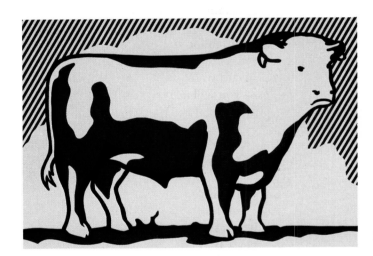

Roy Lichtenstein, *Bull II from Bull Profile Series.*

Roy Lichtenstein, *Bull VI from Bull Profile Series.* 5 color litho/ screen/linecut, 27" x 35" (69 x 89 cm). Copyright Gemini G.E.L., Los Angeles, California, 1990.

Planning Your Prints

Printmaking can be approached in two main ways: expressive and decorative.

In *expressive* prints your ideas are closely tied to personal experiences. Expressive prints are like expressive drawings and paintings. You want your idea to be captured effectively in a printing process. This means that you will probably have to modify your idea to fit a process.

For example, a detailed linear landscape could be captured in a drypoint etching. For a block print, you might need to simplify your idea or composition and make it bolder. Choose the most appropriate process to express your ideas.

In the second approach, you plan a motif that you will repeat. A *motif* is a self-contained design that you print again and again on one surface, usually to decorate in an "allover" print.

When you design a motif, think ahead to the way the same design can be placed on the printing surface. For example, the motif might be printed in rows, exactly the same over and over. You could also overlap the motif, turn it around for variety, or use an interlocking design.

For most prints, you will need to prepare your block very carefully. Therefore, it is always wise to make sketches to try out ideas and decide on a composition. In prints that combine words and images, design the letter forms carefully. Make sure the letters are reversed on the block.

Use sketching materials that let you see effects similar to those in your print. For example, cut or torn paper is a good choice to make a sketch for a silkscreen because silkscreens use flat areas of color. White chalk or crayon on dark paper is a good choice for sketching ideas for a wood or linoleum block. Think of all the white lines and shapes as parts of the block you will be cutting away.

What motifs have been repeated in each fabric design? Herman Miller, Zeeland, Michigan.

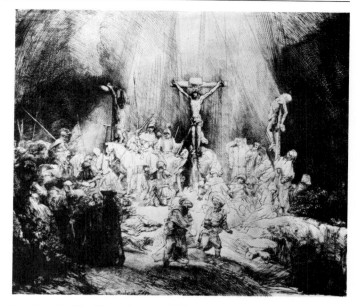

Rembrandt, *The Three Crosses–third state*. Rembrandt began this etching with many light values. He reworked the etched plate many times, gradually darkening areas. Here you see an etching from the third stage of the work and below, the fourth stage of development. Why might the artist have wanted to darken the etching? Etching, 15" x 17 $\frac{1}{4}$" (38 x 44 cm). Courtesy of Metropolitan Museum of Art, New York. Gift of Felix M. Warburg and his family.

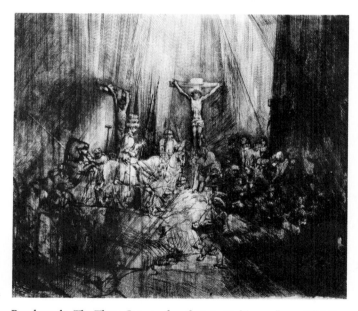

Rembrandt, *The Three Crosses–fourth state*. Etching, 15" x 17 $\frac{1}{4}$" (38 x 44 cm). Courtesy of Metropolitan Museum of Art, New York. Gift of Felix M. Warburg and his family.

Methods of Printmaking

You have seen examples of four main printmaking processes: relief, intaglio, lithography and serigraphy (silkscreen and stencil). Additional information about each process is presented here.

Relief: Ink on surface.

Intaglio: Ink in grooves.

Lithography: Ink resist process.

Relief In relief prints, the raised part of a block receives the ink. The image is carved into the surface of the block. The carved areas will be the color of the printing paper. The printed design will be exactly the reverse of the image carved into the block. A separate block is usually prepared for each color of ink.

Wood engravings are made on the polished end grain of wood using a sharp tool. Fine details are possible and curved lines can be made easily.

Intaglio Intaglio prints are made by incising lines into a smooth metal plate. Ink is forced into the grooves. Then the surface is carefully wiped, leaving ink only in the grooves.

Paper is laid on top of the inked plate and covered with a felt blanket. The felt-covered paper and plate are passed through a printing press. The pressure of the rollers forces the paper into the inked grooves.

In an *engraving*, the grooves are incised into the metal with a burin. In a *drypoint*, lines are scratched with a needle-like tool.

In an *etching*, the metal is first coated with a layer (or *ground*) of wax or resin. Lines are drawn into the ground, exposing the metal. The plate is placed in acid which etches (eats away) the exposed lines.

Lithography This method was invented around 1800. The artist draws an image on a flat slab of stone (or a special metal plate). The image is made with a greasy crayon or paint that resists acid and water. The surface of the stone is covered with acid. The acid dissolves some of the stone, leaving the greasy image surrounded by a slightly pitted, etched, surface.

Water is applied to the surface of the stone. Next a brayer is used to spread greasy ink on the surface. This kind of ink sticks only to the greasy crayon image. It does not adhere to the wet areas (grease and water don't mix). The inked image is then printed with a press.

Photograph courtesy of Bernie Toale.

Photograph courtesy of Bernie Toale.

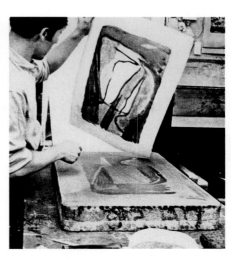

Pulling an impression, lithography.

Stencil.

Serigraphy: Ink through a screen.

Serigraphy

Serigraphy In serigraphy (silkscreen), a stencil is used to print images. The stencil is fixed onto a fine screen mounted on a frame.

Paper is placed under the screen. Ink is pulled across the screen with a *squeegee*, which is a rubber blade mounted in a handle. Several stencils can be used to apply different colors through the same screen.

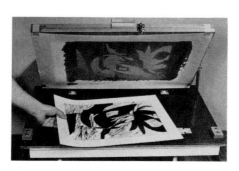

Pulling a print, silkscreen.

Materials for Printing

Each printmaking technique may require some special equipment, but almost all require the following materials.

Surfaces You can make prints on a variety of papers. Artists prefer 100% rag papers, because they last a long time. You might try printing on bond paper, newsprint, construction paper, colored paper, wallpaper, tissue paper, and sheets from magazines.

You can stain papers with paint, then print on top of them. You can print a second color on top of a print you have already made (print a light color first, then a darker color on top). Prints can be made on cloth, sheets of plastic, and many other materials. Always experiment first; you might need special inks.

Leonard Baskin, *Sorrowing and Terrified Man*. Prints can be developed within a variety of shapes. Woodcut, 34 ¹/₂" (88 cm) diameter.

Inks The ink you use for printing will probably be water-based. This means the ink will normally be dry in an hour or so. Use soap and water for cleanup.

Tempera paints can be used as a substitute for printing ink. The prints tend to be fuzzier and less defined. Add a drop or two of glycerin to slow the drying time and increase the ink-like quality of the paint.

Brayer and inking slab A brayer is a special roller used to apply ink to a printing block. The ink is first put on an inking slab – a smooth nonabsorbent surface wider than the brayer. Use plate glass, plastic, sheet metal, Formica or a cookie tray.

Place the ink near the center of the slab. Squeeze the ink tube gently, leaving a trail of ink about 2" (5 cm) long (like toothpaste). Roll out the ink with the brayer. The ink must be evenly distributed over the roller of the brayer.

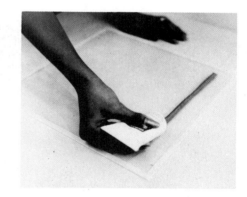

Applying ink to the plate.

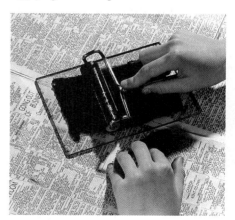

Rolling out the ink. Photograph by Roger Kerkham.

Relief Prints

Linoleum and Woodcuts

Gouges and chisels are the basic tools for a linoleum cut or woodcut. Always cut in the direction of the wood grain.

Scraps of white pine or redwood are soft and available at a lumber yard, carpenter shop or school shop. Sometimes knots and other natural patterns in the wood can suggest an idea or design. Blocks of wood with thick linoleum mounted on top are often used for relief prints.

Make your preliminary sketches the same size as your printing block. Use thin bond paper and soft pencil.

Choose a final sketch, and hold it up to a strong light. You can see the reversed image on the back of the thin paper. This will show you what your final print will be like. Use carbon paper to transfer your design onto the block.

Cut away the wood or linoleum you don't intend to print. Shallow cuts often work just as well as deep ones. Practice some cuts on a piece of scrap wood or linoleum. Cut with the wood grain when possible.

Textural effects and patterns can be created by lightly tapping a texture into the surface with a hammer. Try the end of a small pipe, nails, metal screen or gravel.

Make sure the ink is evenly distributed on the inking slab and the brayer. Then roll the brayer across the printing block using a smooth, even stroke.

Center the paper above the printing block, then put it straight down on the surface. Use the bowl part of a large wooden spoon or your fingers. Rub the paper from the center toward the edges. Your school may have a printing press that you can use instead of hand rubbing. Think of other ways to apply pressure evenly.

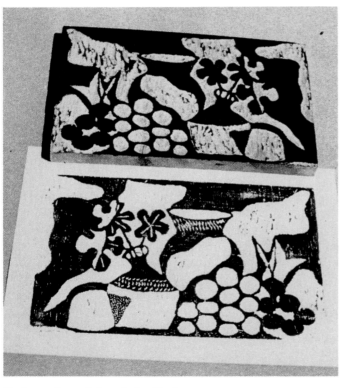

Student print and the printing block.

A board, like the one holding the linoleum block in place, is nailed on one end of the plywood slab, facing down. When hooked over the edge of the table, it keeps the unit from "traveling."

Safety Note Always hold the block securely and cut away from the hand holding the block. Use caution. Work slowly. Wear safety goggles.

A safety block.

To keep your prints clean, make up sets of paper fingers (short strips of clean paper folded in half). Slip them over the edges of the paper and put your fingers on top of them. Lift the paper slowly. This is called "pulling" the print.

When the proof is satisfactory, try out different kinds and colors of papers. Cut them larger than the block, leaving a margin on all sides. Then make an edition of prints.

Sign your best prints with a pencil or black ink. The professional way to sign prints that will be framed is shown at the far right. The symbol "A/P" means artist's proof, a print made before the final edition. In the example, 2/6 means that the print was the second one made in an edition (or total) of six prints.

The order of printing is shown because most blocks or plates are slightly changed by the pressure of printing them. A print numbered 80/100 will generally be more faithful to detail than one numbered 10/100.

This numbering system helps people who collect prints understand how many prints were made from the block. Artists will often strike their plates (destroy them by scratching through them) after one edition has been pulled. This prevents illegal reprinting of the block.

Safety Note Gouges and chisels must be handled with caution. Always hold the block securely and point the cutting edge of the tool away from your hands, fingers and body. Use caution. Work slowly. Wear safety goggles.

Inking the block.

If you have a press, follow all safety instructions given by your teacher.

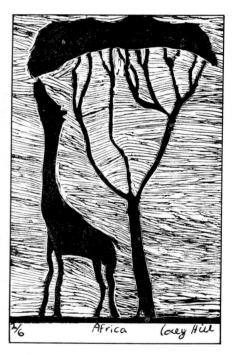
Student art.

Use your hand or a smooth burnishing tool to rub the paper. Photograph courtesy of John Lidstone.

Pulling a relief print.

Wooden spoon, a baren or a smooth rounded stone can all be used to burnish printing paper to produce a print.

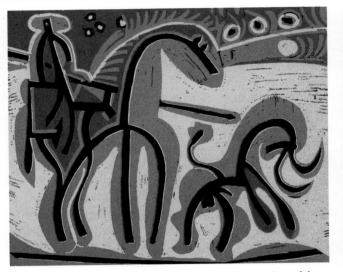

Pable Picasso, *Picador and Bull*, 1959. Progressive carving of the block of this multi-color print allows each color—beige, mauve, brown and black—to be printed in sequence. The images at left illustrate the four stages of printing that Picasso used in *Picador and Bull*, 21" x 24 ¹/4" (53 x 64 cm).

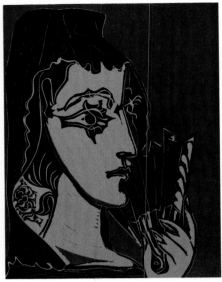

Pablo Picasso, *Head of a Woman*, 1962. One block was carved and printed. Other sections were carved then printed in a second color. The recarving and reprinting gives you a multi-color print from one block. Reduction woodcut printed in beige, brown and black, 14" x 10 ³/4" (36 x 27 cm). Albertina Graphische Sammlung, Vienna.

Multicolored Relief Prints

Multicolored woodcut or linoleum prints can be made by two basic methods.

1. PROGRESSIVE CARVING. Begin by carving large basic shapes in linoleum or wood. Then make six to eight prints of this stage of carving. Clean the ink from the block.

Now choose other areas in the block for linear or textural carving. Overprint your "new" block on the first prints you made using a different color ink.

Take care to register the edges of the block properly. The result is a two-color print. You can make three- and four-color prints by extending this process.

2. SEPARATE BLOCKS. Put together a pad of three sheets of tracing paper interleaved with two pieces of carbon paper. Develop a drawing for a three-color print. Make the full drawing on the top sheet. Next, separate the sheets of paper from the pad. Use one colored pencil on each of the drawings to show areas to be inked. Each color-coded drawing represents a block to be prepared and printed with a different color ink.

Remember to print the lightest colors first, then darker colors. Plan for overlapping areas on the separate blocks. For example, a red area printed on top of a yellow area will be red-orange.

Other Relief Prints

You can create relief prints from almost any raised surface that can be inked. A few possibilities are listed here. You might combine these or invent other ways of creating a surface for printing.

FOUND OBJECT PRINTS. Collect a variety of small, natural or manufactured items that have a flat or slightly textured surface. Experiment to find out which items will print a definite shape, line, or texture. Combine the most interesting ones to create a print (picture or design). Try shells, leaves, bottle caps, thread spools and the like. Try cutting designs in the flat surfaces of a cut potato, turnip or carrot.

WOOD SCRAP PRINTS. Find small scraps of wood and weathered boards. Add textures to some of the blocks. Arrange these "found" pieces on paper to create a pleasing design. One by one, ink the surface of the pieces with a brayer and print them directly onto another paper in about the same location.

Inking a collage-based relief block. A relief block with textures and patterns from collaged materials. Photograph by Roger Kerkham.

A relief block with linear elements from string. Photograph by Roger Kerkham.

A relief block with shapes cut from cardboard. Photograph by Roger Kerkham.

GLUE LINE PRINTS. Use glue to draw a simple linear design with some lines extending to all four edges of the printed area. The plate should be thick, smooth cardboard, Masonite or vinyl tile. When the glue is dry (clear), apply ink over the raised glue lines and print the image.

Because glue lines can be hard to control, it's a good idea to practice first. Squeeze a thin line on stiff paper. Scratch through the glue line with a toothpick. Try dipping the toothpick in glue and drawing lines. Try scraping off wet glue and putting a fresh line on the area. When you feel you know how to control the glue, apply it to your printing plate.

If you wish to create more than five or six prints, coat the whole printing plate with polymer medium and let it dry thoroughly. You might save the plate and use it to create a foil relief (see Chapter 12).

STRING PRINTS. On heavy cardboard, create a line drawing in pencil. Squeeze a trail of white glue over a section of the line. Lay string on top of the glue. A toothpick will help you position the string. Let the design dry completely. A coat of polymer medium will seal the surface. Once the polymer is completely dry, you can create more prints than from an unsealed surface.

Use a clean, soft brayer to apply pressure to the paper. You can also try using a lightly inked (blotted) brayer on top of the paper.

CARDBOARD PRINTS. Cut shapes from heavy paper or thin cardboard, such as index cards or a manila file folder. Glue these to thick cardboard. (A coat of polymer medium will seal the surface.) Ink the surface and print.

FOAM PLASTIC PRINTS. Save foam plastic from egg cartons, meat trays or fast-food containers. Trim away sections until you have flat surfaces to use as small printing blocks. Engrave these with a pencil or ballpoint pen, then ink and print them. You might glue several engraved pieces on a piece of cardboard to create a block.

COLLAGE-TYPE BLOCKS. Cut or tear shapes from rubber inner tubes, felt, thick fabric, embossed plastic, contact paper, electrician's tape or other flat materials. Collect leaves, pressed weeds or grasses.

Glue these to thick cardboard. Try to keep the raised shapes the same thickness. (Seal with polymer medium any materials that may absorb ink.)

Relief blocks assembled from textured items may give you better prints if you place the paper on top of the uninked block and roll an inked brayer across the paper.

Stencil Prints

A stencil is a sheet of paper or thin cardboard with one or more shapes cut out of it. A stencil print is made by placing the stencil on another sheet of paper and applying paint or ink through the opening.

Special stencil paper, lightly waxed, can be bought at art supply stores. A stencil brush, with short, stiff bristles, is the traditional way to apply the paint or ink. It is dipped in the ink, wiped or stippled on newspaper to remove excess ink, then used for printing. A light stippling motion (up and down) or a light "feathery" stroke is commonly used to apply the ink.

Silkscreen Prints

Silkscreen printing, called serigraphy, is a process often used to print posters, textile designs, greeting cards and other graphic designs. It is also a method for creating expressive prints.

Silkscreen is basically a stencil process. Ink passes through a fine cloth screen, except in areas that are covered with paper shapes or other materials that block the ink. These materials are called *block-outs*.

The screen (usually silk, organdy or nylon) is stretched taut on a frame. The frame is attached with loose-pin hinges to a baseboard (screen side down). A kickstand allows the screen to be raised while the paper is placed for printing.

Henri Matisse, *Jazz, The Burial of Pierrot-Plate VIII,* 1947. The shapes in this print were created by using a number of stencil cut outs. Stencil, 16 5/8" x 12 3/4" (42 x 32 cm). Collection of the Grunwald Center for the Graphic Arts, University of California, Los Angeles.

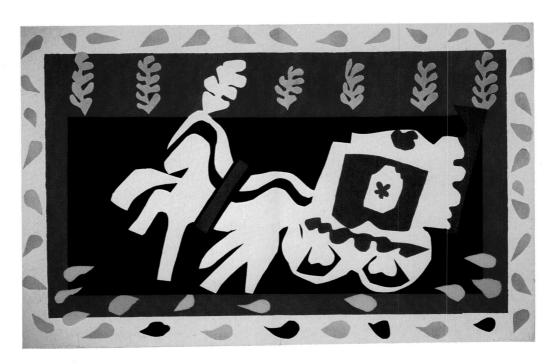

Stencils can have open areas and be combined to create complex compositions.

The tiny openings in the cloth help distribute the ink evenly when the ink is pulled across (and forced through) the screen with a squeegee.

For your first silkscreen print, plan the design by cutting out shapes from white construction paper. Arrange the shapes on a colored background paper. Think of the background as the inked part of your design. Do not paste the shapes down.

When the design is complete, place it under the screen and lower the screen so it is flat against the paper shapes.

Pour screen ink near one end of the screen. Hold the squeegee in both hands and pull the ink across the screen. This will make the shapes stick to the screen so you can make additional prints.

For a multicolor print, plan the design for each color. Each color must be printed with a clean screen. Always print the lightest colors first and the darkest colors last.

There are many kinds of silkscreen. Some involve the use of chemicals and solvents that require special precautions and ventilation. Be sure to follow all directions given by your teacher.

Simple Silkscreens To create a simple screen frame, begin with a shoe-box lid. Cut a window in the center, leaving about an inch margin all around. Stretch the cloth over the outside of the lid and staple it tightly to the vertical sides of the cardboard.

Seal the edges around the opening with masking tape, inside and outside, allowing each piece of tape to overlap the cloth about ¼" (6 mm). Press all edges of the tape together securely.

Cloth, especially organdy, can also be stretched on an embroidery hoop to create a screen. Wax crayon can be used as a block-out. Finger paint can be used for printing on paper.

A squeegee is pulled across the screen to force ink on to the paper below it.

Roger Hollenbeck, *Bright Eyes*, 1960. The positive and negative shapes in this print have been carefully planned. Can you visualize the shape of the stencil used for this silkscreen print? Serigraph, 6 ½" x 12" (17 x 30 cm). Norton Simon Museum. Gift of Mr. and Mrs. Oscar Salzer, 1960.

A silk screen and squeegee.

Rembrandt van Rijn, *Self-portrait by Candlelight*, 1630. Etching. Stattliche Museen, East Berlin.

In a drypoint etching, a sharp tool is used to scratch the surface of the printing plate.

Intaglio Prints

Intaglio prints are difficult to create without a printing press. You might try a simple drypoint print on a thick sheet of acetate.

First, create a drawing with a pen. Place it under the acetate plate. With a steel etching needle, scratch lines into the acetate. Vary the depth of the lines but make sure they are incised deeply enough to hold ink. Make hatched and crosshatched lines to create different values.

Use a felt dauber or stencil brush to work ink into the incised lines. With a flat, folded paper towel or cheese-cloth, wipe away any ink on the surface of the acetate plate, leaving ink in the scratched designs.

To print your plate, put it on the press. Center a sheet of damp paper over it. Cover the paper with several layers of felt and run it through the press.

Note: If you do not have a press, cover the paper with one thin piece of felt. Hold the felt securely and rub over it hard with the bowl part of a metal spoon. Start at the center and rub out toward the edges.

Unless you use a printing press, only the deepest well-inked lines of the plate will print. You might try the intaglio method of printing on smooth vinyl floor tiles or a piece of Formica. Because these materials tend to chip, lines may be irregular.

Safety Note Be sure to wear safety goggles if you use these materials.

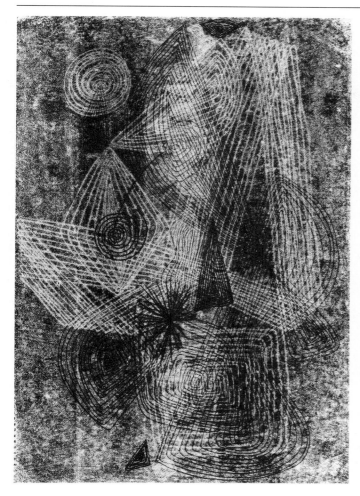

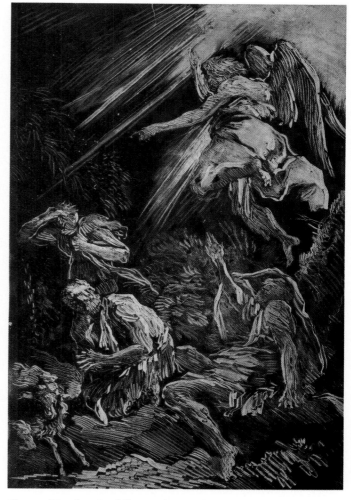

Harry Bertoia, *I, Group XI*, before 1948. A monoprint is often made by inking a smooth surface and drawing into it with one or more tools. This leaves the plate free of ink in some areas. Color monoprint, 14" x 20" (36 x 51 cm). Solomon R. Guggenheim Museum, New York. Photograph by Robert E. Mates.

Giovanni Battista Castiglione, *The Angel Announces the Birth of Christ to the Shepherds*. Dramatic contrasts are achieved in this monoprint from the 1600's. Monotype, 14 $\frac{1}{2}$" x 9 $\frac{5}{8}$" (37 x 24 cm). Albertina Graphische Sammlung, Vienna.

Monoprints

A monoprint is unlike other printing techniques. Mono means one. A monoprint is an impression made on a sheet of paper from another image such as a wet painting or inked surface. Prepare a painted or inked surface on top of glass, Formica, plastic or another smooth, nonabsorbant surface. Create a monoprint by using one or more of the following methods.

Lay a sheet of paper over the inked surface. Draw on the paper with a dull tool such as the handle of a paint brush. Pressure from this or a similar tool leaves an impression of ink on the underside of the paper.

Lay shapes of paper on the ink or painting before the sheet of paper is placed. In the impression, these shapes will be white.

Draw into the ink or paint with paper, cotton swabs or a comb. Then place the paper down and rub it.

New Directions in Printmaking

New directions in printmaking are challenging traditional ideas about this art form. For example, printmaking is usually classified as a two-dimensional art form. As you can see in Stella's work, it can also resemble a three-dimensional art form – a low relief sculpture.

Artists are also challenging traditional ideas about the size of prints and the surfaces on which they can be printed. Prints have been made on clear plastic, baked enamel and other surfaces.

Critical Thinking Do you think it is a good thing for artists to experiment with new ideas about traditional art forms? Why or why not? What would happen if all artists used only traditional art methods and ideas? What would happen if all artists tried to create art without any knowledge of traditional techniques?

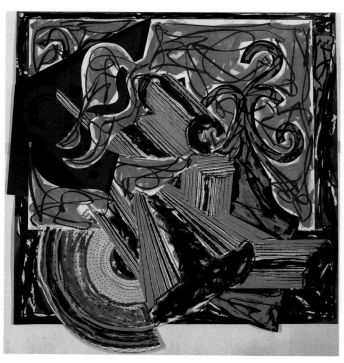

Frank Stella, *The Butcher Came and Slew the OX, No. 8* (From a series of 12 illustrations after Ed Lissitsky's *Had Fadya*, 1984. Hand colored with lithographic linoleum block and silkscreen, 56 ⅞″ x 53 ⅜″(144 x 136 cm). Waddington Graphics, London.

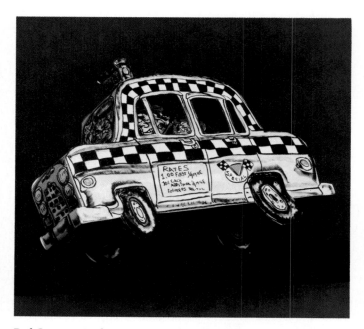

Red Grooms, *Ruckus Taxi*, 1982. Three-dimensional lithograph, 16" x 14" x 28" (41 x 36 x 71 cm). The Worcester Art Museum. Gift of Sidney Rose in memory of his mother, Mary D. Rose, 1984.

Student art.

Student art.

Student art.

Student art.

Student art.

Student art.

Student art.

Student art.

Student art.

Student art.

Summary

During the Middle Ages, carved blocks of wood were used to create pictures for books and printed playing cards. Printmaking as a fine art began during the Renaissance. Prints were a way for artists to sell or display one basic image to many people.

A fine art print is considered original art if: a) the artist creates and prints the image or supervises its printing; b) the total number of prints is limited in number: c) each print is numbered and signed by the artist in the lower right corner, under the edge of the image; d) the artist's signature is handwritten, not printed by the press.

A fine art print is called a "multiple original" because it is created from a printing surface the artist has prepared. Each print made and signed by the artist is called an impression. The total number of impressions made from one printing surface is called an edition.

The printmaking process begins with making an image on a block, slab, or screen. The image is then inked and transferred to paper. Reproductions are images produced mechanically using cameras and large, machine-driven presses. Because these images are machine-made, they are not considered original impressions or prints, even if they are signed by the artist.

Printmaking processes are divided into four major categories: relief, intaglio, lithography, and serigraphy (silkscreen and stencil).

Although printmakers today continue to use traditional methods of printing, many combine techniques and experiment with new surfaces and methods of printing.

Using What You Learned

Art History and Creating Art

1 What are three of Kollwitz's accomplishments as a printmaker and artist?

2 What types of printmaking were common in the following time periods?: (A) Middle Ages, (B) Renaissance, (C) Twentieth century

3 What are three characteristics of an original fine art print?

4 What is the main difference between a reproduction and a fine art print?

Creating Art and Art Criticism

1 Select one of your best prints. Apply your knowledge of the steps in art criticism to describe, analyze and interpret it.

2 State at least four criteria that are appropriate to your best print. The criteria might refer to the subject or theme, design, technique or purpose. Evaluate your print, giving reasons why it does or does not fully meet the criteria.

3 Select one of your least effective prints. Identify at least one step you might have taken to make it more effective.

Aesthetics and Art Criticism

1 Describe the main differences between the following printing processes: (A) relief, (B) intaglio, (C) lithography, (D) silkscreen

2 Select a fine art print in this chapter that interests you. Describe, analyze and interpret it. Use correct printmaking terms to point out its sensory, technical and expressive qualities.

Corporate identity symbols designed by Noel Mayo Associates, Inc.

Chapter 10
Graphic Design

Chapter Vocabulary

graphic design
logo
corporate identity
layout
slogan
serif
sans-serif
typography
calligraphy
crest
free-lance illustrator

A nun sits long hours over a manuscript. The work began early in the morning and will continue until after dark. The pen dips into ink and the nun letters a word flawlessly. By evening, three pages will be finished. The book she is copying is over 1,000 pages long.

It is the sixth century, AD, and many other men and women besides the nun sit hunched over desks. Each one will spend years hand-copying a book. They also create pictures and designs around the words. These designs, often in glowing gold, help communicate the ideas of the book: they become illuminated manuscripts.

Illuminated manuscripts were elaborate forms of graphic design. It took years to make one and few people living at the time would ever see it. Then, around 1450, Johann Gutenberg invented the printing press. Suddenly, a book that took over a year to copy could be printed in a day.

As printing became commonplace, a new type of artist developed: the modern graphic designer. At first, graphic designers were trained strictly as artists or as craftsworkers in the printing business.

By the twentieth century, there were schools for graphic design. One of the most important of these was the Bauhaus in Germany (1919–1933). Bauhaus designers experimented with new types of graphic imagery. Many teachers and students from the Bauhaus later went to England or America. This helped to create an international community of graphic designers.

In 1910, Peter Behrens, a German designer, pioneered using **logos** to give corporations a special sense of **corporate identity**. These symbols communicate some basic feeling or idea about the company: what the company does, what it sells, what it believes in. They are very simple, easily remembered designs that are shown on everything with the company name, from products to buildings.

Most graphic design has a commercial purpose – that is, it is intended to help sell something. Book design, record covers, advertising for magazines, television and outdoor displays: these are all examples of graphic design. Airports use international symbols that can be understood by anyone of any nationality. Other examples of graphic design are seen in wallpaper, fabrics and paper.

In this chapter, you will learn more about graphic design. After you study this chapter and complete some of the activities, you will be better able to:

Art History	• appreciate the development and scope of graphic design.
Aesthetics and Criticism	• perceive, interpret and judge the design of visual communications.
Creating Art	• use your graphic design skills for practical and expressive purposes.

Gallery

Graphic design is as old as the history of written communication. Over thousands of years, there have been many changes in the letters of our alphabet and in the use of letter forms as a means of visual communication.

The graphic designs shown here illustrate a trend toward the use of simple, bold letter forms, especially in the twentieth century. The same trend can be found in the alphabets of many languages in the world.

Critical Thinking What are some explanations for the trend toward simple, bold graphic designs in the twentieth century?

Margaret Macdonald, *German Art and Decoration*, 1902. A booklet cover.

Singing Monks from an Illuminated Manuscript, Middle Ages, England. Copyright The Pierpont Morgan Library, 1990.

3000 BC Cuneiform script

2000 BC Egyptian script

A17BA8

1100 BC Early Greek

ALPHABET

100 Trajan

alphabet

1450 Gutenberg Textura

Alphabet

1530 Garamond

Alphabet

1788 Bodoni

Alphabet

1898 Standard

Alphabet

1955 Univers 55

Changes in letterforms from 3000 BC to 1957.

Cover for Staatliches Bauhaus in Weimar, 1919-1923 by Herbert Bayer.

Saul Bass, United Airlines Corporate identity, 1974.

Robert Indiana, *Love*, 1966. Acrylic on canvas, 71 $^7/_8$" x 71 $^7/_8$" (183 x 183 cm). Indianapolis Museum of Art, Indiana. James E. Roberts Fund.

AEG logotypes, 1806,1900,1907,1908 and 1912.

Saul Bass, Warner Communications Logo, 1974.

Meet the Artist

Bradbury Thompson

1911–

Bradbury Thompson has been called one of the most influential graphic designers in the United States. Born in Topeka, Kansas, he had an early interest in art. Among his first graphic designs were high school and college yearbooks. During high school and college he also did drafting for engineers and architects.

In 1938, Thompson went to New York. His first major commission came from Westvaco, a company that manufactures printing papers. He was put in charge of a periodical, *Westvaco Inspiration for Printers.* Under Thompson's direction from 1939 to 1962, this periodical had an international influence on graphic design.

Thompson's second major job, from 1945 to 1972, was to serve as design director for *Art News.* In this position, he worked with many artists including Miro, Matisse and major artists in New York City. In 1956, he began teaching the history of typography at Yale. He has continued to design many other magazines, including *Smithsonian.*

In 1969, Bradbury Thompson began serving as a designer and design consultant for United States postage stamps. He designed over one hundred stamps and supervised the development of many other series. Some of the most popular are the Love stamp series, Christmas stamps, American Architecture, Indian Art, and Folk Art stamps.

In 1969, Thompson began work on a ten-year project known as the Washburn College Bible. In it, he made graphic design changes that make the text easy to read and a delight to view. It is illustrated with sixty-six masterpieces of religious art from 300 AD to the present. The type is large and the lines of type are divided into natural phrases. This work sets a new standard for graphic design in one of the world's most widely read books.

Bradbury Thompson is considered a master in the art of typographical design. He has been inspired by type styles of the past, art work from many cultures, and even from the design process itself. He has received honorary degrees and the highest awards, including the Gold Medal of the American Institute of Graphic Arts.

Critical Thinking Imagine that your class is a committee that chooses topics for postage stamps. By a class vote, select three topics that you think are appropriate for stamps. Then choose a topic and design a stamp for it. Remember these points: A stamp may not be issued for any living person. A stamp travels all over the world and represents the country that issues it.

Bradbury Thompson. Photograph by Gretchen Tatge and courtesy of Bradbury Thompson.

Bradbury Thompson, Cover of *Art News Annual,* 1964.

Freedom of the American Road. This large-format publication divided into three sections was produced by Ford Motor Company in 1950 for nationwide distribution. It gave attention to all the aspects of automotive improvement.

The Traffic. The publication was profusely illustrated with photographs and drawings. Part 2 was devoted to safe travel and to educating citizens about up-to-date, scientific management of street traffic in the urban areas.

235 The Highway. The format of this 124-page magazine was 10¼ by 12¼ inches. Part 1 explained the need for better highways, citizens' support of a wise fund expenditure, and the fundamentals of efficient highway management.

237 The Driver. Part 3 concerned safe driving habits. It explained how to gain the public support for education, the making of effective laws, and the gaining of respect for safety in all the interests of the automobile driver.

Bradbury Thompson, Page from "The Art of Graphic Design," Yale Univeristy Press, 1988.

Bradbury Thompson, Love Stamps, 1984.

Bradbury Thompson, Indian Art Stamps.

Lindenmeyr Paper Company logo.

Letter forms can be varied in many ways. Each change in the form seems to give the letter a different "personality."

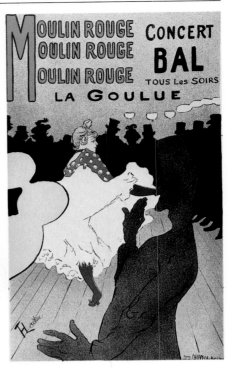

Henri Toulouse-Lautrec, *Moulin Rouge, La Goulue*, 1891. What kind of event does this poster advertise? How would you describe the overall feeling it communicates about the event?

Idea Sources

Ideas for graphic design are as varied as the purposes of visual communication. Many visual communications give us information. Others try to persuade us to support a person (political candidate) or a cause (saving endangered species). Some graphics are designed to identify places, products or services. A pop-up greeting card is designed to amuse us. A beautifully lettered poem may inspire us.

Graphic designers always ask three main questions to get ideas for their work. The first question is: What is the message to be communicated? Exploring the message can often be important. For example, if the basic idea is to remind people to take care of the environment, you can explore specific ways to do this (neighborhood cleanup, recycling waste and so on). Each idea may suggest others.

In many graphic design problems, a group of people will explore ideas in this way. The process is often called "brainstorming." In brainstorming, you come up with as many ideas as you can, even if they seem odd or silly.

The second question designers ask is: Who is the audience for this message? Some messages are for everyone – the general public. Others are aimed at specific groups such as teenagers, car drivers or people in one neighborhood. Still others may be designed just for one person, such as a card for your best friend's birthday. Can you explain how ideas for a graphic design might be influenced by thinking about the audience?

A third question to ask is: What kind and style of graphics will best communicate the message? Graphics can be posters, billboards, handbills (letter-size paper) or advertisements in a newspaper. They can be planned for printing or as unique handmade designs. The style may be formal or informal, realistic or abstract. All these decisions are part of the process of getting ideas for graphic design. Can you explain why these three questions are important to answer before you settle on a graphic design?

Look through the rest of this chapter for some graphic design activites to explore. Some may be class assignments. You might try others on your own.

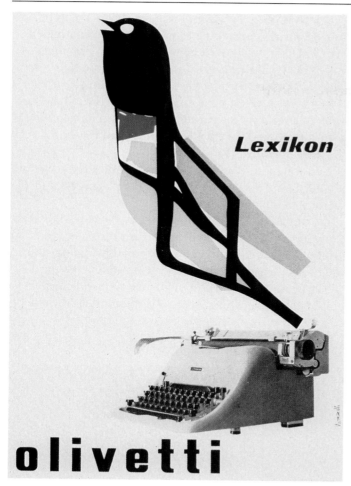

Marcello Nizzoli, Poster for Olivetti, Lexicon 80, 1949.

Marcello Nizzoli, Sketches for poster. The bird form appears in the poster because it influenced the design of the typewriter case.

Marcello Nizzoli, Sketch for poster ad.

Designing Graphics

Graphic designs are usually planned by making many thumbnail sketches of ideas. The best ideas are then selected and developed into several rough layouts.

A rough *layout* shows the general placement of type (lettering) and any illustrations. In a layout, the aim is to work out the overall composition. You also try ideas for lettering styles and color. Often, the lettering is sketched within guidelines.

Sometimes the layout can be planned by a collage method. In this method, the main elements of the graphic design are sketched on separate pieces of paper. Each element can then be moved around quickly to explore different designs.

For example, lettering can be done on a narrow band of paper. The whole strip can then be moved up or down, left or right, to see how it fits with other elements. You can cut the strip of lettering so the same words can be arranged in several lines.

You can also create sketches of illustrations on separate papers. Try them in various shapes and locations. For example, if your design includes a flower, you could sketch it in several sizes on different shapes of paper (a circle, a tall rectangle, a triangle). You can paste the elements down or record the best ones by placing tracing paper over them.

Graphic designers often use the collage method. Sometimes they draw the visual elements on tracing paper so they can see how parts of the design might overlap.

As you develop your layouts, remember to use the principles of design. Use them as questions to evaluate your layouts. For example, would a symmetrical or asymmetrical balance be best for my message? How can I unify the design? What visual elements should I emphasize? Do I have a definite path of movement for the eye to follow? Are the proportions right for the message? Refer to Chapter 2 for other questions you should ask about the elements and principles of design.

Posters

Many important ideas for graphic design are illustrated in the problem of planning a poster. Posters may be vertical or horizontal in format. They can be as large as a billboard or as small as a handbill (letter-size paper). Some are designed to fit a specific space such as the side of a bus, a counter top, or a school bulletin board.

A good poster catches your eye from a distance. It communicates important information quickly. It has a simple design and slogan. A *slogan* is a brief title or message that attracts attention.

If the poster is an announcement for an event, it tells you: what the event is (title), where the event will be held, when it will happen (the dates and time), who is sponsoring the event, and how much it may cost.

Planning a poster

Decide on the subject and facts you want to display. Determine the size and shape of the poster and the medium you will use for the final version.

Begin by making many thumbnail sketches of ideas. A thumbnail sketch is small. About 2" x 3" (5 cm x 8 cm) is a good size for poster ideas. Use pencil for these sketches.

Sketch simple horizontal bands to show bold lines of type. Use lighter lines to suggest smaller type. Sketch only the large simple shapes of the illustration or picture.

Refining your ideas

Choose one or two of your best ideas. Now do several sketches about 5" x 7" (13 cm x 18 cm) to refine your ideas and design. Some combinations of design elements and principles may help you communicate your message better than others.

Here are some ways you might refine your design:

1. STYLE AND SYMBOLS. Think about the overall style of your poster and the symbols. Do you want the viewer to think of the event or topic as lively and fun? Serious and urgent? Dignified and quiet? Super exciting? Try several combinations of elements and symbols that will fit with the mood or feeling you want to communicate.

2. BALANCE. Try two sketches of one idea. Use symmetrical balance in one. Use asymmetrical balance in the other. Which sketch is more effective? Why?

3. EMPHASIS. Try at least two ways to change the emphasis in your design. You might emphasize the lettering in one sketch. Make it large or bold. You might add color to the letters or the background.

In a second sketch, you might emphasize the illustration. Try making the main parts simple and large. You might exaggerate the size of parts or put a colorful negative space around them. Which sketch is more effective? Why?

4. MOVEMENT. Try several ways to set up a path of movement. Try arranging elements around an implied arrow leading toward the center of interest (the main words or the illustration). Use color harmonies or a flowing rhythm to guide the eye to the main elements.

5. UNITY. A cluttered poster is hard to read. Make sure you try several ways to unify your poster. For example, plan some open space between the letters, the words and the lines of words.

You might unify the work by using one large shape or related colors for the main words. Try placing related words in a separate shape.

6. COLOR. Try several color schemes for your best idea. Remember that warm, cool and neutral colors have symbolic meaning. For a monochromatic scheme, you might add bright accents in a different hue.

Try colors based on complements, split complements or an analogous color scheme. Another possibility is a color triad along with some neutral colors.

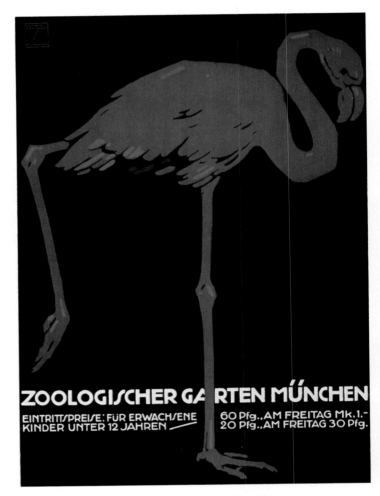

Ludwig Hohlwein, *Zoological Garden*, 1912. Münich.

7. LETTERING. Choose and arrange lettering so it is easy to read. Horizontal lettering is usually the easiest to read.

Think about letter styles that go with your message. Letters may be all capitals (uppercase), all small letters (lowercase), or a standard combination of these. The letters can be condensed (narrow) or extended (wide). Letters may be bold or thin, straight or slanted, with *serifs* (tags) or *sans-serif* (without tags).

Sketch the lettering on a temporary strip of paper marked with guidelines. The strip will let you try several placements of one whole line of words.

You can also cut the strip to see how words might be grouped into meaningful units. You might try to create custom letters that illustrate what they mean (the letters for a word like "jazz" might have irregular edges).

Creating your final poster

Choose your best sketch. Judge it with some classmates. Be sure to ask yourself these questions: Which design is easiest to read? Which has the most important idea? Is the idea clearly presented? Will the design attract attention? Is all the important information included? Is it properly spelled?

To begin your final poster, enlarge your best sketch onto a sheet of paper. The paper should be the size of the poster. (If almost all your poster elements will be cut from paper and pasted down, you can skip this step.) With a soft pencil and light lines, trace your design on to the poster board or draw light guidelines around the elements you will paste down.

Complete your poster. Tempera paints, cut paper, markers and watercolors are possibilities. After the work is finished and dry, erase any guidelines.

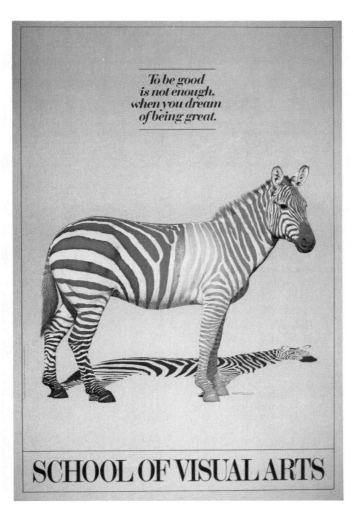

Simplicity is often the key to a successful poster. What ideas are communicated by the slogan, combined with the image of the zebra? Poster for the School of Visual Arts.

Rafael Martanez, Poster for the film "Lucia," 1968. The bold, stylized shapes and strong color contrasts are eye-catching elements in this poster. What other design qualities attract your attention? Designed for the Cuban Film Institute. Silkscreen. Courtesy of the Center for Cuban Studies, New York.

Stan Brod. Carefully planned curved forms are the main ingredients of this logo.

Stan Brod. The reversed p in this logo helps to create a simple tree form. Leaf-like forms and an eye are symbols for attending a theater in the park.

The symmetry and careful use of positive and negative shapes make this design effective.

Other Ideas to Explore

Visualizing Words

Typography is the art of designing and using different styles of type. Sometimes the shapes of letters and overall design of a word can help to illustrate its meaning. For example, the word "ice" could use letter forms that look like chunks of carved ice. The word "flower" could have letters that resemble flowers.

Look through some picture magazines or newspapers for examples of letters designed to illustrate what they mean. Sketch other examples that you see in your community – on billboards, posters, or signs.

After you have studied these examples, select a word that has special meaning to you. Create an illustrated version of it showing the meaning. Plan the shape of each letter and the spacing between them. Some of the letters might be shaped so that they are illustrations. The letters might be unified by a common background illustration.

Make several sketches first. Evaluate them for contrast, emphasis and meaning. Choose your best design to render (present) in a final form. You might render the artwork using India ink, felt tip markers or another medium.

For a challenge, you might present your design in a three-dimensional medium or one with many textures.

Dd

dinosaur

Dorothy Schmiderer. Original art for The Alphabeast Book, 1971. Transforming letters into recognizable forms is one of many fascinating graphic design ideas. Courtesy of the artist.

abcdefghijklm
nopqrstuvwxyz
ABCDEFGHIJKL
MNOPQRSTUVW
XYZ

You might use this sample alphabet to practice calligraphy. The mark next to the letter a indicates the height of letters in relation to widths of the pen nib.

Calligraphy

Calligraphy, which means beautiful writing, was once the major way people in ancient times recorded important ideas in books, scrolls and other documents.

In Japan, there is a long tradition of practicing calligraphy as a form of self-discipline and meditation. It is considered a skill that all strong, gentle people should develop. In Arabic and Oriental cultures, the letters of the alphabet are so complex that calligraphic skills are needed just to write simple sentences.

During the Medieval period in Europe, monks and nuns in monasteries carefully hand-lettered copies of religious books. Beautiful, complex illustrations often surrounded the first letter on the page or the border of the page. Such books are called illuminated manuscripts.

Today, clear handwriting is still valued in all walks of life. Clear, beautiful writing is practiced by calligraphers – artists who specialize in handwritten messages.

For practice, use a calligraphy pen with a medium nib and chisel point. Make the height of capital letters about seven times the width of the pen nib. The height of lowercase letters should be about five times the width of the nib.

Draw parallel lines as guides for practice or use lined notebook paper. Develop your skill in making diagonal, vertical, horizontal and curved strokes. Then practice combining them to create letters. Be sure to hold your pen at a constant angle and pull the nib toward you.

Use your skills to letter a short poem, quote or message that has special meaning to you. With a pencil, draw very light guidelines and create a layout for the words. Leave extra space between the letters and lines to allow for the larger width of the pen nib. Check your spelling!

Do some practice strokes on scrap paper to build up your rhythm. Then letter your final version.

Calligraphy means beautiful handwriting. Title page for a book of writing hands, Nürnberg, 1665.

Crests with Visual Symbols

A crest is a form of graphic design first developed for noble families and groups organized for a special purpose (religious, political, economic). For example, in Europe a lion became a visual symbol for the strength of royal families.

In China, a beautiful mythical bird was the symbol for the Empress. A five-toed dragon was a symbol for the authority of the Emperor. Crests have often been used on flags, banners, shields or smaller things such as medallions and rings.

Most crests have an overall symmetry. Sometimes the borders or the central design are also symmetrical. The overall shape is often a circle, an ellipse, a square or a triangle.

Think about visual symbols for a crest for your family, your school, a club or another group. You could even design a crest just for yourself.

Make sketches of the visual symbols you might include. Choose your best symbols and plan the crest within a simple background shape. The shape might be a circle, triangle, or the shape of the main visual symbol in your crest. Develop your design from the center outward or from the border inward.

Make sketches in pencil or cut paper. To create symmetrical shapes, draw part of the design and then fold your paper in half (or in quarters). Draw with a soft pencil so you can transfer the design to the other sections by rubbing the back of the paper.

Use a color scheme and choose a medium that fits the meaning of your design. For a simple, bold design you might create a collage. What media would be appropriate if the design has many fine details?

Animals have often been used as symbols in family or royal crests. Why?

Adrinkra symbols. Clockwise from left: hene, symbol of royalty; Aya, symbol of defiance; Hye wo nhye, symbol of forgiveness; Fihandra, symbol of safety or security in the home; Akoma, symbol of patience and endurance; Dwanfmen, symbol of strength.

This yin-yang symbol from the Zen religion captures the idea that complementary forces (such as sadness and happiness) are always present in our life.

Heraldic Tapestry, French, 17th century. Heraldry developed in the Middle Ages in Europe to identify families, clans, and other groups. Colors and symbols were used on banners, shields, and many other items. Silk, 50 1/2" x 52" (128 x 132 cm). The Metropolitan Museum of Art. Rogers Fund, 1913.

Illustration

Graphic designers use illustrations of many kinds. Sometimes they create these illustrations themselves. Often, they select the work of a free-lance illustrator.

A *free-lance illustrator* is one who is hired by many different companies to do specific illustrations. Some illustrators specialize in cartoons, comic strips and other funny illustrations. Others write and illustrate picture books for children. Some illustrators specialize in using one medium, such as airbrush.

Many illustrations you see in ads, books and magazines are photographs. Some photographs of products are retouched (changed) with an airbrush or line drawing. Retouching can let you to see a product's interior and exterior. It also helps to present something in a more ideal form than the typical one (a "perfect" hamburger, not a typical one).

Collect some examples of illustration from newspapers and old magazines. Cut them out and classify them by general style and medium. Identify effective and ineffective examples. Explain how you made your judgments.

Identify one of your favorite poems or write an original one. Carefully letter or type it on a sheet of paper. Create an illustration for it. Use a medium of your choice. If you have access to a computer and software, you might use it to create your illustrated poem.

In the library, find children's books that have received the Caldecott Award for illustration. Select one that you think is well illustrated. Write a report to explain why you think the illustrations are effective.

Lena Anderson, Cover of "Linnea in Monet's Garden," 1985.

William Blake, *The Tyger*, a page from "Songs of Innocence and Experience." William Blake wrote and illustrated many poems. Are you familiar with this one? Relief engraving printed in color, 4 3/8" x 2 11/16" (4 x 7 cm). The Metropolitan Museum of Art. Rogers Fund, 1917.

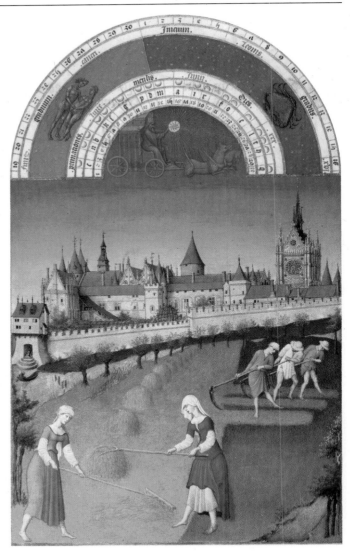

June, from "The Duke of Berry's Book of Hours" by Pol de Limbourg. This painting with signs of the zodiac at the top is from a medieval calendar book. Each painting depicts activities associated with a month and season. Courtesy Museè Cond, Chantilly, France.

Calendars

Almost every culture has some system for measuring and recording time. Most systems were based on seasonal changes, observations of star movements, or important ceremonies.

The first calendars were often organized around a series of symbols carved in stone or impressed in clay. The Mixtec people of Mexico created a folding book calendar in which they recorded days that might be protected by their rain god.

Calendar-like paintings with zodiac signs were created in Medieval times. These evolved into elaborate calendar books of paintings for the French aristocracy.

Calendar designs are an interesting graphic design problem. New calendars are usually designed a year in advance and sold for several months just before and after the new year begins.

Calendars vary in form from pocket-size to wall-size. Some are designed so you can enter the month, day and date. Some are organized to show one day at a time. Others have pages that show a full week, a full month or a full year. Many include reminders of national holidays and illustrations.

Your class might design a calendar as a project. Choose a general theme and format for the whole calendar, then work in small groups on pages for each month. You might create a master design for one month (without dates) and photocopy it as a basic layout. Each small group might be responsible for illustrating the month and adding the correct lettering (such as dates and holidays).

The design of this salt container has changed over the years. What are some of the changes you see? Why do you think they were made?

The design on each side of a package is important. Why? Designed by Noel Mayo and Associates, Inc.

Package Design

Package design is an important branch of graphic design. Businesses depend on graphic design to help sell their products. Packages in a supermarket or department store compete for your attention. Often the products inside are similar. Some people choose a product just by the package.

Many package designs are printed labels that fit on a standard size of container (can or box). Other packages are custom designed and have an unusual form. The package designer may invent a three-dimensional display case to hold the product.

Most package designs are clearly identified on the front, back and sides. In this way, the consumer can identify the product no matter how the package is stacked on a shelf.

You might try redesigning a package for a boxed product. You can do this by carefully releasing the glued sections of an empty box. Use the original box as a template. Trace the outer edge of it on stiff paper. Create your design on the stiff paper.

After your design is complete, fold and paste it into a box form. You could also glue paper to the flat box, create your design and then reassemble the box.

You may prefer to design a container with a distinctive form. Plan it with paper. A ruler and compass may help. Work out the structure and decide where the container will bend or fold. When your paper template is satisfactory, create another version in a stiffer paper.

You might enjoy making a new or satirical package design for a product you invent. A satire is a form of humor that pokes fun at the claims made by someone (or some product).

Milton Glaser, Grand Union Supermarket, 1980, Exterior. Courtesy Milton Glaser, Inc., New York.

Milton Glaser, Grand Union Supermarkets-Corporate identity scheme. The graphic designer sets up the plan for the use of the company name and logo in a variety of forms—building signs, brochures, uniforms, trucks, and the like. Courtesy Milton Glaser, Inc., New York.

Other Activities

Visit a modern printing plant and learn about the mechanical process of printing. Observe the stages a printed publication goes through: First the making of printing plates, then the actual printing process, then the trimming, binding and packing for shipment.

Obtain samples of printed cloth, woven cloth and dyed cloth. Explain how you can tell the difference between a printed design and a woven design. Contrast wood, stone, brick and tile designs printed on Formica or contact paper with real samples of wood, stone, brick and tile.

Visit the studio of a local graphic designer or invite a graphic designer to the classroom. Ask the designer to describe his or her work and to share examples of layouts or mechanicals prepared for printing.

Cut out advertisements for grocery stores. Which is the easiest to read? Which is the hardest? Why?

Collect examples of contemporary graphic design from Japan, Germany, China, the Soviet Union and the Scandinavian nations. Look for advertisements in foreign magazines, labels on foreign products, etc. Identify the symbolic components you can understand even though you cannot read the written language.

Develop your skills in graphic design using a bulletin board. Learn how to put up papers or pictures so that they line up vertically and horizontally. Obtain or cut out large letters for titles. You might type smaller captions. Test the effect of the bulletin board from near and far distances.

Get several sheets of transfer type, a dry, rub-on lettering used in commercial art studios. Practice using it to achieve proper alignment and spacing of letters. Create a personal letterhead with the transfer type. Have your letterhead stationery printed in a nearby vocational school or a local printing company. You could even use a good photocopy machine.

Visit a gas station or fast-food restaurant. List all the products and objects on which the logo of the company appears. Notice whether the company colors are used on the building, uniforms and the like. How do these things strengthen the company's visibility? Now imagine you are an adult who owns a company. After deciding on your business philosophy, and the products or services you will sell, design a logo and make sketches to show the variety of places you would display it.

Student art.

Student art.

Student art.

Student art.

Student art.

Student art.

Summary

Graphic design is a visual art form that you encounter every day. Graphic designers plan a variety of images that have type (lettering) as an expressive element. Among these are posters, book and album covers, signs, billboards and many other items with words as expressive elements. Some graphic designers specialize in surface designs for cloth, wallpaper and the like.

Graphic designers prepare layouts—type, illustrations and other details of the design. The final design is then printed, usually by technicians who operate high-speed presses. Graphic designers are especially concerned with the clarity, spacing, interest and unity of their work. These qualities are essential for visual communication.

Logos are visual symbols that identify a corporation, group or agency. In a corporate identity program, a logo appears on a variety of items made by or used within the company or agency.

Graphic design is an outgrowth of a long tradition of calligraphy, illuminated manuscripts, handmade books, and printed surface designs. With the Industrial Revolution, the demand for printed publications and advertisements increased.

By the twentieth century, this demand was so great that schools were set up to train graphic designers. One of the most important of these was the Bauhaus in Germany. Its teachers helped to start an international interest in graphic design as a form of art.

Using What You Learned

Aesthetics and Art Criticism

1 Briefly define or illustrate these terms:

- *graphic design*
- *logo*
- *typography*
- *corporate identity*
- *layout*
- *serif*
- *sans-serif*
- *free-lance illustrator*
- *slogan*
- *crest*
- *calligraphy*

2 Identify at least four characteristics of an effective poster design.

3 From an old newspaper or magazine, cut out two advertisements for the same type of product (for example, two grocery store ads, two automobile ads, two furniture ads). Prepare an evaluation of both. Clearly identify at least four criteria you will use in judging the ads.

4 List ten forms of graphic design you see every day.

Art History

1 What was the Bauhaus? How did it have an influence on graphic design?

2 For what is Johann Gutenberg famous?

3 Who is credited with inventing the idea of a logo as one element in a larger corporate identity program?

4 Identify at least three forms of calendar that were developed before the twentieth century.

5 In what cultures has calligraphy been a highly developed form of art?

Creating Art

1 Select your most effective graphic design. Describe and analyze its major strengths and weaknesses in relation to (A) originality in concept or idea, (B) effective design in relation to purpose, (C) appropriate choice and skillful use of a medium, (D) overall crafting.

2 In this chapter, you have learned about a variety of graphic design activities. Select one of the activities you find most interesting. Complete an independent original project that demonstrates your skill in graphic design.

Henry Holmes Smith, *Small Poster for a Heavenly Circus*, 1975. Dye transfer print, 12 ⁷/₈" x 9 ¹¹/₁₆" (33 x 25 cm). Henry Holmes Smith Archive, Indiana University Art Museum, Bloomington, Indiana. Photograph by Michael Cavana Montague.

Chapter 11
Camera and Electronic Arts

Chapter Vocabulary

photography
negative
positive
transparency
lens
aperture
depth of field
photogram
blueprint
cinematography
video art
animation
special effects
computer hardware
computer software
holography

You have probably spent many hours watching television and movies (motion pictures). Television and motion pictures are often called time and movement arts because these two design elements are so important in them. You have also seen hundreds of thousands of still photographs in color or black and white.

Still photography, motion pictures and television are among the most common forms of art seen by people in industrial cultures. There are wonderful opportunities for personal expression in these media. They are major forms of expression for many twentieth century artists. Some people think these art forms have changed our sense of time, place and reality.

In addition to these camera arts, computers and other electronic media are becoming important means for creating art. Electronic media include lighting of all kinds–neon, fluorescent, lasers–as well as combinations of equipment such as audio tapes, projectors and computers.

In this chapter, you will learn more about camera and electronic arts. If you can do creative work in these art forms, your teacher will provide the necessary technical instruction. You may have skills in photography, video work or computer art that you can teach your classmates or use on your own. Some community and recreation centers offer classes in video and photography.

Most schools have started computer classes or will have them soon. Even if you cannot use cameras and computers in school, you will probably eventually own or use this equipment. Many steps in using a still camera also apply to cameras for making movies and videos. Some of your knowledge about television also applies to computer images. You should know some of the basic steps in using a camera and a computer for creative art. This knowledge can help you appreciate these new forms of art.

After completing this chapter, you should be better able to:

Art History and Aesthetics
• understand and appreciate camera and electronic arts.

Creating Art and Art Criticism
• use appropriate terms and concepts in creating and responding to camera and electronic arts.

Gallery

Camera and electronic arts include still photography, motion pictures, video and computer-assisted art. It also includes the use of lasers and other forms of electronic technology to create art. Because technology is changing rapidly, the artists who work with it are constantly facing new challenges.

Critical Thinking What forms of new technology do you know about? Which ones could be used for artwork? Why do you think so?

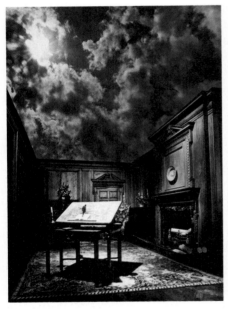

Jerry Uelsmann, *Untitled,* 1976. This surrealistic photograph was made by combining two film negatives to create one print. Why is it surrealistic? Photograph, 15" x 20" (38 x 51 cm). Copyright Jerry Uelsmann.

David Hockney, *Stephen Spender-Mas St. Jerome II,* 1985. This artist has combined "instant" photographs into a collage. How is this work similar to Cubism? Photographic collage, 20 ½" x 20 ¼" (52 x 51 cm). Copyright David Hockney, 1990.

Michael J. Campbell, *Laser Beam: Fantasia.* These photographs are a record of a light show. During the show, the intense pure light of laser beams "dance" on the wall.

Dara Birnbaum, *Will-o'-the-Wisp*, 1985. Many artists are exploring video art. Their work is usually very different from commercial television. Here you see television images on three sets and another image projected on a curved wall. Video installation, 144" x 438" (366 x 1112 cm). The Carnegie Museum of Art, Pittsburgh. Gift of Mr. and Mrs. Milton Fine and the Carnegie International Acquisition.

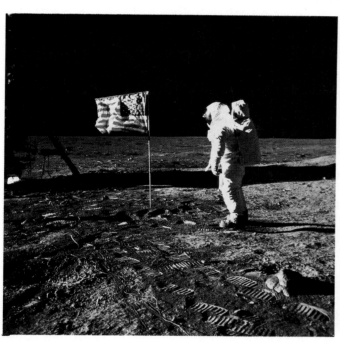

Edwin Aldrin Salutes the American Flag on the Moon, July 20, 1969. Photograph courtesy of UPI/Bettmann.

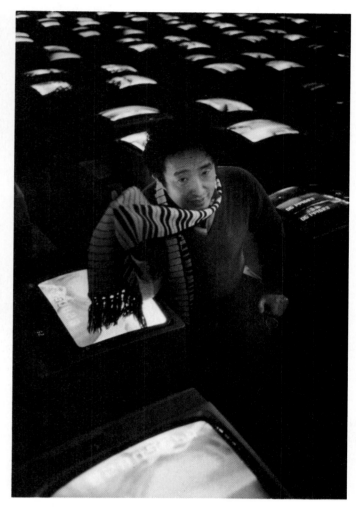

Nam June Paik with Tricolor Video, 1982. Nam June Paik has created video art for over 30 years. He is especially interested in televised images as one element in sculpture. Courtesy Gamma Liaison, New York. Photograph by Jean Claude Francolon.

Sam Sheere, *Hindenburg Disaster, Lakehurst, New Jersey,* 1937. Photographic records of events and places have been made for about 150 years. How did people create visual records of history before the invention of photography? Photograph courtesy of UPI/Bettmann.

Charles Csuri

1922-

An artist sits in front of his work, imagining the next mark he will paint. But this artist's "canvas" is a computer screen, his "brushes" are a keyboard and special computer software, and his "palette" is his great knowledge of computers.

Charles Csuri creates exciting and colorful images of figures, animals, unusual spaces and places. He uses a network of computers at Ohio State University, where he has been a teacher for over 40 years. Csuri works alone and with students to produce a variety of abstract and realistic graphic images. But this process is hardly "work" for this artist. "After twenty five years," he says, "the computer is finally my visual instrument, as I play it, to make art."

Csuri first became interested in art when he was only ten years old. Visits to museums fascinated him, so his brother encouraged him to take art classes.

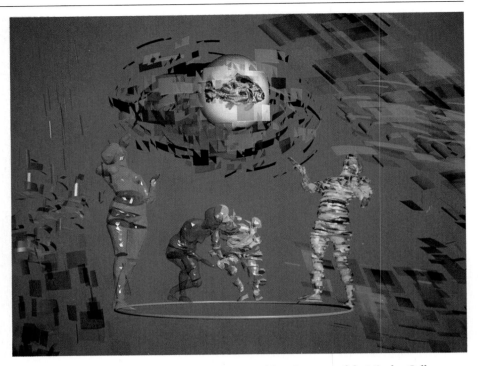

Charles Csuri, *Fragile Fantasy*, 1990. Computer graphics. Courtesy of the Nicolae Gallery.

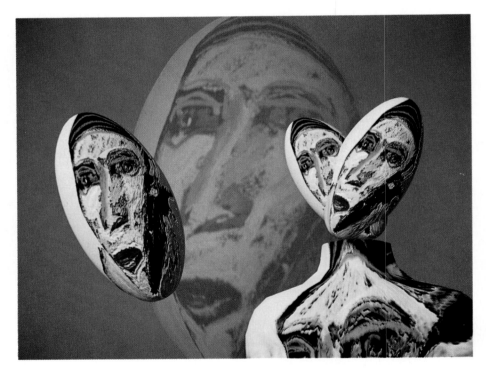

Charles Csuri, *The Mask of Fear*. Computer graphics. Courtesy of the Nicolae Gallery.

Eventually, Csuri decided to study art at Ohio State University. He focused on art for many years, even while playing tackle as an All-American football star. Csuri continued to exhibit his traditional paintings in New York City for ten years.

Then he discovered computers. Csuri experimented with computer programming and technology to learn as much as he could about what computers are able to do. He then put that knowledge to work. He developed techniques to create computer pictures that seem three-dimensional. These images look like they are made of thick paint, charcoal, wood, metal and glass.

Csuri continues to learn today. "My experimental approach with the computer leads to some failures," he admits, "but it is also a wonderful opportunity for the expression of my feelings and concerns." Looking at the wide variety of "paintings" he has created, you can see that his approach is successful.

Csuri is busy developing new computer art and technology. But the excitement of working with students and other computer experts also keeps him occupied. He says he loves the supercharged atmosphere created by people working together, encouraging and inspiring each other. These qualities, together with a strong desire to make things happen, helped to make Charles Csuri one of the leading computer artists today.

Critical Thinking Csuri uses advanced technology and computers to make images which look like they were created with traditional art materials. Brushstrokes of thick paint are just one example of the variety of marks which he makes with his computers. Why do you think Csuri chooses to use a computer when he can use real paint, charcoal, wood or glass?

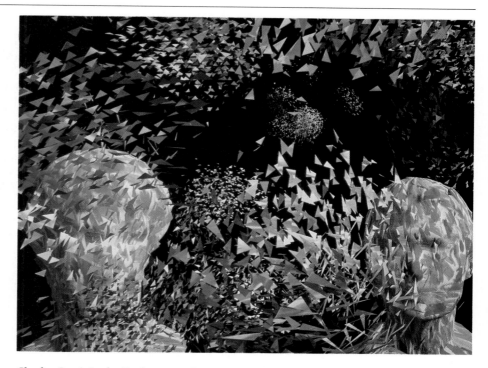

Charles Csuri, *In the Garden,* 1990. Computer graphics. Courtesy of the Nicolae Gallery.

Photograph of Charles Csuri and computer generated image.

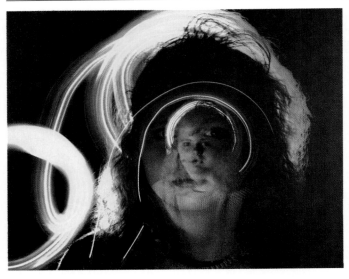

Subjects you see in everyday life can be artfully photographed. Why do you think this photograph and the one on the right are considered works of art? Student art.

John Wawrzonek, *Spring Sunrise III*, 1987. Dye transfer print, 20" x 24" (51 x 61 cm). Courtesy Color Three Associates, Worcester, Massachusetts.

Photography

Photography is a young art. Invented in 1826, it has a fascinating history. Most people were amazed at the realism of photographic images of people, places and things. More than any other medium, the camera provided an accurate and rapid way to capture "real" images.

Photography is both an art and a science. Almost everyone can put film in a camera, aim it and click the shutter. The art of photography comes from the selective eye of the person who uses the camera. It comes from a knowledge of design and techniques for using cameras, films, light sources and printing procedures.

The science of photography begins with light. When you snap the shutter-button on a camera, light enters the camera for a fraction of a second. The light strikes and changes the chemical coating on film. These changes are latent (invisible) until the film is developed by a chemical process.

In the developed film, called a *negative,* the latent image can be seen, but everything is reversed. Black is white and white is black. To make the print, you must use light-sensitive photographic paper. The paper is exposed to light rays sent through the negative. This reverses the whites and blacks so your print is now a *positive:* it represents the light and shadow in the original scene.

Some photographs are made by an "instant" (one minute or less) developing process. The chemicals and dyes to develop the image are manufactured into the film. After you snap the shutter, the developing process begins automatically. "Instant" film is available in color or black and white.

Color photography has developed rapidly since the 1950's. Color photographs can take two basic forms. The first, called a color *transparency*, is a film positive. It can be a slide, filmstrip or movie. These are seen when light is projected through them.

The second form is a color print made from a color negative. In the color negative you will see complementary colors (a blue sky will look orange). The printing process reverses the color so the final print looks "natural."

Using a 50 mm lens. Photo-
graph courtesy of Verna E.
Beach.

Using an 400 mm lens.
Photograph courtesy of Verna
E. Beach.

Using a 105 mm lens. Photo-
graph courtesy of Verna E.
Beach.

There are many ways to hold a camera steady. Try using your arms
and body or other structures as a support.

Creating and Printing Photographs

Most forms of photography involve the use of a camera
and some knowledge of printing techniques.

Basic Camera Skills There are several basic skills in
using any camera, including movie and video cameras.

1. Make sure the film fits the camera and is suitable for
the images you wish to create. The speed of the film is
rated by a number (ASA 125, 200, 400). The higher the
number, the more light-sensitive the film. To make
photographs in dim light, use film with a high ASA
rating.

Color film is made for daylight (outdoors) or tungsten
light (indoors). The color of prints, slides or movies is
distorted if the wrong film is used.

2. Hold the camera steady with your hands and hold
your elbows close to your body. You can also support the
camera on a tripod.

3. Frame the image within the viewfinder. Aim the
center of the camera lens toward the subject you wish to
photograph. To show more space around the subject,
move away from it.

4. Focus the image. Most cameras have an adjustable
focus. To adjust the sharpness of the image, look in the
viewfinder while you turn the focusing ring.

Camera and Lens Types For still photography, there
are many types and prices of cameras, but even a simple
box camera can be used creatively. With a Polaroid
camera, you can see your photographs in one minute or
less.

Most artists use cameras that accept different *lenses*. A
standard lens (50mm) imitates perspective as the eye
normally sees it. Most cameras come equipped with a
50mm lens.

A *wide-angle* lens includes more of a scene than the
eye normally sees. A *telephoto* lens captures part of a
distant scene so it seems close to you. A *zoom* lens has all
these features in one adjustable structure. Special lenses
are used for close-ups and other technical work.

Masumi Keesey, Peacock feather. The artist printed this color photogram by placing fabric and a peacock feather on photo paper, exposing it to light, and developing the print. Photogram, 8" x 10" (20 x 25 cm).

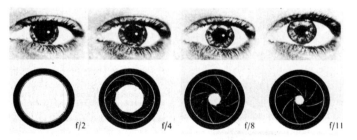

f/2 f/4 f/8 f/11

The aperture of a camera can be opened or closed, like the human eye, to control the amount of light that strikes the film.

Using Adjustable Cameras On adjustable cameras there is an *aperture* control (f-stop). This control determines the amount of light that enters the camera and hits the film. The size of the aperture is measured in f-stops. You can adjust the camera aperture for bright light (about f/11), or dim light (about f/5.6).

The f-stop also controls the *depth of field*. Depth of field refers to how much of what the camera "sees" is in focus. Adjustable cameras have a depth-of-field scale that tells you, for every f-stop, how many feet of sharp image you can expect to record.

The shutter allows light to strike the film. The shutter speed control determines how rapidly the shutter opens and closes (registered in fractions of a second). Suppose you wish to photograph a person riding a bike. If the shutter is set at $\frac{1}{30}$ of a second, the bike will move while the shutter is still open and the film will record a blur. At $\frac{1}{500}$ of a second, the image of the bike will be clear.

The shutter speed and aperture setting determine how much light you record. Most films include charts that tell you how to set f-stops and speeds for different lighting. Your images may be overexposed, underexposed or blurred if you choose the wrong settings.

Darkroom Techniques and Photograms With a darkroom, you can print black-and-white photos from negatives. If you will create photographic prints in school, your teacher will provide information about the steps for printing your negatives. You might crop your negative—print only part of it—to improve the composition. You can also combine two negatives for a surrealistic or fantasy print.

In a darkroom, you can also create *photograms.* Photograms are silhouettes made on photographic paper without a camera. To create a photogram, arrange objects on a piece of clean glass. In the darkroom, place a sheet of photographic paper underneath the glass. Expose the paper to a bright light for about half a minute. Develop the print in a darkroom using the standard process for developing black-and-white prints.

Safety Note For safety and for good photographs, you must follow all rules for darkroom work set up by your teacher. Safety is essential because photographic chemicals can irritate your skin and lungs.

Blueprints Photograms can also be created on *blueprint* paper (used for architectural plans). The print can be designed and processed in any dimly lit room. Arrange items on the paper. Expose the design to bright sunlight or a 100-watt bulb until the paper becomes gray.

Develop the blueprint in a solution of water mixed with a few drops of hydrogen peroxide (a 3% solution, purchased at a drug store, commonly used to clean wounds). A 3% solution of hydrogen peroxide does not irritate normal skin or lungs.

Cameraless Slides

Cameraless slides can be made from exposed 35mm film. Images can be made by laminating or drawing directly on the film. The film is placed into paper or plastic slide mounts from a photo shop.

Remove the emulsion on the exposed film by soaking it overnight in a half-and-half solution of bleach and water. Rinse and dry the film. Cut it to fit the mount.

For lamination, use two pieces of film. Insert colored cellophane, tissue paper or fine threads between the pieces. Add marker ink if desired.

To draw directly on film, first rub the whole surface with a hard eraser. The surface will accept water-based markers or acetate inks. Fine scratch marks, made with a pin, can be added to solid areas of the ink.

Use an iron to enclose the film in a paper slide mount. Plastic mounts have a clip or a slot into which the film is inserted. Make sure any wet ink is dry before the slide is projected.

Preparing a slide.

Closing the slide mount.

Student art.

Projecting a slide.

With blueprint paper, you can create a photogram in dim light. It can be exposed to sunlight and developed without expensive equipment.

Student art.

Flip books are a way to explore the idea of motion pictures without the use of a camera.

A simple zoetrope

Cut an 8" (20 cm) circle from stiff cardboard. Use a compass so the center point is clearly marked.

Cut a 3" x 24" (8 cm x 61 cm) strip of white drawing paper. Mark it off at 2" (5 cm) intervals. Cut a slot 1" deep (3 cm) and about ¼" (6 mm) wide at each mark.

Create drawings between the slots. Make each drawing slightly different to suggest action.

Tape the strip to the base.

Place a thumbtack through the center into a pencil eraser.

Spin the drum and look through the slots.

Images in Motion

Cinematography

Cinematography is the art of making motion pictures on a long, continuous strip of film. The illusion of motion is created by rapidly showing a series of photographs, called frames. The picture in each frame differs slightly from the next. A typical film is shown at the rate of twenty-two to twenty-four frames per second.

Eadweard Muybridge invented an early device for projecting motion pictures. By 1902, Thomas Edison had invented the motion picture camera. George Eastman improved film technology so motion pictures could be made, although they were silent.

Talking movies were introduced in 1910. In the 1920's, Walt Disney pioneered the art of making animated films, based on separate drawings for each second of film. Color motion pictures were made in the 1930's.

Motion pictures are an art form that many people work on at once. A director, camera technicians, writers, actors, editors and sound specialists all help make a motion picture. Even so, this art form is basically visual. Most critics say that a good film should communicate with an audience even if the sound is turned off.

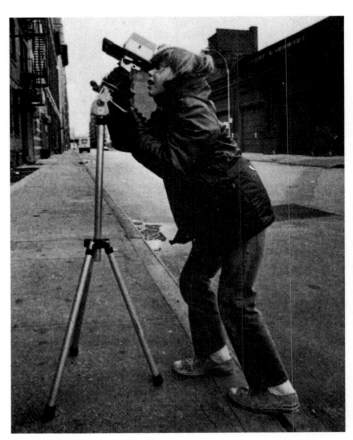

A tripod holds a camera steady so you can concentrate on the design of your shots.

Motion pictures are expensive to make. The film and equipment may not be available in your school. Even so, you can make early forms of motion pictures–flip books and a zoetrope–with only a few materials (see the diagrams on page 240). For the effect produced by a flipbook, rapidly flip pages 225 to 239 in the area close to the figure.

Video Art

Video art and filmmaking are similar in many ways. There are important differences too. Video systems come in various formats and are always changing.

Most video systems have four main components: a camera, a microphone, a recording device (usually a cassette of magnetic tape, similar to an audio tape) and a playback device (usually a television set). Most video cameras have an adjustable aperture, focus and zoom.

A video camera receives reflected light from a scene and transforms it into electrical impulses. The impulses strike particles on the magnetic tape and rearrange them. The images are stored on the tape as magnetic energy. The tape is not visibly changed and does not need to be developed like photographic film.

When the videotape is played, the stored impulses are transformed into sound and light waves. These waves are directed through the television tube, which shoots them onto the screen.

The screen on a color television monitor has many tiny dots placed in about 525 lines. The dots pick up red, blue and green light waves every $1/30$th of a second. What you see appears to be one continuous image. It is really like a dot-filled pointillist painting in electronic form.

Color video cameras and monitors have dials that allow you to adjust the hues toward red, blue or green. You can also change the intensity (level of brightness) in the image and the contrast in dark and light areas.

You have often seen distorted video images. A rollover or split in the image is corrected by adjusting a knob for horizontal hold. Diagonal lines are corrected by adjusting a knob for vertical hold.

Most video cameras and playback devices have speed controls. The reverse and forward controls move the videotape so rapidly that you cannot see an image. A scan lets you see the image at six times the normal speed. A frame advance moves the image forward so you can see single images.

Some video systems have a code on each frame that allows you to search for them by number. These controls are helpful in editing a tape.

Instructions for operating videotape machines are included with the equipment. If it is available, your teacher will provide instruction and will test your basic skill in using it.

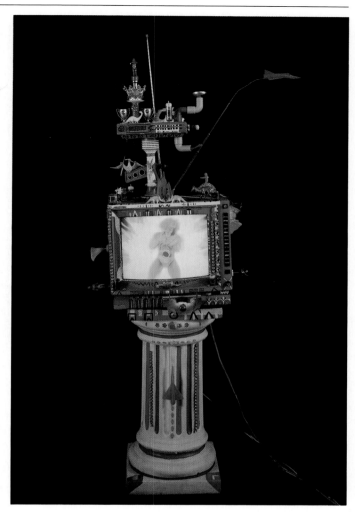

Kenny Scharf, *Opulado Teeveona*. Many video artists are interested in television sets and their moving images as sculpture. What images from history have been added to this set? Do you think television is a major art form in our culture? Why or why not? Acrylic, jewels, toys on Sony trinitron T.V. with plastic pedestal, 4'8" x 1'5" x 1'4" (142 x 43 x 41 cm). Courtesy of the Tony Schafrazi Gallery, New York. Photograph by Ivan Dalla Tana.

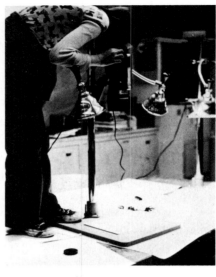

Animated films can be created by drawing directly on discarded 16 mm film in a free-flowing manner. For a structured film, draw pictures in the area of the frame. Photograph by Roger Kerkham.

A video or movie camera attached to a lighting stand can be used to create animations. The images to be animated are placed on the board below.

Animated Films and Videos

Animated movies can be made with or without a camera.

Cameraless animation is made by drawing directly on movie film. Most schools have a 16mm movie projector. At many film laboratories or television stations, you can get discarded 16mm film at little or no cost. Soak it overnight in a half-and-half solution of bleach and water. This removes the emulsion. Rinse the bleach off the film and let it dry.

Draw on the film with soft pencil, felt-tip pens or inks made for acetate. Most media adhere best if you first rub the film lightly with fine steel wool or a hard eraser. You can create a free-flowing abstract film by ignoring the exact spacing of sprocket holes.

For a 16mm film, you must redraw each image at least twelve times for it to be seen on the screen. One minute of 16mm film is about 36 feet (12 m) long. For your first film, create very simple images and movements.

Work in a hallway or on the floor with a team of several classmates. Place a roll of clean paper under the film. Unroll the continuous film in long loops or cut the film into sections about 10 feet (3 m) long. The separate sections of film can be spliced together to make a longer film. You might develop a story plot so team members can work sections.

If you want a structured animation, use a strip of leader film (with countdown numbers). Place it under the clear film as a guide. Draw inside the frames. Match the sprocket holes in the guide and the film.

Animation with a camera is usually made with a movie or video camera mounted on a tripod. A horizontal background paper about 11″ x 14″ (28 cm x 36 cm) is appropriate for most work. Surround the background with black paper. This will make small errors in the framing of shots less noticeable.

Use collage-like cutouts to create the animation. For example, draw and cut out a face along with four separate mouths in different shapes. Place one mouth on the face. Film it four to six times (single-frame button) and remove it. Place the next mouth on the face and film it four to six frames, and so on. Plan the shapes so the face seems to talk, shout, etc.

Oil-based clay is a wonderful medium for animation. Between shots, you can quickly change just a few parts (bend, reshape, add elements). You can also arrange ready-made objects (cans, pencils) for an animation. Other ideas will come to you after some experiments.

For smooth changes between major scenes, slowly adjust the aperture of the camera to darken the scene (fade out), then gradually bring light to the next scene (fade in). Many video cameras have a fade in/out feature. Titles and credits can be filmed while they are being written on a chalkboard. For an animated effect, cut and arrange paper letters.

With videotape, sound and images are recorded at the same time on a single tape. To add sound to a movie, show the film and introduce tape-recorded voice or sound effects. Turn on both machines at the same time to match the picture and sound.

Clay, wet sand, and other materials can be reshaped or rearranged for animations. Photograph by Barbara Caldwell.

The storyboard format shown here is an excellent way to plan the story line and visuals for an animated film. From the animated film "Animal Farm."

A film processing lab can put a blank magnetic stripe on movie film. An audio-visual technician can show you how to use the movie projector to transfer an audio tape directly onto the film. The sound will be on the film every time you show it.

Ideas for Camera Art

Anything you regard as beautiful or special can be a subject for camera art. Your work can be objective, subjective, imaginative or persuasive (fact-based but promoting one viewpoint more than another).

For still photography, consider portraits of your friends, family or pets. Photograph classmates playing sports, eating lunch, standing in line, waiting for a bus or walking home. Photograph one subject at different times of day or in different weather.

Explore imaginative ideas. Photograph inanimate objects like fire hydrants, plumbing connections and door fixtures. Some may remind you of people or animals. Try making double exposures or prints combining two images or negatives.

Try a documentary film, video, or photo essay (a series of photographs that convey a story, sometimes with a written essay). Begin with a broad idea such as friendship, loneliness, fear, pity, poverty or pollution. Explore the meanings of the topic and specific images to tell about it.

Try a time-lapse film or video. On a daily schedule, shoot four to six single frames of one subject such as a building being torn down or a plant growing. Shoot the subject from the same angle and distance. When you show the film at the regular speed, you will see the changes greatly speeded up.

Try imaginative stories, absurd adventures, or your own version of a famous myth or legend. Develop the characters and plot. Show the motivations of each character through appropriate gestures, words and relationships with other characters.

Use your sketchbook to draw and make notes about everyday events. Use them as ideas for films, videotapes, and photo-essays. Write down other notes (language, dress and interaction of people). Notes like this can remind you of photographs to shoot. They can also become a script for a film or video.

Design in Camera Arts

Design Elements in Camera Art

In photography, films and videos, you are composing and recording images. The images you compose will have qualities of *line, shape, form, texture* and *value* just as you would find in other art forms. If you use color film or tape, *color* will also be an important design element. Use all elements of design selectively.

The images you compose in any camera are called *shots*. Shots are described in relation to their implied distance and angle (see photographs below). In a film or video, a shot is a record of activity created from the time a director says "action" until he or she says "cut." "Action" means the camera is on and recording. "Cut" means stop the action and stop recording it.

A film or video shot also has movement. A *zoom* is a movement from a long shot to a close-up or the reverse. In a *horizontal pan,* short for panorama, the camera view moves from left to right (or right to left) often to follow an action such as a person running. In a *tilt pan*, the camera view follows a vertical or diagonal line such as the flight of a bird from ground to sky.

Design Principles in Camera Art

In camera work, you apply the principles of design to compose single pictures or a series of shots.

In all forms of camera art, *lighting* and *contrast* are important to a mood. The brightest areas of a picture are usually seen first. Most film and video compositions have *informal balance* so the visual weight moves from one main point to several others with ease.

In film and video work, *continuity* means that actions and details are maintained so the viewer is not distracted. For example, if a person wears a hat in one scene, we expect to see the hat worn in related scenes unless it is clear from the context that time has gone by.

Continuity can often be improved by editing. Editing is the process of eliminating or rearranging parts of the film or video. In video work, you will usually re-record the best shots in the desired sequence on a second tape. In film work, you can splice film—cut sections and retape them together.

Shots in relation to angle. From left to right: high angle, average angle and low angle.

Shots in relation to distance. From left to right: extreme long, long and close-up. Photographs by Barbara Caldwell.

In film and video work, vary the *rhythm* of shots. Let some last for fifteen seconds, some for six seconds, and so on. The length of each shot should match the mood you want to establish. Try to end the work with an intense, memorable image.

To try design ideas for photo-essays, film and video work, use a storyboard. Storyboards are similar to comic-strip drawings. To make a storyboard, identify the major scenes you want to record. Draw each one on an index card or a small piece of paper about 4" x 6" (10 cm x 15 cm). For a film or video, briefly describe the action underneath each drawing. A storyboard helps you plan ideas before using the camera.

Design Elements in Scripts for Film and Video

Writing a script for a film or video is an art in itself. Use your knowledge from language arts in scripts.

Involve the viewer through your plot and characters. A plot sets up a time and place for the action. It presents an initial event, actions that build to a climax, and a conclusion. The audience should understand the reasons for the characters' actions.

Explore ways to communicate symbolic meanings of scenes and emotional reactions of characters. Try the following scripting techniques.

Foreshadowing: Early in the plot, show an event that later becomes important. *Contrast:* Shift between tense or mysterious events and events that bring comic relief. *Flashback:* Put in a scene showing events that happened earlier. *Flash-forward:* Give the audience a glimpse of future actions.

Special effects: Invented characters, settings and events are designed using models that look convincing when filmed. In an earthquake scene, for example, foam rubber "bricks" might fall from buildings.

When you write the script, think about techniques for editing video or film. Here are a few techniques.

Montage: Show many events that seem to be happening either at the same time or in very rapid sequence. *Parallel editing:* Events from one scene (such as an ocean voyage) are linked with events from another scene (such as a living room) by cutting back and forth between them. *Narrative editing:* Long shots are put together with medium- and close-ups that show the emotional reactions of the actors.

The strong angles and sharp contrasts communicate the idea of rigid strength in this scene. Student art.

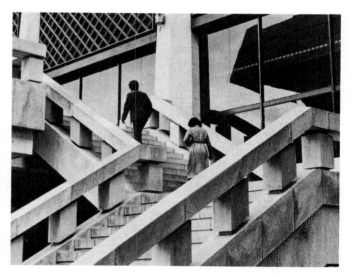

What design elements and principles are used here? What mood do they help to create?

Lighting and contrast are very important in camera arts. Can you explain why? Photographs by Barbara Caldwell.

235

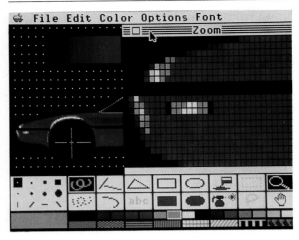

Baudville 816 paint software. This screen shows part of the main drawing and an enlarged section called a zoom. The zoom icon is shown at the bottom right. It looks like a magnifying glass.

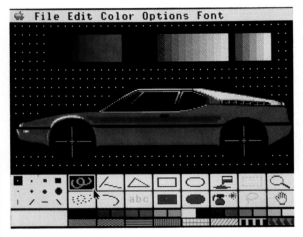

This screen shows some of the choices of color you can make: change the hue, value, and intensity of color in the drawing. Courtesy Baudville, Grand Rapids, Michigan.

A Computer System

Printer

Data and software disks are inserted in slots. They have information and instructions needed by the computer.

Output Device

Extra Drive

Screen

Disk

Computer

Keyboard

Mouse

Input devices allow you to give new information and commands to the computer.

Input Devices

Joystick

Pen and Tablet

Computer Art

A computer is like an electronic calculator with much greater speed. It operates from a series of logical instructions given to very tiny electrical switches arranged in circuits. The instructions, known as *software*, determine what actions the computer can perform. The memory of the computer (also a set of instructions for electronic circuits) determines how software instructions can be processed and how rapidly.

Computer equipment is called *hardware*. The screen or monitor of a computer works like a television set. Each picture is made up of lines that create a grid-like division of space. Each small division in the grid is called a *pixel*. The computer sends a code that lights up each pixel so we see it on the screen as white, black or a color.

Most computers accept several *input devices* such as a keyboard or a pencil-like stylus and tablet. Each input device is a way to give your own instructions to the computer's memory and software.

Other input devices are a light pen that you use to touch the monitor, a *joy stick* (small pole in a box), or a scanner (similar to a photocopy machine). Another input device, called a *mouse*, is held in the hand. It moves on small rollers.

The images you create on a monitor are recorded and saved as data on a magnetic tape or a disk that you insert in the computer. To see the screen image again, you put this data disk (or tape) into the computer. With an input device, you instruct the computer to display the data. You can produce a record of the screen image with a printer, a camera or a videotape. Such records are called *output*.

Ileana Garcia-Montes, *Tiny Dancer* (Three Views of Computer Assisted Animation). The artist first drew 45 separate parts of the body. With the aid of the computer, she assembled the parts to create many poses. These frames are from an animated film. (Ileana Garcia-Montes). Courtesy of MacWorld Magazine.

The icons on these two software programs show a few of the commands you can activate and use creatively. Courtesy of Microsoft Corp.

In most software for computer art, you will see a set of small images, called *icons*, on the monitor. Icons are symbols for the tools and actions you can use to create an image. One tool may help you draw straight lines. Another may help you draw closed shapes. You use an input device to activate each tool.

You can perform many other actions on a computer. Only a few of them are listed here: fill a shape with a definite pattern or color, move part of a shape to another location, shade a shape or background, rotate the position of a shape or line, remove a shape or line, "blend" one shape or color with another.

Today, some artists specialize in making computer images. Some make animated films with the aid of computers. Others create graphics for television and advertising. Many architects and interior designers make plans and perspective renderings using computers. Product designers also use computers for their work.

In art museums, people record information about their collections on computers. Some have placed computer terminals in exhibits so visitors can use them to find out more about an artist, style or other features of an artwork.

Some art museums include computer artwork in their collections. One of the pioneers of this art is Charles Csuri. For many years he created paintings. In the 1960's he worked with a computer expert to make drawings based on computer technology.

Csuri has said that the most complex problem in computer art is creating a convincing likeness of people moving through space. Can you explain why this is such a complex problem?

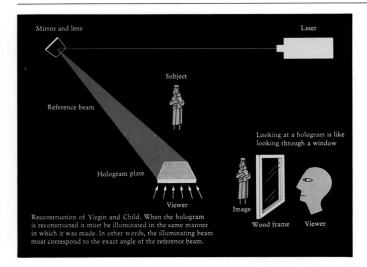

Diagram of how a hologram is made using as the subject a sculpture, *Virgin and Child*.

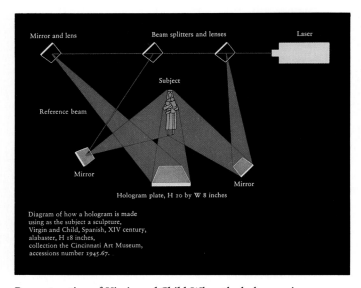

Reconstruction of *Virgin and Child*. When the hologram is reconstructed it must be illuminated in the same manner in which it was made. In other words, the illuminating beam must correspond to the exact angle of the reference beam.

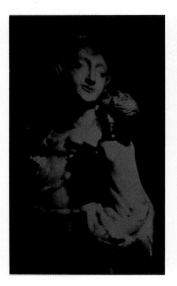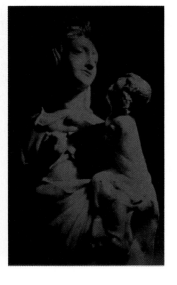

Holography

Artists have experimented with holograms since the 1960's. Holography was invented in the late 1940's by Hungarian Denis Gabor. It became a method of photography in 1962.

A *hologram* (Greek for "whole message") is a three-dimensional image that appears on a film exposed to laser light. The light reflected from an object is captured by "splitting" the laser beams and using mirrors. One beam of laser light hits the object. The other "reference" beam is pointed toward a mirror, then to the film surface.

In a hologram, the film records light in the area where the light from the object and from the reference beam meet. After the film is processed, the image appears to be three-dimensional. The film must be illuminated from the same direction as the reference beam.

Most holographic art is displayed in art or science museums because laser beams are necessary to see it. There are also versions of holography that can be seen in regular light. They are often small and have color distortions. The image seems to be suspended in space behind the surface.

Find out if anyone in your community has created a hologram. See if you can arrange a demonstration for your class. Small holograms can be seen on popular jewelry, credit cards, book jackets, even stickers. When you look at the image from different angles, it seems to be three-dimensional.

Student art.

Student art.

Student art.

Student art.

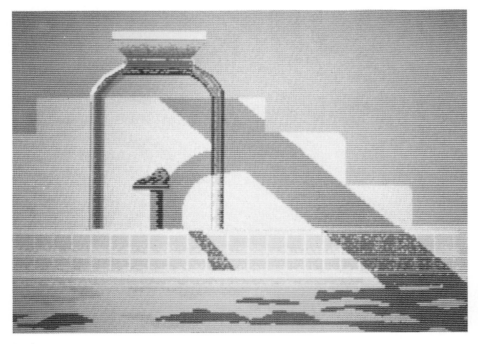

Student art.

Student art.

Student art.

Student art.

Summary

The twentieth century has been called the age of technology. In this chapter you have been introduced to some forms of art created with the aid of technologies such as the camera (still, motion picture, television), personal computer and laser light. Of these, the oldest technology is photography (about 150 years). The personal computer is only about twenty years old.

Artists who work with new technologies know they must adapt to rapid changes in their artistic media. They also know that the artistry in their work still comes from their creative ideas about using technology, including the design of the work.

Fine artists who work with new technologies are primarily interested in exploring and developing their ideas. The same technologies can be used as tools to create commericial art as well as for many scientific purposes.

Using What You Learned

Art History and Aesthetics

1 In what year was photography invented?

2 What is the meaning of the word hologram?

3 Who invented the motion picture camera and in what year?

4 What is the main difference between computer hardware and software?

5 What are four techniques for establishing a definite mood in a script for a film or video?

6 What are three techniques for editing frames from a film or video?

7 What are "special effects" in film and video?

8 In which medium did Charles Csuri first create his artwork? For what type of artwork is he best known?

Creating Art and Art Criticism

1 What are four basic camera skills? Briefly describe or demonstrate why they are important.

2 What are three ways of creating photo-like still images without using a camera?

3 What are two ways of creating the illusion of motion pictures without using a camera?

4 What are three special qualities of design in film and video work? How can each quality influence your judgment of these art forms?

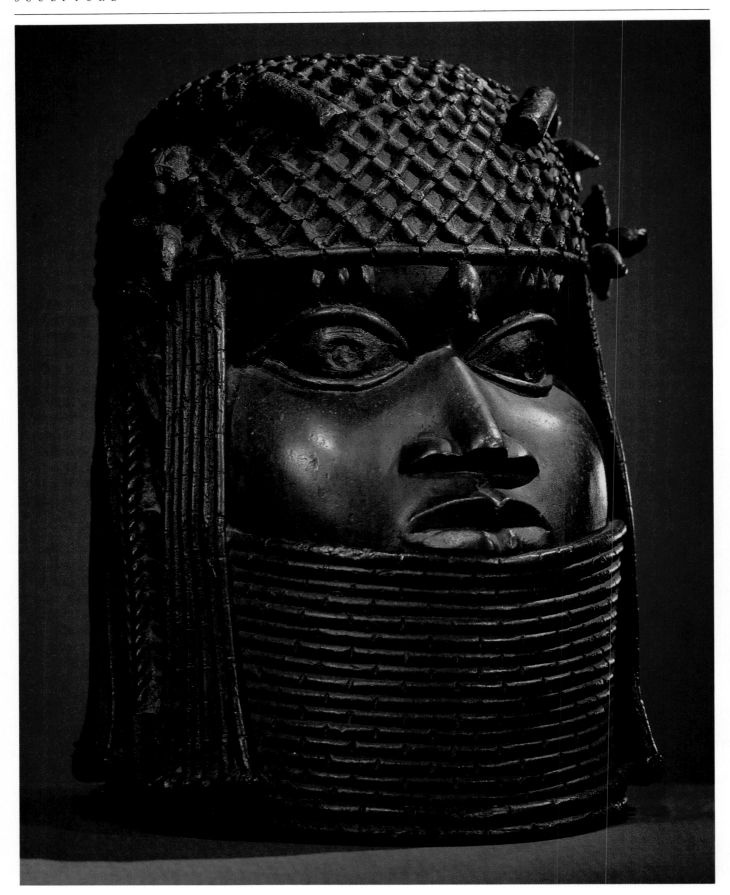

Nigeria, Court of Benin, Bini Tribe, ca. 1550-1680. This bronze sculpture was once part of a courtly culture of the Bini, a group whose royalty lived in Benin (present-day Nigeria). The bronze heads were kept on royal alters as memorials to ancestors. Bronze, 10 ½" (27 cm) high. The Metropolitan Museum of Art. The Michael C. Rockefeller Memorial Collection of Primitive Art. Bequest of Nelson A. Rockefeller, 1979.

Chapter 12
Sculpture

Chapter Vocabulary

concave
convex
assemblage
freestanding
relief
modular
kinetic
mobile
maquette

When you hold something soft and pliable, such as clay, do you like to squeeze and shape it? It is hard not to. Not only can you make interesting forms, but it feels good. Sculpture is the art of shaping material into forms, and it has fascinated artists since ancient times.

Sculpture appeals to most people because it is three-dimensional. It has height, depth and width, like most other things we see. We respond to the textures of materials such as stone, wood and clay. Sometimes we see relationships between an artist's sculpture and "natural sculpture," such as rocks carved by winds or water.

For many ancient people, sculptures served as effigies–models of gods, spirits or ancestors. The sculptures were used in rituals, worship or celebration. The full meaning of the sculpture came from its use, not just its appearance. For example, gifts might be placed at a sculptured shrine for ancestors. In ancient civilizations, such as in Egypt or India, monumental sculptures were carved into cliffs or mountains to honor gods or leaders. Small sculptures were placed in tombs to represent things a dead person might want or need in the afterlife.

Throughout history, sculpture has been used to express religious themes or to honor important people and events. Often, sculpture is integrated with architecture in the form of carved columns, doors or altars. Small, portable sculpture has been important to nomadic people. The sculptured form was often part of a practical object such as vase, a sword handle or a ship's prow.

Contemporary sculpture is a varied and exciting area of art. Subjects and themes for sculptures seem to be as unlimited as the materials artists are using. In this chapter, you will learn more about the art of sculpture and why it has fascinated people all over the world, from ancient times to the present.

After you study this chapter and try some of the activities, you will be better able to:

Art History	• discuss some major subjects, purposes, and varieties of sculpture in history.
Art Criticism and Aesthetics	• apply your skills in art criticism to evaluate your own and others' sculpture.
	• use art terms to describe, analyze and interpret your own and others' sculpture.
Creating Art	• create original sculptures using different themes and processes.
	• use sculptural media, tools and processes expressively.
	• effectively design sculpture.

Gallery

Traditional materials for sculpture include stone, wood, clay, metal, and natural materials such as bone. As you can see in this gallery, some artists continue to use these materials. Others are exploring materials and techniques unknown to artists before the twentieth century. Among these are welded metal, plastic and sculpture with mechanical or electrical parts. Discarded materials–such as parts of old furniture and appliances–have interested some sculptors.

In the past, sculpture took two main forms. A *free standing* work can be seen from all sides. A *relief* sculpture is viewed from one side. After Alexander Calder invented mobiles, sculptors began to think about kinetic (moving) sculpture and forms suspended in space. Today many artists think of sculpture as a changing environment or situation, not just as a statue.

Critical Thinking What are the themes, media and types of sculpture in this gallery? Which sculptures seem to be the most and least traditional? Why do you think so?

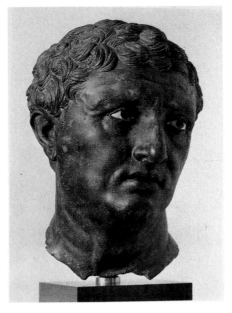

Portrait Head from Delos. Early 1st century BC. National Museum, Athens.

Dorothy Gillespie, *Untitled*, 1982. Enamel on aluminum, 50" x 60" x 46" (127 x 152 x 117 cm). Collection The Museum of Art, Fort Lauderdale, Florida. Photograph by Tom Hicks.

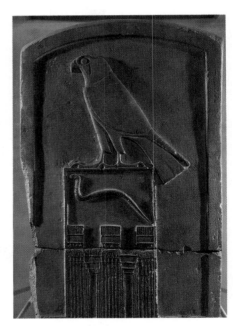

Phillipines, Ifugao offeratory bowl. 6" (15 cm) high. Courtesy of the Hurst Gallery.

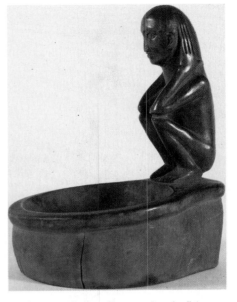

Egypt, 1st dynasty, (ca. 2900 BC). Limestone, royal stele with Horus and serpent. The Louvre, Paris.

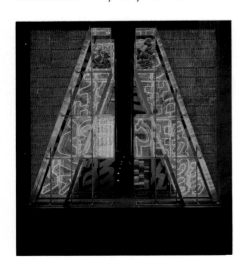

Chryssa, *The Gates to Times Square*, 1966. Welded stainless steel, neon and plexiglass, 120" x 120" x 120" (305 x 305 x 305 cm). Albright-Knox Art Gallery, Buffalo, New York.

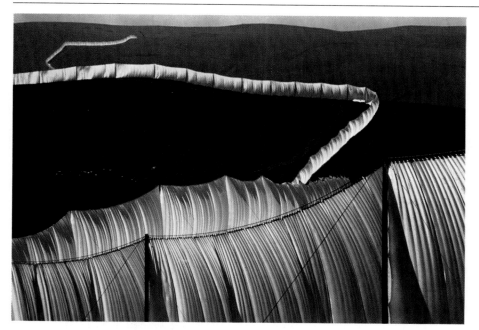

Christo, *Running Fence*, Sonoma and Marin Counties, California, 1971. Woven synthetic fabric, height 18', length 24 ½ miles. Copyright Christo and Running Fence Corporation.

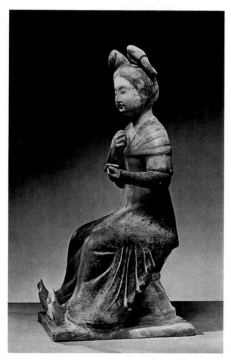

T'ang period, *Seated Court Lady Holding a Mirror*. Fired terra-cotta with colored glazes, 12 ½" (32 cm) high. The Victoria and Albert Museum, London.

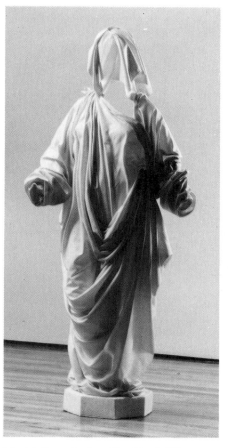

Muriel Castanis, *Standing Hooded Toga I*, 1986. Cloth and epoxy, 76" x 36" x 18" (193 x 91 x 46 cm). Courtesy O.K. Harris Works of Art, New York.

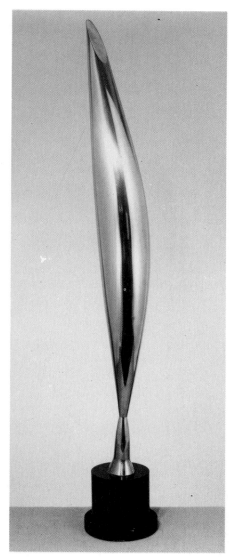

Constantin Brancusi, *Bird in Space*, 1925. Polished bronze, marble base. Philadelphia Museum of Art. Louise and Walter Arensberg Collection.

Louise Nevelson

1899-1988

At the age of nine, Louise Neveleson was asked what she wanted to be when she grew up. She answered "I want to be a sculptor," then added passionately, "and I don't want color to help me." Fifty years later, she fully understood and realized her childhood prophesy.

Where did the artist get her ideas? She said they were inspired by many sources. Hans Hofmann, a great artist-teacher, taught her to think of sculpture as working within "a block of space for light and shadow." Other influences were Mayan art and architecture seen during a trip to Mexico and studies in Oriental philosophy. She said that both gave her a new sense of harmony with the universe. Later, the titles of her sculpture would reflect this sense of spiritual harmony with nature, people, and the world–*Sky Cathedral, Dawn, Moon Garden, Royal Tide, Homage to the World.*

Louise Nevelson was born in Russia. Her family came to America in 1905 and settled in Rockland, Maine. Her father had a lumber business. From childhood, Louise loved the small "dips, cracks, and details" in wood, especially old wood.

Nevelson's innovative work began around 1940. At first, she created sculpture by joining together "found" objects such as wooden duck decoys and stair railings. Gradually, she gathered a huge collection of discarded wood from old buildings and furniture–even old rolling pins. She assembled these "treasures" inside old crates and

Lynn Gilbert, *Portrait of Louise Nevelson,* 1980. Photograph, Pace Gallery, New York.

boxes. Later, she began to stack them on top of each other.

Nevelson's stacked boxes created a rich, mysterious, wall-like environment. She decided to paint her sculpture in one color–black, white, or gold–to heighten the illusion of light and shadow. She called herself "the architect of shadows."

In her later years, Nevelson received commissions for many outdoor works and experimented with steel, aluminum and plastic. For her eightieth birthday, New York City added its tribute to a long list of international honors. A plaza was set aside for seven of her sculptures in steel–some 90 feet (27 m) tall. It is named the Louise Nevelson Plaza.

Critical Thinking As a child, Nevelson thought that sculpture would not be helped by the addition of color. Later, the artist often painted her work in one solid color. Do you think color is important in her work? Why or why not?

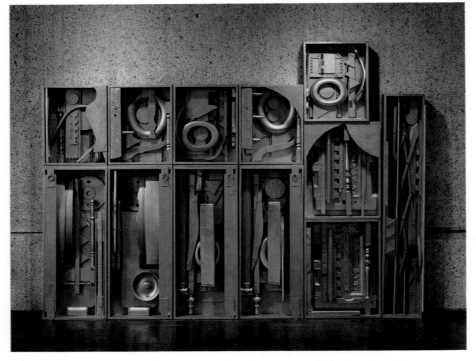

Louise Nevelson, *Royal Tide II,* 1961-1963. Painted wood, 7' 10 $^1/_2$" x 10' 6 $^1/_2$" x 8" (240 x 321 x 20 cm). Collection of Whitney Museum of American Art. Gift of the artist.

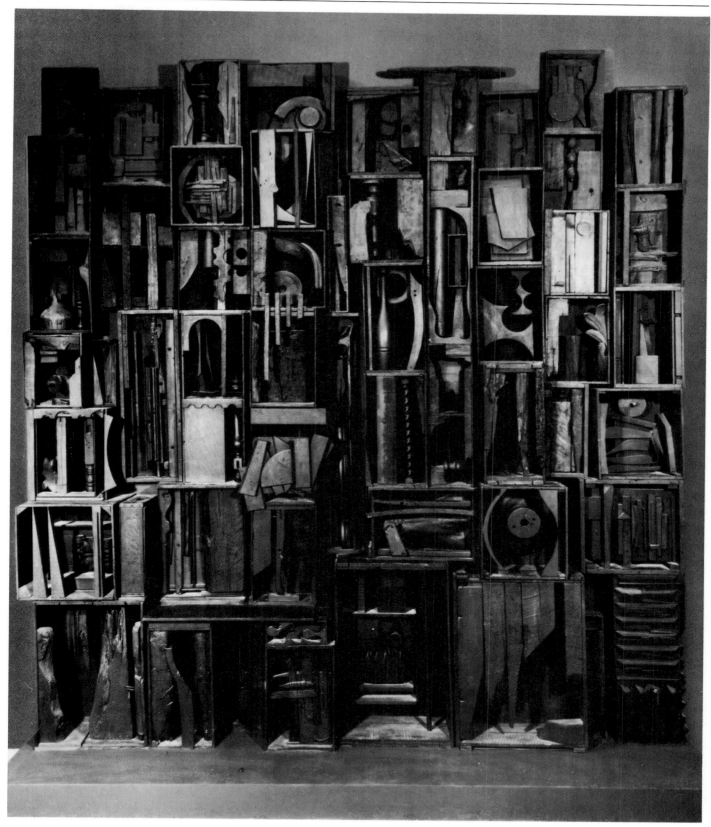

Louise Nevelson, *Sky Cathedral*, 1958. *Sky Cathedral* was among several works in Louise Nevelson's third major exhibition in New York City. It is a mysterious wall-like assemblage of painted wood. You see light, shadow, and many-layered forms. Her assemblage environments have been called "shrines for the eye, mind and spirit." Art critic Hilton Kramer used the phrases "marvelous," "profoundly exhilarating," and "sculptural architecture" to describe her work. Wood construction painted black, 11' 3 $^1/_2$" x 10' $^1/_4$" x 18". Collection, The Museum of Modern Art, New York. Gift of Mr. and Mrs. Ben Mildwoff.

Max Bill, *Construction*, 1937. Can you identify the concave and convex areas in this sculpture? Granite, 39" x 31 ¹/₄" x 31 ¹/₄" (99 x 79 x 79 cm). Hirshhorn Museum and Sculpture Garden. Gift of Joseph H. Hirshhorn, 1966.

Jose de Riviera, *Brussels Construction*, 1958. This work is on a turntable that slowly rotates the form. This allows you to see the changing voids and gracefully tapered lines from many angles. Stainless steel, 46" x 79" (118 x 201 cm). The Art Institute of Chicago. Gift of Mr. and Mrs. R. Howard Goldsmith, 1961.

Design in Sculpture

The Visual Elements

Most of the visual elements you have learned about–line, shape, color, value, texture, form and space–have a special meaning in sculpture.

You are most familiar with *line* as a mark on paper. In sculpture, you can sometimes see incised or engraved lines in surfaces. Line can also be an edge or *contour* where curved or angular surfaces meet. In most sculpture, you can see an outer contour or silhouette of a form. This contour changes as you move around the form. In sculpture made of wire, rods and other long, thin materials, you can see lines arranged in space or moving through space.

In sculpture, we usually speak of *planes* (surfaces) and *forms* rather than shapes. Three-dimensional forms such as spheres, cones, cubes and pyramids are seen more often than flat (two-dimensional) shapes such as circles, squares or triangles. The forms may be organic–related to curved forms we see in nature–or angular, geometric and machine-like. A concave form has a bowl-like depression in it. A convex form is one that comes out into space (like a bowl turned upside down).

Color in sculpture is often part of the material rather than applied just on the surface. Many sculptors want you to see the natural colors of stone, metal or other materials. Others prefer to change the natural color by using paint or chemicals (adding red oxide to clay to make it very red). A *polychrome* sculpture is one that has been planned to include many colors. Most outdoor sculptures change in color due to weathering. The color of a sculpture can vary under different lighting conditions.

Color and light always interact in sculpture. In general, sculptors carefully plan the *values* in their work–the light and dark areas and the highlights and shadows. Angles of light can make the sculpture look very flat or they can accent its three-dimensionality. Although we usually think of sculptural materials as opaque and dense, they can be transparent or translucent. A *translucent* material, such as frosted glass or plastic, allows some light to pass through it. Some clay sculptures have translucent glazes. Polished stone, especially marble, sometimes appears to have a translucent "glowing" surface.

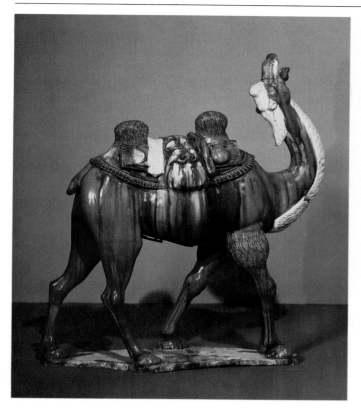

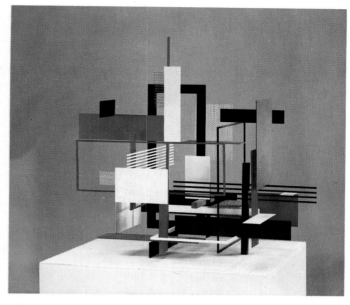

Sidney Gordin. *Construction, Number 10, 1955,* 1955. Geometric shapes are arranged in space to create this sculpture. Painted steel, 36" x 41 ½" x 27" (91 x 105 x 69 cm). Collection of Whitney Museum of American Art. Purchase.

Camel, China, T'ang dynasty (618-906 AD). This sculpture has a dominant path of movement that conveys a feeling of action. Glazed and colored clay, 34 ¾" x 29 ½" (88 x 75 cm). The Los Angeles County Museum of Art. The William Randolph Hearst Collection.

Texture is always important in sculpture. Many artists want you to see natural textures in wood or clay. Others create invented textures. For example, the artist may plan the pattern of marks left by chisels in carving wood. Some artists want the final surface to be polished and smooth.

In sculpture, *space* is a combination of the positive space taken up by the material and the negative space or voids that surround the solid material. Think of negative space or voids as the air around the sculpture or any open part of the sculpture. Most sculptors plan the negative spaces in their work as carefully as they plan the solid forms. Can you explain why?

Applying the Principles of Design
Sculptural forms can be planned by using the same principles of design you have already learned about. But remember, you must now apply them to three-dimensional forms and spaces. For example, your work may have symmetrical *balance* from one view, but from another view, it may appear asymmetrical.

When you think about *movement*, it is not just up and down, or left and right. You must think about movement around the form and perhaps through it as well.

Plan the *proportions* in your sculpture. Depending on your idea, they can be normal, ideal or exaggerated. The actual size of your work may be small, but the design and proportions can make it look important and forceful.

Use the principles of design as questions to ask about your work. Ask yourself if *rhythms* (regular, flowing or "jazzy") are important in your work. Ask whether *patterns*–of textures, colors or forms–might unify it or add variety. Remember: The principles of design are guides for creating expressive artwork, including sculpture.

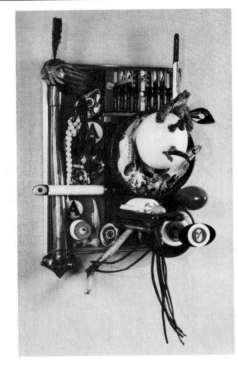

Alfonso Ossorio, *Root Club #2*, 1969. Found objects can be assembled into a relief or a full-round sculpture. Painted mixed media assemblage, 24 ⁵/₈" x 19 ⁵/₈" (62 x 50 cm). Vassar College Art Gallery, Poughkeepsie, NY. Gift of Mr. and Mrs. Frederic Ossorio.

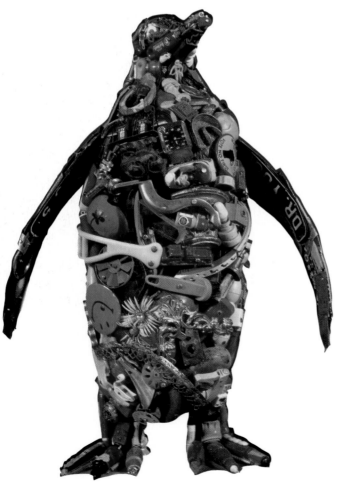

Leo Sewell, *Penguin*, 31" x 20" x 9" (79 x 51 x 23 cm). Courtesy of the artist.

Media and Processes

There are four basic methods for creating sculpture: carving, casting, modeling and constructing (assembling) materials. Each of these processes can be used with a variety of media. Some media and processes that you might explore are illustrated in the rest of this chapter.

Artists think about materials for sculpture in several ways. One is being true to the materials. For example, if you carve wood, you let the grain show. You would not cover the natural wood with paint. A second way is integrating the materials to suit the idea. This means that you might paint a wood sculpture if color was important to the idea. Most sculptors today think about materials in both ways.

Assemblage

Found Objects

An assemblage is a sculpture made by combining discarded objects such as boxes, pieces of wood, parts of old toys and the like. To explore assemblage, you might create a relief sculpture in a shallow box. You could also create a freestanding sculpture or a small environment.

Collect some discarded objects. From your collection, choose things that express a definite theme or idea. The theme or idea might be suggested by the materials you collect. Think about the symbolism of the materials—what they mean to you or to other people. Refer to the principles of design in arranging the items. For example, you might create a nonobjective sculpture with related or contrasting textures, colors or forms as the dominant qualities.

Gertrude Greene, *White Anxiety*, 1943-1944. Wood scraps can be cut and assembled for relief or full-round sculpture. How are the theme and design related in this work and the work below? Painted wood relief construction on composition board, 41 3/4" x 32 7/8" x 2 7/8" (106 x 84 x 8 cm). Collection, The Museum of Modern Art, New York. Gift of Balcomb Greene.

Jean Arp, *Birds in an Aquarium*, ca. 1920. Painted wood relief, 9 7/8" 8" x 4 1/2" (25 x 11 cm). Collection, The Museum of Modern Art, York. Purchase.

Wood

For thousands of years, artists have carved wood to create sculpture. Today, many artists also construct sculpture by assembling finished wood, such as new or used dowels, planks and scraps of furniture. The pieces can be glued, nailed, screwed or bolted together. They can be joined with dowels or strips of metal.

Construct a freestanding wood sculpture. A *freestanding* sculpture is meant to be seen from all sides. It usually has no base or a very small one. Create your assemblage from items such as wooden spools, old chair legs and scraps from a lumber yard or cabinet shop. Often the odd shapes of scraps will suggest ideas for a sculpture.

It is usually best to begin with one or two larger pieces and add smaller shapes to these. Try several positions for each shape before you attach it. A freestanding sculpture should be planned from all sides, not just the front. Turn your work or move around it as you decide where to add new pieces.

Your work should be well-crafted. Make sure you wipe away excess glue before it dries. If you use nails, plan the location and angle before using the hammer. Large nails and nails placed near the end of a piece may cause it to split.

If you want a smooth surface for the sculpture, sand each piece before you join it to others. You might consider staining some pieces with thin acrylic paint before joining them. You might create textures or patterns in some scraps by driving in small nails or tacks, drilling holes or placing screen wire over the wood and hammering it. Often the natural color and grain of wood are beautiful and need no decoration.

A wood sculpture can be left unpainted. To seal the surface from grime and to make the grain stand out, rub linseed oil or wax into the wood or apply varnish. If you want color, use vinyl, latex or acrylic paints.

Safety Note Use shellac, varnish or other paints only with permission and under the teacher's supervision. Read, understand and follow all safety precautions.

Modeling

Getting Started

Modeling is a process of shaping soft materials such as wax, clay, papier-mâché pulp, thin metal or wire. Many artists like to use oil-based clay or wax for "sketches" in three dimensions. Ceramic clay is often used when a more permanent sculpture is desired. Clay gives you freedom to experiment with forms, spaces and textures.

Ceramic clay is a versatile material for creating sculpture. You will find basic information about this medium in Chapter 13, "Crafts". Read about the materials and processes for ceramic work before you begin a sculpture. For sculpture, ceramic clay is often blended with *grog* — fired clay that has been ground up. Grog gives regular clay added strength and a coarse texture. It also helps thick clay dry more evenly.

Your clay sculpture can be formed by direct modeling (whole-to-part method), by assembling clay forms (additive method), or carving out of a solid form such as a cylinder or ball (subtractive method). You can combine methods.

To begin, you might create several slabs, clay pinch pots, or irregular forms over drape molds. Join them together for a basic structure. To join two pieces of moist clay, scratch both surfaces and apply slip (watery clay). Then press the parts together and smooth the joints. Between work sessions, cover your sculpture with a moist towel and an airtight plastic bag.

Once you have shaped the basic sculpture, the surface can be finished in several ways. While the clay is moist, you can stamp or scratch textures into it or build up surface patterns with small balls or coils of clay. When the clay is leather-hard, you can carve it or apply underglazes. Handle unfired clay carefully. It is difficult to repair.

After the clay has been bisque-fired (fired once), color can be added with ceramic glazes and refired to fuse the glaze to the surface. A bisque-fired sculpture can also be decorated with thinned acrylic paint.

Peter Grippe, *The City,* 1942. A slab-like process of shaping clay was used for this sculpture. Terra-cotta, 9 ¹/₂" x 11 ¹/₈" x 16" (24 x 28 x 41 cm). Collection, The Museum of Modern Art, New York. Given anonymously.

Colima standing dog. Proto-classic period. Mexico, 100 BC – 250 AD. Courtesy of the Hurst Gallery.

Surface and Details

e clay or add bits of clay textures, patterns,

A Clay Head

You have probably seen sculptures of people created in bronze, marble and other materials. The artist may have created an idealized sculpture or one that accurately captures the features and personality of a person.

In many cultures, an idealized face is used to suggest people who are leaders, heroic figures or gods. The features are usually simplified and more symmetrical than you would find in the face of a real person.

A realistic approach to a sculpture of a person is called a portrait. The artist usually tries to capture the unique features and personality of the person. These features may include wrinkles, a slight asymmetrical twist in the nose, expressive lips, and so on.

Create a sculpture of a person. Decide if you will create a realistic portrait or an idealized sculpture. Probably you will model just the head and neck using oil-based or ceramic clay. Begin with an egg-like shape for the head and a cylinder for the neck. Join them together firmly.

Always work on the overall form before you work on details. The proportions shown below will help you plan the general placement of the eyes, lips, ears and other main features. Place your work on a turntable or piece of cardboard so you can study the angles and features from all sides.

For a portrait bust in ceramic clay, you might begin with a cardboard and paper core. Cover it with clay about 1" thick. When the clay is leather-hard, remove the core. Don't worry if you don't get all of it out; it will burn away when the work is fired in a kiln. If your sculpture is solid and more than 1" (3 cm) thick, hollow it out. This will help it dry and help to prevent damage when it is fired in a kiln.

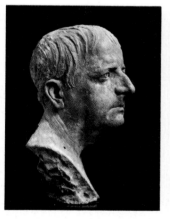
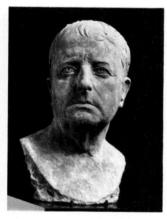

Man of the Republic, Greco-Roman. Terra-cotta. The Museum of Fine Arts, Boston. Contribution, Purchase of E.P. Warren.

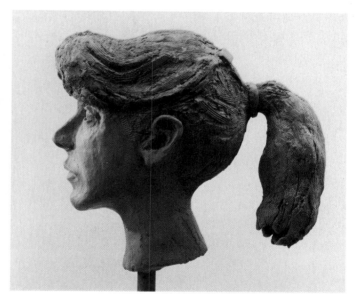

Leon Nigrosh, *Lianne,* 1990. Life-size. Photograph by Stephen DiRado.

William Artis, *Michael* (two views). Typical proportions in the head. Terra-cotta, 10" (25 cm). Courtesy of North Carolina Museum of Art. Gift of the National Endowment for the Arts and the North Carolina Art Society.

Carving

Getting Started

Carving is called a *subtractive* process because you take away material with cutting tools. Stone and wood are traditional materials for carving.

In school, you will probably carve a prepared block of plaster, leather-hard clay, firebrick or softwood such as white pine, redwood or fir. You can also carve blocks of paraffin wax, soap or high-density Styrofoam. Lava stone, soapstone and softstone might be available. Make sure you have the proper tools for the material you will carve. These include chisels, files, knives, sandpapers, hammers and mallets.

A carving must be carefully planned. In most materials, you cannot replace or re-attach material that you have cut off. The idea for your sculpture should be appropriate for the process of carving. Simple rounded forms with few details are usually best. Choose a subject or theme that allows you to carve thick forms rather than thin ones.

Work slowly and carefully. Turn the block often while you are carving it. The sculpture should have a feeling of continuous movement around it. Relate the forms on the front and back to the forms on each side.

Safety Note Safety is especially important in carving. Always hold your cutting tool so it will move away from your body and the hand supporting your work. A bench vise or block may help to support the work. Wear safety goggles. To reduce the dust from carving, put your work in a shallow box or tray lined with damp newspaper. At cleanup, throw the damp newspaper in a waste can lined with newspapers or plastic. Never put wet or dry plaster, clay or other carving residue into the sink. If you have allergies, use an appropriate dust mask or work in a different material.

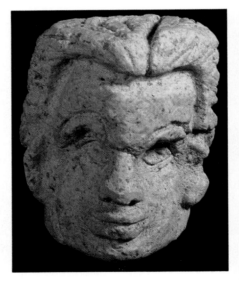

Student art.

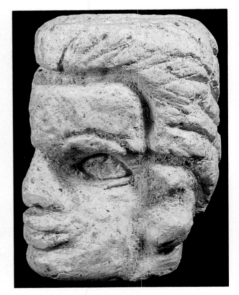

Student art.

Safety First.
Use a safety block. It stabilizes work as it is carved, reduces risk of cuts. Keep both hands behind point of cutting tool.

Safety goggles.

Types of Carving Tools
Handles
Points

V groove
U groove
Chisel

A Human Figure

When you carve, you cut away material from a solid block. Because you cannot re-attach the material you carve away, it is important to plan your work. When you carve a human figure, try these ideas.

Choose a seated pose or a reclining or kneeling figure. Before you begin, make sketches that suggest how the sculpture will look from the front, back, top and both sides.

Sketch some guidelines on the block. Plan the front, back, top and both sides of your block. Remember, your sculpture should have chubby forms, not thin ones.

Carve slowly from each corner of the block toward the center. Turn the block often. Add more guidelines as you work. After the basic forms are carved, add details to suggest clothing, facial features and the like.

Mixing Plaster

1. Cover mixing area with newspaper. Place water in a plastic bucket or bowl. Wear disposable plastic gloves and a dusk mask.

2. Sift plaster through your fingers into the water. Continue until a small peak of dry plaster remains above the water.

3. Slowly mix the plaster with a wooden spoon or stick (about 80 to 100 strokes across the bottom of the bucket or bowl) until the mixture is like thick soup.

4. Gently tap the sides of the container to bring air bubbles to the top of the mixture.

5. Slowly pour the plaster into a mold. The plaster will become very warm while it is setting (becoming hard). Remove the mold after the plaster has cooled and partially dried.

6. Never put wet or dry plaster in the sink. If you wash it down the drain, it will harden in the pipes and block them. Wipe tools, hands and work surfaces with damp paper towels. Line the waste can with newspapers or plastic.

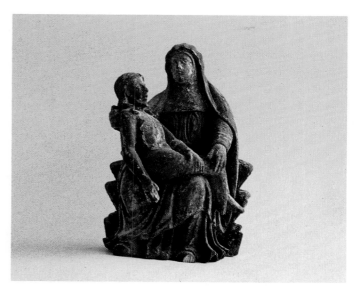

Pieta, 17th century. Polychromed wood, 10" (25 cm) high. Phillipines. Collection of Mr. and Mrs. L.C. Saunders, Hong Kong.

Mixing Plaster
Empty milk cartons (waxed cardboard) are recommended to hold your mixed plaster. Photograph by Barbara Caldwell.

Isa Smiler, *The Archer*. Notice how the base of this sculpture and the base in the Pieta, help to support the work. Inukjuak, stone. Courtesy of the Toronto-Dominion Bank, Ontario.

Student art.

Tino Nivola, *Deus*, 1953. This relief sculpture from sand casting has a subtle textural quality. Sand and plaster, 64 ³/₄" x 34 ¹/₂" (164 x 88 cm). Collection of Whitney Museum of American Art. Purchase.

Casting

Many sculptures you see in parks, museums and galleries are made by casting.

Casting can be done in several ways and in different materials. The usual steps are :

1. A sculpture is first modeled in wax. If it is modeled in ceramic clay, plaster or another material, the sculpture is covered with wax.

2. A heat-resistant mold is made. The mold is heated to dry it out and melt the wax. This leaves an open space in the mold.

3. Molten metal is poured into the open space of the mold. When the metal cools, the mold is removed.

The metal sculpture is like the original model but stronger and more permanent. Sometimes cast sculptures are made from other liquid materials that harden, such as concrete, plaster or plastic.

A Relief Sculpture

You might try casting a relief sculpture in plaster. Your mold will be clean sand or oil-based clay. Find a strong cardboard box about 3" (8 cm) deep, such as a shoe box. Wrap masking tape around the outside edge to strengthen it. Place about 1" (3 cm) of fine damp sand or ¹/₂" (1.5 cm) of oil-based clay in the bottom of the box.

Gather small objects that you can press into the clay or sand. Examples are: a pencil, an old comb, thick rope, paper clips, thumbtacks, shells, nuts. Press these straight down into the sand or clay, then lift them straight out again. You are creating the mold or negative design for the sculpture you will cast. Everything you press down into the clay will be raised up in your final sculpture.

When your design is ready, mix and pour the plaster as directed by your teacher (see page 255 for basic steps). If you want to hang the sculpture on a wall, press a loop of thick string firmly into the wet plaster before it begins to set. After the plaster hardens and dries, peel away the box. Carefully remove the oil-based clay or brush away the sand.

After you have completed your first cast, try others. You can embed stones, shells, rope or other objects that will not rust into the mold. When the plaster is poured, they will be locked into and become part of the final sculpture.

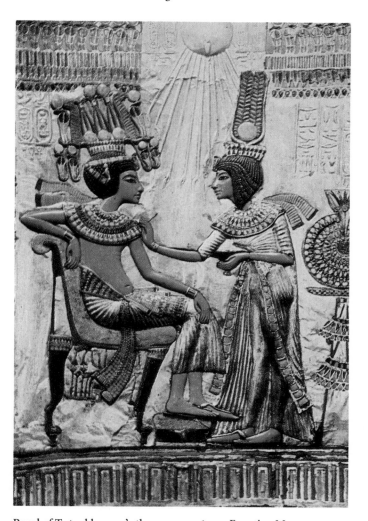

Foil relief over cardboard collage. Student art.

Panel of Tutankhamun's throne, ca. 1361 BC. Egyptian Museum, Cairo, Egypt.

Metal Working

The ancient Assyrians, Egyptians and other groups created metal repoussé sculpture. *Repoussé* is a French word for sculpture created by shaping a sheet of thin metal from one or both sides. There are several ways you can create a relief sculpture using metal foil.

A Metal Relief Sculpture

If you have craft-weight aluminum or copper foil (36 gauge), first place some tape around the edges of the foil for safety. Plan, on paper, a design that will fit the size and shape of the foil. Place the foil on a soft pad of newspaper or an old magazine. Tape your design on top of the foil. Trace over it with a blunt pencil. Press hard enough to make clear grooves in the foil.

Remove the paper design. Now use tongue depressors or other wooden tools to press down the background areas. To make other shapes stand out, turn the foil over and press them from the back.

You could also use extra-heavy aluminum foil (kitchen type) to make a relief sculpture. Begin as though you were making a collage, using varied materials such as textured paper, fabric, buttons, toothpicks, leaves, weeds, or shells. Make sure all these materials are nearly flat. Select and arrange your choices on cardboard, then glue them down.

After the glue is dry, cover the whole design with thinned white glue or white library paste. Before the adhesive dries, place the sheet of foil on top of the design. Gently press the foil down with your fingers. Work from the center to the edges. Fold the extra foil over the back of the cardboard. With a blunt pencil, lightly outline the edges of shapes. Add other lines, textures or patterns to some flat areas of the foil.

To finish your metal repoussé, brush waterproof ink over the design. When the ink is dry, lightly buff the raised surfaces with a dry paper towel (folded). You might mount your work on wood for display.

Metal Foil Surfaces.

Abastenia St. Leger Eberle, *Roller Skating*, ca. 1906. Bronze, 12 ¹³/₁₆" x 11 ¹/₄" x 6 ¹/₂" (32 x 29 x 16 cm). Collection Whitney Museum of American Art, New York. Gift of Gertrude Vanderbilt Whitney.

Frederic Remington, *The Bronco Buster*, 1895. Bronze, 23 ¹/₄" (59 cm) high. Amon Carter Museum, Fort Worth, Texas.

Armatures from wire are useful for action-oriented sculpture.

Other Ideas to Explore

Action Figures with Armatures

Most sculptors have some training in creating action figures. Some sculptors specialize in figurative work–sculpture of people or animals.

Many figurative sculptures, especially those with delicate parts, are first made in wax or clay, then cast in bronze, which is a very hard metal. The model for the bronze cast is usually built up over a wire armature.

An *armature* is like a skeleton. For small sculptures it is usually made of twisted wire. After the basic skeleton has been bent and nailed to a wood base, it is covered with wax or oil-based clay. The armature can also be covered with plaster or papiér-mâché.

Study the examples of action sculpture shown here. Create an armature of soft wire (stovepipe, floral, pipe cleaner, telephone wire). Twist more wire around each part of the skeleton so it will be strong. A double wire also makes it easier to apply the clay, plaster or paper mâché. Firmly attach your armature to a sanded block of wood.

Develop the main forms before you work on details such as fingers and eyes. If you try to bend the wire after you have added clay or other materials, the work may crack and it will be hard to repair.

You might finish your work by adding textures. If the figure is made in plaster, you might stain it with acrylics or shoe polish to resemble metal. You might leave it white. Papiér-mâché can be painted with acrylic.

Susan Bird Kittredge, *Parakeet, Peanuts, Ukulele, and Cookies.* Cotton fabric, applique, 15" x 19" (38 x 48 cm). From "Effective English" Grade, 5, ca. 1979. Reproduced by permission of Silver Burdett Co.

Marilyn Levine, *H.R.H. Briefcase,* 1985. Clay and mixed media, handbuilt (slab constructed) 16" x 17 ¹/₂" x 6 ³/₄" (41 x 44 x 17 cm). Courtesy O.K. Harris Works of Art, New York.

Descriptive Sculpture

Still-life objects have often been the subject of paintings. They can also be the subject of a descriptive sculpture. A *descriptive sculpture* is a model of a familiar object, but created in an unexpected size or material. An example would be ceramic clay shaped into the form of a leather purse.

Descriptive sculptures are surprising. Although a ceramic purse looks "real," it is not flexible and soft like leather. If the clay version is larger or smaller than the expected size, there is a second element of surprise.

This way of interpreting familiar objects was pioneered by Dada and Pop artists who were interested in this question: What makes a work of art (a sculpture) different from a natural form or mass-produced object?

You could model a descriptive sculpture in ceramic clay and glaze or paint it. You might model one in papier-mâché. You could even assemble a soft sculpture from fabric.

Choose a natural form or a manufactured object to represent in a sculpture. Keep the proportions as accurate as you can. You might use a scale of ¹/₂" – 1" (1.5 cm – 3 cm) for an object that is about 12" (30 cm) long. This would make the sculpture about 6" (15 cm) long.

After you complete your descriptive sculpture, offer your own answers to the question that Dada and Pop artists asked.

Modular Sculpture

A *module* is a form that is used over and over to create a larger form. A familiar example is a brick; the same form is used over and over to build a wall. *Modular* sculptures are made by using one basic form again and again. To add interest, the form might be changed in position, color, size or proportion. In David Smith's modular sculpture, the form of a cube is used again and again. How has he added interest to the composition?

Gather or create some modular forms and assemble them to create a sculpture. Your modules might be toothpicks, drinking straws, tongue depressors, index cards (cut, scored, notched), small plastic or paper cups, or natural forms like pine cones or Y-shaped twigs. You might create a set of modular forms from clay.

Try to arrange the forms so you can see a definite path of movement from one module to the next. Make sure that your modules are carefully joined.

Aaronel deRoy Gruber, *Steelcityscape*, 1977. Painted carbon steel, 21' x 8 1/2" x 13 1/2' (640 x 4 x 398 cm). Collection City of Pittsburgh, Fort Dusquesne Boulevard at Ninth Street, Pittsburgh, Pennsylvania. Photograph by Terry deRoy Gruber.

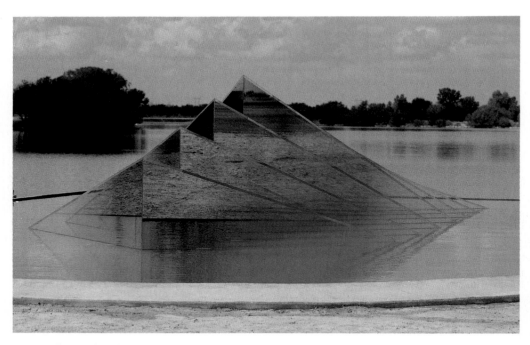

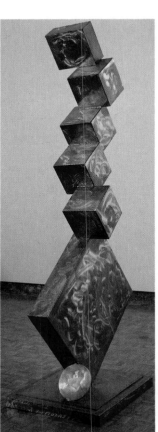

Larry Bell, *Wind Wedge*. Glass, 6' x 20' x 14' (183 x 610 x 427 cm). Nelson Park, Abilene, Texas.

David Smith, *Cubi I,* 1963. What modular forms are repeated and varied in this sculpture? What modular units do you see in the sculpture to the right? Stainless steel, 10' 4" (315 cm). The Detroit Institute of Arts. Founders Society Purchase, Special Purchase Fund.

Student art.

Student art.

Student art.

Student art.

Student art.

Student art.

Student art.

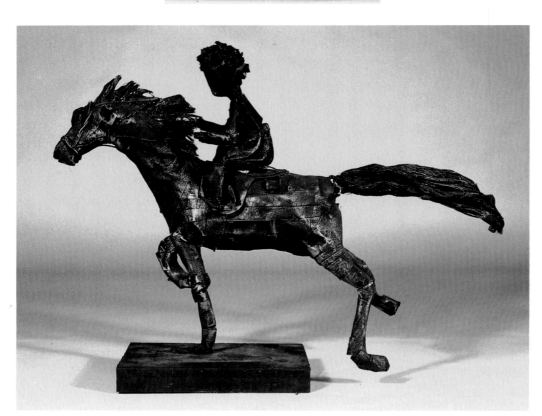

Student art.

Student art.

Summary

Sculpture is a three-dimensional art form. It has height, width and depth. Four basic forming processes can be used to create sculpture: modeling, carving, casting and constructing (or assembling). Relief sculptures are planned to be seen from one main view and are usually placed on or near a wall. Freestanding sculptures can be viewed from all sides. A kinetic sculpture is one that moves or has moving parts.

Sculptures can be created with a variety of themes and styles. Traditional materials, such as stone, wood, clay and metal, are still used but many artists are also creating sculpture from new industrial materials.

Using What You Learned

Art History

1 List three functions (purposes) of sculpture in the history of art.
2 What are two main differences between sculpture created by nomadic people and sculpture created by more settled people?
3 What are four traditional materials for sculpture?
4 For what kind of sculpture is Louise Nevelson best known? What is the main theme or meaning in the titles of many of her sculptures?
5 What question was of interest to the Dada and Pop artists who made descriptive sculpture?
6 Who invented mobiles?

Aesthetics and Art Criticism

1 Briefly define these terms:
- *freestanding*
- *relief*
- *kinetic*
- *assemblage*
- *modular*
- *maquette*
- *mobile*
- *concave*
- *convex*

2 Apply the method of criticism in Chapter 3 to evaluate your most successful and your least successful sculpture. Be sure to state the criteria you are using for your judgment.

Creating Art

1 Briefly describe the four main methods for creating sculpture.
2 Why is it important to plan a sculpture that will be carved?
3 What is an armature and why is it used in sculpture?
4 What are three examples of materials artists use for modeling sculpture?
5 Select your most successful sculpture. Describe two problems you faced in creating it and how you solved them.

Careers in Sculpture

Sculpture is known as a fine art. Today, this means that many artists are primarily interested in exploring sculptural ideas as they choose. Some artists regularly compete for commissions to create sculpture for public spaces or new corporate buildings. Others have galleries or dealers who sell their work.

Most industrial and fashion designers as well as architects study sculpture because they can often apply concepts about three-dimensional form and space to their work. The automotive, toy, entertainment and machine-tool industries all employ workers who have skills in sculpture. These workers often create models in clay, wax or other media.

Toby Buonagurio, *Robot on Panthers*, 1985. Ceramic with glazes, lusters, acrylic, paint glitter, 29 ¹/₄" x 17" x 18" (74 x 43 x 46 cm).

Chapter 13
Crafts

Chapter Vocabulary

ceramics
weaving
stitchery
macramé
batik
jewelry
mosaics
papermaking

Safety Note Many crafts require special safety precautions. Learn and follow all safety instructions given by your teacher.

In many ways, the crafts are the most basic art forms. They developed from the practical need for food, clothing, shelter, tools and utensils. In some parts of the world, food containers are still handmade from clay or other materials such as woven vines, hollowed-out wood or animal hides. The crafts include many types of handmade, useful products such as furniture, clothing, jewelry, containers and rugs.

A craft can be described as a skill in using one material to create a variety of products. The first craft guilds and present-day trades are based on this idea. For example, a skilled leather worker might make shoes, saddles and many other products from one material. A skilled metal worker might create armor, elegant chalices or fine jewelry.

Some crafts are identified by their processes or techniques. Weaving, for example, is a process for interlocking strips of fiber-like materials. We think of weaving thread or yarn, but weaving can be done in wire, or strips of wood, paper or clay.

The crafts are also expressive art forms. Most people are not completely happy with merely useful objects. They want to create or to own objects that have special meaning and beauty in design. For the Shaker people, a religious group in America, this meant that household items were made with great care and simplicity. In many cultures, elaborate handcrafted items have been valued as symbols of wealth or power.

Today, many craftsworkers are more interested in design, expression and creativity than the actual function of an object. Others prefer to refine and extend traditional forms of crafts.

Common to all craftwork is the highly skilled use of materials, tools and processes. This idea is often expressed by saying a work is "well-crafted" or shows "excellence in crafting."

Because there are so many crafts, only a few can be introduced in this chapter. Your teacher will help you decide which crafts to try. Time, cost of materials and available equipment must be considered along with your interest and prior work in crafts. It is unlikely that you can complete work in all the crafts discussed in this chapter.

After you study the chapter and complete some of the activities, you will be better able to:

Art History • understand some traditional and experimental methods of creating crafts.

Art Criticism and Aesthetics • apply your knowledge of aesthetics and art criticism when you create crafts and study them.

Creating Art • demonstrate your skills in creating well-crafted, well-designed, expressive handcrafts.

Gallery

The crafts can be grouped in many ways. Sometimes they are displayed to show one kind of *product*, such as containers or jewelry.

Crafts can also be displayed to show how one *material* (such as clay) can be used to create a variety of different products, such as containers, jewelry or lamps.

A third way to group crafts is by *process* or technique. For example, weaving can be done with metal wire, yarn, strips or coils of clay, or thin strips of wood.

Look at the crafts in this gallery. What types of products, media and processes are shown?

Critical Thinking Look at this gallery and other crafts in this chapter. Divide a sheet of paper into three columns. In each column, write descriptions of various crafts. For example:

products	processes	materials
container	modeled	clay
jewelry	modeled	paper
fabric	woven	yarn

Roslyn Brown, Fan. Handmade paper, 30" x 40" x 3 ½" (76 x 102 x 9 cm). Courtesy of the artist.

Blackfoot beaded muslin blanket strop\stole. Beads, quatrefoils and diamonds, 54 ½" (138 cm).

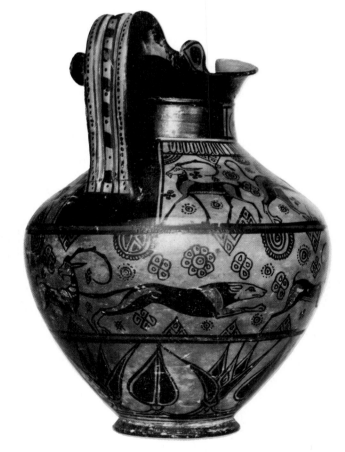

Rhodian *Oinochoe*. Animal friezes, 6th century BC. Museum of Fine Arts, Boston. Gift of Mrs. T. Morse.

Sam Maloof, Fiddleback Rocking Chair.
Maple and ebony. Photograph courtesy
George Erml.

Barbara Chase-Riboud, *Le Manteau (The Cape)*, 1973. Bronze, hemp,
[ro]pe and copper, 72" x 58" (183 x 147 cm). Collection Lannan
Foundation, Los Angeles.

Roger Wilbur, Bracelet. Sterling, ivory, coral, lapis and veracite.
Courtesy the artist.

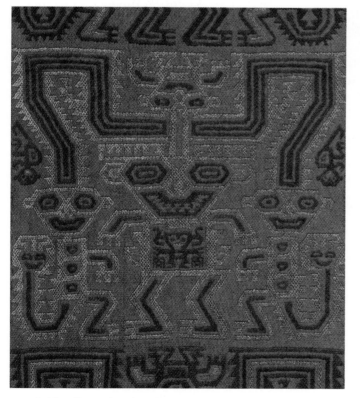

Mantle (detail), wool, embroidered with colored wools. Pre-Inca
period. Early Nazca, ca. 600. The Metropolitan Museum of Art. Gift
of George D. Pratt, 1932.

Louis Comfort Tiffany

1848-1933

Louis Comfort Tiffany. The New York Historical Society. Photograph by Pach.

Louis Tiffany, a well-to-do young painter, was decorating his studio. What, he wondered, could be done with the windows? He loved the old stained glass he had seen in Europe, but nothing like that existed anymore.

Looking for color rich enough to suit his painter's eye, he discovered that cheap jelly jars and wine bottles had better color than the finest glass. This was because of mineral impurities in the cheaper glass. He was unable to convince makers of fine glass to leave the impurities in, so he built furnaces and made his own.

Thus, Louis Tiffany the painter became Louis Tiffany the glass-worker.

His father was the founder of Tiffany and Co., a New York firm that specialized in silversmithing and jewelry making. Louis studied painting with George Inness and other artists for three years. In 1876, he exhibited his paintings in a major show in Philadelphia. In the same year, he also created his first stained glass window.

In his day, Tiffany's work was seen as abstract, natural and simple. His ideas for design often came from ancient cultures, especially the curved lines and forms of Islamic and Japanese art. Many of his crafts became well-known examples of a style called Art Nouveau (French for "new art"). In Art Nouveau, the curves of plants and other organic forms are prominent.

He brought new excitement to the art of glasswork, especially vases, stained glass windows, lampshades and lamps. He became so well known that he was commissioned to redecorate the red and blue rooms at the White House in Washington DC. When Thomas Edison installed the first electric footlights on a stage, the globes around them were Tiffany's. One critic said it was like "fire in monster emeralds."

He developed new ways to color and shape glass without painting, burning or etching designs in the surface. At one point, his company had 300 tons of glass stored in the cellar, with 5,000 different colors all neatly labeled – an enormous palette at his fingertips!

Tiffany broke away from the idea that crafts always had to be useful. Most of his work was created to be looked at in the same way you might look at a painting or sculpture. He once wrote: "It is curious, is it not, that line and form disappear at a short distance, while color remains visible." All his life he worked to bring out the extraordinary possiblities of color.

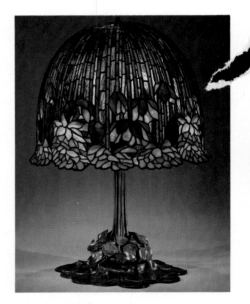

Table lamp, Tiffany Studios, New York, ca. 1910. Bronze base, leaded glass shade, 26 ¹/₂" x 18 ¹/₂" (67 x 47 cm). The Metropolitan Museum of Art. Gift of Hugh J. Grant, 1974.

Critical Thinking Glass is made from minerals heated in a furnace. The molten glass is shaped by attaching it to a long hollow tube. The craftsworker blows air through the tube to create a bubble—the interior of a vase or related form. The craftsworker can spin the tube and use paddles to stretch or press the molten glass into a final form. How do you think sheets of colored glass are made? Where could you find out more about glassmaking?

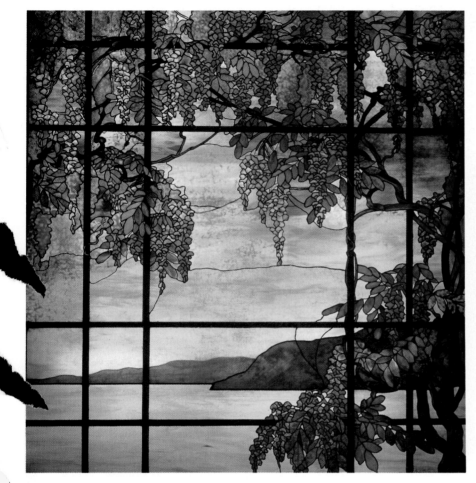

Louis Comfort Tiffany, *View of Oyster Bay*. From the McKean Collection, on extended loan to the Metropolitan Museum of Art. Courtesy of the Morse Gallery of Art, Winter Park, Florida.

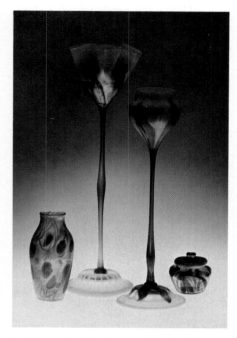

Louis Comfort Tiffany, *Favrile Glass bottle and Vases*. Favrile glass is an iridescent gold, like a golden mother-of-pearl surface. Blown glass. Courtesy of the Metropolitan Museum of Art. Gift of H.O. Havemeyer, 1896; Gift of Louis Comfort Tiffany Foundation, 1951; Anonymous Gift, 1955.

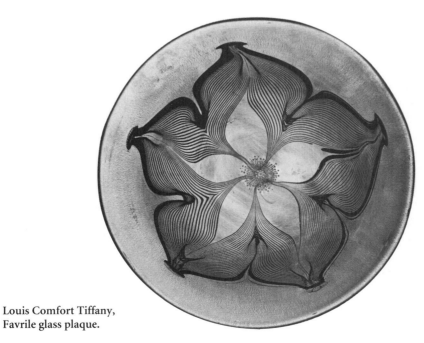

Louis Comfort Tiffany, Favrile glass plaque.

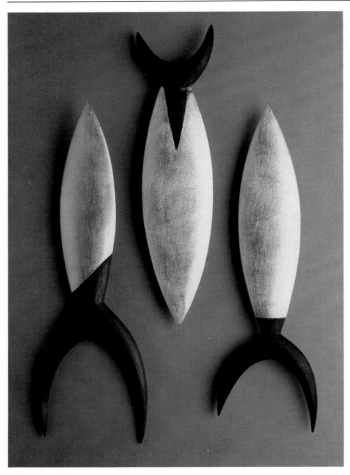

Didi Suydam, Squid, Tetra, Swordtail Brooches. Courtesy of the artist.

Jan Havens, *Bird*, High-fired stoneware, nonfired ceramic stain, acrylic paint finish; hand built, 23" (58 cm). Photograph by Barry Havens.

Finding Ideas

Ideas for crafts can come from many sources. A familiar source of ideas is nature. For example, ideas for jewelry might be suggested by flowers, insects and the like.

You can explore broad themes in the crafts. With fabrics and yarn, for example, you might explore the theme of "play." The theme might give you ideas for stuffed toys, pillows to sit on for quiet games, or a model for a giant macramé rope gym.

Imagination and fantasy are sources of ideas for crafts. Clay containers, for example, can be created so that they are round and dumpy or tall and stalwart. They might be aloof or mysterious and threatening.

Ideas for expressive crafts can also come from the use of the object. For example, the design of jewelry for your own use might differ from the design you might plan for a friend. How might a wallhanging for a kitchen differ from one designed for a child's bedroom?

The Design Process

Sketches and small models are important ways of planning your work in the crafts. Sketches and models can save you time and help you plan an effective design. Planning is important because some crafts are expensive.

You can sketch ideas for claywork by working directly in the medium. For weaving, you can make small samples, about 2" (6 cm) square, to try ideas for colors, textures and patterns. For stitchery, appliqué or rug hooking, you can make sketches in crayon, felt-tip markers or cut paper.

When you are planning your craft design, explore the symbolism of the medium, colors and other art elements you want to use. Think of the symbolic meanings of colors (warm, cool), textures (smooth, rugged) and shapes (active, quiet).

Review the elements and principles of design in Chapter 2. Use them to analyze your ideas for crafts and then later to evaluate your completed work.

Ceramics

Ceramics is the process of making objects from clay (refined earth). Ceramic objects are *fired* (heated to a high temperature) in a furnace-like oven called a *kiln* (pronounced "kill").

Pottery, bowls, vases and other clay containers were first made by hand with simple tools. The potter's wheel, invented about 4,000 BC, made it possible to produce pottery very quickly.

Today, ceramic clay is used as a medium for traditional crafts as well as sculpture. It can also be combined with other media. Before you begin work in clay, review the ceramics vocabulary and safety precautions for this medium.

Basic Concepts

Clay is easily shaped when it is moist. *Grog* (grains of fired clay), is often added to the wet clay. It adds strength and texture for sculpture or large work. *Leather-hard* clay is partially dry.

Greenware is a totally dry, unfired work in clay. It must be carefully handled. When the dry clay is fired in the kiln, the intense heat will harden the clay.

After greenware is fired, it is called *bisqueware*. Bisqueware can be glazed. Glaze is a mixture of water and colored minerals. A glazed work must be refired. The fired glaze helps to waterproof clay and often gives it a glassy finish.

To join pieces of moist or leatherhard clay, scratch both surfaces, apply slip and press the pieces together. *Slip* is clay mixed with water to the consistency of mayonnaise.

To keep clay moist between work periods, cover it with a damp cloth and place it in an air-tight plastic bag. To avoid problems in firing, hollow out solid forms to a thickness of 1"(3 cm). Cover thin parts with a damp cloth so they will dry at about the same rate as the whole piece.

CERAMICS VOCABULARY

Bisque Clay that has been fired once but not glazed.
Engobe A colored clay slip applied to a leather-hard or bisque-fired work.
Glaze A paint-like mixture of finely-ground colored minerals that melt at high temperature to form a thin, permanent, often glassy surface on clay.
Fired Hardened by the high temperature of the kiln.
Greenware Dry, unfired clay.
Kiln The furnace-like oven in which the clay is fired.
Leather-hard Slightly moist but firm clay that holds its shape.
Sgraffito Italian for "scratched through." A process of scratching through a layer of colored slip to expose the clay color underneath.
Slip Clay mixed with water to form a thick liquid.
Wedging A process used to release air bubbles from clay by kneading it or cutting it in half with a taut wire, then slamming the pieces onto a hard surface.

Safety Note Do not ingest or inhale the ingredients of clay. If you have dust allergies, inform your teacher and work in another medium and in an area away from dust.

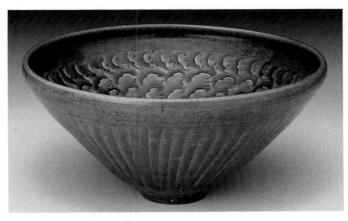

Chinese, Bowl. Northern Sung dynasty, 11th-12th century AD, 8" (20 cm) diameter. The Art Institute of Chicago. Bequest of Russell Tyson, 1964.

Materials

Your hands are the best tools for working in clay. Other tools are: two flat sticks about 3/8" (9 mm) thick, a rolling pin, a work-cloth of canvas or burlap, a modeling board, a sponge, water containers, plastic bags, an old knife and fork and items to create textures.

Preparation

Moist ceramic clay might need to be wedged to remove air pockets. If the air is not removed, it can "explode" and cause damage when the work is fired.

Wedging can be done by kneading the clay like bread dough. Stand up. Using the heel of both hands, press down and forward on the clay. Firmly roll up the clay again and repeat the process five or six times.

If you have a wedging board, cut the clay with a wire. Put one half on the board. Slam the other half on top of it. Repeat this process until the air is forced out.

Forming Processes

There are many ways of forming clay. Try some of the following techniques.

1. COIL. A coil is a long, flexible cylinder of clay. Roll out coils about 1/2" (1 cm) thick. Use your fingers and palms, working from the center outward.

Create structures by laying the coils on top of each other and blending them together. You can use a bowl as a mold for coil work. Line it with gauze or thin, kitchen-type plastic wrap. Press coils into the mold so they form a design.

Remove the clay just before it is leather-hard. The coil pattern can be seen on the outside wall of the bowl. It can be left plain or decorated with other textures.

2. PINCH POT. Support a ball of clay in both hands. Press both thumbs into the center of the ball. Slowly rotate the ball and gently pinch the clay to create even walls.

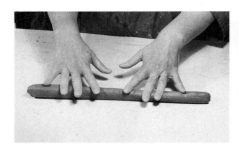

Coil Method. Roll out the coils. Clay is rolled to form a coil.

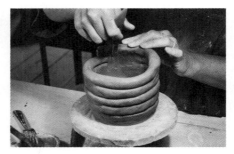

Coils are built up and welded together on the inner surface to form the wall of the pot. The outer surface may also be made smooth if so desired.

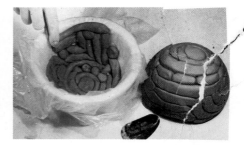

Laying coils into a mold such as this kitchen bowl will yield exciting results. Be certain to blend the coils on one side of the wall. The rubber rib shown in the foreground is a useful tool for blending.

A well-crafted pinch pot has walls of even thickness.

Maurice Sapiro, A Covered Box. Coils can be joined to create patterns in a work. Courtesy of the artist.

Combine several sizes of pinch pots, or use them with slabs and coils. Pinch pots are also a quick way to begin a clay sculpture.

3. SLABS. Clay with grog works best. First, lay a work-cloth on a table. Partially flatten a lump of clay with your hands. Put a flat stick on each side of the clay.

Press a rolling pin down on the center of the clay. Roll the clay from the center to each end until the pin glides on both sticks.

To cut geometric shapes, use a straight edge (ruler) or a piece of cardboard cut to the shape desired. Place it on the slab and trace around it with a pointed tool. For circles, press the open end of a can straight into the slab.

Engraved or raised decorations are best made on moist slabs, before they are joined. Assemble flat slabs just before they are leather-hard. Score the edges and apply slip, then join them.

A large soft slab can be shaped by draping it over a cloth-covered mold. A slab can also be sagged into the inside of a mold. The mold can be a bowl or any form with smooth contours and no undercuts. Trim and remove the shaped slab before the clay is leather-hard.

Try rolling a slab into a cylinder. Combine it with smaller cylinders, coiled work, pinch pots or other slabs.

Diane Kruer, *Sweeties Piece*, 1984. Moist slabs can be impressed with textures, then gently formed into bowls, trays, and the like. Hand-built porcelain, 10" x 15" x 15" (25 x 38 x 38 cm). Courtesy of the artist.

Slab Method. Roll out a slab. Courtesy of Alice Sprintzen.

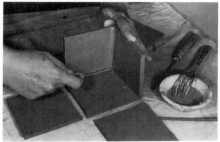

Score the edges. Add slip before you join the slabs.

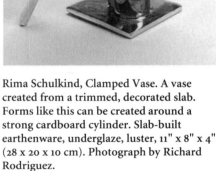

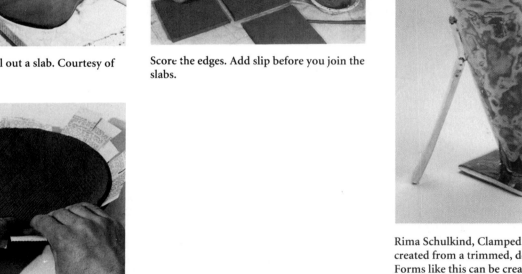

Draped or sagged slabs. Cover a curved form with gauzelike cloth. Press a slab around or into the form. Trim and remove the leather-hard clay.

Rima Schulkind, Clamped Vase. A vase created from a trimmed, decorated slab. Forms like this can be created around a strong cardboard cylinder. Slab-built earthenware, underglaze, luster, 11" x 8" x 4" (28 x 20 x 10 cm). Photograph by Richard Rodriguez.

4. WHEEL-THROWN CERAMICS. A potter's wheel has a turntable on which you place a lump of clay. As the turntable spins (by foot or electrical power), you shape the moist clay by gently pressing inward or outward against the clay.

If you use a potter's wheel, your teacher will provide additional instruction on the steps for wheel-thrown work.

1. Center the clay. Place your hands on opposite sides of the clay. Press the heel of your right hand and push toward the center with the left hand. Always brace your hands and elbows on your body or the edge of the wheel.

2. Open the beehive-like form. Press both thumbs into the center of the clay.

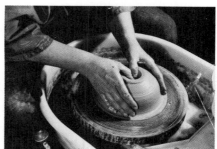

3. Open the center of the beehive. Pull thumbs apart.

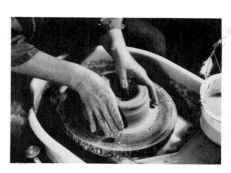

4. Raise the center. Place your fingers on the inside wall just above the fingers on the outside wall. Keep the fingers in this position and slowly bring them up from the bottom of the pot. The clay will be pushed up to form a cylinder.

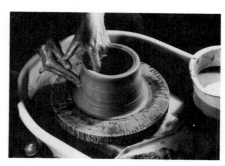

5. Change the cylinder. To narrow the form, press inward. To widen it, press outward. Courtesy of Alice Sprintzen. From "Crafts: Contemporary Design and Technique," Davis Publications, Inc., 1987.

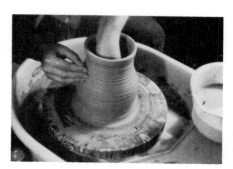

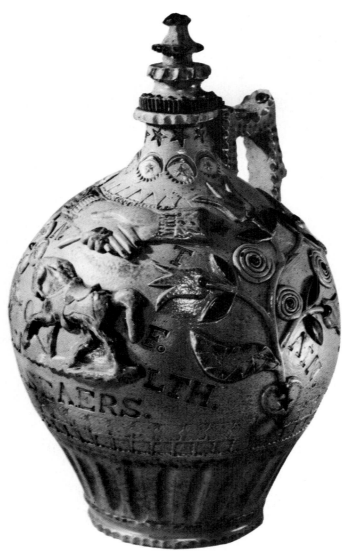

Jug, E. Hall Newton Township, Tuscarawas County, Ohio, 1858. This early American jug has incised and applied motifs. Stoneware, 17 ½" (44 cm) high. Henry Ford Museum and Greenfield Village, Dearborn, Michigan.

Student art.

Student art.

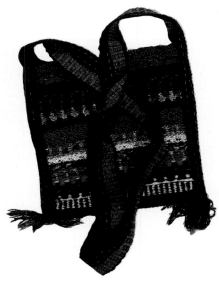

Student art.

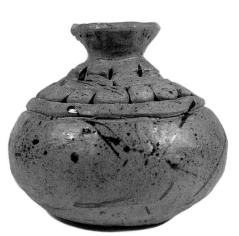

Student art.

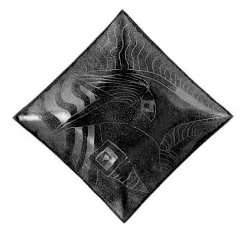

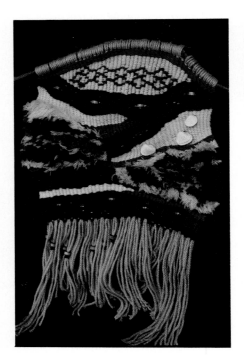

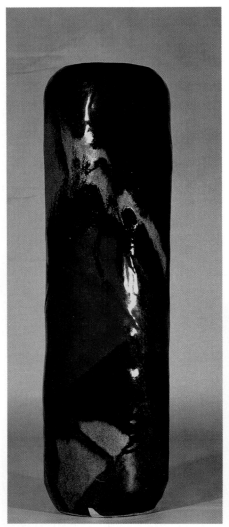

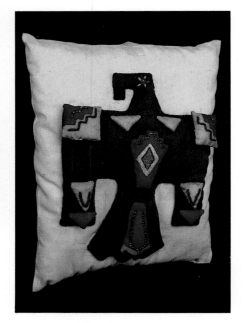

Student art.

Student art.

Student art.

Student art.

Summary

Crafts can be described as handmade objects created with great skill. They can be broadly classified by type of product (such as jewelry or container), medium (metal, clay) or process (weaving, casting).

Traditionally, crafts have been practiced to create things for use in everyday life or special ceremonies. The design qualities usually reflect the values and beliefs of the culture.

Today, many craftsworkers approach their work as a form of creative art, for personal expression. Some critics and historians say that Tiffany's work in glass helped to establish the crafts as creative statements, not just functional or decorative products.

Design ideas for crafts can come from many sources – nature, imagination, broad themes and the use of the object. Each craft process and medium has a technical vocabulary.

In this chapter, only a few of many crafts have been discussed. These are ceramics, metalworking, mosaics, papermaking, fiber arts and jewelry.

Using What You Learned

Art History

1 What is the style name for many of Louis Tiffany's crafts?

2 When was the potter's wheel invented? How did this invention change the kind of pottery that people could make?

3 Explain why people in some cultures may value jewelry created with colorful stones, feathers and other natural materials.

4 What were three uses of mosaics in ancient times?

5 In what two countries was papermaking developed over 2,000 years ago.

6 From what practical work did the art of macramé develop?

7 In what country is the art of batik a highly developed traditional craft?

Aesthetics and Criticism

1 Suppose you were asked to organize a crafts show. There would be many kinds of crafts. Name three ways you might group the crafts for display.

2 Most crafts use many technical terms. Select one craft in which you have worked. List the main technical terms and use each one correctly in a sentence.

3 Select one of your most effective works in crafts. State the criteria you have used in judging the work. Then describe the qualities (sensory, technical, expressive, design) that help to make it effective.

Creating Art and Aesthetics

1 Select the craft area you like best. Describe the processes you most enjoyed. Explain why you found them enjoyable.

2 Creative problem-solving is an important part of working in crafts. Describe at least one problem you encountered and solved while working in a craft. (The problem might have been in the design or the use of a process or medium).

3 What is meant by the phrase "a well-crafted work?"

Glossary

abstract An abstract artwork is usually based on a subject you can identify. The artist leaves out details, simplifies, or rearranges some elements so that you may not recognize them. Abstract work based on a subject which you may not be able to recognize is called nonobjective art.

Abstract Expressionism 1945-1960. A painting style in which artists applied paint freely to huge canvases to suggest ideas, feelings and emotions. The style is often called "action painting." Many artists used slashing, active brushstrokes and techniques such as dripping, pouring or spattering paint on canvas.

academic A general term for artworks that seem to be based on rules set up by some person or group other than the artist. Artists created academic artwork by following rigid rules made by leaders of European art schools or academies in the 1700s and 1800s.

acrylic (a-CRILL-ik) A paint which uses liquid acrylic plastic to hold the color or pigments together. It is similar to oil paint but acrylic can dissolve in water before it dries.

Action Painting See *Abstract Expressionism.*

active Expressing movement. Opposite of static.

actual Anything you can perceive through the senses. Lines, shapes, textures or other elements you can sense. (See *implied.*)

adhesive (add-HEE-siv) Glue or other sticky substance used to join materials together.

advertising Communications meant to convince an audience to do or buy something.

aesthetic judgment (es-THET-ik JUDGE-ment) An opinion about art based on whether or not the art produces an aesthetic response. (See *aesthetic perception.*)

aesthetic perception (es-THET-ik per-SEP-shun) A response to art or the environment involving positive thoughts, sensations and feelings.

afterimage A sensation in the eye and brain created by looking at a color for a long period of time. Afterimages appear as complementary colors. If you stare at something red, the afterimage is green.

allover A pattern that covers an entire surface, from one border to another.

alternating A form of visual rhythm created in an artwork by repeating two or more different artistic elements, one beside or near the other.

American Regionalism 1930s. An art history term for a painting style inspired by life in rural areas and small towns in the Midwest.

American Scene Painters 1910-1950. An art history term for artists who portrayed American life in a direct, simple manner.

analogous (an-AL-o-gus) Colors that are closely related because they have one hue in common. For example, blue, blue-violet, and violet all contain the color blue. Analogous colors appear next to one another on the color wheel.

animation A form of moving picture. A series of drawings or other images are photographed one by one. Each photograph shows a small change in the position of the images. When the pictures are shown quickly one after the other, they seem to move.

aperture (A-purr-chur) In a camera, the opening that is formed when the shutter is used.

appliqué (ah-plee-KAY) A process of stitching and/or gluing cloth to a background, similar to collage.

arbitrary color Color chosen by the artist to stand for an idea or to express a feeling. Opposite of *optical color.*

architect A person who has been trained to design buildings or communities.

architecture The art of designing and planning the construction of buildings, cities and bridges.

arcology (ar-KOLL-oh-jee) A philosophy of architecture which combines buildings with plenty of open land.

armature (ARM-a-chur) A skeleton-like framework used to support other materials.

art criticism The process and the result of thinking carefully about art. Art criticism involves the description, analysis and interpretation of art. It does not always include a stated judgment of worth or value.

Art Moderne (art mo-DAYRN) 1920-1940. A style of design and architecture that combines smooth curves with sleek, machine-like geometric forms.

Art Nouveau (art new-VOH) 1900-1915. Means "New Art." A style of art based on the use of curved, plant-like forms. Artists working in this style especially liked the linear qualities of vines.

artisan A person skilled in creating handmade objects.

Ashcan School 1908-1914. American artists who painted pictures of city life, especially alleys, old apartment buildings and people living in slums. The group's original name was "The Eight."

assemblage A three-dimensional work of art consisting of many pieces joined together. Art made by combining a collection of three-dimensional objects into a whole.

asymmetrical A type of visual balance in which the two sides of a composition are different yet balanced. The two sides are equal without being just the same. Also called *informal balance.*

atmospheric perspective (aerial perspective) A way to show how light, air and distance make flat surfaces look different. It is usually done by using blues and light, dull hues for objects which are far away.

avant garde art (ah-VONT guard art) A term which describes art that is original and different from traditional styles of art. Avant garde artists often experiment with new materials and ways of expressing ideas.

background Parts of artwork that appear to be in the distance or behind the objects in the foreground or front.

balance A principle of design that describes the arrangement of parts of an artwork. An artwork that is balanced seems to have equal visual weight or interest in all areas. It seems stable.

Baroque (bah-ROKE) 1600-1700. Baroque is an art history term for a style marked by swirling curves, many ornate elements and dramatic contrasts of light and shade. Artists used these effects to express energy and strong emotions.

bas-relief (bah ree-LEEF) Also called *low relief.* A form of sculpture in which portions of the design stand out slightly from a flat background.

batik (bah-TEEK) A method of dyeing cloth that involves the use of wax to prevent dye from coloring certain areas of material. Wax is brushed on parts of the design where the color of a dye is not wanted.

Bauhaus (BOW-house) 1918-1933. A German art school that stressed the need, in an industrial time, to join science, technology, fine art and craft.

Beaux Arts (boze art) 1800-1900. A style of art popular in European art schools. The style combines elements of the fancy Rococo, Neo-classicism and Romanticism.

Benin Kingdom (ben-een KING-dom) A former kingdom of western Africa whose artists achieved a high level of quality, especially in bronze casting.

bisque (bisk) Ceramic that has been fired once but not glazed.

block In printmaking, a piece of flat material such as wood, linoleum or metal used to make a print. In sculpture, any solid material that can be used for carving.

block printing The process of making prints by creating a raised design on a flat surface. The design is inked or covered with color and stamped on a surface such as paper or cloth.

brayer A small, hand-held rubber roller used to spread printing ink evenly on a surface before printing.

brushstroke A line, shape or texture created by putting paint on a surface with a paint brush.

burnish To smooth a surface by rubbing it with a tool that has a hard, smooth surface.

Byzantine (BIZ-ann-teen) 300-1500. An art history term for a style that blended Roman, Greek and Oriental influences. It developed in the Eastern Roman Empire (called Byzantium). It includes rich color (especially gold), flat, stiff figures, and religious themes. An example is Hagia Sophia in Constantinople, now called Istanbul, Turkey.

calligraphy (cah-LIH-grah-fee) Flowing lines made with brushstrokes similar to Oriental writing. It is also the art of using a pen or brushes to write beautiful letters and words.

caricature A picture in which a person's or an animal's features, such as nose, ears or mouth, are different, bigger or smaller than they really are. Caricatures can be funny or critical and are often used in political cartoons.

cartoon A full-sized drawing used as a plan for a painting, especially for a mural. A cartoon can also be a funny drawing that tells a story.

cast The process of reproducing an object, such as sculpture or jewelry, by creating a mold into which liquid plaster, concrete or metal is poured. A cast is also the object produced by this process.

center of interest The part of an artwork which attracts the viewer's eye. Usually the most important part of a work of art.

ceramics (sir-A-miks) The art of making objects from clay, glass or other minerals by baking or firing them at high temperatures in an oven known as a kiln. Ceramics are also the products made in this way.

charcoal A soft drawing material made from charred wood or vines.

chiaroscuro (key-AH-ro-SKUH-ro) An Italian word meaning light and shadow. In two-dimensional art, chiaroscuro is the gradual or sharp contrasts in value that make something look three-dimensional. Chiaroscuro is also called *modeling* and *shading.*

Chippendale A style of furniture developed by the English woodworker Thomas Chippendale (1718-1779).

chroma (CROW-mah) The intensity of a color—the brightness of a hue.

cinematography (SIN-eh-mah-TAH-grah-fee) The art of making motion pictures.

cityscape An artwork that uses elements of the city (buildings, streets, shops) as subject matter.

classical An art history term for any art inspired or influenced by ancient Greek or Roman art. Classical works usually have perfect form and proportion. They show little emotion, and seem ideal rather than real.

collage (coh-LAZH) A work of art created by gluing bits of paper, fabric, scraps, photographs or other materials to a flat surface.

collagraph A print made from a surface that has been built up like a collage.

Colonial American art 1600-1776. American art created during the period when the English ruled.

color See *hue*.

Color Field painting 1950-present. A style of painting involving large flat areas of color. Color Field paintings are usually meant just to make viewers think about what they see, not to express a definite idea or emotion.

color interaction A sensation that colors seem to change when placed beside or near other colors.

color scheme A plan for selecting or organizing colors. Common color schemes include: warm, cool, neutral, monochromatic, analogous, complementary, split-complementary and triad.

color spectrum A band of colors produced when white light shines through a prism. The prism separates the light into different wavelengths. Visible colors are always seen in the same order, from longest wavelength to shortest: red, orange, yellow, green, blue, violet. A rainbow displays the color spectrum which we can see. A color wheel shows the spectrum arranged in a circle.

color triad Any three colors spaced an equal distance apart on the color wheel.

color wheel A circular chart of colors of the visible spectrum. It is commonly used to remember color relationships when working with pigments.

combine painting Artwork created by mixing together or combining flat, painted surfaces with three-dimensional objects.

complementary Colors that are directly opposite each other on the color wheel, such as red and green, blue and orange, and violet and yellow. When complements are mixed together, they make a neutral brown or gray. When they are used next to each other in a work of art, they create strong contrasts.

composition To create, form or design something by arranging separate parts to create a whole.

computer drawing program Software used to create drawings on the computer.

concave A form that has a hollow area like the inside of a bowl.

conceptual art Artwork in which the concept or idea is more important than the technique or material used to create it.

Constructivism 1917-1920. A style of three-dimensional art that uses industrial materials such as metal, glass and plastic to create abstract art.

contour A line which shows or describes the edges, ridges or outline of a shape or form.

contour drawing A drawing which uses only contour lines.

contrast A large difference between two things: for example, rough and smooth, yellow and purple, and light and shadow. Contrasts usually add excitement, drama and interest to artworks.

converging lines Actual or implied lines that seem to point toward a central place in space. A technique related to linear perspective.

convex A form with a raised surface, like the outside of a bowl or hill.

cool colors Colors often connected with cool places, things or feelings. The family of colors ranging from the greens through the blues and violets.

corporate identity program In graphic design, the design of visual elements, including a logo, used consistently to identify the products and services of a company.

crackle Fine lines formed in a surface, usually while using a specific material and technique.

craft guild See *guild*.

crafts Works of art, decorative or useful, that are skillfully made by hand.

craftsworker A person highly skilled in creating useful or decorative artwork by hand. An artist who designs and creates useful objects such as textiles, ceramics and jewelry.

crayon etching A technique in which crayon is applied heavily to a surface then covered with more crayon or an opaque ink or paint. Designs are scratched (etched)through the covering material to show the crayon below.

crayon resist A drawing made with wax crayon and covered with a thin coat of paint. Since water does not stick to wax, the paint will not cover the crayoned part.

criteria for judging art Standards for art that you can state to others. The standards are not strong personal opinions or vague preferences.

crosshatch The technique of placing lines close together in opposite directions to create dark areas in a drawing or print.

Cubism 1907-1914. An art history term for a style developed by the artists Picasso and Braque. In cubism, the subject matter is broken up into geometric shapes and forms. The forms are analyzed and then put back together into an abstract composition. Often, three-dimensional objects seem to be shown from many different points of view at the same time.

Dada (DAH-dah) 1915-1923. An art movement in which artists created work based on chance. These artists often used ready-made objects to create new art forms. They are also known for having criticized contemporary culture. Many artists involved in the Dada movement became leaders of Surrealism and other new styles of art.

De Stijl (day SHTEEL) 1917-1932. Dutch for "the style." A style developed by Piet Mondrian and other artists. They believed that pure abstract art should be based only on vertical (up and down) and horizontal (side to side) flat areas, and the three primary colors with black, white, gray.

decalcomania (dee-CAL-co-may-nee-ah) A technique of creating random texture patterns. Thick paint is applied to the front of two papers or canvases. The painted surfaces are pressed together and then pulled apart, leaving a textured pattern.

deckle The upper frame of a mold used in hand-forming a sheet of paper. The deckle determines the shape of the paper.

depth of field In camera work, the distance between the camera and the scene that will be in sharp focus when you record the image.

Der Blaue Reiter (dehr BLAH-way RIGHT-er) 1911-1914. German for "the Blue Rider." This name was adopted by a group of European artists who explored the spiritual and expressive meanings of color in painting. The artist Kandinsky used this name for the title of a painting.

design The plan, organization or arrangement of elements in a work of art.

diagonal A direction that a line can have. Diagonal lines may be used to show motion.

Die Brücke (dee BROOK-eh) 1905-1913. German for "the bridge." This group of artists developed a bold, expressionistic style of art, often borrowing design ideas from art created by children or self-taught adults.

dimension A term used in art for actual measurements of length, width and depth. These measurements are used to distinguish between flat or two-dimensional art (such as drawing or painting) and three-dimensional art (such as sculpture and architecture).

docent (DOE-sent) A teacher-guide who leads people through a museum.

dominant The part of an artwork that is most important, powerful or has the most influence on the viewer.

dry media Pencil, chalk, crayon and other media that are not wet and do not require the use of a liquid.

drypoint A method of intaglio printing in which the image is scratched into the surface of the printing plate with a steel needle. The print is also called a drypoint. The lines and tones in the printed image often look very soft.

dye A colored liquid that soaks into a material and stains it.

dye-bath In batik, a container filled with enough dye to stain a fabric soaked in it.

Early Christian art 31-400 AD. Art created by the first Christians, especially in the area around Rome.

Earth/Land Art Sculpture in which land and earth are important as ideas or used as a media for expression.

earthenware A coarse pottery which tends to absorb moisture. Earthenware is usually buff or reddish, and has been fired at a low temperature.

earthwork Any work of art in which land and earth are important media.

easel painting A small- to medium-sized painting that can be supported on an easel.

eclectic (ek-leck-tik) Art that combines elements from different styles.

edition In printmaking, the total number of impressions or prints made at one time and in the same way from the same block or plate.

elements of art/design The visual "tools" artists use to create art. The elements (categories) include color, value, line, shape, form, texture and space.

Emotionalism A theory of art which values communication of moods, feelings and ideas.

emphasis Area in a work of art that catches and holds the viewer's attention. This area usually has contrasting sizes, shapes, colors or other distinctive features.

engobe (en-GO-bee) A colored clay slip put on leather-hard or bisque-fired ceramics as a form of decoration.

engraving The process of using a sharp tool to cut a design into a material, usually metal. Engraving is also an intaglio printmaking process based on cutting grooves into a metal or wood surface.

environment The surrounding area in which we live. The environment includes the natural world and all of the elements that people have constructed, changed or added.

etching An intaglio printmaking process. The image is made by coating the surface of a metal plate, scratching through the coating, then placing the plate in acid. The acid burns through the scratched lines, making grooves in the metal that can hold ink.

exhibit A temporary show or display of a group of artworks.

expressionism A style of art in which the main idea is to show a definite or strong mood or feeling. If written with a capital E, Expressionism is a definite style of art which was created mostly in Germany, from about 1890 to 1920.

expressive qualities The feelings, moods and ideas communicated to the viewer through a work of art.

Fantasy art Artwork that is meant to look unreal, strange or dream-like.

Fauves (fohv) 1905-1907. French for "wild beasts." A group of painters who used brilliant colors and bold distortions in a surprising way. Henri Matisse was the leading artist of the Fauves.

Federal Art Program A United States government program, set up during the Depression to create jobs for American artists.

fiber artists Artists who use long, thin, thread-like materials to create artwork.

figure A general term for any shape or form that we see as separate from a background. A figure is also a human form in a work of art.

fine art Art that is valued for its design, its ideas and the kind of feeling it creates in viewers.

firing In ceramics, the process of placing a clay object in high heat in order to harden it permanently. This process usually happens in an oven called a kiln.

fixative A thin liquid applied to a surface to prevent the smearing, flaking or fading of a medium, or to give a permanent finish.

focal point An area of an artwork that attracts the viewer's attention.

folk art Traditional art made by people who have not had art training in a school. Folk artists may use art styles and techniques that artists have taught each other for many years.

foreground In a scene or artwork, the part that seems closest to you.

foreshortening A form of perspective in which the nearest parts of an object or person are enlarged. This makes the rest of the form look like it goes back into space.

form Any three-dimensional object. A form can be measured from top to bottom (height), side to side (width) and front to back (depth). Form is also a general term that means the structure or design of a work. See *form follows function.*

form follows function A summary of this idea: The design of a useful artwork should come from (and express) the practical use of the work.

formal balance Artwork in which the parts are arranged in about the same way on both sides, like a mirror image. Formal balance is also called *symmetrical* design.

formal order A theory of art developed by Clive Bell and Roger Fry in the early twentieth-century. Formal order is also known as formalism. In this theory, the visual design of an artwork is more important than its subject matter.

formal qualities The structural qualities of an artwork, usually described using the principles of design.

free-form A term for irregular and uneven shapes or forms. Something that is free-form may be difficult to describe in simple shapes or measurements.

free-lance illustrator A self-employed artist who creates illustrations.

freehand A drawing done without tracing paper or drawing tools such as a ruler or compass.

freestanding A sculpture that does not need a special base or platform to support it.

fresco (FRES-coh) A technique of painting in which pigments are applied to a thin layer of wet plaster. The plaster absorbs the pigments and the painting becomes part of the wall.

frottage (froh-TAZH) A method of reproducing textures by rubbing crayon over paper placed on a textured surface. In painting, textures are made by scraping a freshly painted canvas that has been placed over a textured surface.

Futurism 1909-1914. A style named by Italian artists to describe their interest in the future. Futurists were especially interested in the force of motion at high speed (dynamism) and rapid changes in technology in the twentieth-century.

gauge (gage) A system for measuring the thickness of metal. A higher number means a thinner metal.

genre (ZHA-nra) Subjects and scenes from everyday life.

geometric Mechanical-looking shapes or forms. Something that is geometric may also be described using mathematical formulas. Geometric shapes include circles, squares, rectangles, triangles and ellipses. Geometric forms include cones, cubes, cylinders, slabs, pyramids and spheres.

Georgian style A style of architecture with Neo-classical elements associated with the reigns of King George I and II of England (1717-1727, 1727-1760) and named for them.

gesture drawing A quick drawing to show movement.

glaze In painting, a thin layer of transparent paint. In ceramics, a thin coating of minerals fused to clay by firing. Glaze creates a permanent, glassy surface on clay.

Golden Section or **Mean** A ratio (relationship of parts) discovered by Euclid, a Greek philosopher. When this ratio was rediscovered in the early 1500s it was named the Divine Proportion. Many organic objects have a form described by the ratio.

Gothic Art 1100-1400. A period of change in art in Europe during the late Middle Ages. People began to develop cities and trade with each other. The cities were often built near a large cathedral.

gouache (gwash) An opaque watercolor made from pigments ground in water and mixed with a binder. Gouache looks like school tempera or poster paint.

gradation A gradual, smooth change, as in from light to dark, from rough to smooth, or from one color to another.

graphic design A general term for artwork in which letter forms (writing, typography) are important and carefully placed visual elements.

graphic designer An artist whose knowledge of letter forms (writing, typography) is an important part of the artwork.

Greek Revival style A style of art, especially in architecture and sculpture, in which there are elements of ancient Greek art.

greenware Dry, unfired clay artwork or pottery.

grog Ground or crushed fired clay that is added to unfired clay. Grog is used for texture, strength, and often to reduce shrinking and bending.

grottage (grow-TAZH) The technique of scratching into wet ink or paint to create different textures. A variety of tools can be used, including forks and combs.

ground The background of an artwork. A ground is also the surface on which two-dimensional artwork is done, such as paper, canvas or cardboard.

grout A fine cement or plaster used to fill the space between tesserae in a mosaic.

guild In the Middle Ages, a group of skilled craftsworkers. Each guild specialized in one kind of work such as painting pictures, sculpting stone, or shaping metals.

happening A form of performance or event, developed by Allan Kaprow and others during the 1960s. In a happening, there is a plan for unexpected events, or for people to be involved in a natural, unthinking way.

Hard-Edged Painting A style of twentieth-century painting with sharp, definite edges. The values and colors are usually even and flat.

Harlem Renaissance (HAR-lem ren-eh-SAHNSS) 1920-1940. A name of a period and a group of artists who lived and worked in Harlem, New York City. They used a variety of art forms to express their lives as African Americans.

harmony The placement of elements of a composition in a way that is pleasing to the eye. It is similar to a pleasing harmony in music.

hatch The effect made by placing lines next to each other.

Heritage-Based Art A general term for art strongly influenced by the artist's way of life and beliefs, given him or her by a parent, family member or community.

hieroglyphics (hi-row-GLIPH-icks) Picture writing, especially that used by ancient Egyptians.

high relief Sculpture in which areas project far out from a flat surface.

High Tech Art A general term for artwork inspired by technology and using new technologies as art media.

high-key painting A painting using many tints of a single color.

highlight The area on any surface that reflects the most light.

holography Photography done without lenses to create a three-dimensional image. A special photographic plate is exposed to light reflected from an object lit by a laser beam.

horizon line A level line where water or land seem to end and the sky begins. It is usually on the eye level of the observer. If the horizon cannot be seen, its location must be imagined.

horizontal A line or shape that is parallel to the top and bottom edges of a surface.

hue The common name of a color in or related to the color spectrum, such as yellow, yellow-orange, blue-violet, green. Hue is another word for *color*.

idealized More perfect than you would ordinarily find in life.

illuminated manuscript A decorated or illustrated manuscript in which the pages are often painted with silver, gold and other rich colors. They were popular during the Medieval period.

illustrator An artist who creates pictures to explain a point; to show an important part of a story; or to add decoration to a book, magazine or other printed work.

imagination The ability to picture things in the mind, often things that are not seen in the real world.

imitationalism A theory of art in which a work of art is thought to be successful if it looks like and reminds the viewer of something seen in the real world.

impasto (im-POSS-toe) A very thick textured layer of paint.

implied A series of separate points or edges of shapes that the viewer tends to see as connected.

impression Any mark or imprint made by pressure. In printmaking, an impression is a print made by pressing an inked surface against a paper surface.

Impressionism 1875-1900. A style of painting that began in France. It emphasizes views of subjects at a particular moment and the effects of sunlight on color.

incising (in-SIZE-ing) Cutting or carving thin lines on the surface of a material.

industrial designers Artists who design the visual appearance of cars, dishes, toys and other products that are usually mass-produced.

informal balance See *asymmetrical*.

ink slab A smooth, non-absorbent surface on which printing ink is rolled out with a brayer.

Instrumentalism A theory in which the main value of art is its usefulness to people in daily or ceremonial life.

intaglio (in-TAHL-ee-oh) A printmaking process in which the image is carved into the surface. The lines hold the ink.

intensity The brightness or dullness of a hue. A pure hue is called a high-intensity color. A dulled hue (a color mixed with its complement) is called a low-intensity color.

intermediate color A color made by mixing a secondary color with a primary color. Blue-green, yellow-green, yellow-orange, red-orange, red-violet and blue-violet are intermediate colors.

International Style 1930-1970. A style of architecture with machine-like, geometric forms and little decoration.

invented texture A visual sensation of texture created by repeating lines and shapes in a pattern.

jazzy A form of visual rhythm or movement that is complex. It is similar to the rhythms in jazz music.

jewelry saw A C-shaped saw with a thin blade for cutting sheet metal.

kiln (kill) An oven similar to a furnace. Kilns are used for firing ceramic objects or for fusing glass or enamels to metal.

kinetic sculpture A sculpture that moves or has moving parts. The motion may be caused by many different forces, including air, gravity and electricity.

knot-bearing cord The cord you hold tightly when tying a macramé knot.

landscape An artwork that shows natural scenery such as mountains, valleys, trees, rivers and lakes.

landscape architect A person who designs natural settings, such as parks, for people to use and enjoy.

layout The arrangement of type and illustrations for a graphic design.

leather-hard Slightly moist clay that is firm and holds its shape.

lens (lenz) Part of a camera, made of glass, that allows light to shine on the film and create an image.

Light Art Any kind of artwork in which lighting sources and tools are used as media.

limner (LIM-ner) An early American artist who painted signs, houses and portraits.

line A mark with length and direction, created by a point that moves across a surface. A line can vary in length, width, direction, curvature and color. Line can be two-dimensional (a pencil line on paper), three-dimensional (wire) or implied.

linear perspective A system of drawing or painting used to give a flat surface a look of depth. The lines of buildings and other objects in a picture are usually slanted inward, making them look like they move back in space. If you make these lines longer, they will cross at a point on an imaginary line representing the eye level (sometimes called the *horizon line*). The point at which the lines meet is called a *vanishing point*.

linear style A painting technique in which contours or outlines are most important.

linoleum cut (lih-NO-lee-um cut) A relief print made from a piece of linoleum.

lithography A method of printing from a prepared flat stone or metal plate. Lithography is based on the idea that grease and water do not mix together. A drawing is made on the stone or plate with a greasy drawing material and then washed with water. When greasy ink is applied, it sticks to the greasy drawing but runs off the wet surface. This allows a print to be made of the drawing.

local color Color that we commonly think of as a part of the object, without noticing the effects of light or atmosphere.

logo A visual symbol that identifies a business, club or other group. Logos are often made of a few artistically drawn letters or shapes.

loom A frame or related base for weaving cloth. Some threads are held by the loom (*warp* threads) while other threads are woven through them (*weft* threads).

low key painting A painting with many dark values.

low relief See *bas-relief*.

macramé (MACK-rah-may) Artwork based on knotting cords.

Magic/Poetic Realism 1920-Present. A style of painting that combines realism with slightly mysterious and strange elements to create the sensation of a moment or experience.

Mannerism 1525-1600. A European artistic style with very emotional scenes and distorted figures. This style was a contrast to the calm balance of the High Renaissance.

maquette (mah-KET) A small model of a larger sculpture.

matte (mat) Having a dull texture. Not glossy or shiny.

media Plural of medium. The materials used by an artist and the special techniques that make their use expressive.

medium The material and technique used by an artist to create a work of art. It may also mean the liquid that is mixed with powdered pigments to make paint.

metal shears A heavy-duty scissor-like tool for cutting sheet metal.

Mexican Muralists 1910-1940. Mexican artists who brought back the art of fresco mural painting.

mezzotint (MEZZ-oh-tint) An intaglio printing process in which the surface of a metal plate is textured with a tool with fine metal spikes called a rocker. The ink remains in the small cuts made by the rocker. The print is also called a mezzotint.

middle ground Parts of an artwork that appear to be between objects in the foreground and the background.

miniature Very small compared to the size of the human figure.

Minimal Art A style of late twentieth-century painting and sculpture that stressed the idea of using the minimum number of colors, values, shapes, lines and textures.

mixed media Any artwork that is made with more than one medium.

mobile (MOH-beel) A hanging sculpture with parts that can be moved, especially by the flow of air.

model To form clay or another soft material with the hands. A model can be a person or thing an artist looks at in order to create a work of art. It is also a small copy or image that represents a larger object.

modeling A sculpture technique in which a three-dimensional form is shaped in a soft material such as clay. In drawing, modeling is the use of light and shadow to make something look three-dimensional.

module (MAH-jool) A three-dimensional motif or design. A visual unit that is usually repeated to create a larger design.

mold A hollow shape used to make one or many copies of an object. A mold is filled with a material such as plaster or metal. It is removed when the material hardens into the shape of the mold.

monochromatic (mah-no-crow-MAT-ik) Made of only a single color or hue and its tints and shades.

monoprint A printing process that usually involves creating one print instead of many.

montage (mahn-TAZH) A special kind of collage, made from pieces of photographs or other pictures.

monumental Large or extremely large compared to the size of a human.

mosaic (mo-ZAY-ik) Artwork made by fitting together tiny pieces of colored glass or tiles, stones, paper or other materials. These small materials are called *tesserae*.

motif (moh-TEEF) A single or repeated design or part of a design or decoration that appears over and over again.

movement A way of combining visual elements to produce a sense of action. This combination of elements helps the viewer's eye to sweep over the work in a definite manner.

multi-sensory associations Ideas and feelings that combine two or more sense experiences. For example, we speak of "loud" colors.

mural A large painting or artwork, usually designed for and created on the wall or ceiling of a public building.

museum A place where works of art are displayed, studied and cared for.

Native North American A term used to describe the art and cultural traditions of people who lived in North America before the continent was settled by Europeans and their descendants.

Near Eastern Art 3500-331 B.C. An art historical term used to describe the ancient art of many cultures in the geographic region between India and Greece.

negative shape/space The empty space surrounding shapes or solid forms in a work of art.

Neo-Classicism 1750-1875. A style of art based on interest in the ideals of ancient Greek and Roman art. These ideals were used to express ideas about beauty, courage, sacrifice and love of country.

neutral color A color not associated with a hue—such as black, white, or a gray. Architects and designers call slight changes in black, white, brown and gray neutral because many other hues can be combined with them in pleasing color schemes.

nonobjective art 1917-1932. A style of art that does not have a recognizable subject matter. The subject is the composition of the artwork. It is also known as non-representational art. Nonobjective is often used as a general term for art that contains no recognizable subjects.

oil paint A relatively slow-drying paint made from pigments mixed with an oil base. When the oil dries, it becomes a hard film, protecting the brilliance of the colors.

Op Art 1950-present. A style based on optical (visual) illusions of many types. They are meant to confuse, raise or expand visual sensations, especially sensations of movement.

opaque (oh-PAYK) Not allowing light to go through. You cannot see through an object or a material that is opaque. It is the opposite of transparent.

optical color Color seen by the viewer due to the effect of atmosphere or unusual light on the actual color.

organic Having a quality that resembles living things.

Oriental art A general term for art created in Japan, China and other countries in the Eastern Hemisphere.

outline A line that shows or creates the outer edges of a shape or form. It may also be called a contour.

painterly style A general painting style in which patches of color and visible brushstrokes show. A painterly style allows the viewer to see the movements the artist made in putting on paint.

palette (PAL-let) A tray or board on which colors of paint are mixed.

Palladian (pah-LAY-dee-en) An architectural style or detail based on an Italian house designed by the Renaissance architect, Andrea Palladio.

papier-mâché (PAY-per mah-SHAY) French for "chewed" or "mashed paper." Papier-mâché pulp is a modeling material made by mixing small bits of paper in water and liquid paste. It is quite strong when it dries.

passive Any element of art that seems to be quiet, at rest or not moving.

paste-up A detailed layout of a printed page. A paste-up is prepared so it can be photographed and made into a plate for printing.

pastel A chalk-like crayon made of finely ground color. A pastel is a picture made with pastel crayons. It is also a term for tints of colors.

path of movement Any element of art that seems to lead the eye from one part to another.

pattern A choice of lines, colors or shapes, repeated over and over in a planned way. A pattern is also a model or guide for making something.

Performance Art A form of visual art closely related to theater, but created by persons who have experience in the visual arts.

perspective Techniques for creating a look of depth on a two-dimensional surface.

philosophy of art A general system of ideas for thinking about all parts of art, especially in Western culture. It is also called a theory of art.

Photo-Realism 1970-present. A style of painting in which the distortions and special effects of photography are shown or used for ideas.

photogram An image on photograph paper created without using a camera.

pictograph Simple visual symbols representing things, ideas or stories.

picture plane The surface of a two-dimensional artwork.

pigment Any coloring matter, usually a fine powder, mixed with a liquid or binder to make paint, ink, dyes or crayons.

pinch method A method of hand-building pottery or sculpture by pressing, pulling and pinching clay or other soft materials.

pluralistic More than one style and tradition of art existing at the same time.

point of view The angle from which the viewer sees an object or a scene.

Pointillism (POYN-till-iz-im) 1880-1900. A style of painting developed by Seurat in which small dots of color are placed side by side. When viewed from a distance, the eye tends to see the colors as mixed.

polychrome (PAH-lee-crome) Made or decorated with several colors.

Pop Art 1950-Present. A style of art based on subject matter from popular culture (mass media, commercial art, comic strips, advertising).

portfolio A sample of an artist's works (or photographs of them) put together in a book for others to review.

portrait Any form of art expression that features a specific person or animal.

positive space/shape The objects in a work of art, not the background or the space around them.

Post-Impressionism 1880-1900. An art history term for a period of painting immediately following Impressionism in France. Various styles were explored, especially by Cézanne (basic structures), van Gogh (emotionally strong brushwork), and Gauguin (intense color and unusual themes).

Post-modern Architecture 1970-present. A style of architecture which mixes some styles from the past with more decoration than was typical of the International Style.

potter's wheel A flat, spinning disc on which soft clay is placed and shaped by hand.

Pre-Columbian Art 7000 BC. to about 1500 AD. An art history term for art created in North and South America before the time of the Spanish conquests.

Precisionism 1920-1940. A style name for paintings with definite or precise edges.

primary color One of three basic colors (red, yellow and blue) that cannot be made by mixing colors. Primary colors are used for mixing other colors.

principles of art/design Guidelines that help artists to create designs and control how viewers are likely to react to images. Balance, contrast, proportion, pattern, rhythm, emphasis, unity and variety are examples of principles of design.

print A shape or mark made from a printing block or other object. The block is covered with wet ink and then pressed on a flat surface, such as paper or cloth. Most prints can be repeated over and over again by re-inking the printing block.

progressive pattern or **rhythm** A pattern or rhythm that develops step by step - for example, from smaller to larger or brighter to duller.

proof A trial or practice print.

proportion The relation of one object to another in size, amount, number or degree.

proximity The position of one element compared to others. A chair may be in a distant or close proximity to a table.

pulp Mashed up material known as cellulose mixed with water. Pulp is used to make paper.

Queen Anne A style of English furniture from the early 1700s.

quilting A process of stitching together two layers of cloth with padding between the layers.

radial A kind of balance in which lines or shapes spread out from a center point.

ratio (RAY-shee-oh) The relationship between two or more things in size or quantity. For example, the ratio in height of an object two feet tall to an object one foot tall is 2 to 1.

Realism 1850-1900. A style of art that shows places, events, people or objects as the eye sees them. It was developed in the mid-nineteenth-century by artists who did not use the formulas of Neoclassicism and the drama of Romanticism.

realistic Art that shows a recognizable subject with lifelike colors, textures, shadows and proportions.

recycled paper Paper made from the pulp of other paper.

regular rhythm A visual rhythm of equally spaced and repeated motifs.

relief A three-dimensional form, meant to be seen from one side, in which surfaces project from a background. In high relief, the forms stand far out from the background. In low relief, also known as *bas-relief*, they are shallow.

relief print A print created using a printing process in which ink is placed on the raised portions of the block or plate.

Renaissance (ren-eh-SAHNSS) 1400-1600. French for "rebirth." A period that began in Italy after the Middle Ages. The period was marked by a renewed interest in ancient Greek and Roman culture, science and philosophy, and the study of human beings and their environment. Important Renaissance artists are Leonardo da Vinci, Michelangelo and Raphael.

repeated pattern A design with parts that are used over and over again in a regular or planned way, usually to create a visual rhythm or harmony.

repoussé (ray-poo-SAY) In metal-working, a process in which the design is made by pressing or tapping the metal from the reverse side.

representational Similar to the way an object or scene looks.

reproduction A copy of an image or a work of art, usually by a photographic or printing process.

resist A process in which materials such as oil or wax are used because they will not mix with water. The resist material is used to block out certain areas of a surface that the artist does not want to be affected by dye, paint, varnish, acid or another substance.

rhythm A type of visual or actual movement in an artwork. Rhythm is a principle of design. It is created by repeating visual elements. Rhythms are often described as regular, alternating, flowing, progressive or jazzy.

Rococo (roh-COH-coh) 1700-1800. A style of eighteenth-century art that began in the luxurious homes of the French nobility and spread to the rest of Europe. It included delicate colors, delicate lines, and graceful movement. Favorite subjects included romance and the carefree life of the aristocracy. Watteau is one of the best-known Rococo painters.

Romanesque 1000-1200. A style of architecture and sculpture influenced by Roman art, that developed in western Europe during the Middle Ages. Cathedrals had heavy walls, rounded arches and sculptural decorations.

Romanticism 1815-1875. A style of art that developed as a reaction against Neoclassicism. Themes focused on dramatic action, exotic settings, adventures, imaginary events, faraway places and strong feelings.

rubbing A technique used to transfer the textural quality of a surface to paper. Paper is placed over the surface. The top of the paper is rubbed with crayon, chalk or pencil.

rya (REE-ah) A technique of attaching yarn to warp threads to produce the look of pile in a handwoven artwork.

sans-serif (sann SEH-riff) Simple type and handlettering without decorative tags.

satin stitch An embroidery stitch used to fill in a shape.

scale The size relationship between two sets of dimensions. For example, if a picture is drawn to scale, all its parts are equally smaller or larger than the parts in the original.

School of Paris 1918-1937. An art history term for artists who worked in Paris between World War I and II. They created work in many styles.

score To press a pointed instrument into but not through paper or thin cardboard. Scoring creates a line where the paper will bend easily. In clay work, artists score grooves or make scratches into surfaces of clay that will be joined together.

sculpture A work of art with three-dimensions: height, width and depth. Such a work may be carved, modeled, constructed or cast.

seascape Artwork that shows a scene of the sea, ocean, an area near a coast or a large lake.

secondary color A color made by mixing equal amounts of two primary colors. Green, orange and violet are the secondary colors. Green is made by mixing blue and yellow. Orange is made by mixing red and yellow. Violet is made by mixing red and blue.

self-portrait Any work of art in which an artist shows himself or herself.

selvedge (SELL-vidge) The uncut edge of a woven fabric.

serif (SEH-riff) Type and handlettering with tags.

serigraphy (sehr-IG-raff-ee) A print, also known as a silkscreen print, made by squeezing ink through a stencil and silk-covered frame to paper below.

shade Any dark value of a color, usually made by adding black.

shading A gradual change from light to dark. Shading is a way of making a picture appear more realistic and three-dimensional.

shape A flat figure created when actual or implied lines meet to surround a space. A change in color or shading can define a shape. Shapes can be divided into several types: geometric (square, triangle, circle) and organic (irregular in outline).

shed The opening in the warp through which the weft is passed. A shed is formed when certain warp threads are raised or lowered, usually using a heddle.

shuttle In weaving, a tool that holds the weft thread so that it can be easily put through the warp.

silhouette (sill-ooh-ETTE) An outline of a solid shape filled in completely, like a shadow. In a silhouette you cannot see inside details.

silkscreen See *serigraphy*.

silverpoint A drawing made with a thin silver wire. The silver darkens or tarnishes to create a dark line.

simplicity The practice of using similar elements or a small number of different elements in an artwork.

simulated texture The use of a pattern to create the look of a three-dimensional texture on a two-dimensional surface.

sketch A drawing done quickly to show the important parts of a subject. A sketch may be used to try out an idea or to plan another work.

slab A form that is solid, flat and thick. It is also a thick, even slice of clay, stone, wood or other material.

slip Clay, combined with water or vinegar, to form a thick liquid. Slip is used on scored areas to join pieces of clay together.

slogan A short, attention-getting phrase used in advertising.

slurry A fiber-based pulp mixed with water in order to make paper.

Social commentary art Art of any time period or culture that has a strong political or social message.

soft sculpture Sculpture made with fabric and stuffed with soft material.

soft-edge In two-dimensional art, shapes with fuzzy, blurred outlines that have a soft quality.

space The empty or open area between, around, above, below or within objects. Space is an element of art. Shapes and forms are made by the space around and within them. Space is often called *three-dimensional* or *two-dimensional*. Positive space is filled by a shape or form. Negative space surrounds a shape or form.

special effects A term used in theater, film, and video work for any technique that creates illusions.

sphere A round, three-dimensional geometric form, such as a ball or globe.

split complement A color scheme based on one hue and the hues on each side of its complement on the color wheel. Orange, blue-violet, and blue-green are split complementary colors.

spoke In basketry, a bendable reed that is used like a warp thread.

squeegee (SKWEE-jee) A tool for pushing ink through a silkscreen. It has a rubber blade and a handle.

stabile (STAY-beel) A sculpture made of large forms that do not move or hang.

stained glass Pieces of brightly colored glass held together by strips of lead to form a picture or design. Stained glass was first used in Romanesque churches and became a major part of Gothic cathedrals.

statue (STAH-choo) A sculpture, especially of a person or animal, that stands up by itself.

stencil (STEN-sill) A paper or other flat material with a cut-out design that is used for printing. Ink or paint prints through the cut-out design onto the surface below.

still life Art based on an arrangement of objects that are not alive and cannot move, such as fruit, flowers or bottles. The items are often symbols for abstract ideas. A book, for example, may be a symbol for knowledge. A still life is usually shown in an indoor setting.

stipple A technique of marking a surface with dots, often used for shading.

stitchery A general term for artwork created with needles, thread or yarn, and cloth. A stitch is one in-and-out movement of a threaded needle.

straight A line or edge that goes in one direction without bending.

studio The place where an artist or designer works.

style The result of an artist's means of expression – the use of materials, design qualities, methods of work, and choice of subject matter. In most cases, these choices show the unique qualities of an individual, culture or time period. The style of an artwork helps you to know how it is different from other artworks.

subject A topic or idea shown in an artwork, especially anything recognizable such as a landscape or animals.

subtractive method A technique of making sculpture in which a form is created by cutting, carving away, or otherwise removing material.

Super Realism 1970-present. A style of drawing and painting that tries to look as real as a photograph, and includes the distortions of color, scale and detail found in photographs. It is also called *Photo-Realism.*

support The background to which other materials are attached.

Surrealism 1924-1940. A style of art in which dreams, fantasy and the human mind were sources of ideas for artists. Surrealist works can be representational or abstract. Unrelated objects and situations are often set in unnatural surroundings.

symbol Something that stands for something else; especially a letter, figure or sign that represents a real object or idea. A red heart shape is a common symbol for love.

symmetrical A type of balance in which both sides of a center line are exactly or nearly the same, like a mirror image. For example, the wings of a butterfly are symmetrical. It is also known as *formal balance.*

tactile (TAK-tile) The qualities and feelings experienced from the sense of touch.

technical qualities The visual features and effects created by an artist's special way of using a medium.

technique (tek-NEEK) An artist's way of using art materials to create a desired artwork. A technique can be an artist's own way to create artwork (a special kind of brushstroke) or a step-by-step procedure (how to create a crayon-resist).

tempera A slightly chalky, opaque paint that thins in water. The paint is made by mixing pigments with a glue, egg yolk (egg tempera) or another binder. School poster paint is a type of tempera. Egg tempera was popular before the invention of oil painting.

tesserae (TESS-er-ah) Small pieces of glass, tile, stone, paper or other materials used to make a *mosaic.*

textile Artworks made from cloth or fibers such as yarn. These may include weaving, tapestry, stitchery, appliqué, quilting and printed fabrics.

texture The way a surface feels (actual texture) or how it may look *(simulated texture).* Texture can be sensed by touch and sight. Textures are described by words such as rough, silky, pebbly.

theme The subject or topic of a work of art. For example, a landscape can have a theme of the desire to save nature, or to destroy nature. A theme such as love, power or respect can be shown through a variety of subjects. The phrase "theme and variations" usually means several ways of showing one idea.

three-dimensional Artwork that can be measured three ways: height, width, depth or thickness. Three-dimensional artwork is not flat. Any object that has depth, height and width is three-dimensional.

thumb-nail sketch A small sketch. Several are usually made on one page.

tie-dye A textile technique in which the design is created by tightly tying or binding the cloth and dipping it in dye. The tied or bound areas do not soak up the colored dye.

tint A light value of a pure color, usually made by adding white. For example, pink is a tint of red.

tjanting tool (CHAN-ting tool) A tool used in batik. It holds hot wax and has a small spout that allows the wax to flow onto the fabric.

traditional art Artwork created in almost the same way year after year because it is part of a culture, custom or belief.

translucent (tranz-LOO-sent) Allowing light to pass through so that the exact colors and details of objects behind the surface cannot be clearly seen.

transparent Allowing light to pass through so that objects behind the surface can be clearly seen. Transparent is the opposite of *opaque.* Window glass, cellophane and watercolors are transparent.

trompe l'oeil (trump l'oy) French for "fool the eye" or "trick of the eye." A term for paintings in which objects look so three-dimensional that the viewer may wonder if the image is a painting or real objects.

two-dimensional Artwork that is flat or measured in only two major ways: height and width.

typography The art of designing and artistically using alphabet forms.

unity A feeling that all parts of a design are working together as a team.

value An element of art that means the darkness or lightness of a surface. Value depends on how much light a surface reflects. *Tints* are light values of pure colors. *Shades* are dark values of pure colors. Value can also be an important element in works of art in which there is little or no color (drawings, prints, photographs, most sculpture and architecture).

vanishing point In a perspective drawing, one or more points on the horizon where parallel lines that go back in space seem to meet.

variation, variety A change in form, shape, detail or appearance that makes an object different from others. As a principle of design, variation is the use of different lines, shapes, textures, colors and other elements of design to create interest in a work of art.

vertical A line that runs straight up and down from a level surface. Vertical lines are at right angles to the bottom edge of a paper or canvas. They are parallel to the side of the paper or canvas.

Victorian Name for a decorative use of elements from many earlier styles. The name is connected to art created during the time of Queen Victoria's reign in England.

video art Non-commercial artwork created by or using television technology.

viewfinder A small window in a camera (or a rectangle cut into a piece of paper) that an observer looks through in order to see or plan the composition of a picture.

viewpoints The sides and angles from which an object can be seen. If you put a cup and saucer on a table you can move around the table to have different viewpoints of the cup and saucer.

visible color spectrum Lightwaves of color that the human eye can see. It is made up of the primary and secondary hues, which are often arranged in a circle on a "color wheel."

visual environment Every visible thing that surrounds you, usually divided into two groups: the natural environment (trees, flowers, water, sky, rocks) and the human-made or built environment (buildings, roads, bridges, automobiles).

visual texture The illusion of a three-dimensional textured surface. Something that looks like it has a textured surface but is actually smooth.

void An empty space.

warm colors Warm colors are so-called because they often are associated with fire and the sun and remind people of warm places, things and feelings. Warm colors range from the reds through the oranges and yellows.

warp A series of tight threads stretching lengthwise on a loom, through which the weft is woven.

wash A very thin coat of paint. It is also a color that has been thinned with water (or turpentine, if the paint is oil). When it is brushed on paper, canvas or board, the surface beneath can still be seen.

watercolor A transparent paint made by mixing powdered colors with a binder and water. The term also means an artwork done with this paint.

weaver An artist who creates woven art. In basketry, a weaver is a bendable reed or spoke that has the same use as a weft thread in weaving.

weaving The process of interlocking threads or fiber-like materials to create a fabric. These threads are usually held at right angles to one another on a loom.

wedging A process used to get air bubbles out of clay. Wedging can be done by kneading clay or by cutting clay in half with a wire, then slamming the pieces onto a hard surface.

weft In weaving, thread or other fiber-like materials that are woven across the warp from side to side.

wet media Drawing and painting materials which have a fluid or liquid ingredient.

woodcut A type of relief printing in which areas of the wood block are carved away; ink is put on the raised surface and it is printed onto paper when pressure is applied.

workboard In macramé, a surface on which you can place macramé cords while knotting them.

Bibliography

Aesthetics and Appreciation

Belves, Pierre, and François Mathey. *Enjoying the World of Art.* New York: Lion Books, 1966.

—, *How Artists Work: An Introduction to Techniques of Art.* New York: Lion Books, 1968.

Borreson, Mary Jo, *Let's Go To An Art Museum.* New York: G.P. Putman, 1960.

Browner, Richard, *Look Again.* New York: Atheneum, 1962.

Brommer, Gerald F., *Discovering Art History.* Worcester, MA: Davis Publications, Inc., 1988.

—, *Drawing: Ideas, Materials and Techniques.* Worcester, MA: Davis Publications, Inc., 1972.

Campbell, Ann. *Paintings: How to Look at Great Art.* New York: Franklin Watts, 1970.

Chase, Alice Elizabeth, *Looking at Art.* New York: Thomas Y. Crowell, 1966.

Feldman, Edmund B., *Thinking About Art.* Englewood Cliffs, NJ: Prentice-Hall, 1985.

Franc, Helen M., *An Invitation to See: 125 Paintings from The Museum of Modern Art.* New York: Museum of Modern Art, 1973.

Fraser, Kathleen, *Stilts, Somersaults, and Headstands: Game Poems Based on a Painting by Pieter Bruegel.* New York: Atheneum, 1968.

Holme, Bryan, ed., *Drawings to Live With.* New York: Viking Press, 1966.

—, *Pictures to Live With.* New York: Viking Press, 1960.

Levy, Virginia K., *Let's Go To The Art Museum.* New York: Harry N. Abrams, Inc., 1988.

MacAgy, Douglas, and Elizabeth MacAgy, *Going for a Walk with a Line: A Step into the World of Modern Art.* New York: Doubleday, 1959.

Moore, Jane Gaylor, *The First Book of Paintings.* New York: Franklin Watts, 1960.

—, *The Many Ways of Seeing: An Introduction to the Pleasures of Art.* New York: Franklin Watts, 1961.

Munro, Eleanor C., *The Golden Encyclopedia of Art.* New York: McGraw-Hill, 1967.

Paul, L., *The Way Art Happens.* New York: Ives Washburn, 1963.

Art History

Ayer, Margaret, *Made in Thailand.* New York: Alfred A. Knopf, 1964.

Baldwin, Gordon C., *Strange People and Stranger Customs.* New York: Norton, 1967.

Batterberry, Michael, *Chinese and Oriental Art, Discovering Art Series.* New York: McGraw-Hill, 1968.

Baumann, Hans, *The Caves of the Great Hunters.* New York: Pantheon, 1962.

Broder, Patricia J., *American Painting and Sculpture.* New York: Abbeville, 1981.

Chase, Judith, *Afro-American Art and Crafts.* New York: Van Nostrand Reinhold, 1971.

Dockstader, Frederick, *Indian Art of the Americas.* New York: Museum of the American Indian, 1973.

Fine, Elsa H., *The Afro-American Artist.* Miami, FL: Brown Book, 1973.

Glubok, Shirley, *Art and Archaeology Series: The Art of Ancient Egypt, The Art of Ancient Greece, The Art of Ancient Rome, The Art of the Etruscans, The Art of the New American Nation, The Art of the North American Indian, The Art of the Southeastern Indian, The Art of the Spanish in the United States and Puerto Rico.* New York: Harper & Row Junior Books.

—, *The Art of Lands in the Bible.* New York: Atheneum, 1963.

—, *The Art of the Eskimo.* New York: Harper & Row, 1964.

Golden, Grace, *Made in Iceland.* New York: Alfred A. Knopf, 1958.

Helfman, Elizabeth S., *Celebrating Nature: Rites and Ceremonies Around the World.* New York: The Seabury Press, 1969.

Hunt, Kari, and Bernice W. Carlson, *Masks and Mask Makers.* New York: Abingdon Press, 1961.

Janson, Horst W., and Dora J. Janson, *The Story of Painting for Young People.* New York: Harry N. Abrams, Inc., 1962.

Kahane, P.P., *Ancient and Classical Art.* New York: Dell Publishing Co., 1969.

La Farge, Oliver, *The American Indian.* Special Edition for Young Readers. New York: Golden Press, 1973.

Lewis, Samella S. and Rugh G. Waddy, *Black Artists on Art*, 2 vols. Los Angeles, CA: Hancraft, 1969-1971.

Madian, Jon, *Beautiful Junk: A Story of the Watts Towers.* Boston, MA: Little, Brown, 1968.

Marshall, Anthony D., *Africa's Living Arts.* New York: Franklin Watts, 1970.

Quirarte, Jacinto, *Mexican American Artists.* Austin, TX: University of Texas, 1973.

Ruskin, Ariane, *Story of Art for Young People.* New York: Pantheon, 1964.

Sayer, Chloe, *Crafts of Mexico.* New York: Doubleday, 1977.

Smith, Bradley, *Mexico: A History in Art.* Garden City, NY: Doubleday, 1971.

Spencer, Cornelia, *How Art and Music Speak to Us.* New York: John Day, 1968.

—, *Made in China.* New York: Alfred A. Knopf, 1952.

—, *Made in India.* New York: Alfred A. Knopf, 1953.

—, *Made in Japan.* New York: Alfred A. Knopf, 1963.

—, *Made in the Renaissance.* New York: E.P. Dutton, 1963.

Stribling, Mary Lou, *Crafts From North American Indian Art: Techniques, Designs and Contemporary Applications.* New York: Crown Publishing, 1975.

Taylor, Barbara H., *Mexico: Her Daily and Festive Breads.* Claremont, CA: Creative Press, 1969.

Toor, Frances, *Made in Italy.* New York: Alfred A. Knopf, 1957.

Torwell, Margaret and Hans Nevermann, *African and Oceanic Art.* New York: Harry N. Abrams, Inc., 1968.

Willett, Frank, *African Art.* London: Thames and Hudson, 1985.

Individual Artists

Adams, Ansel, *The Portfolios of Ansel Adams.* Boston, MA: Bulfinch Press, 1981.

Aitchison, Dorothy, *Great Artists.* Series (*Rubens, Rembrandt, Vermeer, Leonardo, Raphael, Michelangelo* and others). Loughborough, England: Wells and Hepworth.

Bruzeau, Maurice, *Alexander Calder.* New York: Harry N. Abrams, Inc., 1979.

Freedgood, Lillian, *Great Artists of America.* New York: Thomas Y. Crowell, 1963.

Goldstein, Ernest, *Let's Get Lost in a Painting.* Series (*Winslow Homer, Edward Hicks, Grant Wood* and others). Dallas, TX: Garrard Publications, 1982.

Hollmann, Clide, *Five Artists of the Old West.* New York: Hastings House, 1965.

Lisle, Laurie, *Portrait of an Artist: A Biography of Georgia O'Keeffe.* New York: Seaview Books, 1980.

Locher, J.C., ed., *The World of M.C. Escher.* New York: New American Library, 1972.

Peare, Catherine O., *Rosa Bonheur: Her Life.* New York: Henry Holt, 1956.

Ripley, Elizabeth, *Botticelli: A Biography.* New York: Lippencott, 1960.

—, *Dürer.* New York: Lippencott, 1958.

—, *Goya.* New York: Walck, 1956.

—, *Leonardo da Vinci.* New York: Walck, 1952.

—, *Rembrandt.* New York: Walck, 1955.

—, *Rubens.* New York: Walck, 1957.

Rockwell, Norman, *Norman Rockwell: My Adventures As An Illustrator.* New York: Harry N. Abrams, Inc., 1988.

Willard, Charlotte, *Famous Modern Artists from Cézanne to Pop Art.* New York: Platt & Munk, 1971.

Subjects and Themes in Art

Coen, Rena N., *Kings and Queens in Art.* Minneapolis, MN: Lerner Publications, 1965.

Cornelius, Sue, and Chase Cornelius, *The City in Art.* Minneapolis, MN: Lerner Publications, 1966.

Downer, Marion, *Children in the World's Art.* New York: Lothrop, Lee & Shepard, 1970.

Forte, Nancy, *The Warrior in Art.* Minneapolis, MN: Lerner Publications, 1966.

Gracza, Margaret Young, *The Bird in Art.* Minneapolis, MN: Lerner Publications, 1966.

—, *The Ship and the Sea in Art.* Minneapolis, MN: Lerner Publications, 1965.

Harkonen, Helen B., *Circuses and Fairs in Art.* Minneapolis, MN: Lerner Publications, 1965.

—, *Farms and Farmers in Art.* Minneapolis, MN: Lerner Publications, 1965.

Kainz, Luise C., and Olive L. Riley, *Understanding Art: Portraits, Personalities, and Ideas.* New York: Harry N. Abrams, Inc., 1967.

Medlin, Faith, *Centuries of Owls in Art and the Written Word.* Norwalk, CT: Silvermine, 1967.

Shay, Rieger, *Gargoyles, Monsters, and Other Beasts.* New York: Lothrop, Lee & Shepard, 1972.

Shissler, Barbara, *Sports and Games in Art.* Minneapolis, MN: Lerner Publications, 1966.

Zuelke, Ruth, *The Horse in Art.* Minneapolis, MN: Lerner Publications, 1965.

Careers in Art

Brommer, Gerald F., and Joseph Gatto, *Careers in Art: An Illustrated Guide.* Worcester, MA: Davis Publications, Inc., 1984.

Fixman, Adeline, *Your Future in Creative Careers.* New York: Richard Rosen Press, 1978.

Holden, Donald, *Art Career Guide.* New York: Watson-Guptill Publications, 1983.

Elements and Principles of Design

Brommer, Gerald F., ed., *Concepts of Design.* Series: Books on elements of design (*Line, Color and Value, Shape and Form, Space, Texture*) and principles of design (*Balance and Unity, Contrast, Emphasis, Movement and Rhythm, Pattern*). Worcester, MA: Davis Publications, Inc., 1975.

Collier, Graham, *Form, Space and Vision: An Introduction to Drawing and Design.* Englewood Cliffs, NJ: Prentice-Hall, 1985.

Grillo, Paul, *Form, Function and Design.* New York: Dover Publications, 1975.

Hart, Tony, *The Young Designer.* New York: Frederick Wayne, 1968.

Helfman, Elizabeth S., *Signs and Symbols of the Sun.* New York: Houghton Mifflin, 1974.

Keisler, Leonard, *The Worm, The Bird, and You.* New York: William R. Scott, 1961.

—, *What's in a Line.* New York: William R. Scott, 1962.

Kirn, Ann, *Full of Wonder.* Cleveland, OH: World, 1959.

Kohn, Bernice, *Everything Has a Shape and Everything Has a Size.* Englewood Cliffs, NJ: Prentice-Hall, Inc. 1966.

Landa, Robin, *An Introduction to Design: Basic Ideas & Applications for Painting on the Printed Page.* Englewood Cliffs, NJ: Prentice-Hall, 1983.

Lauer, David A., *Design Basics.* New York: Holt, Rinehart and Winston, 1985.

Malcolm, Dorothea C., *Design: Elements and Principles.* Worcester, MA: Davis Publications, Inc., 1972.

Meilach, Dona Z., Jay Hinz and Bill Hinz, *How to Create Your Own Designs: An Introduction to Color, Form and Composition.* New York: Doubleday, 1975.

Ocvirk, Otto, et al., *Art Fundamentals Theory and Practice.* Dubuque, IA: William C. Brown, 1985.

O'Neill, Mary, *Hailstones and Halibut Bones.* Garden City, NY: Doubleday, 1973.

Strache, Wolf, *Forms and Patterns in Nature.* New York: Pantheon, 1973.

Wolff, Janet, and Bernard Owett. *Let's Imagine Colors.* New York: E.P. Dutton, 1963.

Specific Art Forms

Architecture/Design in Everyday Life

Bardi, P.M., *Architecture: The World We Build.* New York: Franklin Watts, 1972.

Brustlein, Daniel, *The Magic Stones.* New York: McGraw-Hill, 1957.

Crouch, Dora P., *History of Architecture: Stonehenge to Skyscrapers.* New York: McGraw-Hill, 1985.

Hiller, Carl E., *Caves to Cathedrals: Architecture of the Worlds' Religions.* Boston, MA: Little, Brown, 1974.

—, *From Tepees to Towers: A Photographic History of American Architecture.* Boston, MA: Little, Brown, 1974.

Kahn, Ely J., *A Building Goes Up.* New York: Simon & Schuster, 1969.

McAlester, Virginia, and Lee McAlester, *A Field Guide to American Houses.* New York: Alfred A. Knopf, 1984.

Paine, Roberta M., *Looking at Architecture.* New York: Lothrop, Lee & Shepard, 1974.

Pile, John F., *Interior Design.* New York: Harry N. Abrams, Inc., 1988.

Camera/Electronic Arts

Bolognese, Don *Mastering the Computer for Design and Illustration.* New York: Watson-Guptill Publications, 1988.

Bruandet, Pierre, *Photograms.* New York: Watson-Guptill Publications, 1973.

Cooke, Robert, *Designing with Light On Paper and Film.* Worcester, MA: Davis Publications, Inc., 1969.

Eastman Kodak Co., *Movies and Slides without a Camera.* Rochester, NY: 1972.

Editors of Time-Life Books, *Computer Images.* Alexandria, VA: Time-Life Books, 1986.

Halas, John, *The Technique of Film Animation.* Woburn, MA: Focal Press, 1976.

Holter, Patra, *Photography Without A Camera.* New York: Van Nostrand Reinhold, 1972.

Kinsey, Anthony, *How To Make Animated Movies.* New York: Viking, 1970.

Laybourne, Kit, *The Animation Book: A Complete Guide to Animated FilmMaking – From Flip-Books to Sound Cartoons.* New York: Crown Publishing, 1979.

Lewell, John, *Computer Graphics: A Survey of Current Techniques and Applications.* New York: Van Nostrand Reinhold, 1985.

Linder, Carl, *Film Making: A Practical Guide.* Englewood Cliffs, NJ: Prentice-Hall, 1971.

O'Brien, Michael F., and Norman Sibley, *The Photographic Eye: Learning to See with a Camera.* Worcester, MA: Davis Publications, Inc., 1988.

Piper, James, *Personal Film Making.* Englewood Cliffs, NJ: Prentice-Hall, 1975.

Sandler, Martin W., *The Story of American Photography: An Illustrated History for Young People.* Boston, MA: Little, Brown, 1975.

Wilson, Mark, *Drawing with Computers: The Artist's Guide to Computer Graphics.* New York: The Putnam Publishing Group, 1985.

Computer Software

Adobe Illustrator. Mountain View, CA: Adobe Systems.

Cricket Draw. Malvern, PA: Cricket Software.

Fontographer (computer fonts). Plano, TX: Altsys Corp.

Pixel Paint. San Diego, CA: Silicon Beach Software.

Thunderscan (optical scanner and software). Orinda, CA: Thunderware.

Video Works (animation software). Chicago, IL: MicroMind.

Crafts

Ceramics

Nelson, Glenn C., *Ceramics: A Potter's Handbook.* New York: Holt, Rinehart and Winston, 1984.

Nigrosh, Leon I., *Claywork: Form and Idea in Ceramic Design.* Worcester, MA: Davis Publications, Inc., 1986.

Sapiro, Maurice, *Clay: Handbuilding.* Worcester, MA: Davis Publications, Inc., 1983.

—, *Clay: The Potter's Wheel.* Worcester, MA: Davis, 1978.

Sprintzen, Alice, *Crafts: Contemporary Design and Technique.* Worcester, MA: Davis Publications, Inc., 1986.

Fibers

Beinecke, Mary Ann, *Basic Needlery Stitches on Mesh Fabrics.* New York: Dover Publications, 1973.

Belfer, Nancy, *Designing in Batik and Tie Dye.* Worcester, MA: Davis Publications, Inc., 1972.

Brown, Rachel, *The Weaving, Spinning, and Dying Book.* New York: Alfred A. Knopf, 1984.

Guild, Vera P., *Good Housekeeping New Complete Book of Needlecraft.* New York: Hearst Books, 1971.

Held, Shirley E., *Weaving: A Handbook of the Fiber Arts.* New York: Holt, Rinehart and Winston, 1978.

Leeming, Joseph, *Fun with String.* New York: Dover Publications, 1974.

Meilach, Dona Z., *Contemporary Batik and Tie-Dye: Methods, Inspiration, Dyes.* New York: Crown Publishing, 1973.

Rainey, Sarita R., *Weaving without a Loom.* Worcester, MA: Davis Publications, Inc., 1966.

Termini, Maria, *Silkscreening.* Englewood Cliffs, NJ: Prentice-Hall, 1978.

Jewelry

Ferre, R. Duane, *How to Make Wire Jewelry.* Radnor, PA: Chilton, 1980.

Howell-Koehler, Nancy, *Soft Jewelry, Design, Techniques and Materials.* Englewood Cliffs, NJ: Prentice-Hall, 1977.

Meilach, Dona Z., *Ethnic Jewelry: Design and Inspiration for Collectors and Craftsmen.* New York: Crown Publishing, 1981.

Other Crafts

Betts, Victoria, *Exploring Papier-Mâché.* Worcester, MA: Davis Publications, Inc., 1966.

Flower, Cedric, and Alan Fortney, *Puppets: Methods and Materials.* Worcester, MA: Davis Publications, Inc., 1983.

Johnson, Pauline, *Creating with Paper.* Seattle, WA: University of Washington Press, 1966.

Rothenberg, Polly, *Creative Stained Glass.* New York: Crown Publishing, 1973.

Toale, Bernard, *The Art of Papermaking.* Worcester, MA: Davis Publications, Inc., 1983.

Drawing

Brommer, Gerald F., *Discovering Art History.* Worcester, MA: Davis Publications, Inc., 1988.

—, *Drawing: Ideas, Materials and Techniques.* Worcester, MA: Davis, Publications, Inc., 1972.

—, *Exploring Drawing.* Worcester, MA: Davis Publications, Inc., 1988.

Gatto, Joseph, *Drawing Media and Techniques.* Worcester, MA: Davis Publications, Inc., 1987.

Hogarth, Paul, *Creative Pencil Drawing.* New York: Watson-Guptill Publications, 1981.

Kaupelis, Robert, *Learning to Draw.* New York: Watson-Guptill Publications, 1966.

James, Jane H., *Perspective Drawing: A Point of View.* Englewood Cliffs, NJ: Prentice Hall, 1988.

—, *Perspective Drawing.* Englewood Cliffs, NJ: Prentice-Hall, 1981.

Mittler, Gene, and James Howze, *Creating and Understanding Drawings.* Emporia, IL: Bennett Knight, 1988.

Probyn, Peter, ed., *The Complete Drawing Book.* New York: Watson-Guptill Publications, 1970.

Sarnoff, Bolo, *Cartoons and Comics.* Worcester, MA: Davis Publications, Inc., 1988.

Sheaks, Barclay, *Drawing Figures and Faces.* Worcester, MA: Davis Publications, Inc., 1987.

Watson, Ernest W., *The Art of Pencil Drawing.* New York: Watson-Guptill Publications, 1985.

Graphic Design

Barnicoat, John, *A Concise History of Posters 1870-1970.* New York: Oxford University Press, 1972.

Cataldo, John W., *Lettering.* Worcester, MA: Davis Publications, Inc., 1983.

Gatta, Kevin, G. Lange and M. Lyons, *Foundations of Graphic Design.* Worcester, MA: Davis Publications, Inc., 1990.

Gluck, Felix, ed., *Modern Publicity.* New York: MacMillan, 1979.

Herdeg, Walter, ed., *Graphis Posters Eighty-Six: The International Annual of Poster Art.* New York: Watson-Guptill Publications, published annually in October.

Horn, George F., *Cartooning.* Worcester, MA: Davis Publications, Inc., 1965.

—, *Contemporary Posters: Design and Techniques.* Worcester, MA: Davis Publications, Inc., 1976.

—, *Posters: Designing, Making, Reproducing.* Worcester, MA: Davis Publications, Inc., 1964.

Painting and Collage

Ashurst, Elizabeth, *Collage.* London: Marshall Cavendish Publication, 1976.

Brommer, Gerald F., *Transparent Watercolor: Ideas and Techniques.* Worcester, MA: Davis Publications, Inc., 1973.

Lassiter, Barbara Babcock, *American Wilderness: The Hudson River School of Painting.* New York: Doubleday, 1980.

Masterfield, Maxine, *Painting the Spirit of Nature.* New York: Watson-Guptill Publications, 1984.

Porter, Albert W., *Expressive Watercolor Techniques.* Worcester, MA: Davis Publications, Inc., 1982.

Sheaks, Barclay, *Drawing and Painting the Natural Environment.* Worcester, MA: Davis Publications, Inc., 1974.

—, *Painting with Acrylics: From Start to Finish.* Worcester, MA: Davis Publications, Inc., 1972.

Szabo, Zoltan, *Creative Watercolor Techniques.* New York: Watson-Guptill Publications, 1974.

Printmaking

Andrews, Michael F., *Creative Printmaking.* Englewood Cliffs, NJ: Prentice-Hall, 1963.

Brommer, Gerald F., *Relief Printmaking.* Worcester, MA: Davis Publications, Inc., 1970.

Gorbaty, Norman, *Printmaking with a Spoon.* New York: Van Nostrand Reinhold, 1960.

Ross, John, and Clare Romano, *The Complete Relief Print.* New York: Free Press, 1974.

Stoltenberg, Donald, *Collograph Printmaking.* Worcester, MA: Davis Publications, Inc., 1975.

Sculpture

Brommer, Gerald F., *Wire Sculpture and Other Three-Dimensional Construction.* Worcester, MA: Davis Publications, Inc., 1968.

Gendusa, Sam, *Building Playground Sculpture and Homes.* Grand Rapids, MI: Masters Press, 1974.

Hall, Carolyn Vosburg, *Soft Sculpture.* Worcester, MA: Davis Publications, Inc., 1981.

Johnston, Mary G., *Paper Sculpture.* Worcester, MA: Davis Publications, Inc., 1965.

Meilach, Dona Z., *Contemporary Art with Wood: Creative Techniques and Appreciation.* New York: Crown Publishing, 1968.

—, *Soft Sculpture and Other Soft Art Forms.* New York: Crown Publishing, 1974.

Meilach, Dona Z., and Melvin Meilach, *Box Art: Assemblage and Construction.* New York: Crown Publishing, 1975.

Morris, John, *Creative Metal Sculpture: A Step-By-Step Approach.* Encino, CA: Glencoe Publishing, 1971.

Paine, J., *Looking at Sculpture.* New York: Lothrop, Lee & Shepard, 1968.

Reed, Carl, and Joseph Orze, *Art From Scrap.* Worcester, MA: Davis Publications, Inc., 1973.

Rogers, L.R., *Relief Sculpture.* New York: Oxford University Press, 1974.

Zelanski, Paul, *Shaping Space.* New York: Holt, Rinehart and Winston, 1987.

Index

A/P mark (artist's proof), 189
aborigines of Australia, 69
abstract art, 100, 116, 118, 100, 119, 120-122, 168
abstract expressionism, 58, 117
Abularach, Rodolfo, *Vinac*, 25
acrylic paints, 164
"action" painting, 118
Adinkra symbols, 212
advertising art, 14
aesthetic perception, 6, 43-46
African-American art museums, 87
African art, 38, 66-67, 242
afterimage, 27 air-brushing, 213
Albers, Josef, *Homage to the Square: Apparition*, 118
Allen, Ralph, *Untitled*, 118
American quilt, 34
Anderson, Lena, *Linnea in Monet's Garden*, 213
Angkor Wat temple, Cambodia, 73
animation, 14, 15, 232, 233
Anuszkeiwicz, Richard J., *Inward Eye*, 20; *Radiant Green*, 28
applique, 281
Archambault, Louis, *The Call*, 120
Architecture, Bauhaus style, 108; careers in, 10-11; Chicago school, 98; colonial period, 90-95; twentieth century, 108-111
Armstrong, Robb, 18
Arp, Jean, *Birds in an Aquarium*, 251
art criticism, 5, 43, 47-58
art critics, 17
art directors, 14, 112
art museums, 16, 17
African-American, 87
Art Nouveau, 270
art research, 16

art shows, 9, 114
art theories, 58
Artis, William, *Michael*, 253
Asawa, Ruth, *Number 9*, 88
assemblages, 122, 250
Atwood, Charles B., 103
Audubon, John James, *Common Raven*, 96
Auerbach, Leon, *Objects of Bright Pride*, 12
Avery, Milton, *Boats in Yellow Sea*, 25
Aztec culture, 65

balance in design, 34, 49, 249
Balla, Giacomo, *Dynamism of a Dog on a Leash*, 35
Bane, McDonald, *D-1-67*, 22
basketweaving, 279-280
Baskin, Leonard, *Sorrowing and Terrified Man*, 187
Bass, Saul, 203
batik dying of cloth, 283
Bauhaus style, 108, 201
Bearden, Romare, *She-Ba*, 87
Beaux Arts style, 102, 103
Behrens, Peter, 201
Bernini, Gian Lorenzo, *Portrait of a Young Man*, 131
Bertoia, Harry, *I, Group XI*, 195
Bible, Washburn College, 204
Biggers, John, *Sleeping Boy*, 140
Bill, Max, *Construction*, 248
Birnbaum, Dara, *Will-o'-the-Wisp*, 223
Bishop, Isabel, *Waiting*, 135
bisque clay, 273
Blake, William, "*Songs of Innocence and Experience*," 213; *The Tyger*, 213
Blitt, Rita, *Dancing*, 46
"brainstorming," 206
Brancusi, Constantin, *Bird in Space*, 245

Braque, Georges, *Pipe et Raisins*, 56
Brooklyn bridge, 98
Brown, Fred, Blues Series, 4; *The Piano Players*, 4
brushes, 163, 164
Buddhist influence on art, 70, 71, 72, 74, 76, 78
Buonagurio, Toby, *Robot on Panthers*, 266
Burchfield, Charles, *An April Mood*, 50
Burnham, Daniel H., 103

Caldecott Award, 213
Calder, Alexander, *The Arch, 1975*, 120; *Big Red*, 261; *Fish*, 121; kinetic sculpture, 123; *Untitled*, 181
calendars, 214
Callery, Mary, *Amity*, 121
calligraphy, 22, 88, 79, 149, 166
cameras, 227-228
Campbell, Michael J., *Laser Beam: Fantasia*, 222
careers in art, 5-19
caricature, 36
Carr, Emily, *Vanquished*, 89
Carriera, Rosalba, *Self-Portrait Holding Portrait of Her Sister*, 131
cartoons, political, 148
carving, 254-255
Cassatt, Mary, *The Boating Party*, 99; *Mother About to Wash Her Sleepy Child*, 100
Castanis, Muriel, *Standing Hooded Toga I*, 245
Castiglione, Giovanni Batista, *The Angel Announces the Birth of Christ to the Shepherds*, 195
casting, 256
Catlett, Elizabeth, *Mother and Child*, 87

Centennial Exposition, Philadelphia, 103
ceramics, 273-277. *See also* Clay
Cezanne, Paul, *The Basket of Apples*, 168; *The Bridge of Trois-Sautets*, 164
chalks, 137, 165, 166, 167
charcoal, 136
Charlot, Jean, *Mother and Child*, 181
Chase-Riboud, Barbara, *Le Manteau*, 269
chiaroscuro, 25, 160
Chicano art movement, 86
Chinese art, 62, 74, 245, 249, 277
Chippendale furniture, 92, 93
Christo, *Running Fence*, 245
Chryssa, *The Gates to Times Square*, 244
Church, Frederic Edwin, *The Icebergs*, 97
cinematography, 230
clay. *See also* ceramics; sculpture material, 252, 253; use in jewelry, 285 ; working with, 273-277; coil method, 274; pinch pot, 274-275; slabs, 275; wheel-thrown, 276-277
Close, Chuck, *Phil/Fingerprint II*, 130
Cochran, Jane, *Prairie Icon*, 281
collages, 137, 166, 167, 222
color, 24-29, 44, 160, 162, 208, 248
color wheel, 24, 162
Colungo, Alejandro, *Children Playing St. George*, 119
community art shows, 9
computers, 10, 12, 14, 15, 16, 17, 123, 150, 174, 236, 237, 224-225
concave forms, 248

convex forms, 248

Cooley, Sally, *Skunk Cabbage*, 123

Copley, John Singleton, *Portrait of Paul Revere*, 93

corporate identity, 200, 201, 216

Cosindas, Marie, *Conger Metcalf Still Life*, 125

Cozens, Alexander, 134

crafts, 7, 16, 267-291

crayons, 137, 166

creativity, 5-7

Csuri, Charles, 224-225, 237

Cubist painting, 114, 116

curators, museum, 16

da Vinci, Leonardo, 45; *Lily*, 135

Dada, 173, 259

Dali, Salvador, 115; *Paranoiac-Astral Image*, 58

Daubigny, Charles-Francois *Landscape*, 145

de Goya, Francisco, *The Sleep of Reason Produces Monsters*, 180; *The Third of May*, 37

de Kooning, Willem, *Landscape Abstract*, 22

de Riviera, Jose, *Brussels Construction*, 248

decalcomania, 31, 173

Degas, Edgar, *Head of a Roman Girl*, 142; *The Jockey*, 99; *La La at the Circus*, 172

Demuth, Charles, *I Saw the Figure Five in Gold*, 116

design, 21-41

Diebenkorn, Richard, *Sink*, 139

Disney, Walt, 230

Douglas, Aaron, *Noah's Ark*, 162

Dow, Arthur Wesley, 22, 34 , 88

drawing, 9, 129-153; approaches to, 135; geometry and, 147; ideas for, 134; imaginative, 149; interpretive skills and, 148; media for, 136-137; social commentary and, 148; techniques for, 130-131; three-dimensional, 147

drypoint in printmaking, 186

Durer, Albrecht, *Durer's Mother*, 138; early printmaker, 179 *Four Heads*, 131; *Self-portrait*, 134

Dworkowitz, Alan, *Bicycle II*, 147

Eades, Luis, *Salute to Dawn, the Rosy-Fingered*, 36

Eakins, Thomas, *The Gross Clinic*, 101

Eames, Charles, *LCM chair*, 112

Eastman, George and movies, 230

Eberle, Abastenia, *St. Leger Roller Skating*, 120, 258

Edison, Thomas, 230

Egyptian civilization, 57, 66, 243, 257

electronic arts, 221-241

elements of design, color, 24-29, 160; light, 24; line, 22-23, 138, 160; pattern, 141; shape and form, 23, 140, 160; space, 32-33, 160; texture, 30-31, 141, 160; value, 24, 160

emphasis in design, 37, 49

engobe, 273, 277

engraving, 186-187

environmental art, 10-11, 123

Erickson, Arthur, 88, 110, 111

Ernst, Jimmy, *Face*, 138

Ernst, Max, *Europe After the Rain*, 173

Erpelding, Curtis, chairs, 54

Escher, M. C., *Dewdrop*, 141

Estes, Richard, *Drugstore*, 119, 156

Feininger, Lyonel, *Manhattan Canyon*, 136

felt markers, 165

fiber arts, 278-283

Fibonacci, system of proportion, 36

fine artists, definition of, 16

Fisch, Arline, necklace, 286

Fish, Janet, *Three Pickle Jars*, 30

Flack, Audrey, *The Artist with Self-Portrait*, 16

Folk art and crafts, 7

foreshortening, 143, 145

found objects, 250 , 279

Frankenthaler, Helen, *Cravat*, 118

Fransconi, Antonio, *Weighing Fish*, 178

French, Daniel Chester, *Republic*, 103

fresco painting, 86, 155

frottage, 31

Fuller, R. Buckminster, geodesic dome, 111

furniture, 92, 93, 95

Futurist painting, 114

Gabor, Denis, inventor of holography, 238

Garzoni, Giovanni, *Dish of Broad Beans*, 168; *Plate of White Beans*, 54

Geddes, Steve, *Roller Rhino*, 7

geodesic dome, 111

geometry in drawing, 147

Georgian style architecture, 92

Giacometti, Alberto, *Man Painting*, 37

Gillespie, Dorothy, *Untitled*, 244

Girard, Alexander, *Eden*, 28

Glaser, Milton, designer, 216

glazes, 31, 252, 273, 277

Goeritz, Mathias, T*owers without Function*, 122

Golden Mean, 36

Gordin, Sidney, *Construction, Number 10*, 249

graphic design, 201-219

Greco-Roman sculpture, 244, 253

Greek revival style architecture, 95, 108

Greene, Gertrude, *White Anxiety*, 251

Greenough, Horatio, *George Washington*, 97

Griffin, Marion Mahoney, 89

Grippe, Peter, *The City*, 252

Gris, Juan, *Portrait of Max Jacob*, 142

Grooms, Red, *Ruckus Taxi*, 196

Gropius and Breuer, James Ford house, 109

Gruber, Aaronel deRoy, *Steelcityscape* I, 260

Guggenheim museum, 109

Gutenberg, Johann, 201

Gwathmey, Robert, *Across the Fields*, 181

Haleen, Brentano, *Ancient SW*, 174

Hanson, Duane, *Tourists II*, 54, 123

happenings, art, 123

Harlem renaissance, 87

Harmon, Byron, *Banff Springs Hotel and Bow Falls from Tunnel Mountain*, 98

Harnett, William, *Old Models*, 161

Harrison, Jeremy, *Shower Bath*, 180

haute couture, 13

Hawens, Jan, *Bird*, 272

Hayden, Palmer, *56th Street*, 169

Helmuth, Yamasaki, and Leinweber, St. Louis airport terminal, 88

Hepworth, Barbara, *Two Figures*, 23

Herbst, Gerhardt, Collar and Bracelet, 284

Heriot, George, *War Dance, Performed by One or Two Persons*, 96

heritage-based art, 119

Herrera, Carmen, *Green and Orange*, 163

Herrera, Jose Ines, *Death Cart or La Dona Sebastiana*, 86

high tech sculpture, 123

Hindu religion, influence on art, 70-73

Hiroshige, 76

Hispanic influence on North American art. See North American art, hispanic influence

Hobbema, Meindert, *The Avenue Middleharnis*, 32

Hockney, David, *Stephen Spender-Mas St. Jerome II*, 222; Untitled, 174

Hokusai, Katsushika, 132-133

Hollenbeck, Roger, *Bright Eyes*, 193

holography, 238

Holt, Nancy, *Stone Enclosure: Rock Rings*, 123

Hood, Raymond, Chicago Tribune Tower, 108

Hopper, Edward, *The City*, 169

Hoxie, Vinnie Ream, *Abraham Lincoln*, 89

hue, 24, 163

human creativity, 6

Ifuago offeratory bowl, Phillipines, 244

illuminated manuscripts, 201, 202, 211, 214

illustration, 213 images, 7

impasto, 30

Imperial Palace, Beijing, 74

Impressionism, 155

Incan culture, 65

Indian art, 70-71

Indiana, Robert, *The Great American Dream: New York*, 137; *Love*, 203

industrial design, 13

inks, 136, 165, 187

intaglio prints, 180, 186, 194

interior designers, 11

invention, 7

Islamic art, 79

Japanese art, 76-77

Jeffreys, C. W., *Autumn Oak and Beech*, 100

jewelry-making, 284-285

John, Gwen, *A Corner of the Artist's Room in Paris*, 170

Johns, Jasper, *Cups 4 Picasso*, 23; *Flags*, 26

Johnson, Philip, 32

Kannon, Nyoirin, 130

Keesey, Masumi, photogram, 228

Kenzan, Ogata, *Evening Glory*, 76

Khmer architecture, 73

Kingman, Dong, *The El and Snow*, 88

Kittredge, Susan, *Bird, Parakeet, Peanuts, Ukulele, and Cookies*, 259

Klee, Paul, *Twittering Machine*, 137

Knoll, Florence, 113

K'o-Ssu tapestry, 35

Kollwitz, Kathe, *Bread!*, 148; 182-183; *Never Again War!*, 183; *The Parents*, 183; *The Prisoners*, 183;

Seed for Sowing Shall Not Be Ground, 182; *Self-portrait*, 130, 182

Korean art, 78

Korin, Ogata, *Plum Blossom*, 77

Krebs, Rockne, *Sky Bridge Green*, 123

Kruer, Diane, *Sweeties Piece*, 275

landscape architects, 10-11

landscape painting, 114, 169, 96

Lange, Dorothea, *Migrant Mother*, 124

Lariviere, Blair J., 277

lasers, 221, 222, 238

Latrobe, Benjamin H., United States Capitol, 94

layout in graphic design, 207

Le Parc, Julio, *Continual Mobile, Continual Light*, 261

letterforms, 206, 202, 210, 209

Levine, Marilyn, I, 259

Lichtenstein, Roy, I, 180; *Bull Profile Series*, 184; *Forget It, Forget It*, 117

Lin, Maya Ying, Vietnam Veterans Memorial, 10

line, in drawing, 138; expressive use of, 138; implied, 22; in painting, 160; quality of, 22; in three-dimensional space, 22

linoleum prints, 188-189

Lipton, Seymour, *Imprisoned Figure*, 121

lithograph prints, 181, 186

Loewy, Raymond, 112

logos, 12, 14, 201, 203, 205, 216

Long, Jeff, *Flotsam and Jetsam*, 3

looms, 278-279

Louis XVI style architecture, 95

Loyd, Dick, 14

Lozowick, Louis, *New York*, 148

Lundeberg, Helen, *Tree Shadows*, 27

MacDonald-Wright, Stanton, *Conception Synchrony*, 106

Machu Picchu, Peru, 64

macrame, 282

Maloof, Sam, rocking chair, 268

Mann, Thomas, *Dog Box Neckpiece*, 285

maquettes, 262

Marin, John, *Lower Manhattan*, 156

Martanez, Rafael, poster, 209

Matisse, Henri, *Jazz, The Burial of Pierrot-Plate VIII*, 192; *Purple Robe and Anemones*, 157; *The Red Room (Harmony in Red)*, 29

Mayan culture, 65

Mayo, Noel, designer, 13

media, mixed, 166-167

Melanesian art, 68

Mexican art, 86, 96

Michelangelo, *The Pieta*, 57; *Studies for the Libyan Sibyl*, 146

Micronesian art, 68

Mills, Clark, *General Andrew Jackson*, 97

Ming dynasty, China, 74

Mitchell, Joan, Ladybug, 171

mobiles, 121, 261

modeling for sculpture, 252

Modersohn-Becker, Paula, *Self-portrait*, 172

Mohican art, 65

Monet, Claude, 159-159; *Grainstack, Sunset*, 29, 159; *Haystacks, End of Day, Autumn*, 159; *Rouen Cathedral, West Facade*, 44, 158; *Rouen Cathedral, West Facade, Sunlight*, 44, 158; *Water Lillies*, 99

monoprints, 195

montage, 8, 102, 124, 166, 167, 235

Moore, Charles, Piazza D'Italia, 111

Moore, Henry, *King and Queen*, 56; *Pink and Green Sleepers*, 166

Mora, Francisco, *Tree of Life*, 30

Morse, Samuel F. B., 102

mosaics, 167, 286-287

mosques, 66, 79

motif, 38, 184, 185

movies, 221, 230, 235

Munch, Edvard, *The Scream*, 29

Murdoch, Peter, paper chair, 52

museums of art, 16, 17, 96, 98, 237

Muybridge, Eadweard, *Attitudes of Animals in Motion*, 99; 230

Nadar, Flix, *Claude Monet*, 158 Nadelman, Elie, *Man in the Open Air*, 120

Nagoya castle, Japan, 76

Native North American art, 83-85; Artic peoples, 84; Blackfoot beaded blanket, 268; Great Plains tribes, 84; Navaho blanket, 82; Pacific Northwest peoples, 84; Southwest tribes, 85

Neito, John, *Turquoise Fancy Dancer*, 157

Neo-expressionism, 119

Neoclassical style, 94, 97

netsuke, 31

Nevelson, Louise, 246-247; *Black Secret Wall*, 39; *Dawn's Wedding Chapel*, 122; *Royal Tide II*, 246; *Sky Cathedral*, 247

Niten, *Bird and Branch*, 149

Nivola, Tino, *Deus*, 256

Nizzoli, Marcello, posters, 207

Noguchi, Isamu, *Big Boy*, 31

Nok culture, 67

nonobjective art, 45, 46, 116, 118

North American art. *See also* Twentieth century art. African influence, 87, 119; Asian influence, 88; early colonial period, 90-91; hispanic influence, 86; industrialization period, 98-102; late colonial period, 92-93; post-colonial period, 94-98; trends up to 1900, 104

Oceanic art, 68-69

O'Keeffe, Georgia, *Radiator Building-Night*, 116; *Summer Days*, 42

Oldenburg, Claes, *Typewrite Eraser as Tornado*, 149
Olmec culture, 65
Op art, 113, 118, 162
Oppenheim, Meret, *Object*, 31
Orozco, Jose Clemente, 86,115
Ossorio, Alfonso, *Root Club #2*, 250
O'Sullivan, Timothy, *Ancient Ruins in the Canyon de Chelle*, 102

package design, 215
Paik, Nam June, video artist, 223
painterly style painting, 160
painting, 155-177
approaches to, 156; brushes for, 163; in colonial period, 91, 93, 96; computer, 174; expressing action in, 171; history of, 155; imagination and fantasy in, 173; in industrialization period, 100-101; media for, 164-165; papers for, 163; principles of design in, 161; self-portraits, 172;
painting, styles of, abstractionism, 116; "action," 118; cubist, 114, 116; futurist, 114; hard-edged, 118, 160; impressionism, 100; landscape, 114, 169; linear, 160; new image, 119; non-objective, 116; "painterly," 160; pointillism, 160, 162; pop, 117; post-impressionism, 76, 114; prairie, 96; precisionism, 116; realism, 100, 114, 115, 119, 169; romanticism, 100, 101 soft-edged, 118, 168;
Palladian style architecture, 92
papermaking, 288
papers, 163, 187, 288
papier-mache, 286
"Parlor" sculpture, 102
pastels, 137, 165, 166
pattern, 38, 49, 141 , 249
Pei, I. M., architect, 111
Pellan, Alfred, *Mascarade*, 116

pens, 136
performance art, 123
Perry, Lila Cabot, *Bridge-Willows-Early Spring*, 136, 161
perspective, 33, 49,144-146, 160
philosophers, art, 17
philosophies of art, 54-60
photo Realism, 119
photograms, 124, 228, 229
photographs, 31, 226
photography, 221, 226-235; basic camera skills, 227; cameraless slides, 229; color, 125; in commercial art, 213; darkroom techniques, 228; design elements in, 234-235; design principles in, 234; as a fine art, 125; ideas for, 233; influence on painting, 102; motion, 102
photojournalists, 14
Piazza D'Italia, New Orleans, 111
Picasso, Pablo, *Baboon and Young, Vallauris*, 45; *Head of a Woman*, 190; *Weeping Woman*, 194
pigments, 164
pixels, 236
planes in sculpture, 248
plaster, 255 , 256
pointillism, 160, 162
Pollock, Jackson, *One (Number 31, 1950)*, 117
Polynesian culture, 69
Pop art, 113, 117, 259
portrait bust, 55, 253
Post-Impressionism painting, 76,114, 155
Post-modern style architecture, 111, 113
postage stamps, 204-205
poster paints, 165
posters, 208-209
Prairie style painting, 96
Pre-Columbian art, 64, 65, 269
principles of design, 7, 34-39; emphasis, 37; pattern, 38; proportion, 36; rhythm, 35; unity, 39; use of in painting, 161; in photography, 234; in sculpture, 249; variety, 39

printmaking, 179-199; methods of, 180-181, 186-187; new directions in, 196
prints, 179-181, 184
proportion, 36, 49, 142-143, 249
pulp, 288
Pyramid of the Inscriptions, Mexico, 65

Qing dynasty, China, 74
Queen Anne style furniture, 92, 93
quilting, 281

Ranganathaswanny temple, India, 70
Raphael, *The Sistine Madonna*, 60; *The Small Cowper Madonna*, 157
Ray, Man, *La Fortune*, 33
realism in painting, 100, 119, 169; the Ashcan school, 114; "magic" realism, 115; photo realism, 115; social realists, 115 in sculpture, 120, 122
Reid, Bill, *The Raven and The First Men*, 84
relief prints, 180, 186, 188-191
relief sculpture, 256, 257
religious influence on art, Buddhist, 70-72, 74, 76, 78; Confucian, 74; Hindu, 70-73; Moslem, 79; and sculpture, 243; Zen, 76, 77, 212
Rembrandt, *The Three Crosses-fourth state*, 185; *The Three Crosses-third state*, 185
Remington, Frederic, *The Bronco Buster*, 258
Renaissance, art of, 155
Renick, Patricia, *Stegowagenvolkssaurus*, 262; *Untitled*, 139
Renwick, James, Saint Patrick's cathedral, 94
repousse, 257
Revere, Paul, silversmith, 93
Revival styles in architecture, 95, 108, 112
Rhodian art, 7th century BC, 269
rhythm in design, 35, 49
Rietvald, Gerrit

The Villa Schroder at Utrecht, 23
Rietveld, Gerrit, red and blue chair, 56
Rivera, Diego, 115, *Detroit Industry*, 86; Mexican mural movement, 86
Roebling, John and A. Washington, Brooklyn bridge, 98
Roger, John, "parlor sculpture", 102
Romanticism, description of, 101; North American painting and, 100
Ruiz, Antonio, *The Bicycle Race*, 114
Ruscha, Edward, *Motor*, 146
Ryder, Albert Pinkham, *The Toilers of the Sea*, 101

Saarinen, Eero, pedestal chair, 112, TWA terminal, 110
safety glasses, 284
safety notes, for batik work, 283; for carving, 254; on chalks, pastels, and charcoal, 137; cutting ceramic tile, 287; on darkroom techniques, 228; on felt-tip pen, 136; for jewely-making, 285; on spray fixative, 137; use of gouges and chisels, 188, 189; use of paints, 251; working with clay, 273; working with grout, 287
Sage, Kay, *I Saw Three Cities*, 172; *The Instant*, 115
Saint-Gaudens, Augustus, *Standing Lincoln*, 102
Saint Patrick's cathedral, 94
San Luis Rey Mission, 86
Santa Prisca church, Mexico, 92
Saul, David, *The Artist's Domain*, 16; *Lee Rexrode*, 16
scale in drawing, 36
Schapiro, Miriam, *I'm Dancing as Fast as I Can*, 171; *Maid of Honor*, 38
Schmiderer, Dorothy, "*The Alphabeast Book*," 210
Scholder, Fritz, *Dartmouth Portrait #10*, 85

Schulkind, Rima, ceramic vase, 275

sculpture, 243-265; action, 258; clay, 251-252; constructed, 122; contemporary, 243; descriptive, 259; and elements of design, 248-249; of familiar objects, 259; free-standing, 244, 251; history of, 243; kinetic, 244, 261; media for, 250; minimal, 122; modular, 260; naturalistic, 97; neoclassical style, 94; "parlor", 102; and principles of design, 249; processes for, 250; relief, 244, 256; religious use of, 243

self-portraits, 130, 172, 182

Selvedge, 279

Senzer, John, fashion photography, 15

serigraphs, 181, 187

Serlio, "De Architettura", 144

Seurat, Georges, Sunday Afternoon on the Island of La Grande Jatte, 48; Two Men Walking in a Field, 145

Sewell, Leo, Penguin, 250

sgraffito, 273, 277

shade, definition of, 25; mixing paint and, 163

shading, 140

Shahn, Ben, Dr. Robert J. Oppenheimer, 131; The Passion of Sacco and Vanzetti, 115

Shaker, crafts, 267 furniture, 95

shapes, figure-ground relationship, 23; free-form, 23; geometric, 23, 139; organic, 23, 139; planes and edges, 139; positive vs negative, 139

Sheeler, Charles, Rocks at Steichen's, 128

Sheere, Sam, Hindenburg Disaster, Lakehurst, New Jersey, 223

shuttle, 279

Signac, Paul, Stonebreakers, 143

silhouettes, 139

silkscreen prints, 181, 187, 192-193

silverpoint drawings, 137

Siqueiros, David Alfaro, 86, 115

sketching, 134

skyscrapers, 98, 112

slides, cameraless, 229

slip clay, 273

slurry, 288

Smiler, Isa, The Archer, 255

Smith, David, Cubi I, 260; Cubi XII, 122; Hudson River Landscapes, 22

Smith, Henry Holmes, Small Poster for a Heavenly Circus, 220

soft-edged (color field) painting, 118, 168

Soleri, Paolo, Arcology-Babel II, 110

Sottsass, Ettore, chair, 53

Southeast Asian art, 72-73

space, 32-33, 249

Spanish influence, North American art. See North American art, hispanic influence

special effects, 14

stabiles, 121

stained glass art, 270

standards for judging art, 56-57

Steichen, Edward, The Flatiron, 124

Stella, Frank, The Butcher Came and Slew the Ox, No. 8, 196

Stencil prints, 181, 192

Stephenson, Jim, whiteware, 277

Stieglitz, Alfred, The Rag Picker, 124

still life painting, 168

stitchery, 281

Stuart, Gilbert, Athenaeum Portrait of George Washington, 96

Sullivan, Louis, Carson-Pirie-Scott store, 98

surrealism, 58, 115, 146, 173, 222

Suydam, Didi, brooches, 272

symbols, 6, 7

Tamayo, Rufino, Self-portrait, 172

T'ang dynasty, China, 74

Tanner, Henry O., The Banjo Lesson, 87

tapestry, 17th century France, 212

teachers, art, 17

tempera paints, 164-167, 187

Temple of the Sun, Peru, 64

Tenochtitlan, Aztec city, 65

Teodora, Gatti-Paolini, Sacco chair, 55

Teotihuacan, Mayan city, 65

tesserae for mosaics, 167, 287

texture, 30-31, 141, 249

The Ashcan School, realism in painting, 114

therapists, art, 17

Thomas Jefferson house, Monticello, 92

Thompson, Bradbury, 204-205

Thomson, Tom, Spring Ice, 114

Tiffany, Louis Comfort, 271 table lamp, 271

tint, 25, 163

Tobey, Mark, Five A. M., 164

Tohaku, Hasegawa, Pine Trees, 60; Pine Wood, 32

Toulouse-Lautrec, Henri, Moulin Rouge, La Goulue, 206

trompe l'oeil, 31, 101, 160

Tsan, Ni, Woods and Valleys of Mount Yu, 211

Tscherney, George, Every Wall is a Door, 209

tusche used in printmaking, 181

Twentieth century art, 107-127; architecture, 108-109, 110-111; design, 112, 113; painting, 114-116, 117-119; photography, 124, 125; sculpture, 120-121, 122-123; typography, 210. See also letterforms

Uelsmann, Jerry, Untitled, 125, 222

underglaze, 277

United States Capitol, 94

unity in design, 39, 49

urban renewal, 11, 110

US Air Force Academy chapel, 35

van der Rohe, Mies, Lake Shore Drive apartments, 109

Van Gogh, Vincent, Boats at Saintes-Maries, 141; His Bedroom in Arles, 170; The Yellow Chair, 154

Vancouver government center, 111

vanishing point, 33, 49, 144-145

Velasco, Joe Maraa Hacienda of Chimalpa, 101

Venturi, Robert, chair, 53

Vermeer, Jan, The Little Street in Delft, 157

videos, 221, 223, 232

Villon, Jacques Dance, 47

visual arts, 2-4, 5, 7

Vitale, Julius, The Defeat Garden, 8

Wade, Erika Davis, Red River, 45 Tulips, 125

Walkowitz, Abraham, Cityscape Abstraction, 156

Walter, Thomas Ustick, United States Capitol dome, 94, 95

Warhol, Andy, cow wallpaper, 113 Marilyn, 181

warp, 279

washes, 136

watercolor, 164, 165

Wawrzonek, John, Spring Sunrise III, 226

wax use in batik, 283

weaving, 278-280

Weber, Max, Rush Hour, New York, 115

wedging clay, 273, 274

weft, 278, 279

Wegner, Hans, Ypsilon chair, 52

Wesselmann, Tom, Drawing 1964 for Still Life No.42, 147

West, Benjamin, The Death of General Wolf, 93

Whistler, James, Arrangement in Black and Gray, 100

White, Charles, Preacher, 130

Wilbur, Roger, bracelet, 269

women artists, 89, 119

Wood, Grant, *American Gothic*, 114
woodblock prints, 179, 186, 188-189
Woodruff, Hale, *The Amistad Slaves on Trial at New Haven*, 57
Wright, Frank Lloyd, Asian influence on, 88; Guggenheim museum, 109; Johnson Wax Building and Research Tower, 108; organic architecture, 109, 110, 112; stained glass window, 34; and Zen influence, 76

Yepa, Filepe, *Unfinished Basket*280, 279
Yi dynasty, Korea, 78
Yin-yang symbol, 212
Yuan dynasty, China, 74

Zen religion, influence on art, 76, 77, 212
Zocalo Cathedral, Mexico, 90
Zucker, Joe, *Kung Fu (Tiger vs. Crane)*, 172

Acknowledgements

Many individuals have helped in developing this book. I am particularly in debt to Davis Publications, Inc. for the able, kind and multi-faceted assistance provided by everyone. In addition, many teachers, students, artists and arts institutions have contributed ideas or images.

I would like to thank the Seven Hills Photo Club, Roger Kerkham and Barbara Caldwell for being particularly helpful in providing photographs for use in this book. I am also grateful to Leon Nigrosh, Alice Sprintzen, Bernard Toale and John Lidstone, who provided additional photographs from their books.

I am especially grateful to Chuck Wentzell and Kathi Prisco for their help in providing images of student artwork. I would also like to thank the students involved for creating such exellent examples to use.

My sincere appreciation to the following people and institutions for permission to reproduce works of art from their collections: Helen Ronan of Sandak; Anita Duquette of the Whitney Museum of Art; Tom Grischkowsky of the Museum of Modern Art; Bernice Steinbaum Gallery; Knoedler Gallery; and countless others, all of whom were essential in producing this book.

Alinari/Art Resource: p.60 (right); Art Resource: p.244 (bottom left); George Roos/Art Resource: p.29 (top); Giraudon/Art Resource: p.214 (left); London/Art Resource: p.166 (top right), p.261 (left); Marburg/Art Resource: p.138 (right); Scala/Art Resource: p.37 (top left), p.54 (bottom), p.100 (top right), p.131 (bottom right), p.168 (left), p.287 (left).

Special thanks to the following schools for providing student artwork:

Academy of the Holy Names, Tampa, FL; Alamaniu School, Honolulu, HI; Archie R. Cole School, East Greenwich, RI; Avon School, Avon, OH; Bancroft School, Worcester, MA; Bandera School, Bandera, TX; Bellevue School, Bellevue, OH; Binictican ES; Blue Earth School, Blue Earth, MN; Bolton School, Arlington, TN; Boylan Central Catholic School, Rockford, IL; Brady School, Pepper Pike, OH; Bryan School, Omaha, NE; Cambridge School, Weston, MA; Chagrin Falls School, Chagrin Falls, OH; Clay School, Carmel, IN; Clinton School, Clinton, MS; Columbus North School, Columbus, IN; Columbus School for Girls, Columbus, OH; Commack School, Commack, NY; Craig School, Janesville, WI; Dater School, Cincinnati, OH; Delta School, Munci, IN; Dennison Fundamental School, Lakewood, CO; DuPont Manual School, Louisville, KY; Edgren School, Japan; F.A. Day School, Newtonville, MA; Fuquay-Varina School, Fuquay-Varina, NC; Gaither School, Tampa, FL; Glasgow School, Alexandria, VA; Greensboro Day School, Greensboro, NC; Guy B. Phillips School, Chapel Hill, NC; Hamilton Southeastern School; Harrison School, Great Bend, KS; Haynes Bridge School, Alpharetta, GA; Heathwood Hall, Columbia, SC; Highlands School, Fort Thomas, KY; Hillside School; Honors Art Program, Saint Louis, MO; Horning School, Waukesha, WI; J. P. Taravella School, Coral Springs, FL; Jefferson School, Oak Ridge, TN; John D. Pierce School, Drayton Plains, MI; John Sevier School, Kingsport, TN; Kinnick School; Kiser School, Greensboro, NC; Kiski School, Saltsburg, PA; Kubasaki School, Okinawa; Kuemper Catholic School, Carroll, IA; L.B. Johnson School, Melbourne, FL; Lake Zurich School, Lake Zurich, IL; Langley School, McLean, VA; Lewis and Clark School, Omaha, NE; Lexington School, Lexington, MA; Logan School, Circleville, OH; Lowville Academy, Lowville, NY; Marblehead School, Marblehead, MA; McKinley School, Honolulu, HI; Middlesex School, Darien, CT; Milton Hershey School, Hershey, PA; Nanakuli School, Waianae, HI; Old Trail School, Bath, OH; Pembroke Hill School, Kansas City, MO; Pike School, Indianapolis, IN; Pioneer Trail School, Olathe, KS; Portia School; Rabun Gap-Nacoochee School, Rabun Gap, GA; Russelville School, Russelville, KY; Sacred Heart School, Kingston, MA; Seoul American School, Seoul, Korea; Shaker Heights School, Shaker Heights, OH; Shaker School, Latham, NY; South School, Cleveland, OH; South Miami School, Miami, FL; St. Agnes Academy; St. Andrew's Episcopal School, Jackson, MS; St. Joseph School, Avon Lake, OH; St. Xavier School, Cincinnati, OH; Suitland Center for the Arts, Forestville, MD; The Baldwin School, Bryn Mawr, PA; Volney Rogers School, Youngstown, OH; Warren Abbott School, West Bloomfield, MI; Webster School, Webster, NY; West Bend School, West Bend, IN; West Bloomfield School, West Bloomfield, MI; Winthrop School, Winthrop, MA; Woonsocket School, Woonsocket, RI; Yorktown School, Yorktown, IN.